# ACKNOWLEDGEMENTS

The editor wishes to thank: Tristan Palmer, who
commissioned this book as part of Berg's – now Bloomsbury's – design
list, and his successors Simon Cowell and Rebecca Barden who have
overseen the development of this book; all of the authors whose work
is included here; and Nic Maffei, Jay and Laurel Lees-Maffei,
Kjetil Fallan, Steven Adams and Peter McNeil,
for their help.

Bloomsbury Visual Arts
An imprint of Bloomsbury Publishing Plc

| | |
|---|---|
| 50 Bedford Square | 1385 Broadway |
| London | New York |
| WC1B 3DP | NY 10018 |
| UK | USA |

www.bloomsbury.com

Bloomsbury is a registered trademark of Bloomsbury Publishing Plc

British Library Cataloguing-in-Publication Data
A catalogue record for this book is available from the British Library.

ISBN: HB: 978-0-8578-5352-3

Library of Congress Cataloging-in-Publication Data
Iconic designs : 50 stories about 50 things / edited by Grace Lees-Maffei.
pages   cm
Includes bibliographical references.
ISBN 978-0-85785-352-3 (hardback)
1. Design. I. Lees-Maffei, Grace, editor of compilation.
NK1175.I29 2014
745.4--dc23   2013045858

Designed by Evelin Kasikov

Cover designed by Alice Marwick

Printed and bound in China

# ICONIC DESIGNS

50 STORIES *about* 50 THINGS

*Edited by*
Grace Lees-Maffei

BLOOMSBURY
LONDON · NEW DELHI · NEW YORK · SYDNEY

# CONTENTS

Introduction: Interrogating
Iconic Design,
6 *Grace Lees-Maffei*

## Part One: Hot in the City

1. **Eiffel Tower, France**
(Gustave Eiffel, 1889)
26 *Claire Jones*

2. **Ford Model T, USA**
(Henry Ford, 1908)
30 *Paul Hazell*

3. **London Underground Diagram, UK**
(Harry Beck, 1931)
34 *Christoph Lueder*

4. **Tuk-Tuk, Italy/Thailand**
(Corradino D'Ascanio, 1948–)
38 *Thomas Brandt*

5. **Sydney Opera House, Australia** (Jørn Utzon, Denmark, 1955–1973)
42 *D.J. Huppatz*

6. **McDonald's Golden Arches Logo, USA**
(Jim Schindler, 1968)
46 *D.J. Huppatz*

7. **Mobility Scooter, USA**
(Allan R. Thieme, 1968)
50 *Nicolas P. Maffei*

8. **Concorde, France/UK**
(Pierre Satre/Sir Archibald Russell, Aerospatiale/BAe, 1969)
54 *Amy E. Foster*

9. **The London Eye, UK**
(Marks Barfield Architects, 1999), *Jilly Traganou and*
58 *Grace Vetrocq Tuttle*

10. **The Palm Islands, Dubai, UAE** (Nakheel Properties, 2001–)
62 *Dolly Jørgensen*

## Part Two: Page Turners and Screen Sirens

11. **Isotype, Austria**
(Otto Neurath, Marie Reidemeister, Gerd Arntz, 1925–1934)
68 *Ellen Lupton*

12. ***Metropolis*, Germany**
(Fritz Lang, 1927)
72 *Nathaniel Robert Walker*

13. **Penguin Books, UK**
(Allen Lane, 1935 and Jan Tschichold, 1947–1949)
76 *Paul Shaw*

14. **Helvetica, Switzerland**
(Max Miedinger and Eduard Hoffmann, 1957)
80 *Kerry William Purcell*

15. ***Sgt. Pepper's Lonely Hearts Club Band* Cover, UK**
(Peter Blake and Jann Haworth, 1967)
84 *Alice Twemlow*

16. **Graphical User Interface (GUI), USA** (Apple, 1984)
88 *Paul Atkinson*

17. **Benetton Advertising Campaigns, Italy**
(Oliviero Toscani, 1986–)
92 *Celia Lury*

18. ***Ray Gun*, USA**
(David Carson, 1992–1995)
96 *Julia Moszkowicz*

19. **eBay.com, USA**
(Pierre Omidyar, 1995)
100 *Ida Engholm*

20. **Facebook, USA**
(Mark Zuckerberg, Eduardo Saverin, Dustin Moskovitz, Chris Hughes, 2003)
104 *Alison Gazzard*

## Part Three:
## Genius at Work

**21. Paper Clip, USA**
(Samuel B. Fay, 1867)
110 *Joe Moran*

**22. Wooton Desk, USA**
(William S. Wooton, 1874),
114 *Kenneth L. Ames*

**23. Incandescent Light Bulb, USA** (Thomas Edison, 1880)
118 *Carroll Pursell*

**24. Streamlined Pencil Sharpener, USA**
(Raymond Loewy, 1933)
122 *Nicolas P. Maffei*

**25. Bic Cristal Pen, France**
(Société PPA, 1950)
126 *Susan Lambert*

**26. Polypropylene Chair, UK**
(Robin Day, 1960–1963)
130 *Susan Lambert*

**27. 'Valentine' Typewriter, Italy** (Ettore Sottsass Jr. and Perry A. King for C. Olivetti S.p.A., 1969)
134 *Penny Sparke*

**28. Rubik's Cube, Hungary**
(Ernő Rubik, 1974)
138 *Kjetil Fallan*

**29. Post-it Note, USA**
(Spencer Silver and Arthur Fry for 3M, 1980)
142 *Alice Twemlow*

**30. Apple iMac G3, USA** (Jonathan Ive for Apple, 1998)
146 *Paul Atkinson*

## Part Four:
## Home Rules

**31. Portland Vase, UK**
(Josiah Wedgwood, 1789)
152 *Glenn Adamson*

**32. Heinz 57 Varieties, USA**
(Henry J. Heinz and L. Clarence Noble, 1869)
156 *Michael J. Golec*

**33. 'Strawberry Thief', UK**
(William Morris, 1883)
160 *Emma Ferry*

**34. Frankfurt Kitchen, Germany**
(Grete Lihotzky, 1926)
164 *Finn Arne Jørgensen*

**35. *Clubsessel*, 'B3' 'Wassily' Chair, Germany**
(Marcel Breuer, 1927)
168 *Clive Edwards*

**36. Princess Telephone, USA** (Henry Dreyfuss for Bell Telephone, 1959)
172 *Lasse Brunnström*

**37. LEGO, Denmark**
(Ole Kirk Christiansen, 1958)
176 *Kjetil Fallan*

**38. Barbie, USA**
(Ruth Handler/Mattel, 1959)
180 *Juliette Peers*

**39. Juicy Salif Lemon Squeezer, Italy/France**
(Philippe Starck, 1990)
184 *Grace Lees-Maffei*

**40. Dyson DC01 Vacuum Cleaner, UK**
(James Dyson, 1993)
188 *Louise Crewe*

## Part Five:
## Personal Effects

**41. Chopsticks, China**
(c. 3,000 BC)
194 *Yunah Lee*

**42. *Zōri* and Flip-Flop Sandal, Japan/World** (n.d.)
198 *Martha Chaiklin*

**43. Levi's Jeans, USA**
(Jacob Davis and Levi Strauss & Co., 1873)
202 *Christopher Breward*

**44. Swiss Army Knife, Switzerland** (Karl Elsener, Victorinox, 1891)
206 *Catharine Rossi*

**45. Brownie Camera, USA**
(Eastman Kodak, 1900)
210 *Marc Olivier*

**46. Chanel Suit, France**
(Coco Chanel, c. 1913)
214 *Hazel Clark*

**47. Coca-Cola Bottle, USA**
(Earl R. Dean, 1915)
218 *Finn Arne Jørgensen*

**48. Hello Kitty, Japan**
(Yūko Shimizu for Sanrio, 1974)
222 *Brian J. McVeigh*

**49. Sony Walkman, Japan**
(Nobutoshi Kihara, 1978)
226 *Juliette Kristensen*

**50. Wind-Up Radio, UK/South Africa**
(Trevor Baylis, 1992)
230 *Gabriele Oropallo*

234 Contributors
237 Select Bibliography
240 Trademark Acknowledgements

# Introduction: Interrogating Iconic Design

*Grace Lees-Maffei*

*'Have you noticed how iconic everything is these days? I'm iconic, you're iconic, we're all iconic.'* [1]

Craig Brown, 'The Word "Iconic"'

By no means reserved for design, today the terms *icon* and *iconic* are not only applied remarkably liberally, but they are also used to describe a surprisingly wide range of things, from the music of Beethoven's Fifth Symphony to the fragrance of Chanel No. 5.[2] Both of these things—a symphony and a scent—may be described, to some extent, as designed, but iconicity is perceived not only in objects, images, sounds and scents which are manufactured. It is a status also accorded to natural products such as the pumpkin,[3] which are rendered iconic not through designers' intentions, but through their consumption (both literal and symbolic) and mediation. And, of course, people are described as icons and as iconic, too, as are their utterances in the form of sound bites.[4] So, anyone wishing to understand what these words mean by looking at the various phenomena to which they are applied would have difficulty finding some common characteristics in their physical properties (although a discussion of some formal properties of iconicity appears later in this introduction). However, it is possible to understand more about iconicity, the quality of being iconic, by referring to the history of icons. This introduction begins with the roots of iconicity and examines identifying characteristics shared by religious icons and design icons alike as functions of reception, representativeness, recognition and reverence. It then goes on to examine the words *icon* and *iconic* and the processes of iconization by which iconicity is conferred. The final part introduces this book, its approaches and its structure of thematic parts and chapters which are representative of wider issues in design discourse.

## ROOTS

Today's design icons form part of a long history of iconicity. Rooted in the Greek *eikon* meaning a 'likeness, image or picture', from the fourth century 'icons became more and more part of the everyday life of the faithful'. By the medieval period a holy eikon was consolidated as 'an image used for Christian purposes' such as saint's portrait, to be venerated, or a narrative icon telling a story.[5] The history of icons forms part of a broader

1 *Craig Brown, 'The Word "Iconic"'*, Mail Online, *26 May 2011*. http://www.dailymail.co.uk/debate/columnists/article-1390885/1-000-things-avoid-die-Part-9.html.

2 *For example,* No. 5 Culture Chanel *curated by Jean-Louis Froment, Palais de Tokyo art museum, Paris, 5 May to 5 June 2013.*

3 *Cindy Ott,* Pumpkin: The Curious History of an American Icon *(Seattle, WA: University of Washington Press, 2012).*

4 *Francis L.F. Lee, 'The Life Cycle of Iconic Sound Bites: Politicians' Transgressive Utterances in Media Discourses',* Media, Culture & Society 34, *no. 3 (2012): 343–58.*

5 *Robin Cormack,* Icons *(London: The British Museum Press, 2007), pp. 7–9.*

history of the religious uses, abuses and rejection of visual images in which some faith groups, such as Judaism, ban any 'graven image' of god or saints and idolatry altogether. Mid-nineteenth century design reformer John Ruskin promoted the special value of handmade artefacts, writing of the 'soul' imbued into the stone-carving in medieval cathedrals through its imperfections, as opposed to machine-made perfection.[6]

Theological debates have examined the extent to which icons are perceived by believers as embodying the saints they depict or whether they are simply souvenirs, reminders or records of a saint's time on earth. This important distinction does not, however, obscure the function and mechanics of icons and iconicity. The power of icons is shown not least in the conflict between iconoclasts and iconophiles in the years from 730 to 843 when damage to icons was declared as heresy by the Orthodox Church.[7] French philosopher Jean Baudrillard has recognized that 'the iconoclasts, who are often accused of despising and denying images, were in fact the ones who accorded them their actual worth, unlike the iconolaters, who saw in them only reflections and were content to venerate God at one remove.'[8] Because icons have the capacity to be viewed as embodying or containing saints, iconoclasm has been compared with the crucifixion; to destroy an icon is to destroy Christ or the saint depicted.[9] Baudrillard has referred to the 'murderous capacity of images': images 'murder' the real by standing in for it. He contrasts this position with Western faith in 'the dialectical capacity of representations as a visible and intelligible mediation of the real' based on the belief that 'a sign could *exchange* for meaning'. Religious icons and the practices which surround them suggest that:

*God himself can be simulated, that is to say, reduced to the signs which attest his existence. Then the whole system becomes weightless, it is no longer anything but a gigantic simulacrum—not unreal, but a simulacrum, never again exchanging for what is real, but exchanging in itself, in an uninterrupted circuit without reference or circumference.*[10]

If, according to Martin Kemp, the icon of Christ defines 'the iconic species' and is 'what biologists call the "type specimen"',[11] then what of the icon today, when sociologist Bjørn Schiermer asserts, following founding French sociologist Émile Durkheim, that 'the religious fetishes are dead' and 'religion, in the sense we normally understand the word, might disappear'?[12] Schiermer makes a claim for the 'quasi-religious forces in modern society—and their presence in secular areas where we are unaware of them, or where we do not expect to find them'.[13] Are today's icons not only replacements for religious icons, but also replacements for religion itself? Olga Kravets and Örsan Örge have written about how iconic 'brands get reformed into repositories of cultural myths and ideals, historical events, achievements and aspirations, particularly when traditional cultural symbols become problematic.'[14] What else can we take from the history of icons as religious artefacts to help us understand today's nominal design icons? Several characteristics of the iconic tradition are also seen in the mass-manufactured commodities that are today deemed iconic.

## IDENTIFYING ICONICITY

### Reception

To label a designed object as iconic places it within a 'canon' of good design, a group of designs also deemed iconic. A canon is a list of saints. The term has been extended into the field of culture so that literature has a canon of celebrated works and design, too,

6 *John Ruskin, 'The Nature of the Gothic', in* The Stones of Venice, *vol. 2,* The Sea Stories, *in E.T. Cook and A. Wedderburn (eds),* The Complete Works of John Ruskin, *vol. 10 (London: George Allen, 1904), pp. 189–269.*

7 *Cormack,* Icons, *p. 9.*

8 *Jean Baudrillard,* Simulations, *trans. Paul Foss, Paul Patton and Philip Beitchman (New York: Semiotext[e], 1983), p. 9.*

9 *Cormack,* Icons, *p. 11.*

10 *Baudrillard,* Simulations, *p. 170.*

11 *Martin Kemp,* Christ to Coke: How Image Becomes Icon *(Oxford: Oxford University Press, 2012), p. 4.*

12 *Bjørn Schiermer, 'Quasi-Objects, Cult Objects and Fashion Objects: On Two Kinds of Fetishism on Display in Modern Culture',* Theory Culture Society *28, no. 1 (2011): 81–102, 88.*

13 *Schiermer, 'Quasi-Objects', 88 cites Émile Durkheim,* Les Formes elementaires de la vie religieuse *(Paris: Quadrige/ PUF, 1998), 298, 625–6.*

14 *Olga Kravets and Örsan Örge, 'Iconic Brands: A Socio-Material Story',* Journal of Material Culture *15 (2010): 205–32, 207.*

has a canon of artefacts which are generally agreed to be excellent and which receive a disproportionate amount of attention. Scholars have been extremely critical of these cultural canons even as they have perpetuated them. If religious icons can *become* the saints they depict, so the application of the terms *icon* and *iconic* today is self-fulfilling. To call a thing iconic sets in train a process of iconization, albeit with the caveat that there must be a shared consensus about iconicity. A designer may consciously set out to produce a distinctive design which will be recognized and be deemed iconic. Some clients brief their architects to produce iconic buildings. Design icons attract significant media attention and therefore have the capacity to function as advertisements for their designers, architects and owners. However, some designers resist the processes of iconicity: ultimately, iconic status is not a product of ideation, design, production or manufacture but, rather, of reception. The extent to which a designed object is considered iconic is a result of how it is presented in media channels such as the design press, the popular press, in film, television, advertising and online, and of how it is consequently perceived by consumers. Iconicity is a matter of *reception*, encompassing mediation and consumption. It is a quality which derives from the people who interact variously with the object, person, sound, image or scent in question.

Jay Boulter and Richard Grusin used the influential term *remediation* to describe the ways in which new media mimic, pay homage to or replace old media.[15] But another sense of the term might refer to the way in which ideas and images are circulated and recirculated, mediated and remediated, in the media. Design is mediated to audiences through such means as advertising and marketing, magazine publicity, museum and gallery display, retail promotions, word-of-mouth and personal recommendation etc. Iconic designs receive more attention during this process of mediation, they occupy the mediation stage for longer and they achieve a higher profile than designs not considered to be iconic. In today's social media world, iconic designs take on lives of their own as they are mediated and re-mediated, like Richard Dawkins's 'memes'.[16] This process does not leave the design in question in a pristine state; rather it picks up further references along the way in the form of homages, imitations, fakes, pastiches and parodies. A rich example is found in Shepard Fairey's iconic Hope poster for Barack Obama's US presidential campaign in 2008. It achieved extensive media exposure, prompting a number of related cover designs for magazines *Time*, *Esquire* (and *Dog's Life*), and the US National Portrait Gallery acquired it for display in Washington DC. However, after protracted legal negotiations, Fairey admitted that he had based it on a 2006 photograph by Mannie Garcia for Associated Press and had lied about, and destroyed evidence of, this fact.[17] The meme continues unabated: Tony Ward adapted Fairey's poster for the British tabloid *Sun* newspaper to express support for UK Prime Minister Conservative David Cameron on General Election day, 6 May 2010 with the headline 'OUR ONLY HOPE'.[18] This meme, this iconic design, has been mediated, remediated and appropriated regardless of political differences, but in all cases the iconic design has remained propagandistic.[19]

Just as memes adapt, or are adapted, as they are circulated and recirculated through the media, so iconic designs are modified by their consumers in various ingenious ways, from adapting or 'hacking' a Swiss Army knife (chapter 44) to hold an office key (see Fig. 0.1) to distressing Levi's jeans (chapter 43) and modifying a tuk-tuk auto rickshaw with painted mud flaps and a variety of other decorative treatments. The most iconic of the multitools—and representative of the civilian adoption of military items such as the Zippo lighter, the Jeep, Dr Marten's boots, and Ray-Ban Aviators—the Swiss Army knife's various combinations now include LED lights, MP3 players and laser pointers. Although modification, whether by consumers or manufacturers, might be seen to damage the iconicity of the objects modified, arguably it contributes to their semantic richness and enriches their iconicity.

15 *Jay David Boulter and Richard Grusin*, Remediation: Understanding New Media, *new edition (Cambridge, MA: MIT Press, 2000).*

16 *Richard Dawkins*, The Selfish Gene, *3rd edition (Oxford: Oxford University Press, 2006 (1976)).*

17 http://en.wikipedia.org/wiki/Barack_Obama_%22Hope%22_poster. *Accessed 14 October 2013.*

18 The Sun, *6 May 2010.* http://www.thesun.co.uk/sol/homepage/news/sun_says/2961073/The-Sun-Says-David-Cameron-is-our-only-hope.html. *Accessed 10 July 2013.*

19 *The HOPE poster exemplifies several techniques examined in a recent exhibition on propaganda: it defined the basic techniques of propaganda as including the establishment of authority and a leadership cult, the exploitation of existing beliefs, an appeal to patriotism, the creation of fear, and the implication that everyone agrees.* Propaganda: Power and Persuasion, *British Library, 17 May to 17 September 2013.*

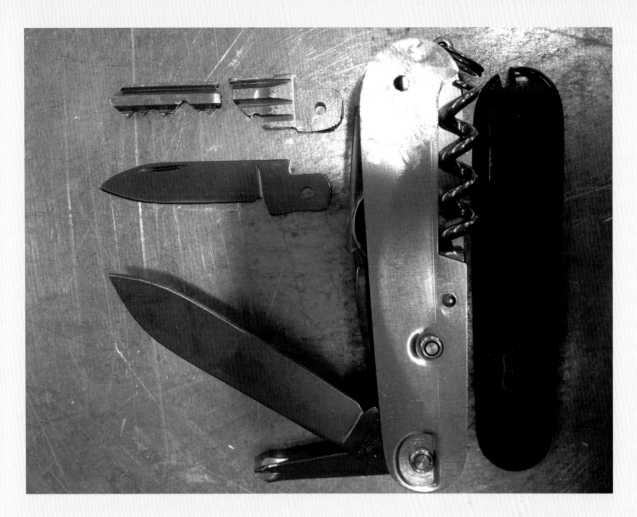

Fig. 0.1   Zoe Laughlin, Pocket knife adapted to hold office door key, 2013. Photograph courtesy of Zoe Loughlin, Institute of Making.

## Representation

We can add to the importance of *reception* the fact that religious icons and design icons are commonly *representative* of an idea of some significance, whether intentionally or as a result of mediation or reception. Icons are symbolic, they traditionally depict a saint or retell a story about a saint or a biblical episode. Art historian Robert Cormack's assessment that '[t]he icon is indeed art, but it is also representative of a way of life' provides a route to understanding design icons specifically.[20] Few design icons are considered to be art, but most are representative of, or associated with, a particular lifestyle which is often aspirational, as this book will show. Ray-Ban Aviators might represent American cool, Italian design is often associated with *la dolce vita*, etc. Each design featured in this book was chosen as a representative of an idea or a story drawn from the history of design or representative of a wider group of designs. For example, the Eiffel Tower (chapter 1) is a globally recognized symbol for Paris and France, echoed in both Blackpool and Las Vegas, which also exemplifies relationships between design and engineering and between iconic design and iconic architecture and, having been built for the 1889 Exposition Universelle in Paris, it also represents the design historical importance of World's Fairs. The final section of this introduction, 'Themes, Parts and Chapters', reviews in more detail some of the ways in which the icons examined in this book are representative.

20  *Cormack,* Icons, *p. 109.*

## Recognition

Icons are always recognizable. In the case of religious icons, they are recognizable as a specific saint or religious story or episode. Icons are recognizable because they are memorable.[21] This has been important in the history of religious icons, which have needed to speak to an illiterate congregation in the past. Stained-glass windows and religious vestments speak as effectively to an illiterate audience as they do to a literate one. The recognition upon which religious and design icons alike rely operates principally without words. Today, when various things are described as iconic, from perfume to people, and from music to mackintoshes (and Macintoshes), iconic designs distinguish themselves from other related objects through particular visual flourishes, such as the whistling bird on Michael Graves's kettle for Alessi. Visual differentiation can secure iconic status: Norman Foster's Swiss Re Building, at 30 St Mary Axe, London (known as the 'Gherkin' for its pickle-like shape) refuses the rectilinear norm for tower blocks, adopting instead an ovoid silhouette. Typography, as the visual manifestation of the linguistic, may be considered iconic (see chapter 14), but the words the typesetter sets are less often celebrated as iconic (see the discussion of semiotics that follows).[22] However, this is not to say that words are not considered iconic; many are, from the Magna Carta and the Declaration of Independence to the Hollywood sign and the currently ubiquitous 'Keep Calm and Carry On'.[23] In one sense, *all* logo and branding design is iconic because it all needs to be recognizable and memorable and, ideally, revered or at least regarded as attractive. When we call an item of product design 'iconic', we attribute to it qualities which are routine in graphic design. The characterization of iconic design as recognizable and memorable fits in with the use of the term 'iconic image' to describe the after-image which remains in the eye when a pattern is briefly seen and then disappears.[24] This lingering image is a metaphor for the impact of iconic design.

Iconic design often relies for its distinction on a unique or unusual shape or silhouette, albeit mass-produced in most cases. Silhouettes emerge in the analysis of design icons as fundamental indicators of iconicity, and the silhouette is a popular mode for communicating visually about design more broadly.[25] The distinctive Eiffel Tower (chapter 1) is one of a number of equally characteristic national identifiers, such as the Sydney Opera House, a UNESCO World Heritage Site (chapter 5) and the London Eye (chapter 9). The latter forms part of a city skyline packed with iconic architecture, such as Tower Bridge, the aforementioned Gherkin, St Paul's Cathedral, Big Ben, the Shard and the Post Office Tower. Just as distinctive, but less famous, is the parabola roof of the former Commonwealth Institute, the new home of the Design Museum.[26] Iconic architecture is also characterized by buildings of extraordinary height combined with distinctive silhouettes, for example, the Seagram Building in Chicago, the Burj Khalifa in Dubai, and Taipei 101. Some iconic buildings have a distinctive footprint, from the Pentagon in Virginia to Tower 42 in London, with a footprint resembling the logo of NatWest bank. The footprint of Dubai's Palm Jumeirah (chapter 10) is visible to air traffic and is perhaps most striking when seen from the international space station (itself an iconic design, generating hundreds of iconic images). Conversely, seen from below, while in flight, an elongated nose cone and ogival wings made Concorde (chapter 8) the pre-eminently iconic aircraft. Its shape may be compared with that of the Shinkansen (Hideo Shima, 1964–), or Bullet Train, named for its tremendous speed and curved nose.

At a smaller scale, McDonald's Golden Arches (chapter 6) function in silhouette as well as in their 'golden' yellow. Philippe Starck's Juicy Salif lemon squeezer (chapter 39) enjoys a silhouette at once utterly distinctive *and* rich in associations (jet age, science fiction, arachnid). Juicy Salif is arguably the epitome of iconic design, due to its infamously

21 John Harvey, 'Seen to be Remembered: Presentation, Representation and Recollection in British Evangelical Culture since the Late 1970s', Journal of Design History 17, no. 2 (June 2004): 177–92.

22 Charles Sanders Peirce, The Essential Peirce, 2 vols, Nathan Houser, Christian Kloesel and the Peirce Edition Project (eds) (Bloomington, IN: Indiana University Press, 1992, 1998); W. K. Wimsatt, Verbal Icon (Lexington: University Press of Kentucky, 1954).

23 B.C. Ardley and M.K. Ardley, 'The Lincoln Magna Carta: Marketing a Document that Changed the World', Marketing Review 10, no. 3 (August 2010): 287–302; Tommy Hilfiger and George Lois, Iconic America, 2nd edition (New York: Rizzoli, 2011), pp. 2–3; Leo Braudy, The Hollywood Sign: Fantasy and Reality of an American Icon (New Haven, CT: Yale University Press, 2011); Bex Lewis, 'The Renaissance of 'Keep Calm and Carry On', The Poster 2, no. 1 (2012): 7–23.

24 Theodore E. Parks, 'Iconic Image', in Richard L. Gregory (ed.), The Oxford Companion to the Mind (Oxford: Oxford University Press, 1987), Oxford Reference Online, http://www.oxfordreference.com/views/ENTRY.html?subview=Main&entry=t159.e436. Accessed 1 July 2013.

25 See, for example the cover design by Victoria Forrest and Namkwan Cho of SMITH® for Penny Sparke, The Genius of Design (London: Quadrille, 2009).

26 On the design and display strategies of the former Commonwealth Institute in Kensington and its transformation in the Design Museum, see Tom Wilson's blog, http://designingcommonwealth.wordpress.com/. Accessed 1 July 2013.

poor functionality and its allusive appearance. Like many other iconic items from Alessi S.p.A, such as Michael Graves's whistling bird kettle, this conversation-starter has achieved success through its suitability as a gift as well as its unique silhouette. Marie Reidemeister, Otto Neurath and Gerd Arntz's Isotype (chapter 11) uses serried ranks of silhouettes. The Coke bottle's curvilinear shape (chapter 47) is ergonomic, keeping a cold drink snug in your hand, recalling the cocoa bean (as opposed to the kola nut) as well as the 'Coke-bottle curves' of one feminine physical ideal. Coke's relationship to the body is invoked by company president Robert Woodruff's oft-repeated 1923 saying that a Coke should always be within an 'arm's reach of desire'.[27] Indeed, Virgin Cola attempted to borrow some of the Coke bottle's iconic power in 1996 with a bottle modelled on the figure of actress Pamela Anderson. The distinctive visual cues of many icons allow them to remain recognizable even as they are mediated in a variety of forms. The popularity and ubiquity of the Hello Kitty identity (chapter 48) depends on branded imagery being applied to more than 20,000 products and counting, which are not independently iconic. They enjoy iconicity by association, as do products featuring Leonardo da Vinci's Mona Lisa, whose ambiguous half-smile has held public attention for five hundred years,[28] and Katsushika Hokusai's 'The great wave off shore of Kanagawa' (c. 1826–33), popularly known as the 'Great Wave', with its distinctive and yet versatile shape (see Fig. 0.2).

27  *Constance L. Hays,* The Real Thing: Truth and Power at the Coca-Cola Company *(New York: Random House, 2005), p. 7.*

28  *'Mona Lisa', in Kemp,* Christ to Coke, *pp. 141–65.*

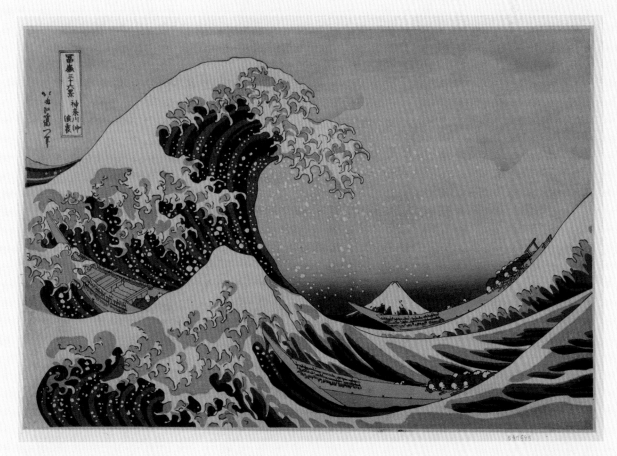

*Fig. 0.2*
*Katsushika Hokusai, Kanagawa oki nami ura (The great wave off shore of Kanagawa), colour woodcut print, 1826–33. Library of Congress.*

The 'Great Wave' is a woodcut, designed to be reproduced in multiple editions. It is part of a series, 'Thirty-Six Views of Mount Fuji', and Hokusai's oeuvre displays a concerted interest in the depiction of waves. As a print, it arguably has no original (the woodcut is not the 'original', it is simply a tool used in the manufacture of the finished print), and it therefore lacks the aura that Walter Benjamin attributed to original works rather than mass manufactured ones.[29] It exemplifies the copy without an original that Baudrillard theorizes in his work on simulacra.[30] And this is surely a distinguishing feature of design, even iconic designs: whether mass-produced or made as part of a limited edition, design icons are very rarely one of a kind (see chapter 24 for an exception). However unique their shapes or other qualities might be, in the case of design icons specifically, this uniqueness is usually shared by all examples of the same design. In the same way that the production of Hokusai's wave woodcut is characterized by multiplicity rather than uniqueness, so Christine Guth explains, its reception is also varied:

*… the image still does not enjoy the same canonical status at home as it does abroad. Its recognition as a masterpiece of world art in Europe and America is bound up with the role that Japanese woodcuts, and Hokusai's in particular, are assigned in the development of European modernism.*[31]

In Japan waves have signified a ring of protection around the island of Japan, and divine agency.[32] As Guth concludes, 'Paradoxically, the aura of alterity that it confers on the products it promotes is dependent on its status as a global icon.'[33]

While not all design icons rely on a distinctive shape or silhouette, all icons should be recognizable, even those that are hidden in plain sight. Some designs are considered iconic because of the extent of their market-saturation. The Bic Cristal pen (chapter 25) has an unremarkable but recognizable shape and is a mainstay of those design surveys which champion everyday design and technical and/or commercial success.[34] Robin Day's polypropylene chair (chapter 26) is also used globally, in classrooms, community centres and canoes, as a result of its low cost and durability, while its curves and colours have helped to make it iconic. Some objects are iconic because of their rarity value and high prices; they hark back to an earlier age of handmade goods produced by expert craftspeople. Others goods are iconic partly because they are affordable and widely available, associated with mass production and consumer culture. The fifty icons examined in this book are all recognizable, whether through exposure and sheer ubiquity (sameness) or due to a unique shape or other distinctive formal device (difference).

## Reverence

A final connection between religious icons and contemporary design icons is that both are *revered*, whether as embodiments or depictions of religious import or as cultural artefacts regarded as excellent. The designs featured in this book have all enjoyed considerable success, critically or in terms of their longevity, and are therefore revered to a greater or lesser extent. Describing a person or thing as iconic is, usually, praise. Ubiquity is a quality of many of the icons examined in this book; it goes hand in hand with fame and recognition. However, the ubiquity which results from copying risks turning icons into clichés. Icons and clichés have their high media profiles in common, but the former are approved and the latter are dismissed.[35] The production, mediation and consumption of imitations of iconic designs is seen by some members of the design cognoscenti to cheapen or otherwise threaten the original designs and designers, as shown in *Elle Decoration* editor Michelle Ogundehin's Get Real campaign with Sir Terence Conran and the Conran Shop. The campaign succeeded in

29 Walter Benjamin, 'The Work of Art in the Age of Mechanical Reproduction', in Hannah Arendt (ed.), Illuminations: Essays and Reflections (New York: Schocken Books, 1968).

30 Baudrillard, Simulations, 1983.

31 Christine M. E. Guth, 'The Local and the Global: Hokusai's Great Wave in Contemporary Product Design', Design Issues 28, no. 2 (Spring 2012): 16–29.

32 Christine Guth, 'Hokusai's Great Waves in Nineteenth-Century Japanese Visual Culture', Art Bulletin 93, no.1 (2011): 468–86, 468.

33 Guth, 'The Local', 29.

34 Paola Antonelli, Humble Masterpieces: 100 Everyday Marvels of Design (London: Thames and Hudson, 2005), p. 69; Jonathan Woodham, 'Bic "Crystal" [sic] Ballpoint Pen', in Volker Albus, Reyer Kras and Jonathan M. Woodham (eds), Icons of Design: The 20th Century (London: Prestel, 2004), pp. 106–7.

35 See Alice Rawsthorn, 'When Cliché Grows Out of Distinction', NYTimes.com, 2 July 2012. http://www.nytimes.com/2012/07/02/arts/02iht-design02.html?_r=0.

amending UK copyright laws to protect designers so that '"artistic" designs of manufactured goods (including certain furniture, lighting and jewellery) created prior to 1987 would now be protected from unauthorized copying.'[36] But, however harmful fakes are to the business of design, they are also manifestations of desire and indexes, therefore, of iconicity.

Icons are not revered without exception, however. In some contexts the adjective *iconic* can be used in a derogatory way. It can be regarded as unfashionable to be too noticeable in design: it is not desirable to be seen to be straining for recognition. Both design that typifies the qualities associated with iconic design and the word itself have been the subject of some criticism from design and architecture critics, sociologists, environmentalists and advocates and practitioners of sustainable design, among others. (For an example, see Jilly Traganou and Grace Tuttle's discussion of the London Eye, chapter 9.) This criticism may well increase as more and more people tire of the overextension of the terms *icon* and *iconic* and as these terms fall foul of the perpetual motion of fashion, to be replaced by new buzzwords.[37] In the meantime, *icon* and *iconic* are still used as terms of reverence.

## WORDS

The *Oxford English Dictionary* defines *icon* as: 'an image, figure, or representation; a portrait; a picture'; 'a monumental figure; a statue', 'a small symbolic picture of a physical object on a VDU screen, esp. one that represents a particular option and can be selected to exercise that option' (chapter 16); in Eastern Christianity, a 'representation of some sacred personage, in painting, bas-relief or mosaic, itself regarded as sacred, and honoured with a relative worship or adoration'; and in philosophy, 'icon' has a semiotic function as a sign. In semiotic theory, pioneered by Charles S. Peirce and Ferdinand de Saussure, iconic signs resemble the thing or idea being signified, such as a scale model. They are distinguished from indexical signs, in which a part stands in for the whole (for example, a pen for literacy and, by extension, reason) and symbolic signs, in which meaning derives from a learned convention rather than any inherent resemblance, such as the word *tree* for the thing, tree.[38]

Iconic signs to have become design icons include Milton Glaser's rebus I ♥ NY, a logo for the New York State Department of Economic Development (1977) termed 'the Coke bottle of graphic design' by Kemp,[39] Paul Rand's Eye-Bee-M poster for the Golden Circle Award announcement (1981), national flags, road signage and Mark Allen's weather symbols for the BBC. Icons in the semiotic sense are not the primary focus of this book, but examples discussed here range from Marie Reidemeister, Otto Neurath and Gerd Arntz's Isotype (International System of Typographic Picture Education, c. 1935), which communicates complex data through simplified, standardized pictograms (chapter 11) to computer 'desktop' icons (chapter 16) and the Portland Vase viewing ticket (chapter 31). While the urban myth that McDonald's Golden Arches (1962) represent an 'M' made of French fries is persuasive— in which case the sign is iconic, not symbolic—D.J. Huppatz relates an architectural root in chapter 6. With 'billions and billions served' the Arches symbolize not only the USA and fast food but also globalization and 'McDonaldization', in sociologist George Ritzer's critiques of the increasingly homogenous nature of global culture.[40]

In 2001, the *OED* added a new meaning for *icon*: 'A person or thing regarded as a representative symbol, esp. of a culture or movement; a person, institution, etc., considered worthy of admiration or respect'.[41] The quotations provided in the *OED* as exemplars of the new usage of the word *icon* range in date from 1952 to 2000, and all concern the United States. Iconic design is dependent upon a historically specific understanding of design based on the heightened appeal of so-called 'designer' goods in increasingly consumerist

36 http://www.conranshop. co.uk/get-real/. *Accessed 17 July 2013. As I write, the bill awaits royal assent. UK Parliament, Intellectual Property Bill [HL] 2013–14,* http://services. parliament.uk/bills/2013-14/ intellectualproperty.html. *Accessed 11 April 2014.*

37 *When children develop language, they may display what linguists call 'overextension', the use of a single term to describe a broad category of things, so that, for example, all four-legged animals are called 'dogs' (underextension is the opposite).*

38 *Daniel Chandler,* Semiotics: The Basics, *2nd edition (London: Routledge, 2007), pp. 36–7. See also Thomas A. Sebeok, 'Iconicity',* MLN *91, no. 6 (December 1976): 1427–56.*

39 *Kemp,* Christ to Coke, *p. 109.*

40 *George Ritzer,* The McDonaldization of Society, *6th edition (Thousand Oaks, CA: Sage Publications, 2010).*

41 *OED Online, 'icon, n.', June 2013, Oxford University Press,* http://www.oed. com/view/Entry/90879? redirectedFrom=icon&. *Accessed 27 June 2013.*

Western societies during the final decades of the twentieth century. From the late 1970s and into the 1980s, designer goods from Gloria Vanderbilt's jeans to Calvin Klein's underpants popularized an idea of design among mass consumers as something produced by recognizable designers or personalities or under the auspices of well-known brand names. In Britain in the 1980s, design was politicized by Thatcherism as a tool of business and promoted for its benefits in driving sales, as it had been in 1930s America. The legacy of this approach is seen in today's UK Design Council which aims to place 'design at the heart of creating value by stimulating innovation in business and public services' and publicizes success stories of its work with business.[42]

*Iconography* is 'the description or illustration of any subject by means of drawings or figures … also, the branch of knowledge which deals with the representation of persons or objects by any application of the arts of design'.[43] Cultural historian Peter Burke has described iconology as the historical study of 'the meaning of images, a visual hermeneutics' which gained ground around 1900 as a 'reaction against the stress, in the art criticism of the later 19th century, on form as opposed to content'. A subsequent turn away from the iconographic emphasis on content followed.[44] In the most recent study of contemporary icons, Kemp is concerned only with 'static' icons and 'flat representations', in other words, still images rather than film or three-dimensional objects. He distinguishes between 'general' icons, such as the lion and the heart, and 'specific' icons, encompassing brands such as Coke and the face of Che Guevara.[45] Launched as a health tonic containing cocaine and caffeine in the 1890s (and now cocaine-free and available with or without caffeine), it is the Coke bottle (designed in 1915), the dynamic ribbon device logo and the serif 'Coke' logo that are iconic rather than the product, a concentrated syrup bought by bottling plants around the world.

*Iconic Designs* deals primarily with branded goods from the period 1850 to the present, but generic type forms can achieve iconic status too. Most icons discussed in this book are specific, but general icons examined include chopsticks and flip-flops. Chopsticks (chapter 41) are used across East Asia with etiquette varying between regions. While huge quantities of used disposable chopsticks represent a waste and sustainability issue, some people follow a traditional practice of carrying their own chopsticks with them. Based on traditional Japanese zōri sandals (chapter 42), with fabric straps attached to soles made variously of rice straw, wood, or cloth, cheaply mass-produced flip-flop sandals were popularized in the West after World War II, with branded versions ranging from Havaianas (Brazil, 1962) to the 'Fit-Flop' (UK, 2007), which references the Masai Barefoot Technology sole (Switzerland, 1996).

So much for what the words *icon* and *iconic* mean, how are they *used*? Rather than signifying inherent formal qualities, these increasingly ubiquitous and now relatively long-standing buzzwords seem to meet a need for praising and—ironically, given their overextension—distinguishing whatever is deemed to be excellent and peerless. They are victims of their own success in expressing what people want to say about design, among other things. Logically, iconicity should imply singularity and be an accolade reserved for only the very best, but in practice media discourse is crowded with icons.

The use of the word *icon* resembles that of the term *genius* in that differences of opinion exist about its application; the latter is reserved by some for Einstein and a select group of scientists, and by others it is applied to people ranging from musician Jack White to entrepreneur Richard Branson, with its use having received some justifiable criticism on the grounds of gender.[46] Men's work is more visible in the public sphere because it better fits the criteria and norms by which outputs are evaluated. Just as far fewer women than men are lauded as geniuses, so women are under-represented in the discourses of iconicity.

**42** http://www.designcouncil.org.uk/our-work/leadership/Case-studies/. *Accessed 14 October 2013.*

**43** *OED Online, 'iconography, n.', June 2013, Oxford University Press,* http://www.oed.com/view/Entry/90897?redirectedFrom=iconography. *Accessed 4 July 2013.*

**44** *Peter Burke, 'Iconography', in Alan Bullock and Stephen Trombley (eds),* The New Fontana Dictionary of Modern Thought, *3rd edition (London: HarperCollins, 1999 (1977)), cites Erwin Panofsky,* Meaning in the Visual Arts: Papers in and on Art History *(Garden City, NY: Doubleday, 1955).*

**45** *Kemp,* Christ to Coke, *p. 4.*

**46** *Christine Battersby,* Gender and Genius: Towards a Feminist Aesthetics *(London: Wiley, 1990). Kemp's discussion of 'The Image of Genius',* Christ to Coke, *pp. 330–4, ignores the gender of genius.*

In this book, we see the work of Marie Reidemeister on Isotype (chapter 11), Coco Chanel's suit (chapter 46), architect Grete Lihotzky revolutionizing the kitchen under the influence of home economist Christine Frederick (chapter 34), Ruth Handler inventing the Barbie doll (chapter 38), Jann Haworth co-creating the cover image for the Beatles' 'Sgt. Pepper's Lonely Hearts Club Band' with Peter Blake (chapter 15), an iconic design composed of depictions of many iconic figures, Susan Kare's central role in the development of the Apple GUI (chapter 16) and Julia Barfield's success as co-architect of the London Eye (chapter 9). However, whereas the term *genius* is usually applied to a person (with exceptions),[47] *icon* and *iconic* are applied to people and products alike. A product described as 'genius' attracts that quality for its designer, whereas 'iconic' relates back to religious roots in which the object or image may stand in for the person or entity it represents. Iconic designs can eclipse their designers entirely: the Jaguar E-type car is generally regarded as iconic—featuring, for example, in a fiftieth-anniversary display which saw the car placed in a tank on the waterfront outside the Design Museum in London (see Fig. 0.3)—but its designer Malcolm Sayer is barely known except by automotive historians and design enthusiasts.[48]

Like the term *genius*, then, the words *icon* and *iconic* have attracted criticism for the way in which they have been overused and misused so that their specific meanings and initial power are lost. The *Guardian* newspaper style guide epitomizes this backlash, describing the word *iconic* as being 'in danger of losing all meaning' and 'employed to describe anything vaguely memorable or well-known … Our advice, even if our own writers rarely follow it, is to show a little more thought, and restraint, in using this term'.[49] The words *icon* and *iconic* might be described as having the widespread success and 'stickiness' of memes[50] and might themselves be considered iconic.

47 *Sparke,* Genius of Design, *2009.*

48 *Jonathan Glancey, 'Malcolm Sayer – Aerodynamic Wizard,' BBC Radio 4, 5 June 2013. '50 Years of the Jaguar E-Type' display at the Design Museum, London, 7 February to 7 March 2011.*

49 *Guardian Style Guide, 'Iconic',* http://www.guardian.co.uk/styleguide/i. *Accessed 4 July 2013; see also David Marsh, 'Open Door: The style guide editor on … an iconic example of the dangers of word abuse',* Guardian, *13 August 2007, guardian.co.uk. Accessed 25 February 2011; Brown, 'The Word "Iconic"'.*

50 *Dawkins,* Selfish Gene, *p. 322.*

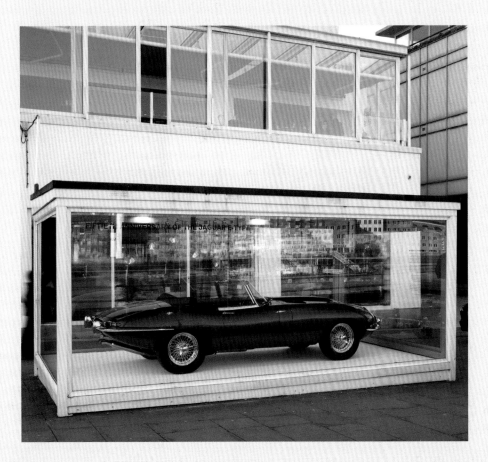

Fig. 0.3

*Jaguar E-type series 1 car, 1961, on display in the tank at the Design Museum, London, 7 February to 7 March 2011.*
*Photograph by Luke Hayes,* http://www.lukehayes.com

51 Design Museum, 'Building Starts on New Design Museum', Press Release, 18 September 2012.

52 Royal Mail stamps 'Celebrating 20th-century British design classics', 13 January 2009; United States Postal Service, 42-cent stamps honouring Charles and Ray Eames, 17 June 2008; Issue #1654, 24 stamps, Canadian Industrial Design, 1997.

53 John Potvin, 'Fashion and the Art Museum: When Giorgio Armani went to the Guggenheim', Journal of Curatorial Studies 1, no. 1 (2012): 47–63, 48. See also Dirk Gindt and John Potvin, 'Creativity, Corporeality and Collaboration: Staging Fashion with Giorgio Armani and Robert Wilson', Studies in Theatre & Performance 33, no. 1 (January 2013): 3–28. Giorgio Armani showed at the Solomon R. Guggenheim Museum in New York, 20 October 2000–17 January 2001 before touring.

54 John Potvin, Giorgio Armani: Empire of the Senses (Farnham: Ashgate, 2013), pp. 22–3.

55 Deyan Sudjic, 'Sale of the Century', Guardian, 8 April 1996, p. 9.

56 Nonie Niesewand, 'The Thrill of the Chaise', Vogue (British edition) April 2011, p. 99.

57 Leslie Sklair, 'Iconic Architecture and the Culture-ideology of Consumerism', Theory Culture Society 27 (2010): 135–58.

58 Ott, Pumpkin; Braudy, The Hollywood Sign; the Yale University Press 'Icons of America' series, which includes titles on people such as Joe DiMaggio, notable objects including the Liberty Bell, and notable cultural works including Gone with the Wind; Martin Eidelberg, Thomas Hine, Pat Kirkham, David A. Hanks and C. Ford Peatross, The Eames Lounge Chair: An Icon of Modern Design (Grand Rapids, MI and New York: Grand Rapids Art Museum in association with Merrell, 2006); Magdalena Droste, Design Classics: The Bauhaus-Light by Carl Jacob Jucker and Wilhelm Wagenfeld (Frankfurt am Main: Verlag form, 1997).

The strangely tautological usage of *icon* and *iconic* is perhaps at the root of some of this criticism. A painting of a saint produced in the Byzantine Christian tradition is an icon, but to describe other cultural artefacts as iconic is to assert such status for the things concerned and to begin to make them so, whether or not they were previously. It is a commonplace of journalism to affirm that the subject of an article is an icon, or is iconic, as a way of insisting on its importance, to secure the attention of readers. The check and balance to this subjective iconicity is the necessity for *recognition*. Today's iconicity is both *subjective* and *shared*. Contemporary uses of the terms *icon* and *iconic* are often lazy assertions, overextended, unhelpful and reductive. However, it is too early for eulogies for these terms; even as they become clichéd, they show no signs of abating.

# ICONIZATION

Iconicity is conferred, communicated and reinforced through a process of iconization, like the process of canonization by which saints are made. Sometimes the iconization process occurs through special rituals, such as the burial of a time capsule featuring designs selected by the London Design Museum's 'Design Circle' members Zaha Hadid, Paul Smith, Norman Foster and Cecil Balmond, as well as Sir Terence Conran and John Pawson to mark the breaking ground on the Museum's new premises at the former Commonwealth Institute.[51] Prizes, like the European Design Awards and the Design Museum's Designs of the Year, form yet more iconizing rituals. So do editions of national postage stamps featuring design, for example the United States Postal Service's 'Pioneers of American Industrial Design' (2011), Royal Mail's 2009 'Celebrating 20th-century British design classics', and Canada Post/Postes Canada's 1997 Canadian Industrial Design stamps.[52]

Museum and gallery exhibitions are a key ritual of iconization. They form part of the mediation of design to the museum-going public and readers of media reviews and make history, and art, from their exhibits. A controversial example was a twenty-fifth anniversary exhibition of fashion designs by Giorgio Armani at the Guggenheim Museum in New York, which transgressed categories: 'Soon questions arose as to the merits of such an exhibition, whether the museum was for rent—or worse, for sale—and what role fashion had within an art museum.'[53] John Potvin has emphasized the Armani exhibition as a chance for the designer himself to regain control of the discourses surrounding his work,[54] noting that the controversy sparked by the exhibition suggests that Armani did not maintain control for long, if at all; mediation is not that straightforward.

Another iconization ritual is that of the auction house sale. In 1996, Deyan Sudjic reported on 'the creation of an important new sale category: modern design', noting however that Bonhams had been auctioning design for several years before Christie's joined in, selling a 1963 Lambretta scooter and a Dieter Rams radio among other celebrated artefacts.[55] Even as recently as 2011, British *Vogue* design editor Nonie Niesewand reported that 'contemporary design is becoming increasingly highly prized—and priced—with galleries increasingly putting designers' work on a pedestal'.[56] She cites the twice-yearly design fair Design Miami/Basel, sister to a leading contemporary art fair, as evidence of the market's buoyancy in recessionary times.

Prize-winning design is, of course, just one small part of the enormous category of design. Designed goods are ubiquitous in everyday life, and in the twenty-first century Western world, most are mass produced and anonymous. Design with a capital 'D' often denotes the products of celebrity designers or objects, which draw attention to themselves as designed through extra-functional tropes such as anthropomorphism or biomorphism,

59 *Michael Idov (ed.)*, Made in Russia: Unsung Icons of Soviet Design *(New York: Rizzoli, 2011).*

60 *Design Museum,* 50 Bags That Changed the World *(London: Design Museum, 2011).*

61 *Steven Heller and Mirko Ilic,* Icons of Graphic Design *(London: Thames & Hudson, 2008).*

62 *Josef Strasser,* 50 Bauhaus Icons You Should Know *(London: Prestel, 2009).*

63 *Gerda Buxbaum,* Icons of Fashion: the 20th Century *(London: Prestel, 2005); Albus, Kras and Woodham,* Icons of Design, *2004.*

64 *Neil MacGregor,* A History of the World in 100 Objects *(London: Allen Lane, 2010).*

65 *Hazel Clark and David Brody (eds),* Design Studies: A Reader *(Oxford: Berg, 2009).*

66 *Douglas B. Holt,* How Brands Become Icons: The Principles of Cultural Branding *(Boston, MA: Harvard Business School Press, 2004), p. 224.*

67 *Charlotte Fiell and Peter Fiell,* Tools for Living: A Sourcebook of Iconic Designs for the Home *(London: Fiell Publishing, 2010); Charlotte Fiell and Peter Fiell,* Design of the 20th Century *(Cologne: Taschen, 2001); see also their* Industrial Design *(Cologne: Taschen, 2003) and* Graphic Design *(Cologne: Taschen, 2005).*

68 *Deyan Sudjic,* Cult Objects *(London: Paladin, 1985); see also Deyan Sudjic,* Cult Heroes *(London: André Deutsch, 1989).*

69 *'Hidden Heroes', Vitra Design Museum in association with the Hi-Cone plastic packaging company, Weil am Rhein, August/September 2011* http://www.hidden-heroes.net/; *'Hidden Heroes – The Genius of Everyday Things' Science Museum, London, 9 November 2011 to 5 June 2012.*

70 *Antonelli,* Humble Masterpieces, *pp. 6–7; Sudjic,* Cult Objects, *pp. 46–9.*

and attempts at narrative (see, for example, chapter 39). The definition of design applied in this book is sufficiently broad to encompass quotidian and anonymous design and works of architecture. Within architectural discourse, iconicity has been extensively critiqued. For example, Leslie Sklair has argued that 'iconicity plays a central role in promoting the culture-ideology of consumerism in the interests of those who control capitalist globalization, namely the transnational capitalist class, largely through their ownership and/ or control of transnational corporations.'[57]

One of the mediating discourses which contribute to the iconization process is the large group of books about iconic design. They include studies focused on one icon, such as the aforementioned pumpkin, the Hollywood sign, the Eames Lounge Chair, and Carl Jacob Jucker and Wilhelm Wagenfeld's Bauhaus-Light (the latter is part of the design publisher Verlag form's Design Classics series).[58] They range from national surveys, such as *Made in Russia: Unsung Icons of Soviet Design* by Michael Idov, which features designs as diverse as the Sputnik and Misha the Olympic bear,[59] to surveys of specific design typologies, such as the London Design Museum's series of miniature canons, including *50 Bags That Changed the World*, with additional titles on hats, chairs, cars and shoes,[60] and design fields, such as graphic design.[61] Steven Heller and Mirko Ilic's *Icons of Graphic Design* is one of a number of titles to tell a history through iconic designs, as does Josef Strasser's *50 Bauhaus Icons You Should Know*, part of Prestel's 50 Series, which also includes *50 Fashion Designers* and *50 Buildings*.[62] Prestel's Icons series includes *Icons of Fashion: the 20th Century* by Gerda Buxbaum (2005) and *Icons of Design: the 20th Century* (2004).[63] Of the eighty-three 'icons' featured in the latter, twelve are also discussed here. A longer, related, history is told by British Museum head Neil MacGregor in his *A History of the World in 100 Objects*, a canon of objects with particular historical value.[64] MacGregor's book begins with the earliest objects of pre-history and is primarily archaeological in focus, so the time period which is normally the focus of design history is given relatively short shrift. Hazel Clark and David Brody's *Design Studies: A Reader* examines, for example, the Eames Lounge Chair, the Tube map and Helvetica.[65] Iconicity has received attention from writers with marketing and business expertise, such as Douglas B. Holt, who has examined 'brands whose value stems primarily from story-telling' rather than those known for 'superior product performance, innovative product designs, advanced technologies, or a superior business model'.[66]

Some books on iconic design exist simply to provide inspiration for design enthusiasts and consumers. Charlotte Fiell and Peter Fiell's *Tools for Living: A Sourcebook of Iconic Designs for the Home*, showcases the 'ultimate' examples of 'aesthetically pleasing' designs, selected for their function and quality, while their substantial *Design of the 20th Century* was abridged for Taschen's Icons series (2001).[67] Books on iconic design veer between celebrating already canonized *Cult Objects* (to use the title of Deyan Sudjic's 1985 book)[68] and promoting under-recognized icons (a contradiction in terms!) David Hillman and David Gibbs' *Century Makers* examines 'one hundred clever things we take for granted which have changed our lives over the last one hundred years', while Paola Antonelli's *Humble Masterpieces* discusses '100 everyday marvels of design'. But while the project of shedding light on these 'Hidden Heroes', to use the name of an exhibition by the Vitra Design Museum,[69] is a valuable one for design history, the masterpieces and heroes they examine are not always as hidden as we might be led to expect. Antonelli's *Humble Masterpieces* begins with the Swiss Army knife, which is also one of Sudjic's *Cult Objects*.[70]

# THIS BOOK

## Approaches

*Iconic Designs* joins a crowded bookshelf of surveys of iconic design, but several strategies are adopted here in order to avoid, as far as possible, the sense that this book forms and reinforces a canon of good design.

Firstly, *Iconic Designs* adopts a critically questioning approach. It responds to the ubiquity of the buzzwords *icon* and *iconic* by asking: What do we mean when we say that a design is 'iconic'? How does that term aid our understanding of design and of iconicity? In so doing, it emphasizes the processes by which design is mediated and explores what design is taken to mean. It is not proposed that the fifty objects discussed here are the most iconic of their era, and the chapters do not necessarily seek to assert the iconicity of the designs examined. However, each of the fifty designs is representative (for example, as discursive or narrative objects or images), recognizable (distinctive and memorable) and revered, whether as the subject of significant discussion and debate or internationally celebrated as excellent. The chapters contextualize the production and consumption and legacy of their focal designs alongside similar or contemporaneous objects. Examination of fifty different iconic designs would reveal different stories and preoccupations. The choice of examples is less important than the fact that the designs included in this book are united by what they contribute to our understanding of iconicity, and they represent important design historical questions and themes.

Secondly, this book features a historically, geographically and typologically diverse group of objects, selected to characterize iconic design. With the exceptions of the Portland Vase (chapter 31), chopsticks (chapter 41) and zōri sandals—precursors to flip-flops (chapter 42)—all of the designs featured in this book date from the mid-nineteenth century onwards. This emphasis is not meant to imply that iconic designs did not exist before that date. On the contrary, we noted above that the attributes of iconicity are derived from religious icons, with more than a millennium of history. Rather, this periodization is consistent with the spread of consumer society and print media in the West and the core period of design historical study. Techniques of mass production have increased the capacity for both things and images to achieve iconic status, as they have enabled objects and representations to be circulated among greater numbers of people. The geographical coverage of this book ranges across continents, predominantly focused on the United States and Europe, but with several chapters concerning the Asia-Pacific region and the closing chapter treating a product developed for use and ultimate manufacture in Africa. Inventor Trevor Baylis OBE developed his wind-up radio (chapter 50) as a tool of information to help curb the AIDS epidemic in Africa. It won the BBC Design Awards for Best Product and Best Design in 1996. A smaller model began production in South Africa in 1997 and a solar panel was later introduced. The Freeplay radio demonstrates that designers are not only perpetrators of climate change; they can also provide solutions and regions of the world need to collaborate in this process.

The designs demonstrated here range typologically from architecture, engineering and industrial design to graphic design, digital design and fashion. *Iconic Designs* provides fifty answers to the questions: What is a design icon, and what is iconic design? It includes some celebrated examples and others which are hidden in plain sight, due to their ubiquity and demotic status, from anonymous goods such as chopsticks (chapter 41), and everyday designs such as the Bic pen (chapter 25), to the extraordinary aesthetic flourishes of, for example, Marcel Breuer's Model B3 'Wassily' chair (chapter 35) and David Carson's *Ray Gun* magazine (chapter 18). Designed at the Bauhaus, the B3 chair represented a radical departure for domestic furniture both technically, in the use of metal tubing and leather strips in place of wooden carcass and sprung and cushioned fabric upholstery, and symbolically,

as it introduced the machine aesthetic into the home. As a visit to the Vitra Design Museum in Weil am Rhein, Germany, will show, the history of chair design is crowded with examples which aimed to reinvent the type form and are therefore distinctive and iconic, including Charles and Ray Eames' Lounge Chair and Ottoman of 1956.[71] Sociologist and professional surfer David Carson was untrained as an art director when he began work on *Ray Gun* and rejected a modernist emphasis on legibility and neutrality, which has softened in his later, large-scale advertising campaigns for companies such as Microsoft.

Thirdly, the book's catholic and critical approach is demonstrated in the images chosen to illustrate the chapters. Most are contextualized, and avoid the 'white cube' approach in which a design is iconized by being set apart from all others, isolated on a white background.[72] The iconic status of the objects examined here and the online access that roughly 39 per cent of the world's population enjoys[73] mean that if you want to know what the London Eye looks like, a web search will show you, immediately. This book is therefore liberated from the need to show our fifty designs in conventional modes. Many of the images selected for this book emphasize the mediation of the designs in question, showing sketches and diagrams, templates, patents, prints and a ticket, advertising and marketing images, appropriations, documentary photographs and portraits.

Contributing authors have approached their subjects in a range of ways, too, of course. Each chapter necessarily addresses an example of design work, whether material or visual and the iconicity which has accrued around that design. Some authors have focused on that iconicity, while others have provided broader accounts, in which iconicity is one story among several to be told about the designs in question. Some have emphasized the history of their focal iconic design, where this is relevant. For example, Carroll Pursell's chapter on Edison's light bulb (chapter 23) explains how Edison drew on earlier technologies and previous attempts to produce a cheap and reliable light source. Writing on Coca-Cola (chapter 47) and McDonald's (chapter 6), Finn Arne Jørgensen and D.J. Huppatz respectively address the negative associations of brands which remain hugely popular. Although it has been heavily criticized on nutritional and ethical grounds—by, for example, award-winning investigative journalist Eric Schlosser—McDonald's remains extremely prevalent. As Ritzer put it, 'I think it unwise to hold our breaths hoping that Eric Schlosser will replace Ronald McDonald as an international icon.'[74] *Iconic Designs* follows the example set by poststructuralist cultural theorist Roland Barthes[75] in providing concise analyses of popular cultural artefacts which are of interest to a general readership and specialists alike. Because it emphasizes representativeness as a quality of iconicity, this book functions in part as an accessible introduction to design history through expert discussions of fifty remarkable designs, telling fifty design historical stories.

## Themes, Parts and Chapters

*Iconic Designs* is divided into five parts, each addressing a thematic place or site, arranged in a sequence from the public to the personal. It opens with design icons in the urban spaces which surround us and the transport infrastructures which service those places and travels through the virtual mediating worlds of page and screen, to the worlds of work and the home, before finally examining those icons which are worn or carried on the body, upon which we rely to function and for a sense of self. As Sherry Turkle put it, 'Objects are able to catalyze self-creation.'[76] We therefore return full circle, because objects worn on the person are also displayed and seen in the city. The book's structure of increasing degrees of intimacy communicates the ubiquity of design icons: they are all over the place. From the awe-inspiring public scale of the city and transport infrastructures, iconic design infiltrates the intimate personal realm of the body and self-identity and everywhere in between. Within the five sections, the objects are arranged chronologically by date of design.

71 *Eidelberg et al.,* Eames Lounge Chair.

72 *See Brian O'Doherty,* Inside the White Cube: The Ideology of the Gallery Space, *expanded edition (Berkeley and Los Angeles: University of California Press, 2000).*

73 http://en.wikipedia.org/wiki/Global_internet_access. *Accessed 14 October 2013.*

74 *George Ritzer, 'Revolutionizing the World of Consumption: A Review Essay on Three Popular Books',* Journal of Consumer Culture *2, no. 1 (2002): 103–18.*

75 *Roland Barthes,* Mythologies *(Paris: Editions du Seuil, 1957); trans. Annette Lavers (London: Jonathan Cape, 1972).*

76 *Sherry Turkle, 'Introduction: The Things that Matter', in Sherry Turkle (ed.),* Evocative Objects *(Cambridge, MA: The MIT Press, 2007), p. 9.*

Part One, 'Hot in the City', addresses internationally recognized design icons which dominate the urban landscape from Times Square to Red Square and those that have enabled us to get around, and between, cities. The Palm Islands (chapter 10) may be compared with other iconic city planning initiatives such as the futuristic Brasilia, Brazil (Lúcio Costa and Oscar Niemeyer, 1956–), a UNESCO World Heritage Site influenced by Le Corbusier's ideas about city planning published in *Athens Charter* (1943) and *Ville Radieuse* (1935), including his ideas about separating cars and people. As a group, cars are disproportionately iconic, from the globular Volkswagen Type 1, aka the Beetle or the Bug (1938) to the Mini (1959) and the glamorous Jaguar E-type (1961). Notwithstanding its ideation in Germany at the behest of Adolf Hitler, the Beetle became a symbol of the hippy counterculture and its continuing popularity is shown in its 1998 relaunch. Iconic vehicles are represented here with the Ford Model T (chapter 2), which introduces issues of mass production, and the tuk-tuk, or auto rickshaw, a small taxicab developed from the Piaggio *Ape*, or bee (chapter 4), which was itself developed from the Vespa scooter. Versions of the tuk-tuk are found throughout the world, particularly in developing countries. In the West, aging populations and rising obesity rates have meant that the mobility scooter (chapter 7) is increasingly visible in urban centres. Neither a car, nor a stigmatizing wheelchair, the mobility scooter is a tool of bodily freedom, integral to personal identity and posing a challenge to existing urban layouts.

The second part, 'Page Turners and Screen Sirens', explores the public sphere of ideas and the imagination, from design for print to screen-based media and the virtual worlds of cyberspace. Fritz Lang's film *Metropolis* (chapter 12) has influenced subsequent iconic and futuristic visions of the city, from Norman Bel Geddes' utopic *Futurama* (1939) to Ridley Scott's dystopic *Blade Runner* (1982). Several design fields contribute to the cinema, including production and set design, costume design, titles, film publicity and marketing, while fashion design feeds into the celebrity culture that surrounds film stars and to high street versions of red carpet designer gowns and celebrity style. One perhaps unanticipated side effect of digital culture is to imbue printed artefacts with special appeal, such as the much-collected Penguin Books (chapter 13) launched by Allen Lane in 1935 as a new category of publishing, the affordable paperback book. Max Miedinger and Eduard Hoffman's typeface Helvetica (chapter 14) is both a popular success and the subject of derision by the design cognoscenti, like Verdana (Matthew Carter, 1996), which was designed to work well for reading on the screen and Comic Sans (Vincent Connare, 1994). Critical debate has also surrounded Oliviero Toscani's advertising campaigns for Benetton (chapter 17), which have ranged from challenging taboos about race, religion and disease to promoting Benetton's microcredit initiatives in Africa, as in the 2008 campaign 'Africa Works'. The billboards crowding our cities—with exceptions such as São Paulo, Brazil, where outdoor advertising is banned—can provoke thought as well as sales. The web (Tim Berners-Lee, 1989) is now the principle medium for learning about and communicating about design. eBay (chapter 19) is iconic by stealth; its browsers look *through* it to the visual and textual content supplied by the sellers of millions of other designed goods, some iconic, some not. Social media sites such as Facebook (chapter 20) are free, but require users to commoditize themselves. The curated self exhibited on Facebook by 1.11 billion monthly active users (according to Facebook's own figures of March 2013) may be compared with the use of avatars in other socially alienating as well as connective theatres for the hyper-reality theorized by French sociologist Jean Baudrillard[77], from *Second Life* (Linden Lab, 2003) and *Sim City* (Will Wright, 1989) to iconic video games such as *Tomb Raider* (Core Design, 1996) and *Grand Theft Auto* (Rockstar Games, 1997–2005).

*Iconic Designs'* third part, 'Genius at Work', examines objects variously associated with the workplace. While the many compartments of the Wooton desk (chapter 22) have

77  *Baudrillard,*
Simulations.

been replaced by computer memory space, the mythical nature of the paperless office is shown in the enduring popularity of the paper clip (chapter 21), of which Steven Connor has written that 'no object, not even the elastic band, is more allied to active contemplation'.[78] An excellent starting point for understanding the work of the industrial designer, Raymond Loewy's streamlined pencil sharpener of 1933 (chapter 24) has exerted an immense influence on the history of design without ever moving beyond the prototype stage. This static yet aerodynamic object highlights the aesthetic role of streamlining in making goods more desirable to purchasers. Lightweight and portable like a transistor radio, the bright red 'Valentine' typewriter (chapter 27) appears to have been designed for the same youth market as the radio. In applying a pop sensibility to office technology, Sottsass prefigured the iMac G3 (chapter 30), which introduced fashionable globular forms and bright translucent casings to the relatively expensive personal computers sector. The category of executive toys, including, for example, Newton's Cradle, perhaps owes more to marketing than it does to office conduct. Rubik's Cube (chapter 28) is not an iconic form; rather its coloured grid pattern is, which is why it can be applied to so many different products and still be recognized. 3M's Post-it Note (chapter 29) can also be applied to many products, but in this case with low-tack adhesive. Like the personal computer (chapter 30) and the Sony Walkman (chapter 49), the Post-it Note determined a new kind of behaviour in offices and homes alike. It is currently marketed to teens as social stationery as much as it is aimed at office administrators.

Part Four, 'Home Rules', ranges from spaces of domestic labour to objects associated with leisure. It begins with Josiah Wedgwood's copy of the Portland Vase (chapter 31), a classical treasure produced in Rome, Italy in AD 5–25. As well as ceramic inventions such as his 'Jasperware' (1775), Wedgwood was an innovator of marketing techniques, for example cultivating celebrity endorsement of his ceramics among royalty and the aristocracy. Following in the footsteps of the branding innovations of Lever's Sunlight soap, Heinz products have been exported to sixty countries: by 1999, the Heinz 57 brand (chapter 32) was the world's fourth biggest food brand after Coke (chapter 47), McDonald's (chapter 6) and Nescafe. Heinz's iconicity depends on the consistency of food (based on canning, which revolutionized the food industry along with freezing and chilling), and its logo and packaging design, including its trademarked turquoise,[79] as well as diversification with, for example, tie-in foods such as Hello Kitty (chapter 48) and Disney Princess pasta shapes. Character tie-ins, including Star Wars and Harry Potter, are also integral to LEGO's recent business model, which incorporates a shift from the interchangeable iconic bricks developed by Ole Kirk Christiansen (chapter 37) to dedicated discrete building kits such as LEGO Architecture. The LEGO Friends range, aimed at girls, has attracted controversy not least for the fact that its mini-dolls are not compatible with the main LEGO line. Like LEGO Friends, Barbie (chapter 38) exposes young girls to an appearance-oriented, even sexualized, model of femininity. Barbie's shortcomings are revealed when compared with the greater physical flexibility of action figures such as G.I. Joe and Action Man. Options such as Architect Barbie (2011), complete with black-rimmed glasses, hard hat, architectural model and tube carrier for plans, leave critics unmollified.

An iconic figure himself, William Morris worked across a very wide range of fields from literature and politics to embroidery and furniture design. Some of his textiles designs as still in production, such as 'Strawberry Thief' (chapter 33), which is manufactured by Sanderson under the Morris & Co. brand, and today they seem comparatively elaborate. However, as Nikolaus Pevsner made clear, critics of the kinds of designed goods shown at the Great Exhibition of 1851 rejected illusionistic depth in surface design, preferring a pared-down, stylized naturalism.[80] This approach has influenced subsequent landmarks in British printed textiles, such as the work of the Festival Pattern Group, Lucienne Day's

78  Steven Connor, Paraphernalia: The Curious Lives of Magical Things (London: Profile Books, 2011), p. 148.

79  Sak Onkvisit and John Shaw, International Marketing: Analysis and Strategy, 4th edition (New York: Routledge, 2014), p. 310.

80  Nikolaus Pevsner, Pioneers of Modern Design: From William Morris to Walter Gropius (London: Penguin, 1975 (1936)).

'Calyx' and abstractions such as Barbara Brown's 'Reciprocation' (the latter was reissued in 2010 to celebrate UK manufacturer and retailer Heal's bicentenary).

Simplification of Victorian models of domesticity also informed Grete Lihotzky's kitchen for Ernst May's public housing developments. Credited with being the first fitted kitchen, the Frankfurt kitchen (chapter 34) was influenced by Taylorism—an early form of what was later termed scientific management, which applied time-and-motion studies to improve mass production—as filtered through the work of Christine Frederick. The Princess telephone (chapter 36) combined communications technology with fashionable styling, promoted in its advertising slogan 'It's little, it's lovely, it lights'. Representative of post-WW2 US consumerism, a new teenage culture, American industrial design, colour and gender, and the personalization of technological apparatus, the Princess telephone's range of colours prefigured products such as the iMac G3 (chapter 30). Engineer-inventor James Dyson innovated stylistically and technically with his bagless dual-cyclone DC01 vacuum cleaner (1993). His desire to place himself within an iconic tradition is exemplified by his book, *Contemporary Design Icons selected by James Dyson*,[81] while his resignation from the board of London's Design Museum, citing as his reason the museum's exhibition about flower arranger Constance Spry, put him at the centre of a debate about the nature of design in 2004.

The final part, 'Personal Effects', demonstrates the extent to which iconic designs are incorporated into the design of the self by examining icons which are worn and carried on the body. When we carry a drink with us, from Starbucks coffee to Evian mineral water, we 'wear' it just as we wear jeans, a t-shirt or a bag. Clothing is the most obvious opportunity for branding the self, but Hello Kitty (chapter 48) appears on all sorts of consumer goods, from wine, a passenger jet, a maternity hospital, to theme parks. Chanel's skirt suits (chapter 46) have evolved slowly from Coco Chanel's first suits of 1913 to her relaunch in 1954.[82] Like Levi's jeans, the Chanel suit has enjoyed remarkable longevity, its iconic status secured by Karl Lagerfeld's efforts to keep the brand current: Chanel suits are copied to the point of becoming generic. Unlike Levi's, however, Chanel suits are priced for the rich. The tools we carry are extensions of the self from pens such as the Bic Cristal (chapter 25) and multitools such as the Swiss Army knife (chapter 44) to paperback books (chapter 13), magazines (chapter 18), maps (chapter 3) and chopsticks (chapter 41). The Brownie camera (chapter 45) was instrumental in the international development of photography as an amateur leisure practice,[83] and is therefore a forerunner of the smartphone camera. The Sony Walkman (chapter 49) followed the transistor radio in changing the way people behaved by enabling them to listen to music on the go. Initially launched for audio cassettes, with some models also offering radios, the Walkman was succeeded by the Discman for compact discs (CD), and the Walkman brand name has also been used on video players and Sony Ericsson–branded mobile phones. The iPod and iPhone are perhaps its most visible successors.

Many of the icons discussed here could be placed in parts of the book other than the one they currently occupy. The Bic pen, for example is not only a 'Genius at Work'; it is also carried on the person and therefore fits in part five, 'Personal Effects'. Similarly, even though one effect of the light bulb is to extend working hours, it is of course also found in homes and across cities, where it is massed to breathtaking effect. Alternative arrangements for the book might have included a purely chronological structure without thematic sections; a geographical approach organized by region; a typology, grouping objects of the same types or categories together; and a sequence based on design fields, such as clothing, transport, toys etc.[84]

Just as the book might have been differently arranged, so it has been compiled in the knowledge that readers will want to add and subtract design icons from the selection. There

81 *James Dyson, Contemporary Design Icons selected by James Dyson, text by Andrew Langley/Plain Text (Bath: Absolute Press, 1999).*

82 *Daniele Bott, Chanel: Collections and Creations (London: Thames and Hudson, 2005), pp. 12, 21–2, 28; Harold Koda and Andrew Bolton, Chanel (New York, New Haven and London: The Metropolitan Museum of Art and Yale University Press, 2005), pp. 12, 39.*

83 *John Taylor, 'Kodak and the "English" Market Between the Wars', Journal of Design History 7, no. 1 (1994): 29–42.*

84 *The latter approach is taken by, for example, Paul Rodgers in Design: The 50 Most Influential Designers in the World (London: A&C Black, 2009), which has four parts: technology, furniture, home wares and automotive, and by Deyan Sudjic in Cult Objects, in which narrative chapters deal with objects by product type, such as clothing, furniture, packaging, transport design.*

are countless other design icons that warrant a place in this book, from Brazil's Crist Redentor to Mickey Mouse, from the Great Pyramid at Giza, Egypt, to the clay cliff-side homes of the Bandiagara plateau, Dogon Land, a UNESCO World Heritage Centre in West Africa (see Fig. 0.4) and from the iPhone to the erstwhile World Trade Center Twin Towers in New York, the very mention of which invokes heavily remediated images (still and moving) of the towers and passenger planes and the poignant iconic image of the falling man. By providing insights into iconicity in design, this book aims to inform understanding of design icons beyond those explicitly discussed here.

*Fig. 0.4*
*Tellem Dwellings, Bandiagara Escarpment, UNESCO World Heritage Site, Irilli, Mali. Photograph by Ellen Mack, 24 October 2011.*

## CONCLUSION

This introduction has looked briefly at the history, function and language of icons, the rituals and discourses of the iconization process and the approaches and structure of this book. It has established that contemporary design icons (by which I mean things new and old which are currently accorded iconic status) have in common with their religious forebears the qualities of being representative of a concept, recognizable and revered, and that these qualities are conferred on design through the reception process. Therefore, while iconicity seems to have become largely a subjective sentiment as the terms *icon* and *iconic* are applied to things we like a lot, and one woman's icon is another woman's bugbear, a simultaneous criterion of iconicity is consensus. Iconicity is a shared subjective judgment. While the fifty design icons featured in this book may not be the ones each reader would have chosen, there is sufficient agreement about each to warrant their inclusion. Yet, the authors of the chapters which follow do not write about their subjects as though their iconicity is a given; rather they ask why each design icon is considered iconic, with illuminating results. Iconicity is a hegemonic quality; iconic designs are granted an elite status, however quotidian they might be. Iconic designs stick together, as shown in, for example, Turner Duckworth's Coke summer promotion can featuring flip-flops, LEGO Architecture's Sydney Opera House, a London Underground map made of LEGO and Havaianas' ad campaign featuring the flip-flops in front of the Eiffel Tower. The assertion and attribution of iconicity is mutually reinforcing. This book forms part of that reinforcement, part of that canonization, even as it critiques it.

# Part One

# Hot in the City

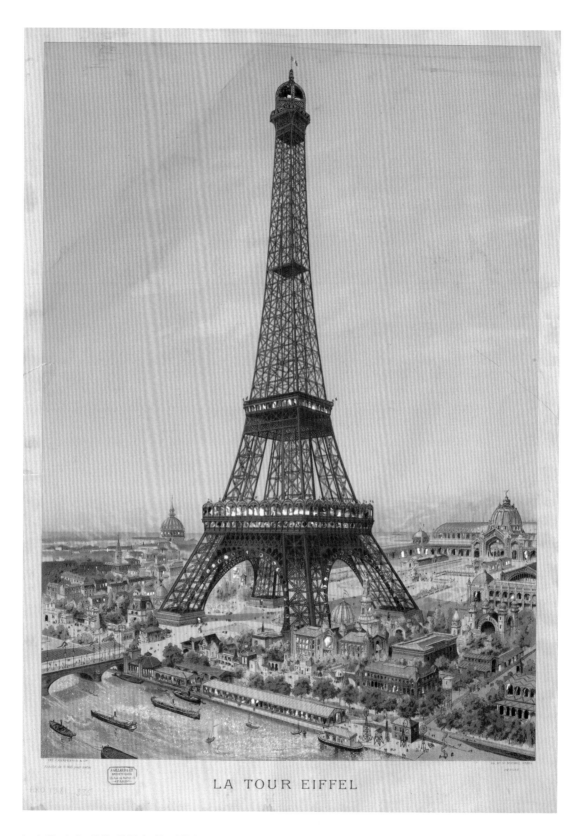

LA TOUR EIFFEL

*Louis Tauzin (c. 1842–1915),* La Tour Eiffel, *colour print, c. 1889, © RMN (Musée d'Orsay) / Hervé Lewandowski.*

# 1

# Eiffel Tower, France
## (Gustave Eiffel, 1889)

*Claire Jones*

## Ideation and Production

The Eiffel Tower was constructed as the entrance to the Paris International Exhibition, which opened on 6 May 1889. It is named after the engineer Gustave Eiffel, whose firm had won a state-sponsored competition for a 300-metre (984-foot) four-sided metal tower to be erected on the exhibition site.

The notion of a tower 1,000 ft (about 300 m) high had occupied architects and engineers since at least 1833, from British inventor Richard Trevithick's proposal for a cast iron tower, and architect Charles Burton's design for converting the Crystal Palace into a 1000-ft-high tower, to American engineers Clarke and Reeves's plans for an iron cylinder for the Centennial International Exhibition in Philadelphia in 1876, and electrical engineer Amédée Sébillot's 1881 proposal for a tower with an electric lamp that would light all of Paris. Although these plans were unrealized, the main ingredients were in place by the time Eiffel took up the challenge of international rivalry to produce the tallest man-made structure in the world, incorporating the most up-to-date developments in engineering, architecture and electricity. At 320 m (1,050 ft), the tower held the title of the tallest man-made structure in the world until 1930, when the Chrysler Building was erected in New York.

This competitive incentive was particularly appropriate to the context of an international exhibition. Originating in the French exhibitions of national products held from 1798 until 1844, the first international event of this nature took place in London in 1851.[1] Held in Hyde Park, the Great Exhibition of the Works of Industry of all Nations featured more than 13,000 exhibits, attracted 6 million visitors, and became the model for all subsequent international exhibitions.[2] Manufacturers were grouped by nation and demonstrated their latest advances in technological and design innovation, from steam engines to tea sets. Crucially, the building that housed the displays set a precedent for pioneering exhibition buildings. At 564 m (1,851 ft) long, Joseph Paxton's 'Crystal Palace' was a landmark in the history of glass and iron construction, employing modular wood, iron and plate glass to produce a vast building of remarkable transparency and lightness.[3]

For the 1889 International Exhibition in Paris, two structures rivalled the Crystal Palace in their scale and ambition: the Eiffel Tower and the Galerie des Machines or 'Machinery Hall', a glass and iron building which, at the time, had one of the widest interior spans in the world.[4] The Galerie des Machines was pulled down in 1910, and the Eiffel Tower is now the only survivor of the numerous buildings and attractions that extended throughout the Exhibition's site.

In addition to its commercial, cultural and imperial aims, the 1889 International Exhibition also coincided with the centennial celebrations of the French Revolution. Within this context, the historian Miriam Levin considers the Eiffel Tower as 'a conscious and pragmatic artistic expression of the Republican social ideal'.[5] Its design, construction and materials are symbolic of the transformative powers of science and technology towards social progress and social cohesion. Each small interlocking part is an integral element of the whole. Constructed of 7,300 tonnes of wrought iron, the Eiffel Tower's modular design,

1  *Jeffrey A. Auerbach*, The Great Exhibition of 1851: A Nation on Display *(New Haven and London: Yale University Press, 1999).*

2  *John E. Findling and Kimberly D. Pelle (eds),* Historical Dictionary of World's Fairs and Expositions, 1851–1988 *(New York: Greenwood Press, 1990).*

3  *Philip Morton Shand, 'The Crystal Palace as Structure and Precedent',* Architectural Review *81 (1937): 65–72.*

4  *John W. Stamper and Robert Mark, 'Structure of the Galerie des Machines, Paris, 1889',* History and Technology *10, no. 3 (1993): 127–38.*

5  *Miriam R. Levin, 'The Eiffel Tower Revisited',* The French Review *62, no. 6 (May 1989): 1052–65, 1058.*

comprising 18,038 metallic parts held together with 2.5 million rivets, enabled it to be partially prefabricated off site. It took an average workforce of 200 just over two years to complete.[6] Republican ideals were also articulated in each of the tower's three levels, which were accessible at a cost of 2, 3 and 5 francs in ascending order (half-price on Sundays). The upper level housed 'an observatory and laboratory such as was never until now at the disposal of science'.[7] On the second floor, the newspaper *Le Figaro* printed a souvenir edition, *Le Figaro de la Tour*. The first floor housed Anglo-American, Flemish, Russian and French refreshment areas, reflecting the international flavour of the exhibition. These were surrounded by 'a covered gallery, with arcades, whence visitors can enjoy a view of Paris and its environs, as well as of the Exhibition'.[8] By the end of the exhibition nearly two million visitors had ascended the tower.

## Initial Reception and Consumption

Despite its engineering and design innovation and appropriateness to the context of an international exhibition, the Tower was initially the subject of severe criticism in the French press. In 1887, during the initial phases of construction, a group of artists, writers and thinkers known as the 'Committee of Three Hundred' published a petition which condemned the tower as an affront to French taste. They warned that its scale, materials and commercial aims would destroy Paris's historic cityscape:

*Is the city of Paris about to associate itself with the grotesque and mercantile imagination of a machine-maker, irreparably to disfigure and dishonour itself? … Imagine for a moment a dizzily ridiculous tower, overlooking Paris like a gigantic black factory chimney, overpowering with its barbarous mass Notre Dame, La Sainte Chapelle, the tower of Saint-Jacques, the Louvre, the Invalides Dome, and the Arc de Triomphe—all our monuments humiliated, all our architecture dwarfed … [under] the hateful shadow of the hateful column of bolted sheet-iron.[9]*

This petition was led by the prominent architect Charles Garnier, and its wording attempts to assert the supremacy of the architect over the engineer. It preferences permanent stone buildings over ephemeral iron structures; places of religious, artistic and historic significance over commercial and industrial ventures; and the man-made over the machine-made. It aligns the architect within a historic continuum of building in Paris and situates the engineer, by contrast, as an uneducated interloper bent on financial gain. The tower's estimated cost of 6.5 million francs was only partly funded by the State. Eiffel's contract authorized him to receive all income from the commercial exploitation of the tower during the exhibition and for twenty-one years thereafter. From its outset, the project was therefore clearly identified as a commercial, and potentially short-term, venture.

## Legacy and Influence

Despite its opponents, the Eiffel Tower was completed in time for the opening of the 1889 International Exhibition. One objection continued to occupy critics, however: its apparent lack of utility. Various suggestions were put forward, many of them reflecting the scientific and technological aspirations of the original scheme: astronomy, vegetable chemistry, meteorology, physical science and even defence.[10] Yet it is the Tower's less practical function as a viewing tower for personal and communal entertainment that has contributed perhaps most profoundly to its iconic status, and to its survival.

This temporary iron demountable structure still stands on the Champ de Mars and continues to reap profits as a site of mass spectacle. Like the Crystal Palace before it, the

6  *This modular construction meant that the Tower (like the Crystal Palace, which was relocated to Sydenham in 1854), could be dismounted and re-erected elsewhere.*

7  *Gustave Eiffel, 'The Eiffel Tower', from the* New Review, *reprinted in* The Science News-Letter *18, no. 488 (16 August 1930): 107.*

8  *Eiffel, 'The Eiffel Tower', p. 108.*

9  *'Protest against the Tower of Monsieur Eiffel',* Le Temps *(14 February 1887), trans. 'Protest against the French "Tower of Babel"',* Pall Mall Gazette *(15 February 1887): 6838.*

10  Guide Officiel de la Tour Eiffel *(Paris: Imprimerie et Librarie Centrales des Chemins de Fer, 1893), p. 36.*

tower structure was designed without walls. This, combined with its height, allows visitors an unimpeded view of Paris. The tower provokes a particular visual relationship with the city and its inhabitants that embodies the modern urban experience of seeing the city, seeing in the city, and being seen in the city. As the literary historian William Thompson has observed, this human factor represents a shift in focus from the early emphasis on the technological aspects of this innovative iron structure, towards the more artistic, philosophical and literary interventions which followed.[11] These express tensions between the old and the new, the individual and the collective whole, modernity and the celebration of Parisian life.

Authors and philosophers, including Walter Benjamin and Roland Barthes, have underlined the significance of the Eiffel Tower in shaping, reflecting and providing a key to understanding the experience of modernity. It can be encountered from below, from above, from within the structure, at a distance and close up, as an original unique work or in the form of a reproduction. For Barthes, it enables the individual to rise above the city and 'transcend sensation and to see things *in their structure*'.[12] Perhaps most significantly in terms of understanding the iconic status of the Eiffel Tower, Barthes proposes that the Tower does not hold a single universal meaning, but instead represents many things to many people:

*Beyond its strictly Parisian statement, it touches the most general human image-repertoire: its simple, primary shape confers upon it the vocation of an infinite cipher: in turn and according to the appeals of our imagination, the symbol of Paris, of modernity, of communication, of science or of the nineteenth century, rocket, stem, derrick, phallus, lightning rod or insect, confronting the great itineraries of our dreams, it is the inevitable sign; just as there is no Parisian glance which is not compelled to encounter it, there is no fantasy which fails, sooner or later, to acknowledge its form and to be nourished by it.*[13]

And herein lies the longevity of the Eiffel Tower's resonance in urban history and its status as an urban icon. It stimulates the imagination and absorbs and generates a multiplicity of meanings which are both universal and particular to each individual who encounters it. As Barthes recognized, the Tower's lack of a single predetermined function makes it a 'pure' sign, a 'total monument'; *because* it is 'an utterly *useless* monument', '*it means everything*'.[14]

Today, the Eiffel Tower is perhaps most often recognized as a symbol of Paris. For many, it *is* Paris. As such, it is deeply embedded within particular understandings of what Paris itself has come to represent: luxury, romance and historic and contemporary culture from the Louvre to the latest haute couture fashion creations. Other landmarks compete with the Eiffel Tower as symbols of Paris, notably the metro with its uniform station entrances designed by the Art Nouveau architect Hector Guimard for the 1900 International Exhibition. Outside France, the Tower has generated direct imitations from entrepreneurs keen to tap into its symbolic and transformative powers, as in the Blackpool Tower which opened in northern England in 1894, and half-scale replica erected in Paris, Las Vegas, in 1999. However, these imitations and pastiches, including the countless t-shirts and postcards which bear its image, reinforce rather than dilute the Eiffel Tower's uniqueness as well as its ubiquity. There is only one genuine Eiffel Tower, and its location within Paris has contributed to its status not only as an icon of Paris, but also as the prototypical urban icon.

11 *William Thompson, 'The Symbol of Paris: Writing the Eiffel Tower',* The French Review *73, no. 6 (May 2000): 1130–40.*

12 *Roland Barthes,* The Eiffel Tower and Other Mythologies, *trans. Richard Howard (Berkeley, Los Angeles and London: University of California Press, 1997), p. 9.*

13 *Ibid., p. 4.*

14 *Ibid., pp. 5, 4.*

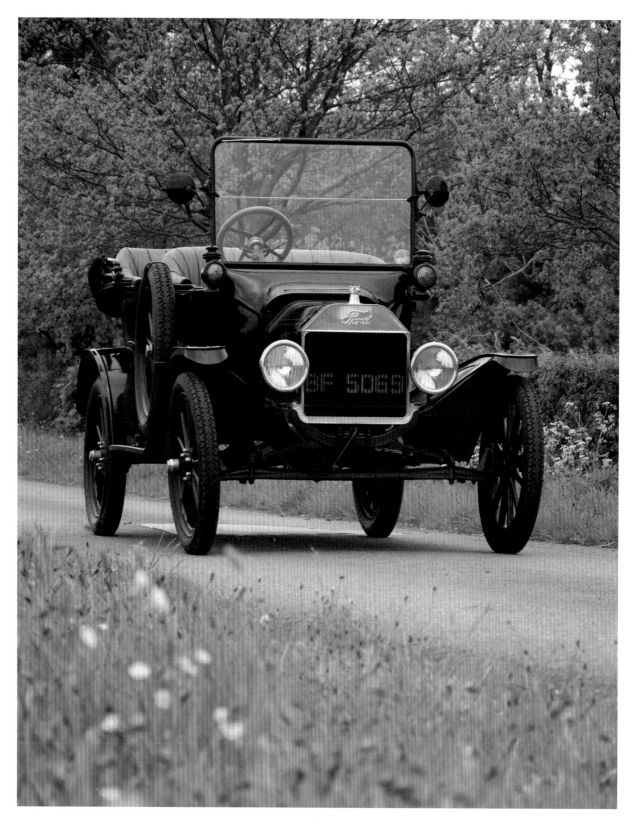

*1915 Ford Model T tourer owned by Michael Flather. © Paul Hazell 2012.*

# 2

# Ford Model T, USA
## (Henry Ford, 1908)

*Paul Hazell*

In many ways the Ford Model T was quite an ordinary car.[1] It was not the fastest of its day, nor the most luxurious, and its layout broadly followed newly forged conventions. However, soon after its introduction in 1908 it began to carry far more than just people and goods: it also carried revolutionary ideas. It was these ideas and associated value complexes that led to, and informed, the Model T's iconic status and, like any icon, the Model T has come to stand for things that transcend the artefact itself.[2]

At the beginning of the twentieth century, private motoring was reserved for the wealthy elite. As an invention, the automobile was less than twenty years old. Early cars were often complex, unreliable and hugely expensive machines intended for the rich enthusiast or the mechanically adept chauffeur.[3] Henry Ford was determined to change this and to create 'a motor car for the great multitude' through innovation in production methods and constant cost reduction.[4] In the 2010 BBC television series 'The Genius of Design', Ford's Chief Creative Officer, J. Mays, declared 'Henry Ford didn't invent the automobile but he invented a way of getting it to the most possible people at the most affordable price.'[5]

From Ford's determination to create a car for the average American worker emerged not only the Model T, but also the moving assembly line. These twin innovations brought a new kind of revolution to American society through the democratization of personal transport and the birth of the modern consumer society.

## A Means of Production that Would Change the World

The story of the Model T began in Detroit at the Ford Plant on Piquette Avenue. Ford had been producing cars since 1903, starting with his first experimental design, the Model A. He rapidly moved through a range of models—some were little more than prototypes—and gradually his designs developed until the Model N in 1906. It sold well by the standards of the day, however Ford was not satisfied; he was looking for a much larger market for his automobiles.

The mythology surrounding the Model T, upon which its iconicity is built, suggests that the design of the car was solely Henry Ford's. Certainly the concept of a light, simple car, inexpensive to manufacture and operate, *was* his, but the detailed design and engineering was achieved by a team he gathered together. Already cars were becoming too complex to have a single designer.[6]

The job of a car 'designer' as we might understand it today (concerned with the styling of a vehicle) did not exist in 1908, as the project of producing a car was driven by engineering considerations such as the need for a lightweight chassis of vanadium steel, three-point suspension giving huge axle articulation for the primitive rural American roads of the day and easy-to-maintain mechanical components. Bob Casey, Curator of Transportation at the Henry Ford Museum explained, 'When Henry Ford looked at a Model T he in essence looked through the body, and [saw the] chassis, and he knew all the ingenuity which had been designed into it. He appreciated it. To him it was beautiful.' Casey continues: 'The body design was a bit of an after thought. It was necessary obviously, you

1 *I acknowledge the support of Robert Casey, Curator of Transportation, The Henry Ford Museum, Detroit; Michael Flather, Ford Model T owner; Christopher Barker, Archivist, Model T Ford Register of Great Britain.*

2 *Gijs Mom, 'Translating Properties into Functions (and Vice Versa): Design, User Culture and the Creation of an American and a European Car (1930–70)',* Journal of Design History *21, no. 2 (2007): 171–81.*

3 *Leonard Setright,* Drive On! A Social History of the Motor Car *(London: Granta Books, 2002), p. 4.*

4 *Henry Ford,* My Life and Work *(London: William Heinemann, 1923), p. 31.*

5 The Genius of Design, *1. 'Ghosts in the Machine' [Video: DVD], London, Wall to Wall Media Ltd for the BBC, 2010.*

6 *Robert Casey,* The Model T: A Centennial History *(Baltimore: The John Hopkins University Press, 2008), p. 19.*

had to have a body, you had to have seats, but it was never very high on Henry Ford's list [of priorities].'[7]

The Model T was developed with ease of manufacture and ease of maintenance in the forefront of Ford's mind, leading to considerable innovation in its design. One such innovation was the determination for the consistent interchangeability of parts. Until the Model T, it was not uncommon for cars to have components that were made to fit an individual vehicle, which in turn required considerable time and a highly skilled workforce to manufacture. This usually meant a worker standing at a workbench assembling major components or even constructing the entire car as part of a small team. But with standardization came the potential for much more rapid mass production as every component could be relied upon to fit first-time.[8]

However, mass production could only be developed so far using the engineering of the car alone. The means of production would be key to both the volume of Model T's that could be produced and how cheaply this could be done. Demand for the Model T rapidly outstripped supply, but Ford wanted to manufacture all that he could sell. By degrees, Ford realized if the design of the car was 'frozen', the production process could be developed to manufacture it as efficiently as possible.

Taylorism had become influential at the turn of the twentieth century as a method of improving industrial efficiency through the enforced standardization of production methods and the removal of decision making from the worker.[9] All manufacturing decisions were to be made by managers, not by a craftsman standing at a bench. This Taylorist approach, combined with Ford's interchangeable components, meant the *workers'* activities could also be standardized.

The first development was 'station working'. This entailed individual workers assembling small subcomponents and then passing them along a workbench for the next stage of manufacture. This innovation, combined with the systematic development of how the components required could be placed near the workstation, rapidly increased efficiency. Ford was also aware of the moving *disassembly* lines already employed in large abattoirs.[10] Workers would remain in one location, and carcasses would come to them via an overhead conveyer system. This allowed for different specialist butchering skills to be employed along the line, thereby decreasing the time taken to process the meat. When reversed for Model T production, and combined with the efficiency gains of 'station working', the assembly line resulted.

The development of mass production from the 'station working' process of 1908 to three moving assembly lines in the enormous and purpose built factory at Highland Park, Michigan, was rapid. By 1914, the price of a Model T had halved from that of 1908 and Ford had 48 per cent of the domestic automobile market with nearly a thousand cars being produced each day at the plant.[11]

## Selling Freedom

Marketing for the Model T promoted the pragmatic virtues of the car: affordability and reliability. It also promoted the intangible but powerful idea of how life-changing car ownership could be. Mays described the Model T as 'completely transform[ing] the way people think about moving from point A to point B and that was probably the biggest thing Ford brought to society: the idea of freedom.'[12]

With a Model T, those living rurally, in small towns or in cities could now travel farther, faster and to a destination of their own choosing. Motoring as a leisure activity for the masses began to emerge. Henry Ford was a reluctant marketer but at the insistence of his sales director, Norval Hawkins, the company exploited the idea of affordable freedom and

7 The Genius of Design, 'Ghosts', 2010.

8 *For further reading on the development of standardization in American manufacturing see David Hounshell,* From the American System to Mass Production, 1800–1932: The Development of Manufacturing Technology in the United States *(Baltimore: The John Hopkins University Press, 1985).*

9 *Frederick Taylor,* The Principles of Scientific Management *(New York: Harper & Brothers, 1911).*

10 *Casey,* The Model T, *p. 52.*

11 *Daniel Raff, 'Wage determination theory and the five-dollar day at Ford: a detailed examination', (PhD thesis, Massachusetts Institute of Technology, 1987).*

12 The Genius of Design, 'Ghosts', 2010.

as a result created new markets for the Model T amongst those who had never had the opportunity to own a car before.

However the *idea* of freedom did not mean actual freedom for all. The moving production line determined the pace at which an employee on the factory floor worked, and the task was now unskilled and repetitive. Ford was struggling to keep employees for more than a few weeks with an annual staff turnover exceeding 380 per cent. The efficiency losses this caused now threatened to undermine Ford's drive for cost reduction. He concluded that his workers' pay should be more than doubled to five dollars (US) a day—to discourage them from leaving.[13] This in turn developed his reputation as a philanthropist and at a stroke meant his own employees could now afford the product they were building. Both were to increase sales still further.

## We Want More

The Model T not only catered to a market sector, it *created* one. Ford wanted his car to be 'a commodity, something every family might own and enjoy' but also the *only* car they would ever own if he was to have his way.[14] The very strength of the Model T that had allowed for the most efficient mass production—the freezing of its design—was to become its Achilles' heel by the mid-1920s.

Ford's much-quoted phrase 'any colour so long as it's black' summed up the situation well.[15] Early Model T's were available in a variety of colours, but the constant drive for improved manufacturing efficiency and cost reduction meant only black paint was in use by 1913. The phrase was intended to celebrate the continuous efforts to make the Model T more affordable and therefore more obtainable. However, Ford was forced to again introduce a range of colours in the mid-1920s to improve the car's appeal. Now 'any colour so long as it's black' implied stagnation and lack of choice.

Competitors such as General Motors and Chrysler realized that designers needed to restyle the appearance and occasionally update the engineering of the vehicles. This would make them continually attractive not only to new customers but also to existing car owners who now had a reason to want to replace their automobile. 'Planned obsolescence' was required along with the offer of 'a new and improved' replacement.[16] Simply making changes to the range of colours was not going to be enough.

Falling sales of the Model T forced Ford to halt production in 1927. A new model was designed: the Model A, so named to emphasize the notion that the company had started afresh with a totally new design. However, Henry Ford's reluctant replacement of the Model T had come later than it should, and the Ford Motor Company was no longer the world's dominant car manufacturer. With the emergence of a consumer society, in which Henry Ford and the Model T had been so instrumental, it was no longer enough for a product to be affordable and functional. In an increasingly crowded automotive market the product also had to be *desirable*.

Even so the Model T had done enough to deserve its iconic status. The virtuous circle of mass production was pushed as far as it was possible with the Model T: the more you can make, the cheaper you can make it, the cheaper you can make it, the more you can sell. Ford had created the first global car by making it widely available, reliable and affordable and thereby spawned Fordism.[17] This means of production became the very foundation of mass-consumerism and as a consequence a cornerstone of modern capitalism.

13 *Casey*, The Model T, *p. 63.*

14 *Ford Motor Company Product Literature*, Ford Motor Cars *(Detroit: Ford Motor Company, 1911).*

15 *Ford*, My Life and Work, *p. 31.*

16 *Bernard London*, Ending the Depression through Planned Obsolescence *(Pamphlet, New York, 1932),* http://en.wikipedia.org/wiki/File:London_(1932)_Ending_the_depression_through_planned_obsolescence.pdf. *Accessed 8 May 2012.*

17 *Steve Jones*, Routledge Critical Thinkers: Antonio Gramsci *(New York: Routledge, 2006), p. 109.*

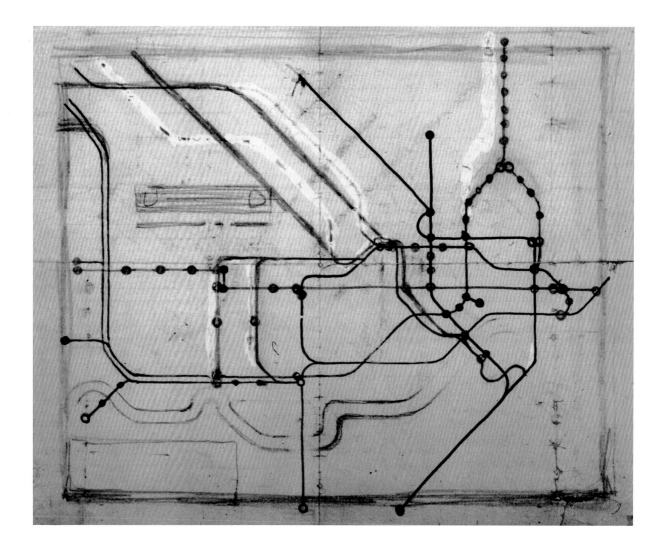

*Preliminary sketch for the first Diagrammatic Tube Map, Harry Beck 1930. Image courtesy of London Transport Museum.*

# 3

# London Underground Diagram, UK
## (Harry Beck, 1931)

*Christoph Lueder*

The London Underground diagram made history as the first underground transport diagram to abandon geographic accuracy in favour of legibility, but it has also become the stuff of cultural history, inviting references and comparisons to contemporaneous diagrams and works of art over the course of its evolution.

## The Diagram under Development

In 1931, a 29-year-old temporary electrical engineering draughtsman for the Underground Group named Harry Beck, who was between contracts, sent to the publicity department of his employer a radically new diagram of the London Underground network conceived in his spare time. His first proposal was rejected, but the following year, a second attempt met with success, and in January 1933 the publicity manager finally sent a first card folder edition of the diagram to be printed and distributed to the public.

Like a painting by Piet Mondrian, the first in a series of numerous iterations of the Tube diagram begins to formulate a series of graphic rules: The Central Line provides a horizontal axis, anchoring other lines, which are constrained to either 90-degree or 45-degree angles. While in the drafts, all stations still notate as circles; the first card folder differentiates interchanges, drawn as diamonds, from stops, indicated by short ticks. The River Thames is the only above-ground feature of London that figures on the diagram. Graphic rules continue to evolve, evidenced by Beck's last published version from 1959, which is graphically anchored not only by the horizontal Central Line, but also by the vertical of the Northern Line and the new Circle Line, forming a 'bull's eye' configuration, which further enhances its memorable quality. Graphic symbols undergo a series of variations, such as the interchanges, which turn from diamonds into various configurations of interconnected circles. Beck's last versions successively eliminate most diagonal tube lines in favour of increased rectilinearity. Nevertheless, in the modifications of Beck's design by a series of other designers from 1960 onwards, Beck's original rules, even in rudimentary observation, ensure a graphic identity and continuity that remains unparalleled in any other metropolitan subway diagram. Massimo Vignelli's seminal New York Subway Map of 1972 may have established a similarly strong visual identity through its own set of graphic rules, only to be succeeded by Michael Hertz's design of 1979, which completely eradicated all of the earlier rules.

Beck radically departs from the Underground maps of his time. Much more than those maps, Beck's diagram recalls the graphics of the electrical wiring diagrams for signalling circuits he had been drafting for his erstwhile employer, a fact which is prominently advertised on the current Transport for London web page and evident from the 'spoof diagram' Beck drew in 1933 for the *Train, Omnibus and Tram Staff Magazine*, which replaces station names with terms such as 'Amp', 'Grid Leak', or 'Output Transformer'. The modernist architect Le Corbusier describes the engineer as 'inspired by the law of Economy and governed by mathematical calculation, (...) in accord with universal law'.[1] In Beck's case, the economy is one of visual attention, the universal laws are those of instant

1 *Le Corbusier*, Towards a New Architecture *(London: Architectural Press, 1982), p. 1.*

legibility, and the mathematical calculation is that of a topological transformation. Topology is a branch of mathematics concerned with properties of space, such as connectedness. Topological continuous deformation applied to a geographical London Underground map will preserve the system of connections between stations, but deform distances; the original map and Beck's diagram are homeomorphic, meaning that they can be deformed into the other without cutting or pasting.

## Recording/Explaining/Imagining

Diagrams can serve very different agendas; at one extreme, they can be automated recordings, with only a minimum of human intervention. Etienne-Jules Marey has famously described these as 'the language of phenomena themselves';[2] GPS traces are contemporary examples. Beck's diagram exemplifies another category; it aims to explain rather than record. Yet another contrasting typology of diagrams, proposed by the Situationist International in the 1950s and 60s, concurrent to Beck's refinement of the Tube diagram, refers to topological transformation. It derives its name from 'situography', quoting Henri Poincaré's mathematical concept of situ analysis, which closely relates to topology. One of its leading proponents, Guy Debord, in 'Introduction to a Critique of Urban Geography' of 1955, argues for diagrams that engage aesthetics in the sense of the sublime and elicit emphatic reactions from their viewers. Debord compares the Paris Métro Map to the seaport paintings of Claude Lorrain because of 'the particularly moving presentation, in both cases, of a sum of possibilities.'[3] Simon Sadler, in *The Situationist City*, surmises that Debord appreciated 'the way the drifting nets of track reminded him of psycho-emotional wanderings'.[4] In *Mémoires* of 1959, Debord included an old map of London's railway network alongside the Métro map of Paris, but he took care to use a map drawn before 1931, when Harry Beck 'rationalized' the Underground diagram.[5] 'The Naked City', a diagram of aboveground Paris which Guy Debord and Asger Jorn published in 1957, has achieved iconic status in the world of art, akin to the place Beck's diagram occupies in the public imagination.[6] The Situationist International professes to push situ analysis 'in an egalitarian direction under the name topology', and aims to 'set a plastic and elementary geometry against egalitarian and Euclidean geometry, and with the help of both to go towards a geometry of variables, playful and differential geometry.'[7] The Situationist's love affair with theoretical jargon contrasts with Beck's sobriety, and 'The Naked City's' diagram of 'psycho-emotional wanderings' stands at odds with the Tube diagram's economy of visual attention and minimization of travel time. Yet, both diagrams not only supply tools of navigation, but invite imaginative voyages through their cities; paraphrasing Anthony Vidler, both diagrams are 'instruments of thought and act as its mirror'.[8]

## Icon and Diagram

The philosopher Charles Sanders Peirce states that 'a diagram is a kind of icon particularly useful, because it suppresses a quantity of details, and so allows the mind more easily to think of the important features';[9] moreover, he claims that 'all necessary reasoning, without exception, is diagrammatic', as 'we construct an icon of our hypothetical state of things and proceed to observe it'.[10] According to Peirce, we draw on our experience of urban spaces and our journeys through these to form spatial hypotheses, diagrammatic abstractions of how these spaces relate to each other. These abstractions help us to conceptualize complex urban networks and systems and furnish us with a 'mental diagram', which assists us in finding our way through the metropolis. The urbanist Kevin Lynch has conducted surveys of the 'mental maps' of North American cities held by their inhabitants; by asking respondents to sketch their individual mental maps, and by overlaying responses,

2 *Etienne-Jules Marey,* La méthode graphique dans les sciences expérimentales et principalement en physiologie et en medecine *(Paris: G. Masson, 1885).*

3 *Guy-Ernest Debord,* 'Introduction to a Critique of Urban Geography', Les Lèvres Nues #6 (September 1955), trans. Ken Knabb, http://www.cddc.vt.edu/sionline/presitu/geography.html. Accessed 22 December 2012.

4 *Simon Sadler,* The Situationist City *(Cambridge, MA: MIT Press, 1999), p. 86.*

5 *Guy-Ernest Debord and Asger Jorn,* Mémoires *(Copenhagen: Permild & Rosengreen, 1959).*

6 *Sadler,* The Situationist City, *p. 60.*

7 *Asger Jorn,* 'Open Creation and Its Enemies', Internationale Situationniste #5 (December 1960), trans. Fabian Tompsett, http://www.cddc.vt.edu/sionline/si/open1.html. Accessed 22 December 2012.

8 *Anthony Vidler,* 'What Is a Diagram Anyway?' in Silvio Cassara (ed.), Peter Eisenman; Feints, *(Milan: Skira, 2006), p. 20.*

9 *Charles Sanders Peirce,* 'Of Reasoning in General', in The Essential Peirce, Volume 2: Selected Philosophical Writings, *Peirce Edition Project (Bloomington: Indiana University Press, 1998), p. 13.*

10 *Peirce,* 'The Nature of Meaning', in The Essential Peirce, *p. 212.*

11 Kevin Lynch, The Image of the City (Cambridge, MA: MIT Press, 1960).

12 BBC. New Zoneless Tube Map 'Confusing', 16 September 2009, http://news.bbc.co.uk/1/hi/england/london/8258821.stm. Accessed 22 December 2012.

13 Matthew Moore, River Thames Restored to London Tube Map by Boris Johnson. 17 September 2009. http://www.telegraph.co.uk/travel/travelnews/6201988/River-Thames-restored-to-London-Tube-map-by-Boris-Johnson.html. Accessed 22 December 2012.

14 Shortwalk Team. Download the Walking Map! 27 February 2007, http://shortwalk.blog.co.uk/. Accessed 22 December 2012.

15 BBC. Map Reveals Hotspots of the Tube, 24 August 2009. http://news.bbc.co.uk/1/hi/england/london/8218059.stm. Accessed 22 December 2012.

16 Steve Prentice, Tube Map Variations. n.d. http://www.steveprentice.net/tube/TfLSillyMaps/. Accessed 22 December 2012.

17 Dorian Lynskey, Going Underground, 3 February 2006. http://blogs.guardian.co.uk/culturevulture/archives/2006/02/03/post_51.html. Accessed 22 December 2012.

Lynch aims to identify 'common mental pictures carried by a large number of a city's inhabitants'.[11] 'The Naked City' has become a widely held academic reference, but holds little impact on popular 'common mental pictures' of Paris. In marked contrast, Beck's London Underground diagram facilitates and drives a process of negotiation as well as imposition, by which inhabitants and visitors arrive at a 'shared public diagram' of their city. That process became public in 2009 when London TravelWatch, a 'passenger watchdog', criticized the omission of the River Thames and fare zones as 'foolish',[12] followed by reinstatement of these features, with the Mayor of London 'furious that his plan to make the Thames a more prominent part of London's transport network had been undermined by the new map' and 'ordering [Transport for London] to put it back on'.[13]

Beyond its ease of use and expediency in assisting navigation, this imaginative role of the London Underground diagram accounts for the affection with which it has been embraced by Londoners and tourists since its inception. In its various guises, and through sometimes radical and not always successful redesigns by a series of authors, occasionally in public negotiation, the Tube diagram embodies the quest for a shared public diagram of London, which cannot reach any finite state, but responds to the growth and transformation of the city.

Harry Beck's diagram has established itself as an instrument of spatial thought to such an extent that it is used to visualize, categorize and explain information far beyond its original purpose. Its appropriations and mash-ups include the 'walking map' produced by a group of graphic design students to aid estimation of walking distances throughout London;[14] the temperature map produced by Transport for London's own 'cool the tube' team;[15] more or less witty translations of station names to other languages or meanings,[16] such as the 'rude tube map'; and even categorizations of nonspatial information, such as Dorian Lynskey's 'Tube Map of Music', which relates musical styles and developments to each other, using the lines and crossings of the Tube diagram.[17]

Charles Sanders Peirce's definition of the term 'iconic' explains the Tube diagram's role as 'a kind of icon particularly useful', not only in its economy of visual attention, but also in facilitating the formation of a shared diagram by supplying a graphic platform to complex processes of urban navigation, negotiation and imagination.

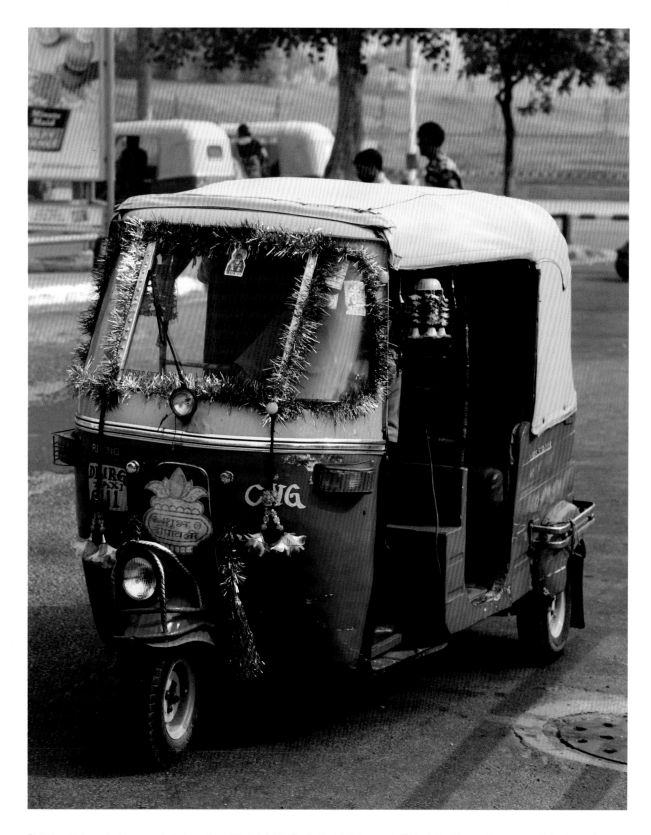

*Piaggio of Italy wanted to promote their version of the tuk-tuk in South-East Asia in generic 'Oriental' settings, with usages akin to those of urban Italy. Decorated auto rickshaw or tuk-tuk at Connaught Place, Delhi, India.*

# 4

# Tuk-Tuk, Italy/Thailand
# (Corradino D'Ascanio, 1948–)

## Thomas Brandt

An icon is, among other things, a radiating image. The striking gold leaf halos of the Russian Orthodox Christian tradition are the most palpable demonstration of this image effect. For modern phenomena like Hollywood movie stars or consumer goods, however, iconic radiance consists of sociocultural inscriptions that signify the immanence of some of the defining narratives of our times. The icons of modernity are conveyers of myths: iconic objects can provide clues to some of the sweeping tales of societal change and the order of things.[1]

If the tuk-tuk is an icon in this sense, it is not easy to immediately discern exactly what it radiates in terms of stories. First of all, as an icon it is outshone by another, far more lucid iconic object. *Tuk-tuk* is one of many unofficial names for the widely used three-wheeled utility vehicle that originated in Italy in 1948. It was designed as an offspring of the Piaggio Company's *Vespa* scooter that was already hailed as a successful novelty within motorized transport in Western Europe. The utility three-wheeled version was given the brand name *Ape*, meaning 'bee' in Italian (as a contrast to the Vespa which means 'wasp'). The word 'tuk-tuk' derives from the Thai language and was commonly used in parts of Southeast Asia from at least the 1960s onwards. It is an onomatopoetic construction, denoting the characteristic sound of the two-stroke engine. Throughout the developing countries of the world, the vehicle is also known as an auto-rickshaw. The word 'rickshaw' stems from Japanese, literally meaning a 'human-powered vehicle'.[2]

Through the etymology of the various names for this particular kind of vehicle, a set of historical narratives emerges. The tuk-tuk exemplifies a history of the transfer of technology from one part of the world to many others. Further, it reveals a history of how these transfers of a mass-produced object from one place to another, and yet others, have led to transformations in use and design embedded in changing socio-economic urban situations. The technological features of the Ape in postwar Italy are perhaps similar to those of the tuk-tuk in 1960s Bangkok, but some things have changed along the way.

## Ape Design

The Ape was designed by Corradino D'Ascanio, the Piaggio Company's leading aviation engineer, who had also been responsible for the Vespa scooter launched in 1946. With the Ape, Piaggio aimed to fill a gap in the postwar transportation market. Few people had access to automobiles; instead many customers devised creative solutions for adapting their scooters to carry larger cargoes. The home-made sidecars and flatbed truck bodies mounted on Vespas may have inspired Piaggio to develop a new product. D'Ascanio designed a tricycle version of the Vespa that enabled users to appropriate the vehicle to their specific needs. Technically, the Ape was identical with the Vespa in the front part, with the characteristic shield covering the rider, the handlebars, and a pressed, electro-welded monocoque body. The 125-cc two-stroke engine was also the same, and it was seen fit to carry 200 kg plus a driver for a stretch of 35 to 40 km on a fully loaded fuel tank, at a modest speed of 40 to 45 km/h. In the rear, however, the design deviated from the original

1 *Mircea Eliade,* The Sacred and the Profane *(New York: Harcourt Brace, 1987), p. 68; Morton Klass,* Ordered Universes *(Boulder, CO: Westwood, 1995), p. 125; Hans Blumenberg,* Work on Myth *(Cambridge, MA: MIT Press, 1985), p. 163; Roland Barthes,* Mythologies *(London: Vintage, 1993).*
2 *Oxford English Dictionary, 'tuk-tuk,* n.*', 'rickshaw,* n.*', Online version June 2012.* http://oed.com/view/ Entry/243068, http://www.oed. com/view/Entry/165604.

Vespa. The direct transmission of the Vespa was replaced by a two-chain differential. A chassis with the two rear wheels was added to allow for a range of uses.[3]

According to semiotician Omar Calabrese and sociologist Marino Livolsi, the Ape was 'intentionally designed to be both simple and yet open to modification, almost as if it were a Meccano set'.[4] It was targeted at the small-sized businesses so central to the Italian postwar economy and was adapted to various uses, ranging from delivering flowers to rubbish collection. Shops and manufacturers used the Ape hood for advertisements, thereby turning Italian road traffic into a veritable jungle of mercantile signage.[5]

Just like the Vespa, the Ape was an affordable vehicle for many Italians, helped by the hire purchase plans that had gained popularity in the Italian market before World War II. The Ape was by no means the only three-wheeled utility vehicle in Italy: both Moto Guzzi and Aermacchi had launched transport versions of their traditional motorbikes. Moreover, from the early 1950s onwards Piaggio's fiercest competitor in the scooter market, Innocenti of Milan, introduced several three-wheeled transport models of their Lambretta.[6]

Italy in the 1950s was an emerging economy, fuelled by low labour costs, and export-led growth combined with a sustainable home market for the many small-sized businesses; the latter market was difficult to penetrate for foreign companies due, in some measure, to protectionism.[7] The Ape stands as an icon of this period, signifying on the one hand the small-scale, bustling and meandering economic activities leading to prosperity in Italian towns and hamlets, and on the other, a poor-man's replacement for the proper four-wheel vans available to businesses outside Italy in the West. Three-wheeled vehicles may be suitable for short rides in narrow streets at low speeds, but they are not designed for stability over longer rides at higher speed, or larger cargoes. Just as the Vespa was, for many, a substitute for a private car, the Ape formed a stop-gap while people waited for four-wheeled vans to become available.

## A Global Icon of Prosperity?

The Vespa became a globally recognizable icon during the 1950s and 1960s due to several factors, among them an expansive export strategy by Piaggio and the licencing of production to various countries around the world. This was also the case with the Ape. Piaggio officially branded their three-wheeler as 'Vespa Commercial' abroad to make use of their most famous product in promoting this utility vehicle. Especially, the vehicle found a wide range of usages in the emerging markets of Southeast Asia. In countries such as India, Indonesia, Thailand and Pakistan, Piaggio collaborated with local trading companies to establish a market for their vehicle. In 1952, the Piaggio in-house magazine proudly reported how state leaders (or 'authorities of the Orient' as they were called) like Jawaharlal Nehru and B.G. Kher of India and Sukarno of Indonesia had expressed 'eloquent opinions' in praise of the 'social functions' of the auto-rickshaw.[8]

A form of humanitarian sentiment became part of Piaggio's marketing strategy for the Ape auto-rickshaw in these Asian markets. According to Calabrese and Livolsi's Company-commissioned history of the Ape, Piaggio subtly referenced a social mission: the company emphasized that their vehicle would replace the widespread—and for foreign visitors often picturesque—local means of transport, namely the rickshaw. The engine-powered auto-rickshaw had the potential of alleviating the rickshaw carrier from barbarous, slavish working conditions.[9] Looming behind this strategy was the ideal of a Western-style modernization in miniature through the small tuk-tuk. For example, celebratory reports from Indonesia in 1957 describe tuk-tuk cab drivers expressing their 'newly won dignity' by giving their vehicles Western names like *My Darling, Sinjo Bobby, De Lux* and *Rock and Roll*.[10] In short, Piaggio wanted to convert the rickshaw from a symbol of social misery into

3 *The Company magazine* Piaggio 2 (1949), pp. 12–13; Piaggio 3 (1949), p. 10; *Omar Calabrese and Marino Livolsi,* The Story of the Ape – Around the World on Three Wheels *(Pontedera/Pisa: Piaggio/Pacini, 1999), p. 28.*

4 *Calabrese and Livolsi,* The Story of the Ape, *p. 20.*

5 *For examples, see* Piaggio 2, *p. 12.*

6 *Vittorio Tessera,* Innocenti Lambretta. The Definitive History *(Milan: Giorgio Nada, 1999), pp. 162–87.*

7 *Michelangelo Vasta, 'Italian Export Capacity in the Long-term Perspective (1861–2009): A Tortuous Path to Stay in Place',* Journal of Modern Italian Studies *15, no. 1 (2010): 133–56.*

8 Piaggio 4 *(1949), p. 13;* Piaggio 17 *(1952), p. 12.*

9 *Calabrese and Livolsi,* The Story of the Ape, *p. 48.*

10 Piaggio 48 *(1957), p. 18.*

an icon of prosperity. Piaggio desired to portray its vehicle in Asia as merely an extension of the Italian situation: the ice cream parlours or broomstick vendors of the generic 'Orient' were just exotic versions of the small businesses of Capri and Amalfi.

Motorized three-wheelers did indeed catch on in many Asian cities from the late 1950s, albeit the Italian vehicles went through several mutations before entering into service in Asia. Although the production and use of three-wheeled motorized vehicles in Asian markets is under-researched, it is possible to make two general observations about the difference between the European Ape and the tuk-tuk of Asia. Firstly, while the Ape has always been used in Italy primarily for the transportation of goods, the tuk-tuks or auto-rickshaws are predominantly used as taxis in Asia. Secondly, while the tourist gaze today often picks up on the occasional ornamented, colourful and personalized tuk-tuks of Bangkok, Bangalore or Dhaka, this individualization through adornment seems to be a rather marginal phenomenon. More often than not, the tuk-tuks and auto-rickshaws of Asia have uniform liveries; like the yellow cabs of New York City, tuk-tuks need to be instantly recognizable as authorized taxis in a thronging, fast-paced urban landscape.

## Users as 'Voiceless Subalterns'

Beyond the tuk-tuks or auto-rickshaws as jolly, colourful icons of a down-scaled version of Western-style modernization, another narrative emerges: the story of its users. For instance, of the more than 100,000 'auto lads' of Mumbai, 95 per cent are immigrants from poorer regions.[11] Like many taxi drivers worldwide, they have a heightened risk of contracting serious diseases, but the rudimentary engine and bodywork design of the auto-rickshaw make it an unusually polluted, noisy and hazardous working environment. Electrification of the tuk-tuks and bans on the polluting two-stroke engine (removing the audible 'tuks' from the tuk-tuk) are among the solutions suggested for these problems.[12] Such actions will not, however, help tuk-tuk drivers out of their poverty; their wages are insufficient to support a family. While this story may run the risk of portraying tuk-tuk drivers as 'voiceless subalterns', to paraphrase the postcolonial theorist Gayatri Spivak, it is clearly the task of future design historiography to investigate their role in shaping design.[13]

The leading auto-rickshaw producer of India, Bajaj, the licensed producer of Piaggio's products since 1960, is now a world-leading exporter of three-wheeled utility vehicles in its own right. Bajaj has entered new markets in the style of Piaggio in the 1950s. In Dar-es-Salaam so-called 'bajajis' are seen to serve a niche market between poorly maintained, overcrowded *daladala* minibuses, and expensive taxicabs, although the pollution is still a problem. Most bajajis today are, however, not produced by Bajaj, but by Chinese manufacturers.[14] The design processes behind the tuk-tuk can no longer be linked to specific sites or individuals, but are to be found in a densely meshed web of global trade transactions. The three-wheeled vehicle of so many names and guises is, then, an apt icon for entering a variety of narratives, not the least those of the both creative and destructive forces of globalization.

11 *Beena Naryan, 'Migrant Workers in Mumbai: A Case of the Transport Sector'*, Shodh, Samiksha aur Mulyankan *2, no. 14 (2010): 62–7*, http://www.ssmrae.com/admin/images/8b5343f6e198a9e4f65a57e8157cee2d.pdf.

12 *Srdjan M. Lukic, Priscilla Mulhall, Gilsu Choi, Mustafa Naviwala, Sairam Nimmagadda and Ali Emadi, 'Usage Pattern Development for Three-Wheel Auto Rickshaw Taxis in India'*, Vehicle Power and Propulsion Conference 2007, IEEE (*9–12 Sept. 2007*): *610–6; Mohammad Rafiq Khan, 'Banning Two-Stroke Auto-Rickshaws in Lahore: Policy Implications'*, The Pakistan Development Review *45, no. 4 Part 2 (Winter 2006): 1169–85*.

13 *Gayatri Chakravorty Spivak, 'Can the Subaltern Speak?' in Cary Nelson and Lawrence Grossberg (eds)*, Marxism and the Interpretation of Culture (*London: Macmillan, 1988*).

14 *Annie Weinstock and Deo Mutta, 'Bajajis Come to Tanzania'*, Sustainable Transport *21 (2009): 10–11*.

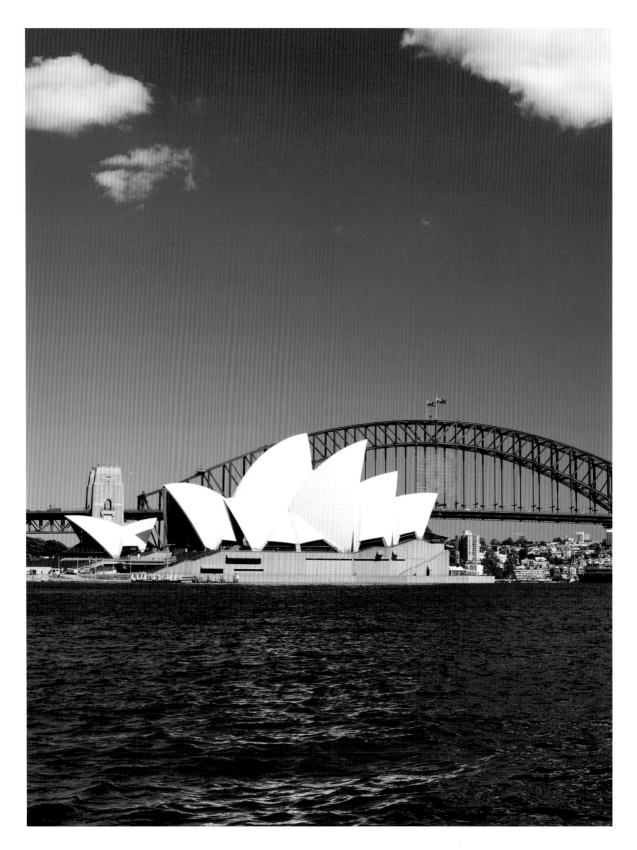

*Sydney Opera House, Australia. Photograph by Chris Howey, 11 January 2012.*

# 5

# Sydney Opera House, Australia
## (Jørn Utzon, Denmark, 1955–1973)

### D.J. Huppatz

Inscribed on the World Heritage List in 2007, the Sydney Opera House is the first modern architectural icon. Its distinctive, photogenic form, situated prominently on Sydney Harbour, has accrued civic, national and design mythologies, and the story of the building's design and construction is an integral part of its fame. More than simply a functional concert hall, the Sydney Opera House encapsulates an event—often simplified as a visionary architect's heroic but ultimately failed struggle against government bureaucracy, public indifference and technical difficulties. However, the complex interplay of design, construction, politics and public opinion belie its striking simplicity today.

## Cultural Boosters

While Australia's prewar culture remained attached to British ideals and negative towards modernism,[1] the postwar era opened up possibilities for change. Australia's economy was strong due to high wool prices and European migration was changing the nation's demographic and cultural mix. Its premier city, Sydney, had long been central in representations of Australian urban life, but, while the spectacular Harbour Bridge was emblematic of recent technological progress, cultural progress was widely believed to be lagging. It was in this context that Eugene Gossens, British conductor of the Sydney Symphony Orchestra, began lobbying for a dedicated performing arts venue in 1947.

State Premier John Joseph Cahill took up the idea and, in 1954, established an Opera House Committee to begin a feasibility study. Architectural advisors included the state chapter of the Royal Australian Institute of Architects, led by Henry Ingham Ashworth, Professor of Architecture at the University of Sydney. From the beginning, the project was 'the fruit of political ambition—Cahill's—and architectural will—Ashworth's',[2] an uneasy combination that characterized the Opera House's future. In 1955, the State government announced an international design competition with few limitations and no indication of a budget. The design brief specified two auditoriums, a major hall to seat 3,000 to 3,500 people, and a smaller one to seat 1,200 people, as well as rehearsal rooms, a broadcasting centre, a restaurant, meeting rooms and bars. The site, a promontory called Bennelong Point, proved crucial to the Opera House's later iconic status. With the Botanical Gardens on its eastern side and the other three sides surrounded by water, it was ideally situated, though critics worried that the future Opera House's front would face the Harbour and its rear face the city, or vice versa.

Local architects lobbied unsuccessfully for an Australian designer or a national competition; an anonymous international competition yielded over two hundred submissions from twenty-eight countries, and the four judges comprised two local architects, plus American Eero Saarinen and Briton Leslie Martin. An unknown and relatively young Danish architect, Jørn Utzon, submitted the winning scheme, comprising three shell-like forms atop a platform. Utzon's unusual design was controversial and garnered immediate national and international media attention. A local newspaper summed up the debate with the headline, 'Poetry or Pastry? Argument on the Opera House Plans',[3] and prominent architects including Frank Lloyd Wright weighed into the debate: 'It's sensationalism and nothing else' Wright argued, 'This project has no significance for Australia, it isn't an opera house, it's only a shell.'[4]

1 *John Frank Williams, The Quarantined Culture: Australian Reactions Against Modernism, 1913–39 (Cambridge: Cambridge University Press, 1995).*

2 *Françoise Fromonot, Jørn Utzon, The Sydney Opera House, trans. Christopher Thompson (Corte Madera, CA: Gingko Press, 1998), p. 12.*

3 Sydney Morning Herald, *30 January 1957.*

4 *Cited in Fromonot, Jørn Utzon, p. 27.*

Utzon's winning drawings of curved forms atop a podium were not only poetic, but also seemed to fully exploit the spectacular site. Though he had not visited Sydney, he had studied photographs, a film and even nautical charts of Sydney Harbour and compared the promontory to that of Kronberg Castle at Helsingør, near his studio. Utzon situated the two concert halls side by side and related them intimately to the Harbour. As he knew the forms would be visible from all four sides, Utzon conceived the project as a sculptural whole with the roofs bearing little relation to the interiors within. The podium was derived from his interest in ancient Central American monuments, but the initial designs also registered Utzon's interest in Chinese temples and Central European modernism—a global and eclectic set of historically and spatially diverse references. Before it was even completed, the eminent critic Sigfried Giedion compared the procession to the Opera House to that of the theatre at Delphi and of Mayan and Aztec platform temples, creating both an historical and sacred lineage for the unfinished icon.[5]

## From Vision to Reality

While the design was visionary on paper, there were significant technical problems to solve before it could be built. The 1950s saw numerous architectural experiments with new forms made possible by reinforced concrete; architects such as Pier Luigi Nervi and Felix Candela were experimenting with concrete domes. Utzon, who had envisaged his organic shells in concrete, was paired with the London-based engineering firm, Ove Arup & Partners, to realize his visionary forms. The architect arrived in Sydney in 1957, and work on the foundations began two years later. From the beginning, cost overruns and delays plagued the project. The promontory comprised weaker stone than originally thought and required considerable strengthening to build the massive concrete podium. Meanwhile, the vision of concrete shells proved problematic for both architect and engineers, with Utzon's small studio producing various models and plans between 1957 and 1961. Finally, the architect proposed a workable scheme based on spherical geometry in which each of the shells was a segment derived from a single, virtual sphere.[6] The design process, which began with intuitive sketches of organic forms, shifted to pragmatic problem solving in order to create a buildable system comprising prefabricated units assembled on site.

After the competition, Utzon dedicated his time almost exclusively to the Opera House and moved his family to Sydney in 1963. His movie-star looks and charming, good-humoured persona were intimately linked to the project, as was his uncompromising modernism. 'I like to be absolutely modern and work at the edge of the possible', he declared on Australian television.[7] His design process was based on exhaustive research that began with sketching and models and involved extensive research into possible materials and construction techniques. The search for the right colour, texture and composition for the white roof tiles, for example, took three years of research and trips to China and Japan before Utzon finally settled on some Japanese bowls which were reproduced in a Danish workshop. The tiles were then integrated into prefabricated 'tile-lids' that required computerized calculations to structure and install.[8]

This meticulous design process and painstakingly slow construction culminated in the Opera House's final act, starring the architect, the State Government, the engineers, contractors, and the Australian media. After the 1965 State election, in which the project was a crucial political debating point, the new conservative government confronted the architect over the awarding of contracts and working processes, while the media constantly detailed the project's spiralling costs and delays.[9] Left in an untenable position, Utzon formally resigned in February 1966 and the State Government appointed their own team of Hall, Todd and Littlemore to complete the Opera House. Despite a protest by several thousand Sydneysiders and a petition that included telegrams of support for Utzon from leading international architects, Utzon left Sydney, never to return. His designs for the remaining

5 *Sigfried Giedion*, Space, Time and Architecture *(Cambridge, MA: Harvard University Press, 1982), p. 688.*

6 *Michael Pomeroy Smith*, Sydney Opera House: How It Was Built and Why It Is So *(Sydney: Collins, 1984), p. 36.*

7 *Jørn Utzon in 'The Edge of the Possible: Jørn Utzon and the Sydney Opera House', directed by Daryl Dellora, ABC-TV, 20 October 1998.*

8 *David Taffs, 'Computers and the Opera House: Pioneering a New Technology' in Anne Watson (ed.),* Building a Masterpiece: the Sydney Opera House *(Sydney: Powerhouse Publishing, 2006), pp. 84–101.*

9 *Peter Murray,* The Saga of the Opera House *(New York: Spon, 2004).*

construction, including the glass walls overlooking the Harbour and his vision of interiors resembling a modern Gothic cathedral of prefabricated casings of plywood sheets, were never realized. After Utzon's departure, the Government altered the brief for the interiors, and the Major Hall became the concert hall while the smaller one became the opera hall. Ironically, despite media and government criticism about escalating costs and construction delays, the Opera House took another seven years to complete at an estimated total cost of $100 million (more than eight times that in today's money).

## A Modern Icon

By the time of its completion in 1973, the controversy had abated and the Opera House entered an entirely different Australian cultural landscape. Gough Whitlam's Federal Government had initiated a new cultural policy aimed at promoting and celebrating a self-consciously Australian modern culture. The initial cosmopolitan and European high cultural connotations of an opera house, an international competition and a Danish architect were tempered by local cultural expression in the interiors and at the opening ceremonies. A vast abstract mural by Australian artist John Olsen, for example, dominated the concert hall's foyer, while popular culture programmes and celebrity appearances dominated the opening ceremonies. Fittingly perhaps for a city and nation not known for their operatic culture, 'opera and symphony concert programming were conspicuously absent' from official press releases and promotional material in an effort to downplay any lingering European high cultural pretensions.[10] The opening was also a significant international event, as the building's unusual form, the political controversies, long time frame and high cost all contributed to the Opera House's newsworthiness, and its iconicity.

From his original vision of white sails or clouds floating on a platform, Utzon knew the potential power of a building as a condensed image. Distinctive yet ambiguous, the Opera House's form has 'provoked a superabundance of metaphorical responses',[11] generally references to shells, petals, scales, fish, sails or waves. This organic ambiguity differentiated Utzon's Opera House from the mechanistic and functional emphasis of earlier modernist architects, instead highlighting architecture's 'force of expression' and its communicative role.[12] For Kenneth Frampton, the Opera House's design addresses primordial issues, juxtaposing 'earthwork', or integration with the site, with 'roofwork' that both engages with the sky above and challenges the dominance of modernism's rectilinear forms and flat roofs.[13] But beyond its architectural significance, Richard Weston argues that 'Utzon's exhilaratingly open platform and cave-like shells positively invite inhabitation',[14] and it remains a popular place today for both celebrations and protests.

A high-profile cultural monument such as the Opera House was always destined to be photographed, and the entire construction process was meticulously documented and disseminated across the globe many years before the building's completion. Almost instantaneously, its distinctive silhouette became a civic and national logo, used in innumerable tourist campaigns and more recently as part of the 2000 Sydney Olympics logo and by local sporting teams. As a design icon, the Sydney Opera House is a direct precursor of Frank Gehry's Guggenheim Museum in Bilbao (1997) and a host of subsequent distinctive cultural buildings and performance halls now dotted around the globe, from Michael Wilford's Esplanade National Performing Arts Centre in Singapore (2002), to Zaha Hadid's Guangzhou Opera House (2010).[15] However, Utzon's vision of shell forms atop a podium was not simply manifest as an organic whole, but evolved and changed during its long gestation so that the interaction between government policy, design development, engineering and construction processes that created the Opera House is often suppressed by its endless reproduction as a finished icon.

10  Estelle O'Callaghan, 'The Sydney Opera House: What Does it Mean? A Study of the Shifting Meanings of the Sydney Opera House in Sydney: 1957–73', MA thesis, Department of History, University of Melbourne, 2000, p. 50.

11  Charles Jencks, The Language of Post-Modern Architecture (London: Academy Editions, 1977), p. 43.

12  Giedion, Space, p. 677.

13  Kenneth Frampton, 'Between Artifice and Nature', in Michael Juul Holm, Kjeld Kjeldsen and Mette Marcus (eds), Jørn Utzon – The Architect's Universe (Denmark: Louisiana Museum of Art, 2008), pp. 18–21.

14  Richard Weston, 'Platforms and Plateaux in Utzon's Architecture', in Holm et al. (eds), Jørn Utzon, p. 35.

15  Charles Jencks, The Story of Post-Modernism (Chichester, UK: Wiley, 2011), p. 203; Charles Jencks, The Iconic Building (London: Frances Lincoln, 2005), p. 12.

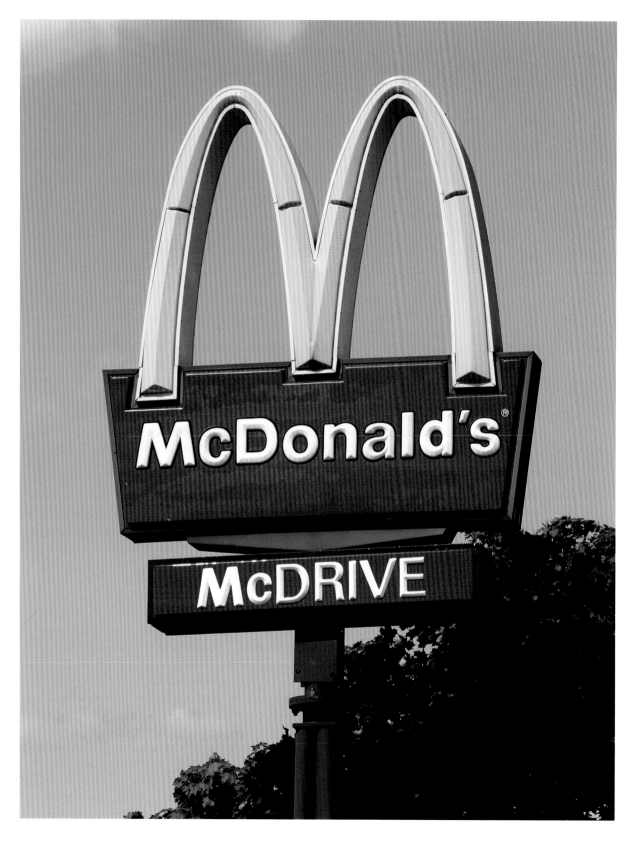

*McDonald's Golden Arches street sign. Salo, Finland, 2 June 2013.*

# 6

## McDonald's Golden Arches Logo, USA (Jim Schindler, 1968)

*D.J. Huppatz*

The bright yellow McDonald's 'M', often set against a red background, is recognized around the world. More than simply a logo for a fast food chain, the 'Golden Arches' logo has accrued both positive and negative associations from fun, ease and simplicity to associations with obesity, the homogenization of global culture and, in some instances, a perceived over-reaction to local protests against the company.

### From Architectural to Graphic Arches

In 1954, milkshake-mixer salesman Ray Kroc visited Maurice and Richard McDonald's hamburger stand in San Bernardino, California. He was impressed by the assembly line production, self-service system, cleanliness and the simple menu featuring hamburgers, French fries and milkshakes. Though the brothers had already considered a few franchise deals, Kroc wished to replicate and expand the McDonald brothers' business into a fast-food empire. The McDonalds showed Kroc their newly commissioned design for a drive-in hamburger stand covered in a bright red and white striped tile pattern. The stand featured distinctive yellow parabolic arches protruding through the roof, lit underneath by neon lights. Kroc's contract with the brothers entailed copying their system and menu, as well as design details, and included a statement that future 'buildings would have to be exactly like the new one their architect had drawn up with the golden arches'.[1] By 1959, Kroc had franchised 100 restaurants, and a decade later, over 1,000 restaurants were open across the United States, all with the prominent yellow arches.

The changing cultural landscape of late-1950s America suited Kroc's expansion. The rise of suburbia, car culture and a growing youth market with disposable income coincided with McDonald's rationalized, systematized and low-cost model of fast food production and service. In this context, McDonald's and its fast food competitors successfully detached eating from domestic intimacy, and the small business restaurant was standardized into a corporate food experience. As McDonald's expanded across the United States, design played a key role in maintaining uniformity, and the visual image established by the McDonald brothers remained consistent. The striking image of the candy-striped drive-in stand, designed by Stanley Clarke Meston, was instantly recognizable, particularly for drivers. Prior to television, 'the vivid image of the poised parabolic arches was a commercial tool' and its proliferation made it a preeminent example of roadside vernacular architecture.[2] McDonald's early success was founded on roadside visibility and automobile access as well as its consistency, service, high-turnover and low prices, exemplified by the 15-cent hamburger.

The McDonald brothers' original mascot, Speedee, a winking chef with a bun-shaped face who appeared to be in hasty motion, was a graphic symbol of their efficient service. Until the early 1960s, Speedee appeared on McDonald's merchandise, packaging and signage at McDonald's drive-in stands, often within a large yellow arch similar to the architectural arches. When the McDonald brothers sold out in 1961, Kroc briefly flirted with the idea of using the McDonald family crest as a new logo, but in 1962, senior executive

1 *Ray Kroc,* Grinding it Out: The Making of McDonald's *(Chicago: Contemporary Books, 1977), pp. 9, 67.*
2 *Alan Hess, 'The Origins of McDonald's Golden Arches',* Journal of the Society of Architectural Historians 45, no. 1 (1986): 60.

Fred Turner suggested a simple 'V' shape. Resident McDonald's designer-engineer Jim Schindler 'used that to sketch a logo that pictured the slanted roof line of the store piercing a line drawing of the golden arches in the form of an 'M''.[3] In 1968, the slanted line was dropped and the McDonald's name added to complete the logo that is still used today. At this time, Kroc engaged design consultant and psychologist Louis Cheskin, who advised retaining the memory of the arches in the 'M' form, arguing that such suggestive rounded forms also 'had Freudian applications to the subconscious mind of the consumer'.[4] Among other things, the new 'Golden Arches' logo reminded consumers of the original architectural arches—the logo had effectively shifted from three to two dimensions—and its bold simplicity was in line with a new era of modernist corporate logos.

From 1968, the original drive-in hamburger stands were gradually replaced by a standard restaurant design, with indoor seating and a distinctive mansard roof, and the yellow arches disappeared. Speedee was replaced by the colourful and more child-friendly clown Ronald McDonald as the official humanization of McDonald's, and the yellow 'M' logo was adopted consistently across signage, packaging and advertising. Although uniformity was crucial to the corporation's success, store design after 1968 did make some concessions to the 'localization' of the interior décor.[5] The simple yet powerful logo remained consistent, seemingly an embodiment of Kroc's corporate ideals of 'Quality, Service, Cleanliness and Value'. But the yellow 'M' was also inextricably linked to a spatial environment and, increasingly, to a particular experience, with associations of fun and family participation that ultimately took precedence over food consumption.

From the beginning, the McDonald brothers referred to the parabolic forms on their hamburger stand as 'golden arches', and the appellation stuck. Though clearly yellow, the arches were 'transformed by a bit of verbal alchemy into golden arches',[6] such that 15-cent hamburgers acquired associations of quality and purity, while the experience of passing beneath the 'Golden Arches' was quasi-spiritual. Significant investment in advertising, particularly via the new medium of television, helped to make the McDonald's logo and brand widely recognized. McDonald's executives were also keenly aware of the potential of a new consumer group, children, and saturation advertising and promotional campaigns in the 1980s and 90s meant that by the early twenty-first century, more than '95 percent of American children recognize[d] the Arches'.[7] The bright, block colours and simple form of the 'M' aid recall, even by toddlers, while brand loyalty is widely believed to be founded upon an emotional connection to the logo from a young age,[8] a process surely embodied in the children's 'Happy Meal'. However, despite its positive connotations, the McDonald's logo has more recently also become emblematic of a fast-food culture that has been criticized within America and beyond from both health and corporate ethics perspectives.[9]

## A Global Icon

Building upon initial franchising success in the United States and Canada in the late 1960s, McDonald's global expansion really got underway in the early 1970s when the firm successfully opened franchises in various European countries as well as Japan and Australia. The consistent image that had been developed in the United States was subtly adapted to various cultural contexts, but the McDonald's logo and its associated experience entered a new phase with exportation: outside the United States, the store design, menu, service, and marketing were understood as quintessentially American. With its rapid global growth in the 1980s and 90s, the McDonald's logo became a highly visible symbol of the spread of American power and influence, and in turn became difficult to separate from American social and political values.

In the United States, a yellow 'M' by the roadside signified a cheap, convenient and quick meal for busy families, but in other cultures it took on radically different meanings,

3 John F. Love, McDonald's: Behind the Arches (New York: Bantam Books, 1986), p. 148.

4 Thomas Hine, The Total Package (Boston: Little, Brown and Co., 1995), p. 214.

5 John Jakle and Keith Sculle, Fast Food (Baltimore, MD: John Hopkins University Press, 1999), p. 160.

6 Hine, The Total Package, p. 220.

7 Joe Kincheloe, The Sign of the Burger (Philadelphia: Temple University Press, 2002), p. 146.

8 Paul M. Fischer, Meyer P. Schwartz, John W. Richards, Jr, Adam O. Goldstein and Tina H. Rojas, 'Brand Logo Recognition by Children Aged 3 to 6 Years', Journal of the American Medical Association 266, no. 22 (1991): 3145–8.

9 Eric Schlosser, Fast Food Nation (Boston: Houghton Mifflin, 2001).

particularly as it was first introduced in relatively wealthy urban areas. The total design of the store, branding and experience were recognized in many countries as symbols that expressed modernity, wealth and social progress. In Asian cities in the 1980s, for example, the McDonald's logo popularly represented 'an exotic export' that appealed 'to the busy, upwardly mobile middle classes … precisely because it promises—and delivers—predictability and cleanliness.'[10] In the 1990s, in former Eastern Bloc countries, the yellow 'M' represented a visible sign of long repressed 'American' culture—including the embrace of popular entertainment, leisure time and conspicuous consumption—while in Beijing, where McDonald's first opened in 1992, the experience of Americana was ultimately more important than the food.[11]

By the 1990s, the yellow 'M' embodied a series of 'conflicting perceptions', in which 'the nature of the signification differs dramatically depending on whom one asks, illustrating the deep divisions both inside and outside the United States in readings of contemporary culture'.[12] Globally, the McDonald's logo had become a site for contestation of national identities and the relative merits of popular culture, although connotations varied widely from place to place.[13] In debates about globalization, McDonald's was often conflated with alienated labour and its staff depicted as low-paid, deskilled automatons, while the company's increasingly powerful control over food supply chains and aggressive expansion were depicted as threats to local food cultures. In this context, McDonald's became a focus for various antiglobalization movements in the 1990s.[14] High-profile media events, such as French farmers dismantling a partially finished store in 1999 and the notorious 'McLibel' case in which McDonald's sued activists on libel charges for distribution of a critical pamphlet, further expanded the logo's symbolic connotations.[15]

McDonald's innovative organizational systems and practices, built on expansion, low wages, and strict control of overheads, have come to embody multinational corporate practices more generally. This process, known as 'McDonaldization', is characterized by the idea that 'McDonald's has succeeded because it offers consumers, workers and managers efficiency, calculability, predictability and control',[16] a paradigm of business innovation that has been copied by other industries. While many have argued that through such processes, McDonald's renders the world homogenous, several critics have noted 'how McDonald's molds its products, architecture and atmosphere to local conditions and generates a multiplicity of experiences, social functions and significance in diverse local conditions.'[17] Embodied in the consistent image of the yellow 'M', organizational standardization has been crucial to the company's success from the beginning. However, it is precisely because of this standardization and familiarity of the signage, menus and interiors, that for many children around the world, 'the Golden Arches symbolize more than just food; McDonald's stands for home, familiarity and friendship',[18] a remarkable reversal of the reality of industrialized fast-food production and consumption.

By 2012, McDonald's was operating over 33,000 restaurants in 119 countries, according to its website. With high-profile global sponsorship such as the 2012 Olympics and commercial agreements with Disney, the yellow 'M' is one of the most recognized symbols on the planet. More than a corporate logo, it has become an icon invested with the cultural and political values of Western capitalism, exemplified by Benjamin Barber's popular depiction of global conflict as 'Jihad vs. McWorld' or Thomas Friedman's utopian image of one-world harmonized by the 'Golden Arches Theory of Conflict Prevention'.[19] Remarkably, this innocuous yellow 'M' has evolved from its humble origin as an architectural ornament on a hamburger stand to an icon of such compressed complexity that one critic argues, 'choosing or resisting McDonald's is not just an issue of individual choice, but it is also a social, ethical and political issue'.[20] That the McDonald's logo is believed to encapsulate such weighty considerations attests to its iconic power.

10 *James L. Watson, 'Introduction', in* Golden Arches East: McDonald's in East Asia *(Stanford University Press, 1997), pp. 35, 33–4.*

11 *Yunxiang Yan, 'McDonald's in Beijing: The Localization of Americana', in Watson,* Golden, *p. 47.*

12 *Kincheloe,* The Sign, *p. 8.*

13 *Thomas Hylland Eriksen,* Globalization *(Oxford: Berg, 2007), p. 141.*

14 *Naomi Klein,* No Logo *(London: Flamingo, 2000), pp. xix–xx.*

15 *John Vidal,* McLibel *(London: Macmillan, 1997).*

16 *George Ritzer,* McDonaldization: The Reader *(Thousand Oaks, CA: Pine Forge Press, 2006), p. 14.*

17 *Douglas Kellner,* Media Spectacle *(London: Routledge, 2003), p. 40.*

18 *Watson,* Golden Arches East, *p. 22.*

19 *Benjamin Barber, 'Jihad vs. McWorld',* The Atlantic, *March 1992; Thomas Friedman,* The Lexus and the Olive Tree *(New York: Farrar, Straus, Giroux, 1999).*

20 *Kellner,* Media Spectacle, *p. 57.*

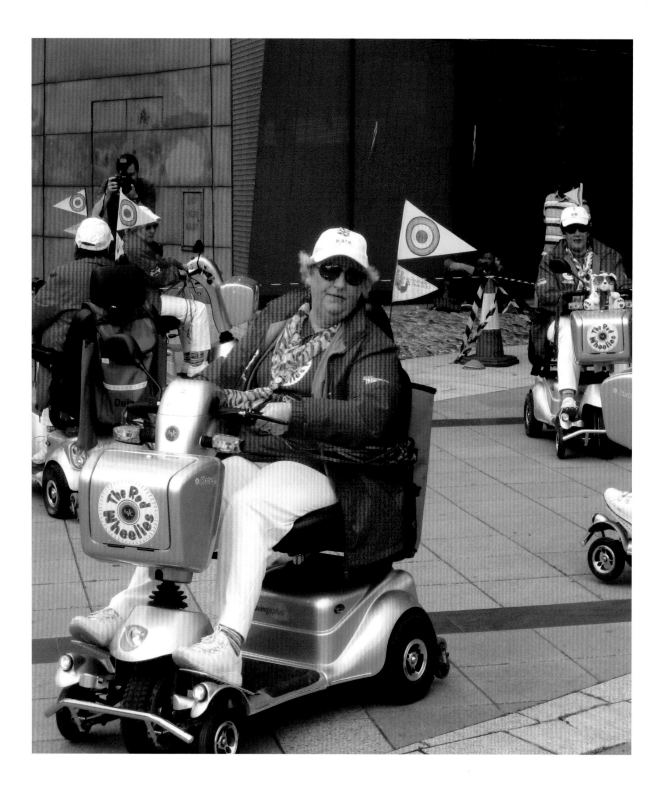

*Red Wheelies, Mobility Scooter Display
Team, Peckham, London, 2010.
Photograph by Iain Aitch.*

# 7

# Mobility Scooter, USA
# (Allan R. Thieme, 1968)

*Nicolas P. Maffei*

1 *Department for Transport, Inclusive Mobility, 15 December 2005,* assets.dft.gov.uk/ publications/access-inclusive-mobility/inclusive-mobility. pdf; *Office for National Statistics, Ageing in the UK Datasets, 2011 Pension Act and 2012 (N.I) Pension Act Update, 'Table 8 Percentage of Population Aged 65 and Over 1992–2033'; The NHS Information Centre, Statistics on Obesity, Physical Activity and Diet: England, 2012, pp. 6, 20.*

2 *Phil Barham, Philip Oxley and Anna Board, 'Review of Class 2 and Class 3 Powered Wheelchairs and Powered Scooters (Invalid Carriages), Final Report on Stage 1', UK Department for Transport, 2004, p. 66; Martin Delgado, 'Illegal: Britain's 250,000 Mobility Scooters', Mail Online, 25 November 2006,* http:// www.dailymail.co.uk/news/ article-418615/Illegal-Britains-250-000-mobility-scooters.html.

3 *'The Electrifying Experience',* The Magic Carpet *XXXIV, no. 2 (1987): 32–9.*

4 *Mitchell P. LaPlante, 'Demographics of Wheeled Mobility Device Users', Paper presented at the conference Space Requirements for Wheeled Mobility, Center for Inclusive Design and Environmental Access, State University of New York Buffalo, New York, 9–11 October 2003, p. 10.*

5 *Fengming Su, Michael G. H. Bell and Jan-Dirk Schmöcker, 'Mobility Scooter Usage in London – Results from the Scootability Project' (Transport Canada, 2007), p. 2.*

6 *Barham, Oxley and Board, 'Review', pp. 1, 27; LaPlante, 'Demographics', p. 3.*

In recent decades, with unprecedented increases in elderly and obese populations and legislation requiring access for all, the mobility scooter has become a highly visible symbol, both of independence and of the supposed excesses of modern living. Part III of the UK Disability Discrimination Act of 1995 gives disabled people the right to access goods, services, facilities and premises. In the United States, the Americans with Disabilities Act of 1990 requires similar access rights.[1] While tabloid newspaper readers' online comments regarding speeding grannies invading the pavements and shop aisles and health professionals linking inactivity to obesity, hundreds of thousands of disabled and less mobile people have gained life-changing freedom through this revolutionary form of transport. Expressing 'mounting concern' and a need for government intervention, press coverage in the UK has been highly emotive, characterizing mobility scooter drivers as either 'culprits' or 'victims' and painting a scene of pavements and shops flooded with the dangerous devices, causing innumerable injuries to pedestrians and property.[2] While the mobility scooter can be associated with a large-scale invasion of the pedestrianized environment, such vehicles can also be understood as profound agents of personal empowerment.

Many disabled consumers have chosen to ride scooters because of the negative connotations of electric wheelchairs, which are often associated with institutionalization and illness. In 1987, readers of the *The Magic Carpet*, a leading UK publication on transport for disabled people, said they were 'apprehensive' about being seen in wheelchairs and felt that scooters provided an 'acceptable answer to this qualm'.[3] A US study of 2003 showed that about 41 per cent of scooter owners also had a manual wheelchair exclusively for indoor use, which suggests that scooters have been seen as a more publicly presentable transport option than the wheelchair.[4] Furthermore, according to a UK study of 2006, people with disabilities when offered a loan of either an electric scooter or a wheelchair chose the former, as it provided 'improved movement and independence and [was] viewed as less stigmatizing than a … powered wheelchair.'[5]

Many studies show that the market for electric mobility scooters is rising rapidly due to an ageing population, improved styling of scooters and the ease with which they can be purchased.[6] In addition, disability legislation has led to an increase in more accessible environments.[7] Between 1990 and 2000, scooter usage in the United States more than doubled from 64,000 to 142,000.[8] In the United Kingdom, the number of mobility scooters in use nearly tripled from 70,000 in 2007 to almost 300,000 in 2012, with around 70,000 scooters now sold each year.[9] Schemes like Shopmobility, which in 2002 lent scooters to over 200,000 people for more than 1.5 million shopping trips, have helped to make mobility scooters even more visible on UK high streets and in shopping malls.[10] A UK study of 2004 observed a styling trend towards 'non-stigmatizing' pavement vehicles, making explicit the efforts by designers to differentiate mobility scooters from wheelchairs.[11] Not coincidentally, these design developments occurred in the years following the introduction of disability legislation in the United States and United Kingdom that emphasized accessibility.

7 'Disability in the United Kingdom 2012: Facts and Figures' (Cambridge: Papworth Trust, 2012) http://www.papworth.org.uk/downloads/disabilityintheunitedkingdom 2012_120910112857.pdf; Rehabilitation Research and Training Center on Independent Living Management, Disability Rights Timeline, 2002, isc.temple.edu/neighbors/ds/disabilityrightstimeline.htm. In the United States, 'The American Standard Specifications for Making Buildings Accessible to, and Usable by, the Physically Handicapped' was published in 1961 by the American National Standards Institute, Inc. (ANSI). In 1968, the Architectural Barriers Act legislated physical accessibility in all federal buildings.

8 H. S. Kaye, T. Kang and M.P. LaPlante, 'Mobility Device Use in the United States', Disability Statistics Report 14 (Washington, DC: US Dept. of Education, NIDRR, 2000), p. 13.

9 Amelia Gentleman, 'The Trouble with Mobility Scooters', www.guardian.co.uk/society/2012/may/02/trouble-with-mobility-scooters, 2 May 2012.

10 ORI for the Disabled Persons Transport Advisory Committee, Attitudes of Disabled People to Public Transport, November 2001–January 2002, 41, http://www.transport-research.info/Upload/Documents/200608/20060811_110503_45123_UG395_Final_Report.pdf.

11 Barham, Oxley and Board, 'Review', p. 27.

12 'Thalidomide Vehicles', Magic Carpet XXII, no. 2 (1970): 18–19.

13 'Shop Window', Magic Carpet XXXI, no. 2 (1979): 42.

14 'Shop Window', Magic Carpet XXVIII, no. 3 (1976): 35.

15 'Shop Window', Magic Carpet XXXI, no. 1 (1979): 8.

16 Doris Zames Fleischer and Frieda Zames, The Disability Rights Movement: From Charity to Confrontation (Philadelphia: Temple University Press, 2001).

17 Range Rider advertisement, Magic Carpet XXXVIII, no. 1 (1986): 7.

## Technology and Origins

On 16 March, 1971, US patent no. 3,570,620, for a lightweight, three-wheeled 'electrically powered vehicle', was granted to the inventor and entrepreneur Allan R. Thieme. This would be the basis for the commercially successful Amigo. The patent drawing depicts a slim, tubular framed, three-wheeler with a basic seat and a streamlined front fairing. The overall design indicates an effort by the inventors to combine the existing visual language of two-wheeled transport with new styling, thereby fusing fashionability and familiarity in a radically new form of transport. Despite the existence of such an early innovation, the uptake of electric pavement vehicles was slow. In the 1970s, UK laws prohibited 'mechanically propelled vehicles on the pavements', despite the availability of appropriate technology and the production of a limited number of motorized scooters, including a handful produced for children with mobility needs.[12] One such vehicle, the Hobcart marketed by the UK government as 'remedial toy-cum-transport', was available in 1969. Like a recumbent bicycle, the Hobcart had a low centre of gravity and bicycle hand brakes, but with tiller steering, two wheels at the front and a single wheel at the back.[13] Even the later development of four-wheeled pavement buggies, despite the marketing rhetoric of 'ruggedness' and the appeal to the 'active' 'disabled' (discussed later), might have been perceived as toy-like and therefore rejected as infantilizing by potential adult users. While the technology for electric mobility scooters—compact batteries, lightweight structural materials and small motors—was available in the late 1960s, their development was delayed, perhaps in part by the juvenile associations of such early forms of electric pavement transport.

Promoted as 'electrically powered chairs' rather than scooters, a number of four-wheeled buggy-style and three-wheeled, lightweight, electric pavement vehicles were offered to those with mobility needs in the UK in the 1970s. It is around this time that many of the four-wheelers adopted the language, technology and design variations employed by the automotive industry. A 1976 advertisement noted that the Batricar, 'resemble[d] a small car', was powered by an automobile battery, and was available in a choice of red, green, blue or yellow. In an age before dropped kerbs, the copy proudly proclaimed its pavement-mounting prowess.[14] In 1979 another four-wheeler, the BEC Ranger Mk I, was profiled in Magic Carpet. The brochure exuded the gusto of automotive journalese, while appealing to a desire for empowerment, declaring that the 'rugged all purpose outdoor kerb-climbing vehicle for the more active disabled' 'hammers along at 4 miles per hour'.[15] In a world of segregated traffic, the carlike connotations may not have eased the acceptance of the Batricar and BEC Ranger Mk 1 onto public pavements. The more assertive tone and enabling message of this and other advertisements for electric vehicles, however, echoed a call for equal treatment and access for disabled people in the 1970s and 1980s.[16] 'Don't Be Pushed Around! Get a BEC portable Electric Wheelchair', one 1973 advertisement stridently proclaimed. The sales copy for the Range Rider (1986) attempted to normalize the existence of both mobility vehicles and disabled people: 'Strange Rider? Not at all. There's nothing strange about me or my new Range Rider.' Like advertisements for four-wheel-drive cars, the copy emphasized freedom and adventure, connoting a message of potency and emancipation. 'Designed for almost unlimited outdoor use, it's taken me up steep muddy hillsides, across pebbly beaches and sand dunes. Snow, ice, and large kerbs are no problem either.'[17]

In the early 1980s, lightweight, three-wheeled electric chairs began to gain prominence in the urban scene. Previously, the term 'electric chair' was commonly used to describe three- and four-wheeled electric mobility vehicles, but in the early 1980s the term 'scooter' began to be frequently used in product names and descriptions. This may have been

PART ONE: HOT IN THE CITY

an attempt to emphasize the notion of outdoor mobility inherent in the term and to gain distance from the idea of domestic stasis, which the word 'chair' perhaps implies. Scooters that appeared on the market were promoted as fun and included endearing and user-friendly product names such as the Amigo, Portascoot, Scoota, Elo-boy and Runaround, perhaps aimed to overcome any perceptions of danger, toughness or technical complexity that might have been associated with previous mobility vehicles. Allan R. Thieme's Amigo was perhaps most characteristic of this approach to promoting the scooter as an accessible and sociable form of transport. Advertisements for the three-wheeled Raymar Amigo, 'The Friendly Wheelchair for People on the Go', appeared in the UK in the summer of 1980. The ad copy emphasized its 'friendliness' while presenting less mobile people as active and on the move. 'Now, thanks to AMIGO, almost everyone that has difficulty can enjoy an active life. Use it in the home, outside on hard surfaces, for shopping, travelling, working in the office, going to a restaurant, the theatre, or a museum … any place, anywhere.'[18] The Amigo's emphasis on companionship would have appealed to those who may have suffered social isolation due to their lack of mobility.

In recent years, the design of mobility scooters has dramatically shifted from engaging the imagery of easy chairs and automobiles to that of motorbikes and space capsules, perhaps reflecting a wider acceptance of personal electric vehicles. Complete with chrome mudguards and chopper handlebars and 'inspired by leading designs in the motorcycle industry', the Sport Rider mobility scooter suggests rebelliousness, danger and speed. In 2011, *Disability Now* compared it to the 'Harley Davidson ridden by the Terminator …'[19] General Motors' 'transportation pod', the EN-V personal mobility concept vehicle, offers a high-tech, futuristic fantasy for the urban commuter.[20] In 2009, Honda introduced its electric EV-Monpal, a four-wheeled, solar-powered mobility scooter. In the tradition of Thieme's Amigo scooter, the intention of the EV-Monpal's designers was to create a pavement vehicle that was so 'cute' and 'approachable', and easy to use, that it would become a 'partner in life'. The 'cute' and 'lovable animal face' of the vehicle was considered key in achieving these goals.[21]

## Conclusion

The Charter for Pedestrians' Rights adopted by the European Parliament in 1988 considered pedestrians and those using mobility devices, including scooters, to be entitled to a healthy environment and 'to enjoy freely the amenities offered by public areas'. A 2011 International Transport Forum report concluded that the 'vitality' of a city is derived to a great degree from people being out and about, noting that those on foot or on electric motorized vehicles activate cities, not just through the practice of accessing goods and services, but through 'sojourning', 'which is at the heart of urban life and contributes to livable, attractive, prosperous and sustainable cities'.[22] Yet, for scooters to become more universally accepted, and thus contribute more widely to the culture of cities, they must appeal to the less mobile *aesthetically*, as well as practically. Mark Hermolle, managing director of Kymco Healthcare, notes that scooter users today insist on stylish and powerful vehicles. 'An earlier generation would say: if I can't get there with my stick, I won't go anywhere. But scooters have become much more acceptable. Scooters are an extension of your self. Just as you think, "I can either buy an ugly suit or a smart one," the same is true of scooters. People take pride in these products. They don't want to look as if they are driving around on an old bread bin.'[23]

18 *Amigo Advertisement*, Magic Carpet *XXXII, no. 3 (Summer 1980): 25.*

19 *Drive Medical catalogue 2012,* www.drivemedical. co.uk/Catalogue/Scooters-Accessories/Scooters/SPORT-RIDER-SCOOTER-IN-BLACK-SROO1BLK.

20 *'GM Reveals EN-V Concept', 24 March 2010,* gm-volt.com/2010/03/24/gm-reveals-en-v-concept/.

21 *'Designers Talk no. 3, Tokyo Motor Show, EV-Monpal',* world.honda.com. design/designers-talk/tms2009/ ev-monpal/index.html.

22 *Pedestrian Safety, Urban Space and Health, 2011 report,* http://www. internationaltransportforum. org/Pub/pdf/11PedestrianSum. pdf.

23 *Gentleman, 'The Trouble with Mobility Scooters'.*

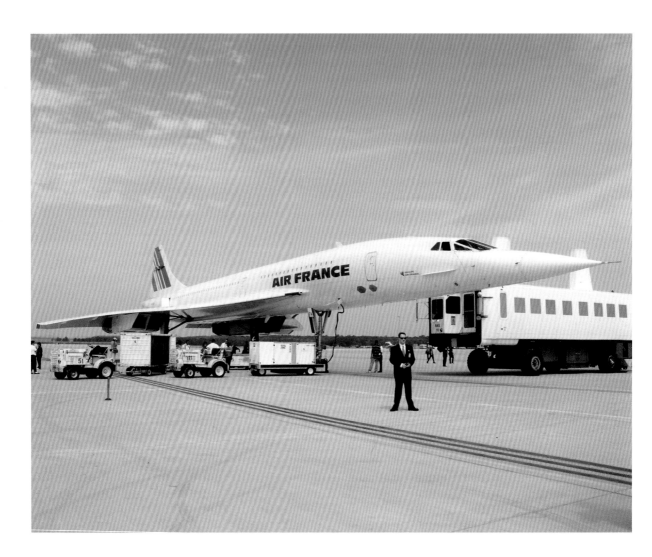

*Concorde F-BVFA arriving at Dulles International*
*Airport, Washington, DC, on its way to join the*
*collection of the National Air and Space Museum,*
*Smithsonian Institution, 12 June 2003.*
*Photograph by F. Robert Van Der Linden,*
*Curator of Air Transportation, Special Purpose*
*Aircraft, National Air and Space Museum*
*Smithsonian Institution.*

# 8

# Concorde, France/UK
# (Pierre Satre/Sir Archibald Russell, Aerospatiale/BAe, 1969)

## *Amy E. Foster*

Concorde—there is nothing quite like her. Except for the Soviet Tupolev Tu-144, no other passenger plane offered travellers the opportunity to recreate Scott Crossfield's record-setting Mach 2 flight (20 November 1953). One look at her iconic, innovative and beautiful design suggests that, even compared to the Tu-144, she was unique. With her sleek delta-wing design and extendable nose cone, she is both elegant and stark and remains one of the most recognizable, and iconic, aircraft of the twentieth century. Concorde's iconicity engages the erstwhile glamour of air travel, before budget airlines, terrorism and associated security concerns, and anxieties about environmental impact combined to tarnish the passenger experience.

Only twenty Concordes were ever built; the first two were prototypes used for test purposes, and two were pre-production aircraft that saw extensive testing but were never refitted for commercial use.[1] From a statistical standpoint, the Concorde was a minor player. She was not one-of-a-kind as was the Wright Flyer or the *Spirit of St. Louis*. Nor was there one individual Concorde that captured public attention, such as Boeing's B-29 *Enola Gay* or the 747 serving as the *Air Force One.* So how is it that this small fleet of aeroplanes has become so iconic?

Certainly her elegant appearance has something to do with it: Concorde's shape is unique—distinctive and therefore iconic. But it is more than just her iconic look that has made the history of the Concorde significant and so memorable. Concorde was the first and really the only plane that offered the general public the chance to fly higher and faster than ever before. In terms of the history of technological achievement, which in the twentieth century particularly translated into 'faster, farther, higher', the Concorde was the pinnacle of aeronautical development, one that has yet to see its equal or successor.[2] Aviation historian Guillaume de Syon has compared the technological hope for the Concorde to that for the TGV (France's version of the Japanese Shinkansen or bullet train).[3]

The Concorde is the product of an agreement between France and Great Britain signed in November 1962. The responsibility of designing and building the prototypes and the production vehicles fell to the British Aircraft Corporation (BAC) and France's Sud-Aviation, better known as Aérospatiele.[4] During the design phase of this project, the Anglo-French alliance, the United States and the Soviet Union were all in pursuit of a supersonic commercial vehicle. Each nation viewed the achievement of the world's first supersonic transport (or SST) as a technological feather in their caps. In the aviation field, the SST was the equivalent to NASA's Apollo programme.[5] Juan Trippe, chairman of Pan American World Airways, commented in July 1966 about the British and French effort to build the Concorde, 'If they did get going and we were left behind we would find that we would be in a pretty bad shape from the point of view of public patronage and public acceptance without something on the oceans that would stay in the ring with them.'[6]

Pride and politics, more than any other factors, kept this project alive. As part of the agreement between BAC and Sud-Aviation, both companies built and flew their own aeroplanes (the same emphasis on national pride is echoed in British novelist Nevil Shute's

1 *'Concorde Fleet',
Heritage Concorde,* http://
heritageconcorde.com/?page_
id=6789. *Accessed 17 July 2012.*

2 *See Terry Gwynn-Jones,
'Farther: The Quest for Distance'
and John D. Anderson, 'Faster
and Higher: The Quest for
Speed and Power', in John T.
Greenwood (ed.),* Milestones
of Aviation *(Washington, DC:
Hugh Lauter Levin Associates
Inc., 1989), pp. 14–77, 80–147.*

3 *Guillaume de Syon,
'Consuming Concorde',*
Technology and Culture *44,
no. 3 (July 2003): 653.*

4 *F.G. Clark and Arthur
Gibson,* Concorde *(New York:
Paradise Press, Inc., 1978):
pp. 5–6.*

5 *Ibid., p. 2.*

6 *Kenneth Owen,*
Concorde and the Americans:
International Politics of
the Supersonic Transport
*(Washington, DC: Smithsonian
Institution Press, 1997): p. 63.*

*In the Wet*, a story that recounts an Australian pilot's experience flying the Australian high-speed transport for the Queen).[7] This was a project to which the French were wholly committed, but as the British faced continuing technical challenges and subsequent growing development costs, their dedication to the project waned. However, the political ramifications of breaking the alliance and risking the British image by pulling out of the technological race meant that they saw no option but to forge ahead.[8]

Even the naming of this new plane showed how connected this project was to national image. Early in the collaboration, the British referred to the aeroplane as the SST, like the Americans. The French, understandably, called it the TSS (for 'transport supersonique') or, more often, the 'Super-Caravelle', a nod to Sud-Aviation's medium-range jet aircraft, the SE 210 Caravelle. The name 'Concorde' came from a suggestion made by a BAC executive to build on an English word emphasizing the partnership behind the aeroplane, but adding the 'e' to acknowledge the French half of the team.[9]

The race to be the first country (or partnership in the case of the Concorde) to fly the SST continued through the 1960s. Aérospatiale rolled out the first prototype of the Concorde, 001, from its Toulouse assembly hall in December 1967. Its first subsonic flight did not take place until 2 March 1969. But the race to get into the air was won by the Soviets with the first flight of the Tu-144 taking place on 31 December 1968.[10] Each benchmark moment for any of the three SSTs was closely scrutinized by the competing nations. Like the Space Race between the United States and the Soviet Union, this three-way push for control of the commercial airways was arguably as heated when it came to the SST. The publication *Aviation Week and Space Technology* closely reported on the progress of all three designs.[11] The political battle over the SST between the United States, France and Great Britain—despite their long-standing allegiance in the twentieth century and particularly during the Cold War—took on an intensity that most people may not have realized existed.

Historian Kenneth Owen noted that at least as early as 1966, the Central Intelligence Agency was actively gathering information on the Concorde's progress, evaluating the technical problems still left to solve, as a way to gauge when she would go into production and, ultimately, service.[12] The major concern for the United States was whether Boeing (the company contracted to develop the US SST) could reach production of its anticipated Mach 3 vehicle quickly enough behind the Concorde (as it most certainly would not beat the Concorde into the air) to capture enough of the international market to make the American effort economically viable.

The Concorde first entered commercial service on 21 January 1976 with Air France flying from Paris to Rio de Janeiro via Dakar, Senegal, and British Airways flying from London to Bahrain.[13] The next fastest commercial aircraft in the field was the Boeing 747, which entered service in February 1969 with an average cruising speed of 640 miles per hour (approximately .85 Mach at sea level). Comparatively, though, the Concorde only carried around 110 passengers versus the 747's 374-person capacity.[14] Concorde's size was actually one of the major arguments against the design, one that came down to economics. That, among other controversies, distinguished the Concorde.

Perhaps the greatest controversy associated with the Concorde (one that defined or arguably tarnished its image) was its environmental impact. For a transoceanic aeroplane that carried just over one-quarter of the passengers of the 747, the Concorde was seen as a major abuser of limited fuel resources, particularly during the oil crises of the 1970s. As the environmental movement gained momentum in the 1970s, advocates took special issue with the Concorde for its carbon footprint. Equally important was the fact that the Concorde would fly at altitudes above 50,000 feet.

7 *Nevil Shute*, In the Wet *(New York: Ballantine Books, 1953).*

8 *Owen*, Concorde and the Americans, *pp. 51–2.*

9 *Clark and Gibson*, Concorde, *p. 8.*

10 *Ibid., p. 34.*

11 *See* Aviation Week and Space Technology, *93, no. 1 (2 July 1970) and 94, no. 6 (2 February 1971) for significant spreads on the American SST and the Concorde respectively.*

12 *Owen*, Concorde and the Americans, *p. 69.*

13 *'Concorde Timeline', Heritage Concorde,* http://heritageconcorde.com/?page_id=3114. *Accessed 28 July 2012.*

14 *All data is representative of the early 747-100 and -200 models. See* http://www.boeing.com/history/boeing/747.html.

PART ONE: HOT IN THE CITY

Environmentalists were concerned that at that altitude the nitrogen oxide in the Concorde's exhaust would accelerate the depletion of the planet's ozone layer. But it was noise pollution that raised the most hackles and made the Concorde so memorable.[15] Although the decibels produced by Concorde's Rolls-Royce engines were high, they stayed within the limits set for subsonic commercial aircraft. Major opponents to the arrival of the Concorde were the residents surrounding John F. Kennedy International Airport in Long Island, New York. They already tolerated significant noise from air traffic and openly protested about the introduction of more. The continued concern was the effect of the sonic boom on the ground. Even though builders of the Concorde were committed to flying at supersonic speeds only over the oceans, environmentalists still expressed concerns about how the noise and pressure waves might affect marine life.

On 4 February 1976 the US Secretary of Transportation William T. Coleman, Jr. authorized a sixteen-month demonstration involving limited commercial flights of British Airways and Air France flights of the Concorde to Dulles International Airport outside Washington, DC and at JFK. Coleman understood the unpopularity of such a decision noting, 'I am fully cognizant of the fact that a complete bar of the Concorde would be a popular and widely acclaimed course of action, particularly by environmentalists and by the citizens in many of the areas surrounding the airports. Perhaps I would even be depicted by the press, however mistakenly, as the man who stood up to some undefined but sinister pressure to let the Concorde in.'[16] Environmentalists and the Port Authority of New York protested and appealed the decision, delaying the arrival of the Concorde until 23 November 1977. New Yorkers lost the fight to keep these aeroplanes out of their city, and the London–NYC and Paris–NYC services came to define the business and elite travel that made the Concorde famous and were its raison d'être.

In April 2003, British Airways announced that the Concorde service would be coming to an end later that year (the last commercial flight of a British Airways Concorde took place on 24 October that year).[17] Since their retirement almost all the remaining Concordes have found homes in museums, including the Smithsonian Institution's National Air and Space Museum, testimony to the iconography and passion associated with the Concorde. Air France made a similar announcement with suspension of its service on 31 May.[18] Although numerous countries have discussed the possibility of developing what amounts to the Concorde 2.0, including a partnership between Great Britain, France, the United States, Germany and Japan, or some combination of those nations, and a desire to develop a hypersonic transport, it is unclear whether the technology of supersonic flight has yet to catch up with the economics. (In 2003, a round-trip ticket aboard the Concorde still cost $8,148.)[19] As Air France Chairman Jean-Cyril Spinetta remarked upon the announcement of the Concorde's retirement, 'the Concorde will never really stop flying because it will always have a place in people's imaginations'.[20]

15 *Owen*, Concorde and the Americans, *p. 161.*

16 The Secretary's Decision on Concorde Supersonic Transport *(Washington, DC: U.S. Government Printing Office, 1976), p. 59.*

17 *'End of an Era for Concorde', BBC News,* http://news.bbc.co.uk/2/hi/uk_news/3211053.stm. *Accessed 18 July 2012.*

18 *Pierre Sparaco, 'Air France Ends Supersonic Ops',* Aviation Week & Space Technology *158, no. 21 (26 May 2003): 46. Accessed 13 July 2012.*

19 *'The Concorde',* http://www.centennialofflight.gov/essay/Aerospace/Concorde/Aero53.htm. *Accessed 30 July 2012.*

20 *Frances Fiorino, 'AIRLINE OUTLOOK',* Aviation Week & Space Technology *158, no. 23 (9 June 2003): 15.*

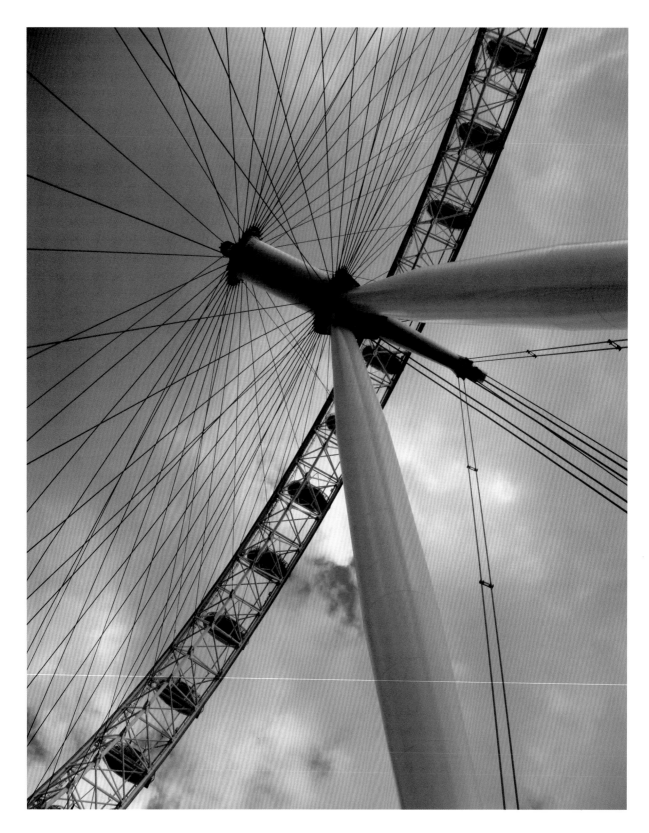

*Passenger's view of the London Eye (Marks Barfield Architects, completed March 2000) seen from below, 3 May 2009.*
*Photograph by Grace Lees-Maffei.*

# 9

# The London Eye, UK
# (Marks Barfield Architects, 1999)

*Jilly Traganou and Grace Vetrocq Tuttle*

The London Eye was erected in 1999 as a temporary kinetic monument to the new millennium, becoming the world's tallest observation wheel at the time of its construction.[1] Emblematic of its time and place, the London Eye presents the combination of fame, symbolism and aesthetic quality that characterizes architectural icons of the global era.[2] This revolving transportation machine has transformed London's riverside skyline and urban imagery and carries aloft over three million people each year, lifting them to a voyeuristic encounter with the city at 443 feet above ground. During the thirty-minute 'flight' on the Eye, visitors are immersed in an experience that projects, according to press statements, 'a sense of order into the chaotic city that is London'.[3] Elegant and mechanistic, it continues a tradition of high-tech architecture that started in Britain in the 1970s. It 'purports to adhere to a strict code of honesty of expression', and looks at the industries of transport, communication, flight and space travel as sources 'both of technology and of imagery'.[4] Exploiting cutting-edge cable-car technology, the Eye is an impressive cantilevered structure over the River Thames. Its rim is made of a circular steel truss holding glazed observation pods that move continually along a track. The Eye evokes a giant bicycle wheel keeping a stately pace (moving at only eight-and-a-half feet per minute), the use of spoke and cables creating unexpected visual lightness.

Conceptualized during a period of recession-enforced economic inactivity and against the backdrop of millennial anxiety and image-making politics, the Eye offers a new visual experience of London that is yet dominated by the city's past.

## Story of the Eye

In 1993, when the *Sunday Times* announced a competition in collaboration with the Architecture Foundation for designs to mark the millennium, the architecture firm Marks Barfield proposed a giant Ferris wheel to be located on the south bank of the River Thames. David Marks and Julia Barfield, who worked in the offices of Richard Rogers and Norman Foster respectively, before forming their own practice, shared a passion for engineering. With their proposal, they sought to create a new experience of the city rather than a new object or building, and to contribute to the regeneration of South London.

Although the competition was cancelled without the announcement of a winner, the architects formed the 'Millennium Wheel Company' and persisted with their idea. Their approach was personal and painstaking: convince all stakeholders, local community groups, heritage organizations and planners of the worthiness of their idea.[5] The support of the *Evening Standard* newspaper, which launched a 'Back the Wheel' campaign, was instrumental in garnering popular support. The iconic potential of the wheel's form was established early on. 3D modelling produced in MicroStation and superimposed on an image of London for a photorealistic effect linked the monumental yet ephemeral design to the place where it would eventually reside.[6]

The project's financing proved to be the first serious challenge. As members of an action group dedicated to improving South London,[7] Marks and Barfield personally knew

1  *Named for its successive owners: the British Airways London Eye (1999–2008), Merlin Entertainments London Eye (2009–11), and EDF Energy London Eye (2011–present).*

2  *Leslie Sklair, 'Iconic Architecture and Capitalist Globalization', City 10: 1 (2006), 25.*

3  *Press Pack for the EDF Energy London Eye, http:// www.londoneye.com/ NewsAndEvents/Press/ PressPack/Default.aspx. Accessed 31 May 2012.*

4  *Colin Davies, High Tech Architecture (London: Thames and Hudson, 1988), p. 6.*

5  *Interview with Julia Barfield, 3 February 2012.*

6  *Martyn Day, 'Marks Barfield Creates a Towering Eyeful for Central London', MicroStation Manager 5 (10 May 2000): 42–3.*

7  *Barfield, interview.*

Bob Ayling, head of British Airways and chairman of the New Millennium Experience Company. In 1994, British Airways became the principal backer of the wheel and formed a company with the architects (dissolved in 2006, when the Eye was bought by the Tussauds Group). This corporate partnership would help associate the Eye with flight, suggesting a luxurious, enthralling experience to visitors.

Acquiring planning permission from Lambeth Council was the second challenge faced by the designers. Taking two years to complete, the legalities were finalized only fifteen months before the delivery date, well short of the two years the entire project was expected to take.[8] The architects collaborated with structural engineer Jane Wernick, formerly of Ove Arup. Her solution adopted the 'use of spoke cables to support the rim' instead of the 'single stiff arm of the competition entry'.[9]

## Made in Europe, Shipped to London

As much as this project serves the locality, it was multinational in execution. Marks Barfield maintained tight control of the design and development process, which involved nine design and engineering companies. In September 1998, Dutch structural steel and mechanical engineering contractor Hollandia B.V. was commissioned to prepare the structural design as well as oversee the production and installation of the Eye. The German manufacturer FAG provided the roller bearings, the Czech firm Skoda Steelworks cast the steel spindle, the cables came from Italy and France's Poma Group fabricated the observation capsules. The overall construction project management was handled by London's Mace. The wheel was assembled off-site and shipped in ready-built sections on river barges. Initially assembled in a prone position, it required a week to be hoisted upright. The thirty-two capsules (completed in France) were attached after the wheel had been erected.[10] The project utilized 1,600 tons of steel from British Steel, but the degree of its Britishness is debatable. It was the true outcome of collective European ingenuity.

## Iconoclastic Pursuits

The Millennium Wheel—as the London Eye was first called—became an uplifting symbol that was said to represent 'the turning of the century and the regeneration of time'.[11] But can an eye be an icon? It may be fair to say that the London Eye with its weightless presence is almost inadvertently iconic. The real icon was meant to be London. The architects intended to create not a new monument but a new experience. The concept was as horizontal as it was vertical. The Eye was meant to be a pilot project that would generate new activities and interest along the river. It was no accident that the chosen site—metropolitan open land in the western end of the Jubilee Gardens, in Lambeth—was near that of the temporary Dome of Discovery, built for the Festival of Britain in 1951 and once a national symbol much like the Eye. For Marks and Barfield, the greatest success of the project is that 1 per cent of all ticket sales goes to the local community in perpetuity.[12] Nevertheless, architects' intentions are no prediction of the public interpretation of a design. An ever-changing landscape of media narratives overlaid the Eye with new meanings.

## 'A Glorious Spray of Radiuses'[13]

Intended to express optimism about the new millennium, the Eye has a historical, turn-of-the-twentieth century feel. This play of futurism and retrospection connects the designer's conception to the history of urban voyeurism in pivotal times of modernity. While eighteenth-century panoramas were painted, displaying images horizontally on a rotunda for viewers to observe from a centre platform, the London Eye takes viewers on a vertical tour. And unlike the limited, frontal perspectives offered by the nineteenth-century Ferris

8 David Marks and Julia Barfield, 'More than Architecture', in Alan J. Brookes & Dominique Poole (eds), Innovation in Architecture (London: Taylor & Francis, 2004), p. 89.

9 Ian Lambot, Reinventing the Wheel, The Construction of British Airways London Eye (Surrey: Watermark Publications, 2005), p. 11.

10 Day, 'Marks Barfield', 40–4.

11 Ibid., p. 41.

12 Barfield, interview.

13 Joseph O'Neill, Netherland: A Novel (New York: Vintage Books, 2009 [2008]), p. 253.

wheel, expansive, unobstructed views of the labyrinthine city in its entirety are experienced from the Eye. Still, it generates the same sense of 'disorientation and exhilaration' as all the 'iconic ascensional apparatuses of modernity'.[14]

Armed with cameras and seeking to record a memorable experience, London Eye visitors engage in a kind of surveillance. High up, 'unhinged from the everyday space and experience of the city', they become 'temporarily empowered with a panoptic aerial gaze'.[15] Visual stimulation paradoxically maximizes the effect of detachment from one's direct surroundings. One unexpected outcome of the journey is the view of 'the sprawling mass of London' as 'immobilized, distanced and defamiliarized'.[16] In this way, the ride becomes an inward-turning journey. In the words of novelist Joseph O'Neill, 'a self-evident and prefabricated symbolism attaches itself to this slow climb to the zenith. The thought that occurs to all at this summit [is] that they have made it thus far, to a point where they can see horizons previously unseen'.[17]

## Dissecting the Eye

Most urban boosters and ordinary citizens alike regard the London Eye with affection. It is a marker and a stimulant of urban identity and pride and now a permanent icon. The Eye is regularly featured in films, television, music videos and literature, it figures in London postcards and toys, and it forms a focal point for New Year's Eve celebrations. According to Richard Rogers, it also fulfils its social premise: 'For many years [the Thames] has been the barrier between the rich north side and the poorer south … We must help London's poorest boroughs, we must have inspirational things like the Dome and the Millennium Wheel that brand the city.'[18] It is not surprising that architects like Rogers would applaud. As Michael Levenson observes, the 'artifice of "2000"' converted 'decades of paper design and unemployed architects' idle dreams into commissions and deadlines'.[19] But some mistrusted the London Eye's 'inescapable presence'. The grounds can be an obstruction in Londoners' daily routines, too crowded to allow for a simple walk or cycle ride along the river. Despite the architects' aim to provide 'an architecture that is humane, accessible and a pleasure to experience',[20] the London Eye has been called 'an interloper into many precious London views' that 'confirms the inherent vulgarity of the age'. According to critics of industrialism, it has joined a lineage of architecture that since the nineteenth century 'has failed to establish a meaningful relationship with the river,' and has contributed to metamorphosing 'a noble stream … into a playground'.[21]

The cult of the iconic building per se is also subject to interrogation. Iconic buildings are regarded by some urban geographers as unhealthy, disrespectful of their urban context and excessively expensive.[22] Critics of millennial London's regeneration programmes see the Eye in the context of New Labour's investment in public spectacle. It was produced within the triumphant context of Tony Blair's Cool Britannia, through which 'a community of style' was sought.[23] But unlike the state-sponsored, and ill-fated, Millennium Dome, the Eye's iconic status was shaped and promoted by corporate interests (British Airways, Tussauds, etc.).[24] Like iconic buildings, the Eye is seen as facilitating the interests of a transnational capitalist class and its urban affiliates, targeting tourists and mega-event attendees.[25] In that sense, the London Eye's true legacy is the ambition to keep engaging in 'high-risk, high-profit' projects, more recently epitomized by the London 2012 Olympics. And as the 'entire city is subject to the prying gaze of this giant revolving eye',[26] the wheel becomes a reminder of the real and incessant surveillance to which Londoners submit each day.

**14** Christopher Lindner, 'London Undead, Screening/ Branding the Empty City', in Stephanie Donald, Eleonore Kofman & Catherine Kevin (eds), Branding Cities, Cosmopolitanism, Parochialism and Social Change (New York: Routledge, 2009), p. 102.

**15** Lindner, 'London Undead', p. 101.

**16** Ibid., p. 101.

**17** O'Neill, Netherland, p. 254.

**18** Richard Rogers, 'A Life in Buildings', Times, 21 October 2000.

**19** Michael Levenson, 'London 2000: The Millennial Imagination in a City of Monuments', in Pamela K. Gilbert (ed.), Imagined Londons (Albany, NY: SUNY Press, 2002), p. 231.

**20** 'Marks Barfield Architects', http://www.marksbarfield.com/practice_approach.php. Accessed 31 May 2012.

**21** Roger Woodley, 'Transformations on the Thames', Architectural History 44 (2001): 121, 115.

**22** Donald McNeill, The Global Architect: Firms, Fame and Urban Form (New York: Routledge, 2009), p. 95.

**23** Levenson, 'London 2000', p. 231.

**24** Sklair, 'Iconic Architecture', 31.

**25** Ibid., p. 38.

**26** Lindner, 'London Undead', p. 101.

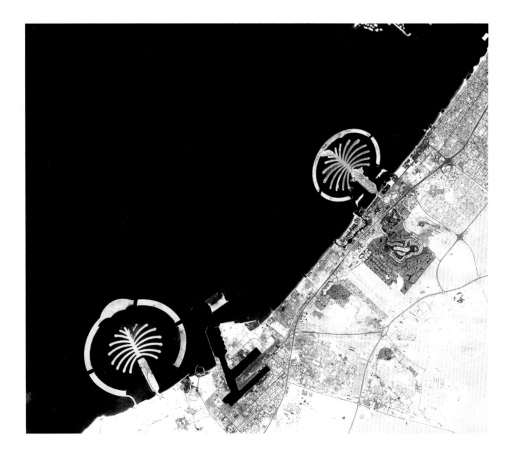

*Palm Jumeirah (right) and Palm Jebel
Ali (left), Dubai, as captured by NASA's
Landsat 7 satellite in October 2006. NASA
Visible Earth http://visibleearth.nasa.gov/.*

# 10

# The Palm Islands, Dubai, UAE
## (Nakheel Properties, 2001–)

*Dolly Jørgensen*

Nothing seems more unnatural than a man-made island shaped like a palm tree, an act of artifice, of design, on a massive scale. Yet when the Sheikh of Dubai decided to invest in such a scheme, naturalness was foremost in his thoughts. As if the technological challenge of creating the largest man-made island in the world was not enough, the Sheikh wanted it constructed out of only 'natural' materials instead of concrete, adding significantly to the technological difficulty of the project. The dream was to create the most natural unnatural island imaginable: Palm Jumeirah.

Urban scholarship on Dubai has stressed the city's penchant for the extreme—the Burj Dubai skyscraper is the world's tallest man-made structure, the Burj Al Arab stands as the tallest hotel in the world, and an indoor ski centre allows year-round skiing in the Arabian desert.[1] Dubai has been labelled 'an urban spectacle' with its focus on urban forms carrying superlatives of the largest, tallest, and first.[2] All of these developments, including the island construction projects, together form the Sheikh's attempt to modernize, or one might say post-modernize, the city. They blend apparently contradictory environmental phenomena: snow in the sweltering heat, green golf courses in the desert and natural unnaturally shaped islands. The Palm Islands have sparked widespread concerns about their environmental impact and sustainability and the pay and conditions of the construction workforce brought in from India and Bangladesh.[3] Just as William Rollins observed that environmental contradictions about the SUV seem diminished in the post-modern consumer world, historians and designers should see these unnatural combinations as a challenge to their ways of thinking about what is natural (or not).[4] Such is the case with the Palm Islands.

## Planting the Seed

Dubai, a city-state in the United Arab Emirates, was just a sleepy trading town as late as 1966. Then oil was discovered nearby, and Dubai rapidly grew into an Arabian urban centre. The ruler of Dubai, Sheikh Mohammed bin Rashid Al Maktoum, along with his late father and brothers, realized, however, that while immediately lucrative, Dubai's oil supply was extremely limited. They turned to cultivating new revenue streams, starting with the Jebel Ali port, the world's largest man-made port, and then turning to tourism. Sheikh Mohammed started Emirates Airlines in 1985, and under his leadership, the country has successfully weaned itself from oil dollars: about half of Dubai's revenues came from oil in the 1980s, whereas it was only 5 per cent in 2006.[5]

To encourage tourism and population growth, the Sheikh decided to build a man-made island to increase the availability of beachfront property, which was highly valued by overseas tourists seeking sun-and-sea vacations, in the mid-1990s. The emirate has only 72 km of natural coastline, and almost all of it was already occupied by the late 1990s.[6] The chairman of Dubai's Financial and Investment Authority, Mohamed Abdullah al-Gergawi put the development of the island idea this way: 'Our problem was that Dubai had run out of beach. We were brainstorming one day. Someone said, "Why don't we make an island?".'[7]

1 *On Dubai's urban development, see Economic and Social Commission for Western Asia,* Urbanization and the Changing Character of the Arab City *(New York: United Nations, 2005); Boris Brorman Jensen,* Dubai – Dynamics of Bingo Urbanism *(Copenhagen: Architectural Publisher, 2007); and Yasser Elsheshtawy,* Dubai: Behind an Urban Spectacle *(London: Routledge, 2010).*

2 *Elsheshtawy,* Dubai.

3 *https://sites.google.com/ site/palmislandsimpact/sources*

4 *William Rollins, 'Reflections on a Spare Tire: SUVs and Postmodern Environmental Consciousness',* Environmental History *11 (2006): 684–723.*

5 *'The Sheik of Dubai',* New York Times, *10 December 2006, http://travel. nytimes.com/2006/12/10/ travel/10entrepreneur.html.*

6 *'The Palm, United Arab Emirates',* Design Build Network, *www.designbuild-network.com/projects/palm-jumeirah.*

7 *'Dubai Journal; Living High and Aiming Higher, Come War or Peace',* New York Times, *4 October 2002, http://www. nytimes.com/2002/10/04/ world/dubai-journal-living-high-and-aiming-higher-come-war-or-peace.html.*

Because the goal was to increase beach area, the development team opted for an innovative design: a palm tree with 17 long fronds, which resulted in significantly more beachfront than a semi-circular island. The date palm, which is native to the Arabian Peninsula, is a food source, a sign of fertility because of its presence at oases and a common symbol in the visual culture of the UAE, including on stamps and currency. By using a palm design, all of these cultural associations could be invoked. Perhaps even more importantly, by creating the island in a unique palm shape, the Palm project has attained global iconic status, instantly recognizable as part of Dubai's brand when it appears in advertising, photographed from the air, as it often does.[8] Yet the island's shape also holds an inherent contradiction: in order to be recognized, it has to be seen in distant aerial view, since the iconic nature disappears when viewed at sea level by people physically experiencing the island.[9]

Construction of the Palm Jumeirah began in 2001, and the first residents moved onto the island in 2008. It is 6 km long, comprises 560 ha of land and added 78.6 km to Dubai's 72-km coastline through its unique shape. The size is difficult to imagine on the basis of numbers alone, but the facilities on the island give a sense of its dimensions: thirty-two hotels to house 25,000 guests, villas for 60,000 residents, five beach resorts, four marinas, a monorail and retail stores. The developer dubbed the project as 'The Eighth Wonder of the World' in its promotional material: the features are so large that they should be visible from the moon.[10] This puts the project on a par with the Great Wall of China in its scope as a man-made construction.

## Making the Unnatural Natural

The website for the developer Nakheel (thepalm.ae/jumeirah) frames the construction material choices for the Palm Jumeirah as a choice about nature: 'The Palm is made from natural materials only—sand and rock. It would have been easier, but less environmentally friendly, to build with steel and concrete instead.' Despite being more expensive and difficult to source, the islands were created from rock instead of concrete slabs because naturalness was key to the idea of the island. Yet the process required to construct a huge artificial island from these 'natural' materials of rock and sand was anything but natural. The irregular palm shape, while intriguing, unique and beach-rich, caused significant technical challenges. Unlike a regular island that could be built by basically dumping material outward from the centre point, the fronds required construction of long and skinny juts of land that needed to properly intersect with each other. The accuracy of the material placement required extensive use of GPS monitoring systems.[11]

The materials for the island came from nearby sources. The island itself has a rock foundation and consists of over 92 million cubic meters of sand. Instead of using sand from the land desert of Dubai, the construction team decided to use sand taken from the seabed because it 'is more environmentally sustainable and more seismically stable than desert sand'.[12] The sea sand was dredged from the Arabian Gulf sea floor 6 nautical miles out at sea after baseline marine surveys found that 95 per cent of the seafloor in the region was barren (only sand and mud).[13] However, some scientists have questioned this assessment, suggesting that there was life, including coral reefs, on the sea bed.[14] Once placed, it was vital to settle the sand before it was built on—a natural process which normally takes millions of years. So, to hasten the settling, the sand underwent a process called vibro-compaction, which according to Nakheel, should mean there is no settlement greater than 1 inch in the next 50 years.[15] Part of the thinking with the material choices was that the Palm would serve as an artificial reef in the Arabian Gulf. The developer's website touts that crabs, sea bass, butterfly fish, urchins, barnacles, sponges and sea grasses have colonized the island and breakwater bases. In this case the island becomes, in a sense, naturalized.

8 *Elsheshtawy*, Dubai; Samer Bagaeen, 'Brand Dubai: The Instant City; or the Instantly Recognizable City', International Planning Studies *12 (2007): 173–97.*

9 *Mark Jackson and Veronica della Dora, "'Dreams So Big Only the Sea Can Hold Them'': Man-made Islands as Anxious Spaces, Cultural Icons and Travelling Visions',* Environment and Planning A *41 (2009): 2086–104.*

10 *'The Palm "Wonder" of Dubai Coastline',* Businessline, *8 November 2002, p. 1.*

11 *Design Build Network, 'The Palm'.*

12 *'Facts and Statistics', Nakheel Co.,* http://www.thepalm.ae/jumeirah/engineering/facts-and-statistics/. *Accessed 16 August 2010.*

13 *'Megastructures: Impossible Islands',* National Geographic, *2005.*

14 *'Our Commitment', Nakheel Co.,* http://www.thepalm.ae/jumeirah/environment/our-commitment-to-a-sustainable-environment/. *Accessed 16 August 2010. The Emirates Environmental Marine Group found that coral patches covered 10 to 15 per cent of the seabed. See Bayyinah Salahuddin, 'The Marine Environmental Impacts of Artificial Island Construction, Dubai, UAE', Master's project, Duke University, 2006.*

15 *Design Build Network, 'The Palm'.*

## Iconic Environment

The Palm Islands project transforms the environment in ways which have attracted controversy. According to the developer, the goal was not only to preserve the environment, but to enhance it: 'A primary goal in creating the island was to ensure that construction not only had the smallest possible negative impact on the surrounding environment, but also enhanced the environment beyond the original, pre-development state.'[16] In making this claim, the designers of the Palm move beyond natural to supra-natural: the designers wanted to make a better world, rather than simply replicating the world around them. Whether or not the Palm Islands really 'enhance' the environment of Dubai—an issue which has been widely debated—they have radically altered it.

The first Palm Island, Palm Jumeirah, was only the first step in Dubai's rapid urbanization of the sea. There are, in fact, three palm islands (Palm Jumeirah, Palm Jebel Ali and Palm Deira), the World complex of islands laid out to resemble a world map, and a project launched in 2008 called the Universe. The environmental change along Dubai's coast since 1990 is staggering as whole new landmasses have risen from the Gulf waters. Dubai's man-made island project has also inspired plans for custom islands elsewhere, including Russia's Island of Federation (which looks like a Russian map and the opening of which was planned to coincide with the 2014 Winter Olympics in Sochi on the Black Sea) and an island shaped like a tulip off the Dutch coast, proposed by the government in 2007.[17]

The Palm Islands of Dubai are iconic symbols of environmental contradiction, as they embody the paradox of using natural materials to construct islands in a most unnatural form, albeit one based on a stylized design based in nature. Their unique shape, as seen from above, is what makes them icons of Dubai (and more broadly the rapidly urbanizing world), whereas they become nearly normal islands when seen from the ground. Unlike other icons of human urban development that tout technical prowess such as the Eiffel Tower, the Palm Islands turn nature into design and design into nature.

16 *Nakheel Co., 'Our Commitment'.*
17 *Jackson and della Dora, '"Dreams So Big"'.*

Part Two

# Page Turners and Screen Sirens

Horse-Power Used in Agriculture. United States

1849
1869
1889
1909
1929

Each man symbol represents 1 million engaged in agriculture
Each horse symbol represents 5 million horse-power    black: machinery    blue: trucks

The technological progress of agriculture which has contributed to make the growth of population in all parts of the world possible began before the industrial revolution reached the Southern and Eastern world. The Chinese developed methods of intensive use of the soil centuries ago. Long ago they learned to fertilize their plants systematically, but without developing natural sciences. Neither India nor the Europe of the pre-industrial age reached this level; the European peasant had to be taught by scientists to adopt new methods of feeding the soil. For the Western world fertilizing is a modern scientific advance; for the Eastern world it is traditional. The mechanization of agriculture did not make much progress in the Eastern world where single plants and combinations of crops were cultivated by hand. Tractors, combines, and similar machines can be used only on large tracts.

The growing western mechanization changed the whole of life, especially the worker's life. Weaving, for instance, was formerly carried on in the workers' homes, wives and children doing their share. When men, women, and children had to go into the factory for long working days, production increased, but home life of the old type was destroyed.

52

Home and Factory Weaving in England

1820
1830
1845
1860
1880

Each blue symbol represents 50 million pounds total production
Each black man symbol represents 10,000 home weavers
Each red man symbol represents 10,000 factory weavers

By this separation of home and place of work the burden of labour grew much heavier. Moreover, the industrial revolution started by lengthening the working time; machinery created a new type of oppression instead of freeing men from the necessity of long hours of slow hand-work. The machine, which should be the best friend of man, seemed to be his enemy. The workers often destroyed the machines which made them work eighteen hours a day or not at all, leaving them unemployed

53

Gerd Arntz, 'Home and Factory Weaving in England',
chart from Otto Neurath, Marie Reidemeister, and Gerd Arntz,
Modern Man in the Making, 1939. © 2014 Artists Rights
Society (ARS), New York / Beeldrecht, Amsterdam.

# 11

# Isotype, Austria
# (Otto Neurath, Marie Reidemeister,
# Gerd Arntz, 1925–1934)

*Ellen Lupton*

What could be more iconic than an icon? Today's airport hieroglyphics and GUI dingbats owe their roots to Isotype, the revolutionary system of picture-based education launched by Otto Neurath in the 1920s. Isotype used images in place of words and numbers, aiming to sidestep cultural and linguistic differences and generate a new form of communication that appealed directly to the eye. Although Neurath was trained as a philosopher and social scientist rather than an artist or maker, he deserves a pedestal among the pantheon of graphic design's founding fathers—or at least among its obsessive uncles and compulsive cousins. The visual and intellectual DNA Neurath left behind courses deep and dark through many veins of contemporary design practice, from data visualization and user experience to architectural signage and exhibition design.

From its inception, Isotype was far more than a stark alphabet of babies, factories and marching men. Isotype used charts, maps and diagrams to educate people about the forces shaping modern life. It was a method and a brand, a theory and a product, a compelling visual vocabulary and a grandiose effort to collectivize human consciousness.

## Decentralizing the Museum

Neurath applied his first efforts in visual education to the short-lived German Museum of War Economy, founded by the German War Ministry in 1917. Neurath became director of the museum in 1918; it was disbanded the same year, with Germany's defeat in World War I. Neurath emigrated to Vienna, where he established the Museum of Society and Economy, designed to promote reforms in housing, health and education. Supported by the city's socialist government, the museum was equipped with electric lights, allowing workers to visit during evening hours. Whereas the period's conventional museums of technology and industry featured cases stuffed with physical artefacts, Neurath's exhibitions deployed maps, charts and diagrams illustrated with pictorial icons. In the method forged by Neurath, each icon represented a quantity, such as 10,000 workers or 50 million pounds of fabric. Viewers could thus quickly compare quantities by contrasting larger and smaller groups of signs rather than reading columns of text and numbers.

Neurath fuelled his endeavour with a lifelong fascination for 'visualization', a term he used long before its rise to fame in the current 'data viz' craze. He collected and studied a rich trove of scientific illustrations and military maps dating back hundreds of years. As a child, he was intrigued by the diagrams of René Descartes' *Opera Philosophica*, a book whose Latin text was opaque but whose pictures opened his eyes to the science of optics. Military maps depicting opposing masses of ships, men and artillery directly inspired Neurath's approach to visual statistics.[1]

Neurath's work soon attracted international attention, leading to projects in Berlin, The Hague, London and beyond. Declaring the 'decentralization of the museum', Neurath created exhibitions that could be produced in multiples and shipped and installed anywhere, from housing expositions to department stores.[2] Neurath saw museums as exploded books and books as portable exhibitions. He argued that museums needed to embrace the principles of mass media, following the lead of the magazines, movies, and

1 *Graphics from Neurath's personal library are reproduced in Otto Neurath,* From Hieroglyphics to Isotype: A Visual Autobiography *(London: Hyphen Press, 2010).*

2 *Quoted in Nader Vossoughian,* Otto Neurath: The Language of the Global Polis *(Rotterdam: NAi Publishers, 2008), p. 79.*

advertisements that dominated urban life. In this new world of constant visual stimuli, spectacle and entertainment had replaced reading and contemplation. Educating the public required absorbing the tactics of the broader commercial culture.

## Words Divide, Pictures Unite

Dubbing his approach the Vienna Method of Pictorial Statistics, Neurath worked with a staff of draftsmen, illustrators and transformers to produce his innovative graphics. The 'transformer' functioned much like today's information designer—compiling data from scientific sources, constructing a meaningful narrative or focus and creating conceptual sketches that became the basis of production-ready images for use in exhibitions and publications. The transformer was a visual editor who devised a story and plan for each piece.

Chief among the transformers was Marie Reidemeister, who married Neurath in 1941 and continued the Isotype enterprise for another thirty years, long after Neurath's death in 1945, becoming a prominent author of illustrated nonfiction books for children and other audiences. Graphic artist Gerd Arntz, who joined the team in 1928, built an army of 4,000 stalwart symbols, amassing a visual dictionary of repeatable forms. Arntz honed the group's approach into a coherent graphic style, distilling ideas from two of the most advanced visual vocabularies of the era: German Expressionism and Russian Constructivism. Neurath's team embraced Futura as its official typeface in 1929. Futura's bold geometry offered a typographic match for Isotype, connecting it to the broader discourse of progressive design.

With fascism boiling in Vienna, Neurath and his team relocated to the Netherlands in 1935. They renamed their method Isotype (International System Of TYpographic Picture Education), embracing an increasingly global outlook and developing a canny sense of branding. In the symbol Arntz created for Isotype, an abstracted human figure holding a blank sign high above his geometric head strives to change the world with the universal power of pictures. Arntz's logo, which appeared on countless books, posters and exhibitions over a forty-year span, depicted communication as an active public enterprise. Seeking a wide reach, the Isotype team generated books and exhibitions on their own accord as well as for clients internationally—publishers, magazines, health organizations, government agencies and more.

The phrase *typographic picture* underscored Isotype's bid to become a universal language of vision, a way station between word and image. Isotype icons were rendered as flat shapes, devoid of perspectival effects. Stripped of unnecessary details, these graphic shadows of the real aimed to combine the objectivity of a photograph with the schematic simplicity of a letterform. An icon's scale did not correlate with spatial dimensions—a car might be no bigger than a telephone. With each image standing for a fixed quantity of some object or process, Isotype charts enabled clear comparisons by avoiding reference to three-dimensional volumes.

Neurath feared that more vivid and complex illustrations would distract viewers, stirring emotion and clouding judgment. He sought to present facts in a pure and naked state, leaving viewers to draw their own conclusions. Neurath proclaimed, 'Just through its neutrality, and its independence of separate languages, picture education is superior to word education.'[3] Based in observation rather than convention, the spare silhouette of each icon emulated writing while striving to replace it with something more reliable and objective. The modern hieroglyph longed to shed the arbitrariness and subjectivity of the verbal sign, forging solid ground with the physical world while recalling the inky flatness of typography.

## Crowds, Not Kings

Isotype's blunt, bold flatness was an argument for anonymity. Favouring the group over the individual, Neurath sought to represent history and modernity as the aggregate momentum of social change. Surging births, fluid urban migrations, the uneven distribution of electricity,

*3  Otto Neurath, 'From Vienna Method to Isotype', in Marie Neurath and Robert S. Cohen (eds),* Empiricism and Sociology *(Dordrecht, the Netherlands: D. Reidel, 1973), p. 224.*

education and mass production—these phenomena encompassed whole populations. Society belonged to everyone, not just to politicians and kings, artists and inventors. The faceless figures of Isotype inhabited a world furnished with equally anonymous light bulbs and radios, milk jugs and loaves of bread, standing for a universally attainable utility.

Among the Isotype team's most ambitious publications was the book *Modern Man in the Making*, issued by the New York publishing house Alfred A. Knopf in 1939. Neurath authored the book in close collaboration with Arntz and Reidemeister. Beautifully printed in seven colours in a hardcover format on generously scaled pages, the book depicts modernity through a series of statistical snapshots interwoven with narrative text. In his introduction, Neurath asserted that the Isotype method 'shows connexions between facts instead of discussing them. Impressive visual aids do not merely act as illustrations or eye-bait in this book; they are parts of the explanations themselves'.[4]

The most satisfying graphics in *Modern Man in the Making* are those that tell a clear story, such as a chart illustrating the shift from home weaving to factory production in England. Each row of figures is divided into black and red; an outline of a factory drawn around the red figures signals their industrial status. Hovering above the figures are bolts of fabric, whose number rapidly outpaces that of the workers who have made them. No verbal commentary is required to point out this huge rise in productivity; Neurath's text elaborates that while output increased dramatically, an old type of home life was destroyed.

Thus, while Neurath aimed to present facts without interpretation, trusting the reader to judge the evidence, he knew that any presentation of facts leads readers towards some argument or inference. In another example, a pair of charts correlating the rise of suicide in the modern era with the rising literacy rate begged its author for explanation. Could literacy be a root cause for the increase in suicides? Offering a narrower explanation for this 'important symptom of modernity', Neurath linked the willingness of modern philosophers to speak freely about suicide to the 'trend to self-destruction' among all Christian nations.[5]

Neurath was himself a philosopher. Working with a group known as the Vienna Circle, he helped found logical positivism in the 1920s and 30s, an endeavour parallel in time and thought to his creation of Isotype. Logical positivism sought to marry two strains of inquiry that the philosophical tradition had long seen as opposed: rationalism, which applies logic and mathematics to the study of reality, and positivism, which asserts the primacy of empirical observation to human knowledge. Modern scientific method had brought them together by using mathematics at a tool for quantifying observable phenomena.

The Vienna Circle sought to do the same for philosophy by identifying a minimal set of direct experiences, seeking out core concepts common to all languages. Creating a schematic, coded language, they sought to construct a linguistic 'mirror of nature' that had both internal consistency and a direct basis in the physical world. Within this new language, according to Neurath, 'all statements lie on one single plane and can be combined, like all parts from a workshop that supplies machine parts'.[6] Thus the flat graphic plane staked out by Isotype's dictionary of symbols had a parallel in Neurath's more formal philosophical thought. Neurath likened his own icons to scientific observations, grounded in the appearance of real things but reduced to minimal statements.

As a specific brand and authored methodology, Isotype came to a natural close, leaving behind a rich genetic heritage that remains vital today. By the time Marie Neurath shuttered the Isotype Institute in 1971, global pictograms had become a worldwide phenomenon, applied to wayfinding, news graphics, instructional literature, Olympic Games branding systems and more. Graphic icons are an integral part of user interface design, where they represent actions and ideas while conserving space and bypassing linguistic barriers. The Otto and Marie Neurath Isotype Collection lives on at the University of Reading, UK, where scholars and designers continue to assess its fundamental place in the modern design discourse.

4 *Otto Neurath*, Modern Man in the Making *(New York: Alfred A. Knopf, 1939), p. 8.*

5 *Ibid., p. 55.*

6 *Neurath, 'Empirical Sociology: The Scientific Content of History and Political Economy'*, Empiricism and Sociology, *p. 326.*

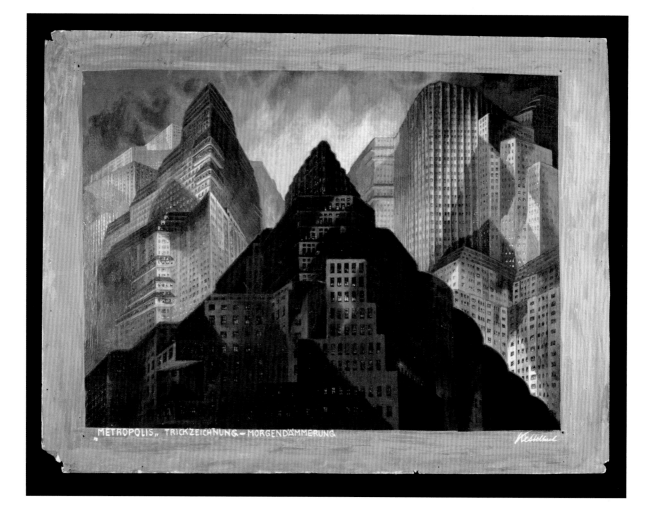

METROPOLIS„ TRICKZEICHNUNG – MORGENDÄMMERUNG.

An expressionist rendering of a towering, modern city
at dawn, painted by Erich Kettelhut while designing
the special effects and sets of the film Metropolis,
1925 or 1926. Courtesy of the Stiftung Deutsche
Kinemathek, used with permission.

# 12

## *Metropolis*, Germany
## (Fritz Lang, 1927)

*Nathaniel Robert Walker*

The 1927 film *Metropolis* was not the overwhelming commercial or even critical success its makers hoped it would be. It cost a fortune for the German studio UFA to produce and ended up nearly ruining it. The film's determined grasp on the imaginations of audiences all over the world, however, has grown exponentially since its lacklustre release nearly a century ago. Generations of filmgoers have returned again and again to confront the film's strange narrative and the stunning design of its futuristic urban sets, both of which powerfully reflect the exuberant optimism and apocalyptic dread felt in industrial societies in the 1920s.

### An Ecstasy of Brightness

*Metropolis* was written by Thea von Harbou (German, 1888–1954) and directed by Fritz Lang (American, born Austria, 1890–1976), a highly successful husband-and-wife team and 'one of the most glamorous couples' in the German film industry throughout the swinging 1920s.[1] Of their earlier collaborative projects, perhaps the two-part fantasy film *Die Nibelungen* made the biggest splash. Posters advertising the film's patriotic theme of mythical Germanic heroes had been plastered all over Berlin, only for the depiction of those heroes as 'false-hearted murderers' to elicit a 'howl of protest' on opening night.[2] Nonetheless, the film's gorgeous, powerfully expressive sets and riveting visual effects ensured that it was, aesthetically at least, 'one of the breathtaking wonders of the silent screen', and its controversial debut earned Lang his first significant coverage in the American press.[3]

The American premiere of *Die Nibelungen* in the fall of 1924 took Fritz Lang on his inaugural visit to the United States. After pulling into New York harbour, border control delays forced him to spend the night just offshore. Standing on the deck of the *S.S. Deutschland*, he watched the sun sink below the horizon and the countless electric lights of the towering New York City skyline come alive. Lang was captivated. Later he would say it was at this moment that he first vaguely conceived *Metropolis*.[4] His impression was only magnified after he set foot on the city's streets: 'Where is the film about one of those Babels of stone which are the American cities?' he asked in the German newspaper *Filmkurier* later that same year:

*The view of New York by night is a beacon of beauty strong enough to be the centrepiece of a film … There are flashes of red and blue and gleaming white, screaming green … and high above the cars and elevated trains, skyscrapers appear … still higher above there are advertisements surpassing the stars with their light.*[5]

Lang had arrived in a decidedly nocturnal city defined from above by dramatically floodlit pyramid skyscrapers and from below by radiant, dazzling signage. It added up to a luminous show of technological force that would, a few years later, inspire American architecture critic Douglas Haskell to say of modern architecture in the 1920s: 'The Europeans get the Day; we get the Night.'[6]

1  *Patrick McGilligan,* Fritz Lang: The Nature of the Beast *(New York: St. Martin's Press, 1997), p. 90.*

2  *'"Die Nibelungen" Meets Disaster in Berlin',* New York Times, *29 April 1924, p. 2.*

3  *McGilligan,* Fritz Lang, *pp. 101–2.*

4  *Ibid.*

5  *Fritz Lang, 'Was ich in Amerikah sah: Neuyork – Los Angeles',* Filmkurier 6, no. 292 *(11 December 1924). Translated by Dietrich Neumann in 'The Urbanistic Vision in Fritz Lang's* Metropolis', *in Thomas W. Kniesche and Stephen Brockmann (eds),* Dancing on the Volcano: Essays on the Culture of the Weimar Republic *(Columbia, SC: Camden House, 1994), p. 147.*

6  *Douglas Haskell, 'Architecture: the Bright Lights',* The Nation 132, no. 3419 *(14 January 1931), 55–6; cited in Dietrich Neumann (ed.),* Architecture of the Night: The Illuminated Building *(Munich: Prestel, 2002), p. 60.*

The Europeans, however, were not so quick to surrender the night. In von Harbou's 1925 novel *Metropolis*, the city that Lang would bring to life on screen was described as 'the wonder of the world'. Seen from above it resembled an 'ocean of light' filling 'the endless trails of streets with a silver, flashing lustre'. It sparkled with 'electrical advertisements, lavishing themselves inexhaustibly in an ecstasy of brightness'.[7] This German metropolis had conquered the darkness — or so it seemed.

## Between the Mind and the Hand

The sets for the film were designed and constructed by Otto Hunte, Erich Kettelhut and Karl Vollbrecht, the same veteran team that had collaborated on the visual feast that was *Die Nibelungen*. When completed, their enormous, highly detailed wooden architectural models and beautifully rendered matte paintings powerfully embodied Thea von Harbou's screenplay — but it took some effort. As architectural historian Dietrich Neumann has shown, early sketches for *Metropolis* reveal a futuristic city of generous sidewalks, elegantly setback skyscrapers, bright sunshine and an old Gothic cathedral — all in all, a decent enough place to live.[8] Subsequent concept drawings show the cathedral crossed out, to be replaced by an ominous, gargantuan 'New Tower of Babel' surmounted by a landing dock for aircraft. A darkening of the streets followed, as towers lost their setbacks and their sheer, monolithic forms choked out the sky, creating an atmosphere that was at once expansive and claustrophobic. The city of Metropolis had an ominous side, and slowly but surely the designers managed to exaggerate and distort their ideas for an ideal skyscraper city until the place became decidedly dystopian.

That ominous side was, of course, more than aesthetic. *Metropolis* tells the tale of a city misruled from a central skyscraper not by a king or a congress but by a technocratic dictator with a distinctly corporate flavour. This was a not a surprising choice on the part of the writer, as anxiety about the rise of industrial corporations and their power to usurp governments had been persistent throughout Western civilization since the mid-nineteenth century, when industrial production had become prevalent and large-scale incorporation the dominant way of doing business.[9] Countless utopian and dystopian novels and manifestos dealt with this issue, from Bellamy's *Looking Backward* (1887) to Gillette's *World Corporation* (1910). Labour was one of the most pressing problems afflicting industrialized society. The countless workers performing mindless tasks under the often-dreadful conditions of corporate industry were anonymous to their bosses, and they could be replaced without even so much as an awkward conversation. Workers had been degraded, as industrial reformer Henry George argued in 1883, into 'mere feeders of machines'.[10]

In *Metropolis*, the labourers who kept those glorious advertisements aglow were truly feeders of machines. Living virtually unseen in vast subterranean tenements and toiling underground, their desperate plight drives the plot of the movie. The protagonist of the film, Freder, a blissfully ignorant son of the city's imperious chief executive, falls in love with a strange but alluring young woman named Maria. She takes it upon herself to minister to the poor workers in their shadowy chambers. When Freder pursues her underground, he witnesses a gruesome industrial accident that is poetically expressed by the film's architecture: a giant, hissing machine slowly fades into the form a fiery pagan temple which consumes workers as human sacrifices. Freder is horrified and runs to his father's lofty office to press for change.

Destiny, however — in classic form as an evil scientist — had different plans. An embittered old inventor named Rotwang kidnaps the cherubic Maria and replaces her with a Doppelgänger robot. The robot goes on a sexy, drunken binge across the electric city and then descends into the underworld to stir up a labour rebellion. The workers go mad, rise

7 *Thea von Harbou,* Metropolis *(Boston: Gregg Press, 1974), p. 50.*

8 *Neumann, 'The Urbanistic Vision', p. 152.*

9 *See, for example, Alan Trachtenberg,* The Incorporation of America *(New York: Hill and Wang, 1982).*

10 *Henry George,* The Complete Works of Henry George Volume 2 *(New York: Doubleday, Page & Company, 1911), p. 140.*

up and smash the city's machinery only to discover that the power that oppresses them is also the power that sustains them, as a flood engulfs their tenements and their children barely escape with their lives. Soon afterwards Freder defeats the evil Rotwang and drags his corporate father and the workers' leader to the portal of an ancient Gothic cathedral. There, in the dusty presence of a forgotten moral order, he forces them to shake hands and make up. Our hero becomes, in the film's famously sappy conclusion, 'the heart mediating between the mind and the hand'.

## The Silliest Film

Famed science fiction author H.G. Wells reviewed *Metropolis* for the *New York Times*, setting the tone right at the start: 'I have recently seen the silliest film. I do not believe it would be possible to make one sillier.'[11] Wells passed over the obvious fact that the set designs and visual effects of *Metropolis* were a cinematic *tour-de-force*, and took issue with the plausibility of the architecture dreamed up by Lang and von Harbou. He declared that it was unlikely to be seen in the future and called it 'stale old stuff'. Like many other critics, he also ridiculed the film's narrative conclusion, laughing at the notion that 'workers and employers are now to be reconciled, and by "love".'

Wells, however, missed the point. Despite the fact that the film was inspired by Lang's impressions of America, its set designs were clearly not meant to be a serious extrapolation of emerging trends in urban design. Metropolis was an allegorical place, 'an exaggerated dream of the New York skyline, multiplied a thousandfold and divested of all reality'.[12] Of course it played upon public expectations and real architecture enough to seem futuristic rather than merely fantastic, but it was a commentary, not a prophecy—its architecture was expressive more than predictive.

As such, it indisputably captured both the 'ecstasy of brilliance' and the anonymous, elephantine quality that many modern cities had acquired since the rise of corporations and the skyscrapers that housed them. The film's success in encapsulating modernity's duality of radiant luminosity and brutal sterility is attested to by the countless subsequent designs it clearly inspired, from the blood-curdling corporate ziggurats of *Blade Runner* (Scott, 1982) to the manic high-rise chasms of *The Fifth Element* (Besson, 1997).[13] *Metropolis* spoke about the power of technology to change the world, while also lamenting the perpetual struggle to ensure those changes are for the better.

But then there is that infamous ending. The sheer *naïveté* underlying the film's jingoistic conclusion is painfully laid bare by the sad fates of Lang and von Harbou. When the volatile energies of 1920s Germany finally coalesced in the monstrous form of National Socialism, the filmmaker duo's partnership came to an end. Von Harbou joined the fascists, and Lang went to America. Years later, Lang would suggest the implausible conclusion of *Metropolis* was the fault of his ex-wife, the Nazi writer—but this clearly was not fair.[14] The idea that corporate industry could be made wholesome by moral improvements was not von Harbou's alone.[15] Countless hardworking reformers and utopian visionaries put faith in the same tempting possibility—a strategy for reform that survives today in the form of fair trade, ethical banking, and other morally tuned business practices.

Ultimately, the film *Metropolis* is an industrial dystopia with a fairy-tale ending; it captured both the wide-eyed optimism and the profound dread not only of its time, but arguably of modernity itself. How does one maintain the 'ecstasy of brightness' while pushing back against the power that fuels it? Lang and von Harbou failed to answer this question, but they asked it beautifully. It echoes still, amid the glistening towers and roaring subterranean machines of *Metropolis*.

**11** 'Mr. Wells Reviews a Current Film', New York Times, 17 April 1927, p. SM4.

**12** Lotte H. Eisner, Fritz Lang (New York: Da Capo Press, 1976), p. 86.

**13** For discussion of the legacy of Metropolis see Dietrich Neumann (ed.), Film Architecture: From Metropolis to Blade Runner (Munich: Prestel, 1996).

**14** Neumann, 'The Urbanistic Vision', p. 145.

**15** Nathaniel Robert Walker, 'Sister Cities: Corporate Destiny in the Metropolis Utopias of King Camp Gillette, Fritz Lang and Thea von Harbou', Traditional Dwellings and Settlements Review 23, no. 1 (Fall 2011), 41–54.

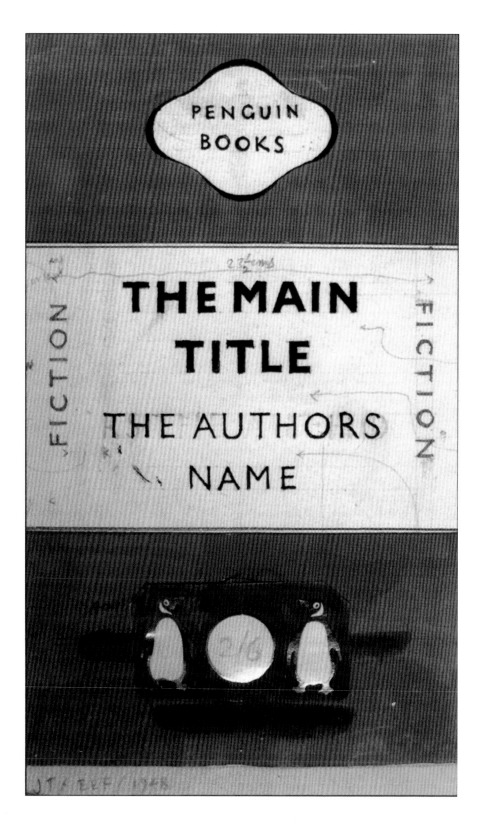

*The Main Title, Penguin Books Series design template, Penguin Front Cover 1948,*
*Copyright © Penguin Books, 1948.*

# 13

# Penguin Books, UK
# (Allen Lane, 1935 and Jan Tschichold, 1947–1949)

*Paul Shaw*

The iconicity of Penguin Books has shifted over the firm's nearly eighty-year history. There is the Penguin symbol, the colour orange, the typographic programme undertaken by Jan Tschichold, the typographic excellence of the book interiors styled by Hans Schmoller, the modernized covers overseen by Germano Facetti using the Romek Marber grid, and, to some, the recent letterpress-printed covers of the Great Ideas series. But the two key moments for Penguin from the perspective of immediate impact and long-term influence were its founding in 1935 and its typographic makeover between 1947 and 1949.

## The Origins of Penguin Books

Allen Lane (1902–1970), the Managing Director of publishers The Bodley Head, thought up Penguin Books in 1935 while returning from a visit to see Agatha Christie. The dearth of inexpensive reading material at Exeter train station inspired him to produce books 'intended for all classes of the community' that would be cheap in price but not in appearance. Lane's idea, refined by his brothers Richard and John, was to sell the books not only in bookstores but also at unconventional outlets such as Woolworth's, the five-and-dime store chain. The first Penguin book was Ernest Hemingway's *A Farewell to Arms*, published by The Bodley Head (with Penguin Books as an imprint) on 30 July 1935, at a price of sixpence (the cost of a pack of cigarettes). A break-even run of 17,500 copies per title was estimated, but within three years Penguin was printing a minimum of 50,000 copies. The quick success of the series, attributed to a balance of 'price, convenience of format and excellence of scholarship', led Lane to establish an independent company in 1936.[1]

Penguin was not the first publisher to create a line of inexpensive classic texts. Predecessors include the early-sixteenth-century pocket books of Aldus Manutius and, in the twentieth century, J.M. Dent's Everyman's Library (1906), the Insel-Bücherei (1912) and the English-language Albatross books published in Germany (1932). The Albatross books, brought back to England by travellers, were a direct inspiration to Lane. Their classic look was the work of Hans (later Giovanni) Mardersteig (1892–1977), Art Director at the Italian publishing house Mondadori. He established a small format of 181mm x 111mm (7⅛ x 4⅜ in.) that matched the Golden Section proportion of 1:1.618, the use of Gill Sans for cover typography, colour-coding to distinguish different series of books, a bird symbol, and dust jackets—all ideas that were subsequently taken up by Penguin.[2]

The Penguin name, coined by Joan Coles, Lane's secretary, during a brainstorming session provided an easy to say and easy to remember trademark. 'Hunting about for a mascot', Lane recalled, 'we hit on the [p]enguin—a lucky shot—and the cover almost designed itself once we knew what we wanted'. Edward Young (1913–2003), then an office junior but later the Production Manager, was sent to the London Zoo to sketch penguins, 'in every pose from the dignified to the ridiculous'. Lane loved the penguin for its 'endearing dignified flippancy', a symbol of goodwill. [3]

1 *Phil Baines*, Penguin by Design: A Cover Story 1935–2005 *(London: Penguin Books Ltd., 2005), p. 12; P.M. Handover, 'British Book Typography', in Kenneth Day (ed.),* Book Typography 1815–1965 in Europe and the United States of America *(Chicago and London: University of Chicago Press, 1965), p. 171.*

2 *Baines,* Penguin, *p. 13; Handover, 'British Book', p. 171; Richard B. Doubleday,* Jan Tschichold Designer: The Penguin Years *(New Castle, DE: Oak Knoll Press and Aldershot, Hampshire: Lund Humphries, 2006), pp. 25, 29;* tauchnitzeditions.com/albatross.htm.

3 *Steve Hare,* Penguin Portrait: Allen Lane and the Penguin Editors 1935–1970 *(Harmondsworth, Middlesex, England: Penguin Books, 1995), p. 5.*

## The Design of Penguin Books

Young created a horizontal tripartite design for the Penguin covers: the company name set in Bodoni Ultra Bold in a 'quartic' frame within the upper coloured band, the title and author's name set in Gill Sans within the white middle band and the penguin symbol within the lower coloured band. The stripes were colour coded: orange for fiction, green for crime, dark blue for biographies, cerise for travel and adventure, and red for plays. The original A format (181mm x 111mm or 7⅛ x 4⅜ in.) was identical to that of the Albatross books, and, like them, the first Penguin books came with a dust jacket. The interior typography initially employed Monotype's Old Style No. 2 before being replaced in 1937 by Times New Roman. The choice of the latter was an accidental offshoot of the search for a workable typeface for the Penguin Shakespeare series. Times New Roman, originally developed for *The Times* of London, was particularly well-suited to the problems inherent in setting Shakespeare's plays since it had a 'really fine range of small caps, titling and italic' that made it ideal for separating speakers' names, headlines and stage directions from speeches. It was also one of the few typefaces available for both Monotype and Linotype composition, crucial for a company that employed a large number of printers.[4]

Young's design—Penguin logo, striped covers and use of the very English Gill Sans as typeface—managed to differentiate the various titles while maintaining a clear brand. This visual brand 'was an important element in attracting new customers to book-buying and in inspiring confidence in the new publisher'.[5] The colour orange, chosen for fiction titles, became indelibly linked to Penguin.

## Jan Tschichold Joins Penguin Books

Compromises forced on Penguin by rationing during World War II led to deterioration in the quality of the books. Lane, eager to elevate Penguin's standards, and to fight off new rivals Pan Books and Corgi Books, sought out someone to replace Young. On the advice of typographer Oliver Simon, he hired Jan Tschichold (1902–1974), the author of the modernist design manifesto *Die neue Typographie* (1928), but since 1933 a designer of classically inflected books for various Swiss publishers. Tschichold began his tenure in March 1947.

Before leaving for England, Tschichold annotated a copy of every single piece of printed paper used by Penguin, as well as examples of all their books 'with his criticisms in pencil, and these comments, circulated to editorial staff before he arrived, were a typographic education in themselves'.[6] This thoroughness was typical of Tschichold. The task before him was unprecedented: to design several hundred books for mass-market production, coordinating a score of printers and suppliers across England. Multiple factories were involved in making books for Penguin, even for a single title: the text was printed by one firm while others were responsible for the monochrome plates, the colour plates (if there were any), the colour covers, the binding and the paper. There was an urgent need for standardization.[7]

## Tschichold's Typographic Overhaul of Penguin Books

The problem of composition was Tschichold's first concern: 'After only a few days in my new job, I saw how urgent it was to establish strict rules for composition. The printers who set the type either had no composition rules at all, or worked to nineteenth-century conventions, or followed one set or another of house rules … That a good hand compositor should always look carefully at capitals and space them by eye is in Britain … entirely unheard of or at least never done. Compositors do not seem to be interested in their work.'[8] To remedy the situation he formulated the Penguin Composition Rules, four pages of explicit yet succinct typographic house rules (e.g. 'All text composition should be as closely

4 *Baines,* Penguin, *13; Doubleday,* Jan Tschichold, *p. 24; Allen Lane, 'Penguins and Pelicans', in* The Penrose Annual, A Review of the Graphic Arts, *vol. 40 (1938), p. 42; Oliver Moore, Man of the Month: Allen Lane', Scope, August 1954, p. 56.*

5 *Baines,* Penguin, *p. 20.*

6 *Baines,* Penguin, *pp. 50–1; Doubleday,* Jan Tschichold, *p. 29; Ruari McLean,* Jan Tschichold: Typographer *(Boston: David R. Godine, Publisher, 1975), p. 88.*

7 *McLean,* Jan Tschichold, *p. 88.*

8 *Doubleday,* Jan Tschichold, *p. 168; McLean,* Jan Tschichold, *p. 92. Jan Tschichold, 'Mein Reform der Penguin Books' in* Schweizer Graphische Mitteilungen *no. 6 (1950).*

word-spaced as possible'; 'When long extracts are set in small type do not use quotes'; and 'Do not mix old style text composition with modern face figures.').[9]

Tschichold stamped proofs with the phrase, 'Equalize letterspaces according to their visual value', yet the English compositors reverted to using spacing material of equal thickness. He also fought to abolish the nineteenth-century practices of wide word spacing, no leading between lines, and extra space after full points. Ruari McLean, who still found them valid in 1975, said that the importance of the Penguin Composition Rules 'to the British printing trade as a whole cannot be overemphasized'.[10]

The Penguin Composition Rules did not include the standardization of typefaces. However, he stopped using Times New Roman, feeling that it was unsuited to books, substituting it with Bembo and Monotype's versions of classical faces Garamond, Caslon and Baskerville.[11]

Tschichold's second step was to create preplanned guides for compositors to follow when laying out pages; positioning margins, titles, prices, series numbers and symbols on covers, and determining the trim of books. Such precision was needed because all communication with printers was by writing, only occasionally by telephone, and rarely in person.[12] Not allowed to redesign the covers from scratch, Tschichold modified Young's tripartite design. He introduced a warmer tone of orange; redrew the penguin symbol, changing it from its crumpled posture to a more upright and dignified one, and for versatility, created variations of it facing left and facing right and reversed out of a framed oval in several sizes; and used Gill Sans in a more consistent manner with a thin rule introduced between title and author.[13]

Tschichold made greater inroads with Penguin's nineteen specialized series (e.g. Pelican Books, Puffin Books for children, King Penguins, Penguin Classics and The Penguin Shakespeare), creating or commissioning new symbols (he drew the Puffin logo himself), refashioning elements such as roundels and adding typographic refinements like swelled rules.[14] Tschichold wrote,

*As the designer responsible for the appearance of all Penguin books, I had to design specimen pages both for the reprints of books already published, and for new titles, as well as chapter openings and advertisement pages at the backs of books; covers had to be either specified typographically or designed entirely de novo; corrections for every book had to be examined typographically page by page, and many other tasks that were part of my job had to be attended to.*[15]

He carried out all of this work himself until Erik Ellegaard Fredericksen (1924–1997) joined him as an assistant in 1948.

## Tschichold's Accomplishment

The British pound was devalued in autumn 1949, precipitating Tschichold's departure from Penguin. In 29 months he had overseen the design of 500 books. However, it is not the quantity of books but their quality that is of lasting importance. What Tschichold accomplished in that short time for Penguin was a total overhaul of the way of doing things that not only influenced its bottom line and reputation for years to come, but which set a model for other publishers, printers and typographers in England that continued to resonate for decades. Although the covers that Tschichold designed tend to get all of the attention, his real work lay in the interiors—a legacy ably carried on by Hans Schmoller (1916–1985) into the mid-1970s. 'We do not need pretentious books for the wealthy', Tschichold wrote late in his life, 'we need more really well-made ordinary books'. This is what he did at Penguin.[16]

9 *The Penguin Composition Rules were first reprinted in Jan Tschichold*, Designing Books: Planning a Book; A Typographer's Composition Rules *(New York: Wittenborn, Schultz, Inc., 1951), pp. 17–20.*

10 *Tschichold, 'Mein Reform'.*

11 *Tschichold, 'Mein Reform'; McLean, Jan Tschichold, p. 88.*

12 *McLean, Jan Tschichold, p. 99.*

13 *Tschichold, 'Mein Reform'; Baines, Penguin, p. 64; Doubleday, Jan Tschichold, p. 47.*

14 *Baines, Penguin, pp. 26, 60; Doubleday, Jan Tschichold, pp. 57, 65, 83–4, 124.*

15 *Tschichold, 'Mein Reform'.*

16 *Doubleday, Jan Tschichold, p. 140.*

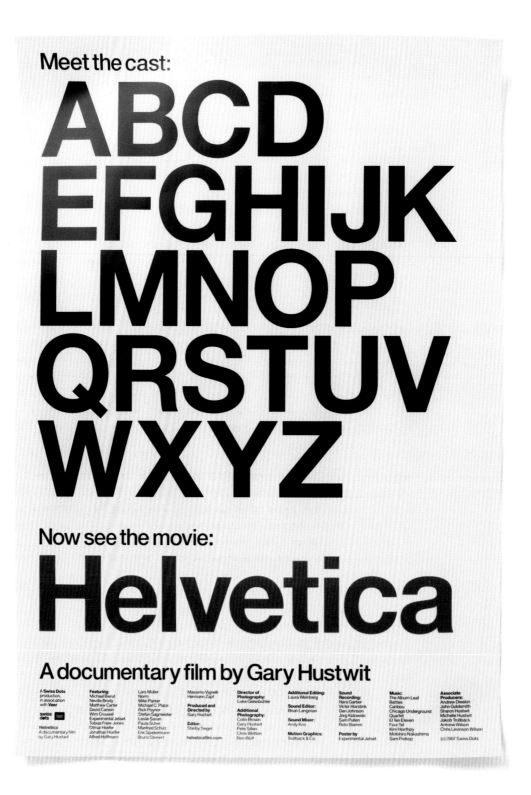

*'Meet the Cast'*, Experimental Jetset (2006), film poster for Helvetica, *directed by Gary Hustwit (Plexifilm / Swiss Dots), 2007.*

# 14

## Helvetica, Switzerland
## (Max Miedinger and Eduard Hoffmann, 1957)

*Kerry William Purcell*

### Swiss Graphic Design and Akzidenz Grotesk

In February 1956, one year before the creation of the typeface Helvetica, an advertisement was placed in the Swiss magazine *Typographische Monatsblätter* by the German type foundry Berthold. The ad sought to promote the enduring values of its sans-serif typeface Akzidenz Grotesk.[1] While it was not one of the earliest sans-serif types (that honour possibly goes to Caslon Egyptian created in 1816), Bertold's Akzidenz Grotesk (created in 1896 as a display face) had been the type of choice for many of the pioneers of the 'Die Neue Typographie' in the late 1920s and 30s. In the decades prior to this advertisement, Swiss graphic designers of the 1940s and 50s had continued with Akzidenz, believing, as Jan Tschichold did before them, that it represented the ideals of universality, objectivity and rationality. For designers such as Anton Stankowski, Josef Müller-Brockmann and Hans Neuburg, with their distrust of the overly ornate and figurative, Akzidenz (known simply as 'standard' in the UK and USA) offered the restrained detail, elegance and perceived neutrality they demanded in a typeface. For Basel-based designer Karl Gerstner, it was 'the work of anonymous typecutters; that is to say, craftsmen and specialists who through experience and the exercise of their trade knew all about the most subtle aspects of typefaces (not only sans-serifs) and the rules to which they conform.'[2] Through Gerstner's, and his compatriots', work for major pharmaceutical and chemical corporations (which were often headquartered in Switzerland), Akzidenz became a graphic synonym for a nation, a visual shorthand for the design work of a country which pioneered the ideals of the International Typographic Style throughout the Western world. As the Berthold advert proclaimed: 'Swiss typographers have created a style whose consummate achievement is now generally recognised as a standard to be aimed for in other countries.'[3]

Towards the end of the 1950s, Swiss graphic design underwent the twin processes of increasing codification and international dissemination. In September 1958, the first edition of the trilingual quarterly *Neue Grafik* was published. Nearly simultaneously (and almost identical in design to *Neue Grafik*), was the launch of *Ulm*, a magazine edited and designed by Hanno Kesting and Anthony Froshaug for the German Hochschule für Gestaltung. The following year, Karl Gerstner and Markus Kutters published *Die Neue Grafik* (Arthur Niggli, Teufen, 1959), which further encapsulated the principles of the International Typographic Style. It was against this widespread advocacy of a constructivist design philosophy, and the centrality to it of Akzidenz Grotesk, that in 1956 the Haas type foundry in Münchenstein, Switzerland, noticed how sales of their own sans-serif typefaces, such as Französische Grotesk (1900) and Normal Grotesk (1943), were declining rapidly. The director of Haas, Eduard Hoffmann (1892–1980), looked to cast a new typeface that, while based on Akzidenz, would strip away its perceived structural variability and inconsistency, reducing the letterforms to geometrically precise units. He commissioned the type designer Max Miedinger (1910–1980) to work on this new design. Having trained as a typesetter, Miedinger had worked with the influential printer Jacques Bollman, while also studying evening classes in typography at the Kunstgewerbeschule in Zurich in the late 1920s (possibly under the tutelage of the seminal designer Ernst Keller). As with many of his

1 *Richard Hollis*, Swiss Graphic Design: The Origins and Growth of an International Style 1920–1965 *(London: Laurence King, 2006), p. 199.*

2 *Karl Gerstner*, Designing Programmes *(London: Alec Tiranti Ltd, 1964), p. 23.*

3 *Hollis*, Swiss Graphic Design, *p. 199.*

design compatriots, Miedinger was schooled in the modernist philosophy that became so dominant in Swiss design throughout the 1940s and 1950s and advanced these ideas as a typographer for the advertising studio of the Globus department store in Zurich (1936–1946). From Globus, he moved to the Haas Type Foundry in Münchenstein to become, not a type designer, but a salesman. He held this post until he decided to return to freelance work as a graphic artist and advertising consultant in Zurich. While Miedinger was in Zurich, Hoffmann invited him to begin work on a new sans-serif typeface that would eventually become known as Neue Haas Grotesk.

## The Birth of Neue Haas Grotesk

Beginning in the autumn of 1956, Hoffmann and Miedinger embarked on a prolonged dialogue in which Miedinger's preliminary sketches and proofs were sent to Hoffmann, who would return them with extensive notes and recommendations. The opening efforts were also shared with designers outside of the company, most prominently the design team of the Basel-based multinational pharmaceutical company J.R. Geigy AG. All these comments were methodically worked through, with the outcome that many of Akizidenz's more esoteric elements were rationalized. The conclusion was a work of rigorous formalism in which the negative space of the letterforms struck a perfectly weighted balance with the positive shapes of the individual letters, while many of the terminals (for example in the 'c' and 'e') were cut horizontally. As a whole, the figure and ground relationship struck a harmonic symmetry. As Mike Parker, former Director of Typographic Development at Linotype, noted, Swiss designers always 'pay more attention to the background. So the counters, and the space between the characters, just hold the letters. You just can't imagine anything moving, it is so firm … It's a letter that lives in a powerful matrix of surrounding space'.[4]

Haas officially launched the typeface to the public at an international print fair held in Lausanne in 1957.[5] Its introduction came at a time when many multinational corporations were looking to develop a new house style, one that could be applied to regional subsidiaries across the globe and work just as well on a letterhead, a new livery or as signage. The desire for such a typeface also served a growing wish amongst many corporations to adopt the stylistic tropes of the International Typographic Style that had emerged from design studios in Zurich (and to a lesser extent Basel), during the postwar period. As already noted, the type of choice for this design philosophy had long been Akzidenz Grotesk, and Neue Haas Grotesk integrated well with the tenets of this approach. For many companies, Neue Haas Grotesk brought a sense of uniformity, cohesion and clarity to their identity in a period of increasing globalization.

Since 1927, D. Stempel AG had owned shares in Haas. Linotype AG in turn had owned Stempel since 1941. In 1959, Hoffmann agreed to produce Neue Haas Grotesk for the Linotype machine, a seminal line casting device that had been the norm in newspaper and magazine publishing for over a 150 years.[6] Hoffmann knew Neue Haas Grotesk had potential, and through Linotype he could open up its use to an even greater audience. However, the head of marketing at Stempel considered 'Neue Haas Grotesk' too awkward a name for the typeface, especially as one of the target audiences was the USA. Heinz Eul, a future director of Linotype, suggested the name 'Helvetia'. Hoffmann considered this impossible, as Helvetia was the Latin name of Switzerland, and he felt you could not name a typeface after a country. Moreover, as the type designer Erik Spiekermann notes, Hoffmann also knew that 'there was a famous sewing machine works in Switzerland already marketing its products under that name … In the end Hoffmann came up with the name "Helvetica".'[7] The allusion to Swiss design, especially as it had become so popular among many of the US design studios, was an intelligent move by Hoffmann.

4 Gary Hustwit, Director, Helvetica, film, Swiss Dots in association with Veer, 2007.

5 Erik Spiekermann, 'The Faceless Typeface', in Manfred Klein, Yvonne Scwemer-Scheddin and Erik Spiekermann (eds), T & T: Type and Typographers (London: Architecture Design and Technology Press, 1991), p. 116.

6 Stempel continued to manufacturer Neue Haas Grotesk in foundry type for several years after the release of the Linotype version.

7 Spiekermann, 'The Faceless Typeface', p. 117.

PART TWO: PAGE TURNERS AND SCREEN SIRENS

Initially, the acceptance and use of Helvetica in the United States was slow. In an attempt to generate sales, Stempel ran a double-sided advert in the Nov/Dec 1963 edition of the US design bi-monthly *Print*. Set in stark constructivist red and black colours, it promoted Helvetica's 'spare simplicity, its utter legibility and its flawless colour'.[8] However, through the work of such designers as Massimo Vignelli (Unimark), Ralph Eckerstrom (CCA) and such institutions as MIT, by the end of the decade, the typeface had become de rigueur for any company wishing to appear modern and professional. As such, Haas Stempel soon began to manufacture different styles and weights to meet the growing demand.

## The Fall and Rise of Helvetica

Parallel to the introduction of Helvetica, the graphic culture of the United States began to change subtly. With the growing protests against the Vietnam War and the far-reaching repercussions of the civil rights movement, the traditionally staid world of corporate design was repeatedly thrown into sharp relief. Influential studios, such as Push-Pin, and psychedelic posterists, like Wes Wilson, were producing work that drew inspiration from these significant social and cultural struggles. Against this, Helvetica, or more accurately, the *uses* of Helvetica, were progressively seen as allied with a corporate world that either remained silent about the war or actively lent its support. As the designer Paula Scher noted, 'I was morally opposed to Helvetica, because I viewed the big corporations that were slathered in Helvetica as sponsors of the Vietnam War. So therefore, if you used Helvetica, you were in favour of the Vietnam War, so how could you use it?'[9] To equate a typeface with a war is extreme and simplistic. Yet, Scher does touch on an important point: Helvetica represented the way in which Swiss graphic design often functioned as a zone, an engine room, in which many of the radical ideas of constructivism and experimental page design that inspired Swiss designers were stripped of their overt political connotations and made palatable for major corporations. By the time such designs made it across the Atlantic, they were totally disassociated from their progressive roots.

In recent years, however, there has been a desire to rehabilitate Helvetica's tarnished image. This rehabilitation found its apogee in Gary Huswitt's 2007 documentary *Helvetica*. In this paean to a typeface, many younger designers spoke affectionately of their appreciation for the work of Miedinger and Hoffmann. For such designers as Michael C. Place and studios such as Experimental Jetset, the utilitarian ambitions of Helvetica contrasted favourably with the worst excesses of postmodern typography that had, no doubt, shaped their perception of typography at the inception of their careers. Over the past decade, Helvetica's inherent sobriety has been used as a foil for illustrative elements of a design that contrast sharply with its functionalist and neutral mien. Just as many corporations have adopted a more handmade aesthetic, in an attempt to appear approachable and accessible to their consumers, so many young designers, appropriating the visual language of the establishment for very different ends, have commandeered Helvetica. Yet, as much of these designers' work has been coveted by companies craving the much-sought-after youth audience, the typeface has gone full circle and re-entered the lexicon of corporate design once again.

From a small town in northern Switzerland to the conspicuous symbols of multinational corporations to its use by a new generation of designers antipathetic to bland corporate brochures, Helvetica's chameleon-like existence reveals that, although born at the height of postwar modernism, it shares with such roman typefaces as Bodoni, Baskerville and Caslon a power to endure. Like the best designs, we are frequently oblivious to its existence. It continues to be that most remarkable of creations: an iconic work whose very success derives from its self-effacing essence.

8  *Paul Shaw. 'The (Mostly) True Story of Helvetica and the New York City Subway',* *Last modified 18 November 2008,* http://www.aiga.org/the-mostly-true-story-of-helvetica-and-the-new-york-city-subway/. *Accessed 21 June 2012.*

9  *Hustwit,* Helvetica.

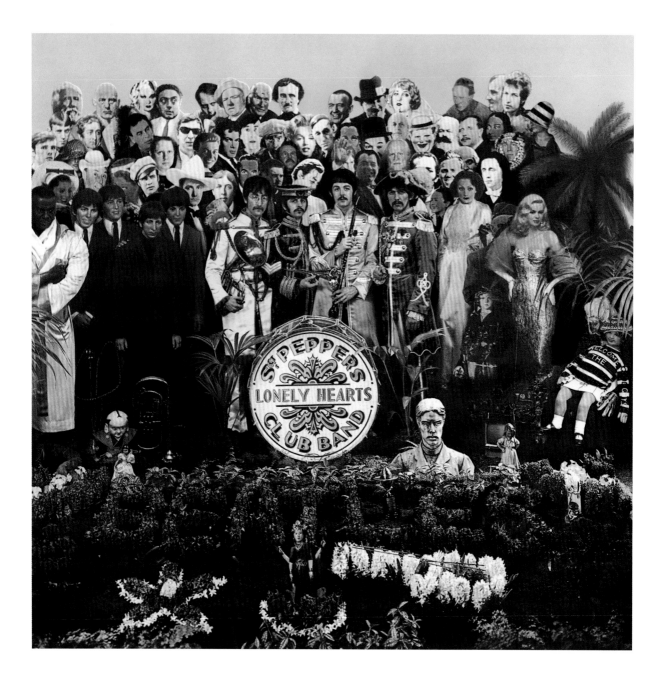

*Album cover for the Beatles'* Sgt. Pepper's Lonely Hearts Club Band, *designed by Peter Blake and Jann Haworth in 1967.* © Apple Corps Ltd.

# 15

## *Sgt. Pepper's Lonely Hearts Club Band* Cover, UK
## (Peter Blake and Jann Haworth, 1967)

### *Alice Twemlow*

Issued on 1 June 1967, *Sgt. Pepper's Lonely Hearts Club Band*, eighth album by the legendary British pop band the Beatles, revolutionized the way albums looked, as well as how they were conceived and recorded. The album was envisaged as if it were the work of the Beatles' alter-egos—ex-army Edwardian-era bandsmen—and the tracks flow seamlessly into one another, rather than with pauses between them, so paving the way for many a concept album. The vibrant cover image, made up of a dizzying assortment of objects and depictions of more than seventy iconic personalities, provided a visual counterpart to the conceptual music and won the 1967 Grammy Award for 'Best Album Cover', going on to become one of the most significant and imitated graphic images of our time.

The image—a photograph of a mise-en-scene of the cultural references that influenced its creators—comprises four rows of life-size two-dimensional models of cult figures, ranging from Marilyn Monroe to Sigmund Freud, some three-dimensional Madame Tussauds wax models of the Beatles from their mop-top period and an eclectic selection of objects including plaster figurines, a hookah, a portable Sony television set and a fukusuke fortune doll, all crowded around the actual band members who stand at the centre of the 12.375 inch/31.4 cm square art work.[1] The Beatles are wearing Day-Glo-hued and lavishly ornamented military outfits made by the theatrical costumer M. Berman Ltd and each clutches the instrument they might play as members of the fictional Sgt. Pepper's Lonely Hearts Club Band, while the crowd of famous faces looms behind them, as if they had gathered to hear a rousing concert at a park bandstand. The word *Beatles* is spelt out in hyacinths, planted in the style of a municipal flower bed, but edged with a row of marijuana plants, and the album title is hand-painted on the surface of a centrally positioned bass drum in drop-shadow, upper-case lettering redolent of fairground signage, even down to the omission of the possessive apostrophe.[2] The reverse of the album package features the song lyrics, the first time this was done, and the interior contains a gatefold photograph of the Beatles, an inner sleeve decorated in a moiré effect design by Dutch clothing and poster designers Seemon and Marijke, and a cardboard sheet of cutouts—a moustache, badges, military chevrons—a pop-art kit of parts for Beatles fans to play with.

### The Construction of an Iconic Image

In the spring of 1967, nearing the end of a recording session lasting many months, the Beatles sought a cover artist to reflect the experimental nature of the new 'sound pictures' they had produced. The art dealer Robert Fraser suggested that they commission two of the artists he represented: Peter Blake (b. 1932) and Blake's then-wife, the American-born artist Jann Haworth (b. 1942). By 1967, both Blake and Haworth were well-established fixtures of the Swinging London art scene. Blake painted publicity-shot-inspired depictions of pop musicians, wrestlers, and film stars and assembled collage-like sculptures from pieces of ephemera; Haworth specialized in sewn and stuffed soft sculptures, especially life-sized dolls that referenced Hollywood celebrity culture.[3]

Blake and Haworth created the set for the album's cover image at Chelsea Manor Photographic Studios. The artists enumerated the names of influential people—writers, Indian

1 *Blake collected the objects from his own home and John Lennon's. They borrowed wax figures of Sonny Liston, Diana Dors and the Beatles from Madame Tussauds wax museum.*

2 *Blake commissioned fairground-sign painter Joe Ephgrave to create the lettering on the drum.*

3 *Blake had been featured, along with Pauline Boty, Derek Boshier and Peter Phillips, in Ken Russell's BBC film on pop art, 'Pop Goes the Easel', broadcast in 1962. Haworth's work had been exhibited at the Institute of Contemporary Arts in 1963, and she had had two solo shows at the Robert Fraser Gallery.*

gurus, actors, comedians, most of whom were male—to include on the cover, incorporating the suggestions of Fraser and the band members. They found images of all the requested people, which they then photographically enlarged to human scale and stuck to human-shaped cardboard cut-outs. They hand-tinted some of the heads, leaving visible on others the grainy black-and-white of half-tone dot of the printed page from which they had been culled.[4] The artists positioned the figures on the set in rows, with six inches of space between rows, to create a tiered effect. This crowded composition allows for the humorous juxtaposition of high and low culture, the silly and the serious: notorious comedian Lenny Bruce is sandwiched between the actress Mae West and the composer Karlheinz Stockhausen. Silent movie comic star Oliver Hardy rubs shoulders with philosopher Karl Marx.

It took two weeks to construct the set, and when Blake and Haworth had assembled all the elements, they positioned the gaudily apparelled Beatles in the centre of the set. Photographer Michael Cooper lit and took the shots. Even though this image is often referred to as a collage or photomontage, it is in fact a sculptural installation or a constructed set, which achieves its collage-quality through its being captured as a photograph. Haworth believes the fact that her father was a Hollywood production designer and that as a child she 'shadowed him on the sets', influenced her work during this period. 'I thought of the installations that I did as film sets', she recalled in 2004.[5] For Blake too, the assemblage was a familiar medium, and the Sgt. Pepper image seems to follow logically from a three-dimensional piece like 'The Toy Shop', created in 1962 from painted wood, glass and a selection of Blake's collection of targets, toys and novelties pasted on the back of the picture inside the shop window.

## A Conceptual Image for a Conceptual Sound

Through its visual complexity and layers of detail, the image approximates the intricate instrumentation of the new Sgt. Pepper studio sound, produced by George Martin and epitomized by the track 'A Day in the Life', with its eclectic range of orchestral, world and home-made instruments and invented sounds. Music fans with the time and inclination to do so could 'read into' the image, much as they did the references to LSD usage in tracks such as 'Lucy in the Sky with Diamonds'. For their benefit, Blake and Haworth had inserted in-jokes, like one of Haworth's Shirley Temple 'cloth figures', bearing on her striped sweater the words *Welcome the Rolling Stones. Good Guys.* The image achieves its aura of authenticity through its painstaking construction and the accumulation of detail. Many of the figures that Haworth and Blake made are not even visible in the final composition, and somehow the fact that they are obscured by someone's shoulder only adds to the veracity and likability of the picture. This is a visual parallel of the Beatles' recording process. In the Eastern-inspired track 'Within You Without You', for example, George Harrison turned the studio into a meditation room, playing sitar and being backed by Indian musicians, everyone seated on a carpet on the floor with lights dimmed and incense burning. You cannot smell incense in the recording but you can almost hear it.

## Collage through an Irreverent 1960s Lens

Blake and Haworth's approach to assemblage epitomizes a renegotiation of the philosophy and practice of collage that was popular among artists and designers in 1960s Britain. For a prewar continental avant-garde, including artists such as John Heartfield and Kurt Schwitters, the deployment of bus tickets, newspaper clippings and other roughly torn pieces of ephemera had provided a shared visual idiom to express some of the anxiety and excitement of the experience of rapid urbanization in early twentieth-century Europe, as well as a means to make political critique. By the early 1960s, however, the political resonances of collage

4 *They used Blake's collection of postcards, engravings, photographs and magazine tear-sheets (which he filed by name and subject matter) as their archive.*

5 *Interview with Jann Haworth, 'Still Swinging After All These Years?'* TATE, ETC. *1 (Summer 2004).*

were diluted. A generation of young artists, with Blake at their forefront, were influenced by their forebears but reinterpreted the medium through an insouciant and apolitical lens.[6]

Cultural historian Alex Seago claims that the medium of collage was instrumental 'in understanding the development of an English postmodern sensibility because it invites the transgression and violation of boundaries of taste, genre, and class'.[7] Brought up in a working class family, Blake remembers fondly his visits with his mother to fairgrounds, music halls and wrestling matches. When he began to paint, as a student at the Royal College of Art, the material culture of his youth—the hand-painted fairground signage, badges, comic books and tickets—found their way into his flattened compositions, providing a vivid counterpoint to other fine art and high culture references.[8] Likewise, in his creative practice, Blake saw an easy interchangeability—unusual for fine artists—between his graphic works, such as the Beatles' album cover or a multiple edition of 'Babe Rainbow' tin plaques for Dodo Designs, and his unique paintings and assemblage sculptures.

## Through Homage and Parody, the Image Endures

Despite its rough-hewn quality, the £2,868 it took to create the cover—about half of which went to photographer Michael Cooper and only £200 to Blake and Haworth—was an extremely high fee for album art at the time. The record label EMI quickly recouped the costs though, as the album sold a quarter of a million copies in the first week and today still ranks as the top selling UK album of all time.

As a testament to the impact of the image, only months after its release, the American guitarist and singer Frank Zappa collaborated with the artist Cal Schenkel to create a dark and protopunk version of the Sgt. Pepper image for his band's, Mothers of Invention, next album. They changed the wording on the drum to 'We're Only In It For The Money', replaced the cult heroes with cult villains, spelled out the band name in rotting fruits and vegetables and added a lightning bolt to Blake's azure blue sky—amounting to a biting parody of the hippy countercultural values that the Beatles then represented. Countless other imitations have followed, including a restaging of the image on the Fox television series 'The Simpsons', where characters from the show gather behind Marge, Homer, Lisa, Bart and Maggie who assume the band members' positions on their living room sofa. American illustrator Ed Lam used the familiar set-up to represent the numerous characters associated with President Clinton during the year of 1998 for the cover of The New York Times Book Review, art directed by Steven Heller. Hillary Clinton, Monica Lewinsky and Clinton himself wear the Beatles' costumes, and many of the original references were replaced with new ones, such as Clinton's saxophone in place of the euphonium and a model of the Statue of Liberty substituting for the Hindu goddess Lakshmi. Thanks to software like Photoshop—digital technology through which you can sample, cut, resize and position images into a composition—the Sgt. Pepper image has become a paint-by-the-numbers visual formula for capturing zeitgeist moments or groups of people who may not all be living or easy to gather for the same photo shoot. All you have to do is insert new faces and change the flower bed lettering to suit the subject at hand.

For their next album, in 1968, the Beatles engaged another British pop artist, but one with a more minimal and intellectual approach to image creation and a more American set of influences than Blake. Although Richard Hamilton (1922–2011) had also produced collages of popular culture, for the Beatles' ninth album he chose to create an utterly minimal white cover with its simple name 'The Beatles' barely discernable in subtly embossed type and an edition number stamped on each cover, as knowing nod to the album cover's new status as artwork—albeit with an edition that numbered in the millions.

6 This irreverence gained its most public forum in Terry Gilliam's animations for the surrealist comedy show Monty Python, first aired in 1969.

7 Alex Seago, Burning the Box of Beautiful Things: The Development of a Postmodern Sensibility (Oxford: Oxford University Press, 1995), p. 105.

8 His 1956 painting 'On the Balcony', for example, combines the ephemera of pop culture ('I Love Elvis' badges, a cornflakes packet) with loftier signifiers of cultural capital, such as a marbled copy of Shakespeare's Romeo and Juliet and a reproduction of Manet's famous painting 'The Balcony' of 1869. See Roger Coleman, 'A Romantic Naturalist; Some Notes on the Painting of Peter Blake', Ark 18 (Autumn 1956): 17.

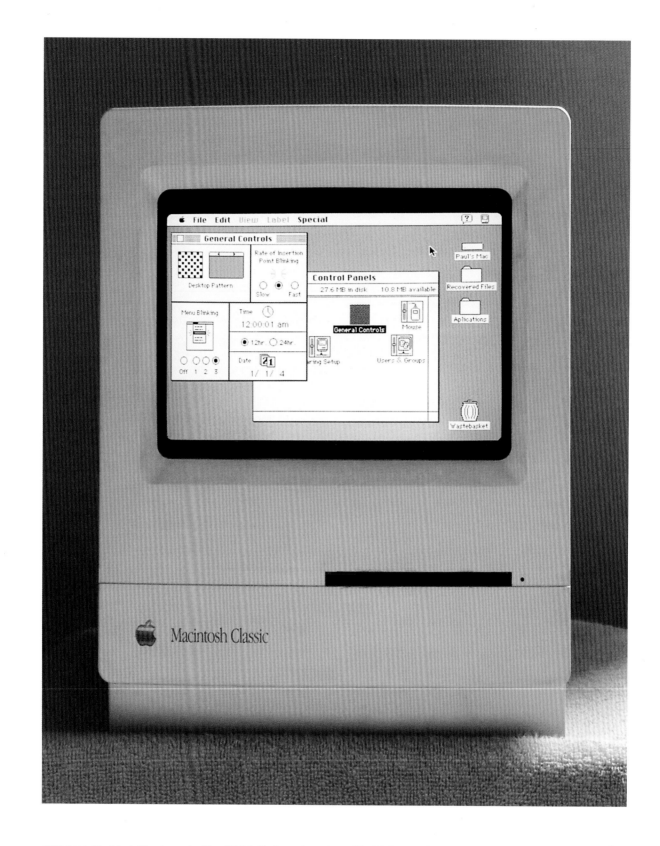

*1991 Apple Macintosh Classic running Mac OS 7.0. Photograph courtesy of Paul Atkinson.*

# 16

# Graphical User Interface (GUI), USA
## (Apple, 1984)

*Paul Atkinson*

Apple's graphical user interface (GUI) changed forever the way people think about computers. It was a paradigm shift in usability that opened up the specialist world of computing to anybody who wanted to become involved and became the de facto way of interacting with digital technology. Although it has changed considerably over the years, the original version remains an icon of graphic design and computer interaction.

## Cryptic Commands

Before the Apple iPhone introduced the gesture-based touchscreen interface, using a mouse and graphical user interface (GUI) became such a pervasive paradigm that it is likely that there are generations of people who have never even encountered a 'command-line prompt', let alone had any experience of using a text-based computer operating system. It now seems such an intuitive way of using a computer that what preceded it appears, in comparison, an idiosyncrasy.

Imagine, when turning on a computer, being faced not with an inviting screen full of icons, but the screen remaining black, with a few puzzling letters and symbols appearing in eerily glowing green type. What exactly was one expected to do when faced with 'C:\>_'? To make it do anything, a series of cryptic commands had to be typed very precisely. The slightest mistake (even a missing comma) resulted in the unhelpful response 'SyntaxError: invalid syntax', with no suggestion of how to rectify the problem. Such poor usability perhaps explains why so many people felt they could live quite happily without computers.

So when with great fanfare, the Apple Macintosh was launched on 24 January 1984, it attracted a lot of attention. Instead of a black screen with cryptic text, the computer's bright white screen carried a cartoon image of the computer itself, with a smiling face showing that it was ready to go. The screen then showed a birds-eye view of a tabletop—the now famous 'desktop metaphor', with icons representing folders and documents on it, and an icon of a dustbin ('trash can' in the United States) for discarding unwanted items. As long as the user knew the basics of how to use a mouse, the rest followed instinctively. Double-clicking on a folder opened a window showing other icons nested inside—subfolders or documents, which opened when clicked on and rested on top of the folder window. Users could open as many folders or documents as they liked, and the windows would pile up, overlapping each other. Clicking on the edge of a window magically brought that file or document to the top of the pile. This seems very simple and straightforward now, but at the time, it was a real revelation. Gone were the days of typing text to access hidden directories. Everything was there, on the desktop, in full view, just waiting to be accessed. The mysterious internal workings of the computer were finally made visible.

## Visionaries

Although the Macintosh first brought the GUI to public attention, it was by no means the beginning of the story. The origins of graphical user interfaces go back to the late 1960s and the work of a few pioneering computer engineers. Douglas Engelbart, inspired by

Vannevar Bush's article of 1945 predicting the future use of information devices,[1] developed a networked computer system with on-screen tiled windows and invented the computer mouse to select items. When he publicly demonstrated this system in 1968, it inspired a generation of technology innovators, among them Alan Kay. Stirred by Engelbart's ideas, Kay envisioned a portable, powerful, educational computer for children called the Dynabook. He took this idea to Xerox, at their new Palo Alto Research Center (Xerox PARC), where many leading technologists of the day were employed. Kay and his 'Learning Research Group' worked towards the Dynabook concept. By 1971, he had developed 'Smalltalk', the first object-oriented[2] programming language, which enabled children to write their own programs, and worked on the Alto computer of 1973, the first personal computer to have a bitmapped screen,[3] GUI and mouse.

How Xerox allowed Apple to steal away its GUI technology has become shrouded in myth, with the popular account obscuring many facts. As Steven Levy wrote: 'To this day, the bone that sticks most deeply in the craw of Apple and Macintosh designers is the charge that all their interface work simply consisted of making, no pun intended, a Xerox copy of the work they saw at PARC.'[4] Briefly, in 1979, Xerox wanted to invest in Apple. Xerox were keen to enter the burgeoning personal computer market that had erupted in 1977 but realized they could never build personal computers cheaply enough. Their hidden agenda was to try to get Apple to build computers for Xerox.[5] Unknown to Xerox, though, Apple was already working on a computer called 'Lisa'—an office computer with a bitmapped screen and GUI. Bitmapped graphical interfaces were well known in technology circles at the time, largely due to academic papers published by Kay's Learning Research Group, although the precise details were highly guarded corporate secrets.

Steve Jobs offered to allow Xerox to invest a million dollars in Apple if PARC allowed Apple's engineers to see what they were working on. Xerox management agreed[6] and ordered PARC's researchers to show Apple what they had achieved. The Apple team saw things never shown in a research prototype anywhere, much less in a commercial system. Having read Kay's papers, Apple's engineers knew exactly what questions to ask. Meanwhile, Steve Jobs jumped about the place excitedly, shouting, 'You're sitting on a gold mine. I can't believe Xerox is not taking advantage of this.'[7]

## Doers

Xerox's GUI was stunning, but far from adopting it wholesale for the Lisa, Apple's team realized a lot of work was needed to make it a commercial reality. First, Jobs commissioned IDEO to redesign the mouse, turning it from a complex, unreliable, expensive, hand-assembled device into a simple, reliable, cheap mass-produced product.[8] Next, Apple's engineers, led by Bill Atkinson, stripped the system down to make it more responsive (Xerox's version was painfully slow) and more interactive by introducing 'direct manipulation'. The Xerox system was very static; everything had to be achieved through menu commands. There was no way of moving windows or icons around. Atkinson figured out how to 'grab' items on screen and move them about, resize windows and open files by double-clicking on them. After a lot of effort involving some incredibly complex coding, Atkinson even worked out how to make windows overlap so that the selected window appeared on top and hid windows underneath. He did this because he thought he had seen it at Xerox, but actually he hadn't, and PARC's researchers were amazed he had managed to do it.[9]

Meanwhile, Xerox released the 'Xerox Star' in 1981, aimed at business users. It had all the features demonstrated to Apple but was still slow, unrefined and ridiculously expensive. When it failed in the marketplace, a group of PARC researchers left and went

1 Vannevar Bush, 'As We May Think', Atlantic Monthly, July 1945.

2 Object-oriented programming is a way of writing complex procedures as modular routines which can be linked together in various ways to perform different tasks.

3 'Bitmapping' means that the computer individually controls every pixel on the screen at the same time. It requires far more computer power than a text-based interface but enables the whole screen to become a single, controllable image. It is widely accepted that in achieving this, the Alto was way ahead of its time, yet it was never released to the public.

4 Steven Levy, Insanely Great: The Life and Times of Macintosh, The Computer That Changed Everything (London: Penguin, 1995), p. 90.

5 Michael Hiltzik, Dealers of Lightning (London: Orion, 2000), p. 335.

6 Walter Isaacson, Steve Jobs (London: Little, Brown, 2011), p. 96.

7 Ibid., p. 97.

8 Paul Atkinson, 'The Best Laid Plans of Mice and Men: The Computer Mouse in the History of Computing', Design Issues 23, no. 3 (2007).

9 Isaacson, Steve Jobs, p. 100.

to work for Apple. Despite this influx of know-how, when the Lisa was released in 1983, it too failed to make an impression. Although not as slow or expensive as the Xerox Star, it was not fast or cheap enough for many to take notice. It did, however, indicate what the Macintosh had to achieve.

Jobs hired the promising young engineer Andy Hertzfeld, whose job was to make the Macintosh interface simpler and so reach more people. Jobs also hired an unusual team member—graphic designer Susan Kare, whose responsibility was the look of the Macintosh interface.[10] Together, Jobs, Hertzfeld and Kare led the work to improve the GUI. Decisions were made to unify the way different programs worked on screen—scroll bars on the sides of windows, title bars at the top and the way pull-down menus worked. The idea was that the interface would look the same no matter what the user was doing. How objects were dragged, how dialogue boxes appeared, even how programs were quit—all were identical in every application. In this way, the steep learning curve of using a new program was minimized, and the whole system became more intuitive.

Kare introduced a new level of refinement to the interface. She added pinstripes to title bars of windows, grey tints to scroll bars and redesigned classic fonts from scratch to avoid licencing fees. Times, Century, Helvetica and others were redrawn and renamed after cities such as New York, Geneva and Chicago, enabling users to fine tune the look of documents for the first time (Helvetica and Times were preloaded as standard in later versions of Mac OS). Kare also introduced the tiny self-portrait of the Macintosh that appeared when the computer was turned on and other icons including the trash can and the old-fashioned bomb that appeared when the computer crashed, which became such recognizable features of the Macintosh.

When the team had finished, the Macintosh interface stood out like a beacon. There, in all its glory, was the culmination of the dreams of Bush, Engelbart and PARC.[11]

## Legacy

The Apple Macintosh was successful, although in sales terms not as successful as Jobs had hoped. But its GUI had a massive and lasting impact. Its exposure to and acceptance by such a wide audience is the significant fact that ensures its iconic status. Once the public became aware of its benefits, it became the way all computers *had* to work. There was no going back to text-based interfaces.

Competitors tried hard to follow the Macintosh, mostly without success. Microsoft, though, had a huge advantage through their ownership of the operating system of the IBM PC, the industry standard in offices across the world. When Microsoft launched their GUI, Windows 1.0,[12] there was an enormous installed base of potential users.

When Jobs accused Microsoft of 'ripping us off', Bill Gates replied, 'Well, Steve, I think it's more like we both had a rich neighbour named Xerox, and I broke into his house to steal the TV set and found out that you had already stolen it.'[13] The courts agreed. By the time Microsoft released Windows 3.0 in 1990, the design had improved immensely, in part due to the input of one Susan Kare.[14] Microsoft reached a global audience; elements of the GUI's iconography became an independent metaphor for working with information in a digital age, enabling users, and even the very act of interaction itself, as evidenced by their appearance in mainstream media. Pull-down menus, title bars, cursor arrows and 'grabbing hands' appeared in adverts on billboards and television screens everywhere, in an attempt by companies to convey being up-to-date, efficient, friendly and accessible. The GUI had become a part of everyday life.

10 *Levy*, Insanely Great, p. 155.

11 *Ibid.*, p. 199.

12 *Microsoft Windows 1.0 was announced in 1983, after the launch of Lisa but before Macintosh. It finally appeared in 1985.*

13 *Isaacson*, Steve Jobs, p. 178.

14 'Kare provided a thorough facelift for the program and designed many of the individual graphic features included in Version 3.0'. Ron Wolf, 'The mother of the Mac trash can', San Jose Mercury News, Business Monday, 28 May 1990.

'White Black Yellow' photograph of pig hearts
by Italian photographer Oliviero Toscani, launched
as a Benetton advertisement on 21 March 1996
for the annual International Day for the Elimination
of Racial Discrimination. Reproduced by permission,
Oliviero Toscani.

# 17

## Benetton Advertising Campaigns, Italy (Oliviero Toscani, 1986–)

*Celia Lury*

### 'Five colours together and three different faces'

The iconicity of Benetton's advertising has been accepted at face value by all of us, if you believe the claims of their marketing personnel: 'If you see five colours together and three different faces, you say "that's Benetton ..." even if it really isn't.'[1] However, it was not until 1984 that the use of imagery described here—'mainly colour and joie de vivre',[2] first began to be used by Benetton to promote its clothing in international advertising campaigns. Until then, the company's marketing had been primarily focused on the representation of its clothing products. The press release accompanying the new campaign described the images as 'Groups of young people of different races and sizes ... photographed jumping and laughing'.[3] These images are still with us, although the slogan accompanying them changed from 'All the Colors of the World' to the now ubiquitous 'United Colors of Benetton' in 1985. In these photographs, young people, sometimes waving national flags or bedecked with national emblems such as stars and stripes, hammers and sickles, with accentuated, racially coded physical characteristics, parade in colourful clothes.

Until 2000, the photographer Oliviero Toscani—himself the son of a photographer—was responsible both for Benetton's overall advertising strategy and for many of the specific images used in the advertising. Toscani sought to differentiate Benetton advertising from that of its rivals through the creation of a distinctive iconography based on his own photographic practice: 'I take pictures, I don't sell clothes'.[4] Toscani's avowed aim was to project a worldview though advertising: 'I don't want to have ideas. I have my own reality.'[5]

Certainly Benetton's advertising was distinctive, at least in the UK, for its use of explicitly racially coded models where, in general, advertising was and indeed continues to be remarkably white. But the insistence on the 'reality' of race is given a twist: in Benetton imagery, race is not presented as natural, but rather as cultural. In Benetton promotional campaigns, young people are colour-coded: they are juxtaposed together to bring out tonal contrasts, as in Benetton outlets in which stacks of jumpers are piled up like so many colour charts. In images in which skin and cloth are rendered equivalent, race—while highlighted—is not a matter of skin colour as the physiological expression of a biological or natural essence, but rather of skin colour as style, of colour itself as a privileged sign of difference. In a promotional illustration for tights, for example, the viewer is confronted by a series of legs in overlapping profile, each slightly different in shape ('different races and sizes'), completely encased in brightly coloured tights. Here skin colour is not made invisible (although no bare skin is visible) but displaced and reworked as a stylized act of choice: what colour is your skin going to be today? In the image shown here, three apparently similar hearts are set against a white background, giant organs without bodies, distinguished only by the words *WHITE*, *BLACK* and *YELLOW*. The difference of race is invoked, only to be shown to be arbitrary.

This mark(et)ing of difference—and, with this promotion of difference, the invitation to the consumer to choose—is what came to define the iconicity of Benetton advertising,

1 Francesca Mattei, 'A Matter of Style', News: United Colors of Benetton (n.d.): pp. 4–5.

2 Ibid.

3 Les Back and Vibeke Quaade, 'Dream Utopias, Nightmare Realities: Imagining Race and Culture within the World of Benetton Advertising', Third Text 22 (1993): 65–80, 67.

4 Oliviero Toscani, 'Taboos for Sale', interview by Michael Guerrin, Guardian Weekly, 26 March 1995, p. 20.

5 Back and Quaade, 'Dream Utopias', p. 66.

at least in its heyday, when the advertising was subordinated to Toscani's not totally unreal 'reality'. So, for example, in later Benetton campaigns, the stylistic equivalence of skin and cloth as achieved in the photographic imagery of the fashion shots was extended to invert a whole series of apparently natural relations and hierarchies, of genres, kinds or types. Indeed, it might be described as the representation of difference within an estrangement of genre, type or kind. This is what lies behind the challenge to the biological basis of mothering in both an image of a black woman breastfeeding a white child and in another of two women, one white, one black, holding an Asian child. It is present in the overturning and reconstruction of the accepted distinction between animals and humans in the use of starkly black and starkly white animals—a white wolf 'kissing' a black sheep—as models, counterparts to the young people of different races jumping and laughing in other images. In some campaigns, life itself—survival in a world under threat—is culturalized, and made a matter of choice. These now infamous images—a seabird covered in oil, a man dying of AIDS, a burning car in a street, the shrouded body of a bloody corpse after a Mafia killing, a soldier holding a human femur behind his back with a Kalashnikov rifle hanging from his shoulder—show images of life, animal and human, in situations of conflict, threat and disaster. Condensed to the moment-of-catastrophe space-time, these photographic images disengage the events they show from specific historical, political and cultural contexts and embed them instead in apocalyptic time, in which our planet faces global dangers.

The representation of the differences of humanity is one of the defining projects to which photography has been recruited—a famous example of which is 'The Family of Man', an exhibition created by Edward Steichen for the Museum of Modern Art in New York in 1955—and Benetton's advertising is self-consciously located in this photo-anthological, photo-anthropological tradition. One of Benetton's most widely discussed advertising images—that of a man dying of AIDS—initially appeared as an example of photojournalism in *Life*, while Benetton describes its promotional magazine *Colors* as 'a hipper *National Geographic*; an ironic *Life*; an amusing, irreverent, light-hearted, scholarly, over-the-top collection of off-beat and on-target stories about the people of the world'.[6] To this project Toscani added a modernist spin:

*I studied at the Zurich School of Applied Arts. They taught us the new photographic objectivity in the best Bauhaus tradition … The white backgrounds of my photographs, the way the subjects all face the camera, the direct message, the strict objectivity—all that comes from Zurich.*[7]

And from this pairing of estrangement of genre, kind or type, with an effacement of context, scale and perspective came the distinctive iconicity of Benetton's campaigns: an appealing faux naivety or literalness of content made vivid by way of contrast: black is not white, an angel is not a devil, life is not death, but each may be rendered stylistically equivalent to the other as they are held still in the exposure of the photographic image. As Toscani puts it: 'Our basic idea is always the same; we are all equal. There is no reason to slaughter each other, to fight, not even to hate each other. We can wear whatever we want, whatever colours we want—just live.'[8]

## Digital Contexts

But much has changed since this iconography achieved a public resonance. The photographer Toscani is no longer responsible for Benetton's promotional imagery, but it is not just that an individual's 'reality' cannot be sustained without the individual: what

6 *Benetton press release*, in Back and Quaade, 'Dream Utopias', 78.

7 Toscani, 'Taboos for Sale', p. 20.

8 Piño Corrias, 'Beneath Jumpers', Guardian, 8 June 1993, p. 16.

photographs are, how they circulate, and how they represent humanity has changed. When I last wrote about Benetton, in 2000, I introduced the claim by the French cultural theorist Jean Baudrillard that we had reached 'the last stage of the social relation'. In this last stage, he writes, persuasion—the 'classical age of propaganda, ideology, of publicity, etc.'—is replaced by deterrence. This is a world in which 'YOU are information, you are the social, you are the event, you are involved, you have the word, etc.' Baudrillard describes this as an about-face through which it becomes impossible to locate one instance of the model, of power, of the gaze, of the medium itself, because you are always-already on the other side. 'No more subject, no more focal point, no more centre and periphery: pure flexion or circular inflexion.'[9] What I want to suggest here is that this transformation is now so well-established that Benetton is no longer able to presume the stability of the genres, types or kinds from which its marking of difference could seem provocative. And this is as much a transformation in photography as in the world it represents.

The most obvious aspect of this transformation is the use of photographs on the web. As many observers note, most contemporary media, including photography, is now widely experienced, created, edited, remixed, organized and shared with software. This software includes stand-alone professional media design and management applications such as Photoshop, Illustrator, Flash, Dreamweaver, Final Cut, After Effects, Aperture and Maya; consumer-level apps such as iPhoto, iMovie, Picasa and Flickr; tools for sharing, commenting and editing provided by social media sites such as Facebook, YouTube, Vimeo and Photobucket, and the numerous media viewing, editing and sharing apps available on mobile platforms such as Instagram. This is linked not simply to an immense expansion in photograph taking,[10] but also to changes in photographic manipulation, storage and circulation.

There are many things that can be said about this transformation, but what is interesting in relation to Benetton's iconography is how it has contributed to a change in how difference is visualized. As noted above, Benetton's iconography was premised on the shock value of the representation of difference as an estrangement of genre or type, where such genres or types were relatively stable and relatively limited. The radical indifference of photography to its content (anything and everything may be the subject of a photograph) emphasized by many commentators was put to work but held in check by the undoing and re-marking of difference in relation to genre, type, kind or race of person. In contrast, the difference that is being made visible in contemporary photographic imagery on the web operates within and across genres that themselves proliferate. In this image-world, each individual is represented multiply, by herself, as well as by others. He may be tagged or not; may be depicted on his own or with others; can be shown in a wide variety of contexts—on holiday or at home, on the top of mountains or in a living room—and in a wide variety of emotional states. She may be posed in relation to intended audiences and received by unintended and unknown audiences. In this environment, the impact of an individual photograph of an individual is less and less its own event, and more and more to do with its membership of a series.[11] The representation of difference is now constituted by—or rather in—movement, by the difference that can be established in the movement of a series of images rather than the difference created in relation to the variation of genre, type or kind. This series is not pre-given; instead, it is produced through automated practices of listing, searching and comparing, and the difference made visible is one of modulation rather than variation, an *a posteriori* effect of indeterminate significance determined by a common relation of ordering. In this world, Benetton's imagery is no longer iconic, it is merely nostalgic; no longer shocking, merely irritating.

9  Jean Baudrillard, Simulacrum and Simulation, *trans. Sheila Fari Glaser (Ann Arbor: University of Michigan Press, 1994), p. 29.*

10  *Consider, for example, the emergence and rapid uptake of photo-sharing websites, such as Flickr (established in 2004). By August 2011, Flickr reported that it hosted some 6 billion images; and while it is difficult to get accurate official figures for Facebook, various company blogs track the growth in the volume of uploads, from some 850 million per month in mid-2009 to 2.5 billion per month in early 2010 to 250 million a day in August 2011.*

11  *Scott McQuire, 'Digital Photography and the Operational Archive', in Sean Cubitt, Daniel Palmer, Nathaniel Tkacz and Les Walkling (eds),* Digital Light *(Sydney: Fibreculture, forthcoming).*

THE LONELIEST MONK
by Dave DiMartino

(I HAVE NO INTEREST

What's the most distasteful aspect of current pop
Predictably, it's RAP, which continues in
the same old way which has never, never
ever changed. I mean, there is only
one rap song in the entire universe which
frightening when you con...er how
many rap records have been made.

Morrissey

photography: chris cuffaro

IN ANY ASPECT WHORDOM'

*David Carson, 'The Loneliest Monk', double-page spread, Ray Gun 14, March (1994). Photography: Chris Cuffaro.*

# 18

## *Ray Gun*, USA
## (David Carson, 1992–1995)

### *Julia Moszkowicz*

*Ray Gun* was a landmark in magazine art direction, one that has been closely analyzed by critics and historians since its launch in the United States in the early nineties. For many, its typographic playfulness and bold visual style represent a significant yet problematic challenge to the modernist ideal of neutrality (exemplified by Helvetica, for example). Widely viewed as intuitively engaging with the zeitgeist of the late 1980s—specifically, poststructuralist theories of deconstruction—*Ray Gun* was conceived as a rule-breaker in the field of graphic design, one that scrambled the established codes of communication, re-mixed its linguistic and visual signs and produced a nonhierarchical open-ended text for the pleasure of (and to challenge) the reader. In 1994, graphic designer Neville Brody described *Ray Gun* as signalling a new era for graphic design—one where traditional print formats actively engaged with emerging visual media and aspired to achieve the same levels of visual stimulation being offered by video games, computers and cable TV. He surmised that *Ray Gun* represented 'the end of print' and argued that it 'says more about the lack of rules in digital media than digital media does'.[1] Critics of *Ray Gun* deplored its rejection of cherished design rubrics, such as the organizational properties of headers and grids. Its admirers argued for the proximity of *Ray Gun* to abstract painting, believing that it rewarded those who engaged with its formal complexity. To this day, the magazine divides historians and critics over the question of privileging a distinctive visual style at the expense of typographic legibility and ease of reading.

### A Magazine for a Music Scene

*Ray Gun* was launched in November 1992 as a music magazine catering to the grunge and independent scene.[2] It aimed to explore new relationships in visual composition, to introduce distinctive arrangements of typographic information and to offer an innovative staging of the reader's engagement with print. The magazine set out to tackle the music scene on many fronts and referred to itself as 'The Bible of Music and Style and the End of Print'.[3] Although the publication was frequently criticized for being self-indulgent, the circulation figures suggest that *Ray Gun* successfully interpreted the field of independent music for its fans. At its height, *Ray Gun* achieved a circulation of 120,000. In this respect, the magazine broke new ground by making experimental design popular. *Ray Gun* clearly hit a nerve with its public; for although it refused to find out exactly 'what it is they want', it acknowledged a desire among consumers for surprising relationships with information.[4] As one reader states, 'I love your graphic form and I don't care if others don't like it.'[5] The readers' letters pages were full of praise for the magazine; they complimented the producers on their selection of front cover imagery and shared stories about how they came across *Ray Gun* for the first time.[6] Even when the formal arrangements were at odds with a fan's desire for unmediated access to photographic content, the banter was light-hearted and familiar. Another reader pleaded, 'Please run that picture of Epic Soundtrack again, only this time without letters over his face, okay?'[7] Indeed, there is open communication between producers and consumers—a relationship of mutual respect that was exemplified

1 *David Carson and Neville Brody, 'Face to Face',* Creative Review *14, no. 5 (1994): 29.*

2 *Carson describes 'the Nirvana era in music',* Marc Cameron, 'The King of Typography', Fotorater, *1 May 2013,* http://www.fotorater.com/art/2012/05/the-king-of-typography-exclusive-interview-with-david-carson/.

3 *Front cover,* Ray Gun *20, October 1994.*

4 *David Carson, 'Interview', in Lewis Blackwell,* The End of Print: The Graphic Design of David Carson *(London, Lawrence King, 1995).*

5 Ray Gun *16, May 1994, p. 6.*

6 Ray Gun *14, March 1994, p. 4.*

7 Ray Gun *25, April 1995, p. 6.*

by the 'Sound in Print' feature, which comprised six to eight pages of readers' illustrations of lyrical material. [8]

*Ray Gun* was also groundbreaking for undertaking its formal experiments in public. This becomes clear when the magazine is placed within the context of its first art director, the designer David Carson. For many critics and historians, the name 'Carson' has become synonymous with *Ray Gun* magazine, even though he left the publication in 1995 (less than halfway through its lifecycle)[9] and despite the fact that Carson views *Beach Culture*—and not *Ray Gun*—as his proudest publishing achievement.[10] Carson has been described as an *enfant terrible*, a professional surfer and sociology graduate who had enough self-belief to approach the publishing world despite having neither academic nor professional training in graphic design. Instead, he entered magazine art direction via a different route, working on a series of subcultural publications—*Skateboarder, Transworld Skateboarding*, *Beach Culture* and *Surfer*—attracting attention for his innovative spreads and radical contents pages from other practitioners of graphic design.[11] In his 'interim report' on contemporary typography, Rick Poynor characterizes Carson's early work in terms of its 'typographic abandon' and 'visual delirium',[12] and it is these formal attributes that he brought to *Ray Gun* in the early nineties.

Carson refused to standardize the pages (or even allocate a numbering system); he generated discontinuous patterns of leading and kerning and squeezed white space out of the familiar organizing form of the margin. At their best, the pages of *Ray Gun* are choreographed sets where dynamic combinations of image and text come to rest at the point of achieving an appealing overall shape. As Carson explains in retrospect, 'It's not really a Generation X thing and it's not limited to design buffs. A lot of people … simply take in visual information differently now.'[13] However, there are points of weakness and inconsistency. 'I would be the first to say', Carson reflects, 'that some of it works and some of it doesn't'.[14]

*Ray Gun* is thereby largely conceived as the product of a self-taught, conceited maestro who once had the arrogance to break the rules of graphic design, largely because—much like a punk—he had no academic training in design. Historians and critics have actively scripted *Ray Gun* and Carson into a cause-and-effect relationship, with the look of the magazine being strongly aligned with the skills and taste preferences of this one-time surfer/egomaniac.[15] In 1995, the year that Carson ended his connection with *Ray Gun*, he reflected, 'I am using my intuition, trying to express things I am reading in the way that makes the most sense to me.'[16] For some, this interpretative approach to design was simply too subjective to serve as an appropriate model for business. While they understood the need to rebel against the corporate deployment of the modernist canon, they felt that Carson's personalized approach was too removed from the day-to-day function of graphic design to form the basis of an alternative paradigm. According to Steven Heller, Carson's work at *Ray Gun* encouraged other young designers to see themselves as 'artistes' rather than communicators. If *Ray Gun* served as a license to be free, it was all the more problematic for serving as a 'license to be "me"'.[17]

This critique is undermined, however, by the fact that *Ray Gun* succeeded with advertisers, especially those who were keen to communicate with the youth market.[18] Under the design and art direction of Carson, *Ray Gun* contained a wide range of clients within its overall scheme, including the new broadcasting channel, *Comedy Central* and various brands of cigarettes, clothing and trainers.

8 *This active dialogue between magazine and audience is evidenced at Southampton Solent University, where pages – particularly front covers – have been torn from* Ray Gun *by enthusiastic readers.* Ray Gun *16, May 1994, front cover.*

9 *Robert Hales, Chris Ashworth and Scott Denton-Cardew followed.*

10 *Carson says, 'It was such a labour of love.' Cameron, 'The King', p. 1.*

11 Beach Culture *won a gold medal from* The Society of Publication Designers. *Cameron, 'The King', p. 1.*

12 *Rick Poynor,* Typography Now: The Next Wave *(London: Booth-Clibborn, 1993), p. 17.*

13 *Warren Berger, 'David Carson is God',* Newsweek, *19 February 1996, p. 17.*

14 *Carson and Brody, 'Face to Face', 30.*

15 *Rudy Vanderlans states Carson 'has a gigantic ego'.* Peter Players and Ray Sawhill, 'The Font of Youth', Newsweek, *25 February 1996, p. 16.*

16 *Blackwell,* End of Print.

17 *Steven Heller, 'The Me Too Generation', in* The Graphic Design Reader *(New York: Allworth Press, 2002), p. 5.*

18 *Players and Sawhill, 'The Font of Youth', p. 16.*

## The Context of Technology

One context for understanding *Ray Gun*'s aesthetic rebellion has been through the advent the Apple Macintosh computer in the mid-eighties and, hence, the introduction of digital techniques to graphic design. Heller, for example, describes Carson as a 'digital type jockey' who 'galloped over the status quo',[19] offering a rapid and pervasive summary of his practice. Closer examination reveals, however, that Carson started his experiments in magazine art direction in a resolutely offline mode. The first edition of *Ray Gun* to be produced *entirely* by digital means did not appear until the fourteenth issue and, therefore, halfway through Carson's time at the magazine.[20] Until then, Carson had been cutting out and re-arranging the layouts by hand and sending them to the printers as pasted-down artwork.

In this respect, Carson shares his working practices with other pioneers of magazine publishing, such as Neville Brody. Brody's work at *The Face* and *Arena* also exhibits a thoughtful—as opposed to automatic—response to digital processes. In conversation with Carson in 1994, Brody described how the Mac had become a prerequisite for doing all the 'daily stuff', yet argued that designers need to be mindful of its implicit (template) structures. Brody was wary of the fact that the later versions of the Mac OS came with Helvetica and Times as preloaded fonts and saw the computer as equivalent to 'a camera with a fixed lens'.[21] Carson agreed, supporting the idea that computers are systems of communication that disguise themselves as (mere) tools for design. He says, 'All these decisions have been made for you.'[22]

Despite this nuanced approach to digital techniques, there is a strong element of technological determinism (or an assumption that new technologies drive innovation) within the histories of experimental art direction and much is made of the potential for type and layout to be manipulated within the framework of a computer. However, does this technological impulse preclude a wider range of readings? Surely there are other factors involved in building *Ray Gun* into a work of iconic design? There are stories to be told, for example, about the role of Marvin Jarrett—*Ray Gun*'s publisher and editor—who remained at the helm of the magazine until its closure in 2000. It was Jarrett who brought the original design team together and was sensitive to changes in youth culture. Carson recognizes that Jarrett was guided by an idea 'that music was changing and a magazine should visually reflect this music'.[23] At the very least, this acknowledgment draws attention away from the singular practitioner and back to the collaborative nature of this renowned publishing venture.

There is also the matter of *Ray Gun*'s popularity with young designers, who took the magazine as a reference point for their own work. Heller dismisses these 'lemming like acolytes' but their letters to the magazine are revealing. For example, there is a note from Kim Hiorthoy (aged 19), from Trondheim in Norway, who admits that *Ray Gun* is a source of inspiration for his own independent zine, *Folk and Revere*: where we 'steal ideas like hell'.[24]

This chapter has traced the history of *Ray Gun* and argued that, in discussions over its iconic status, historians and critics have tended to lose sight of where Carson's responsibility for the artefact ends. Carson is equally aware of an imbalance within these accounts, stating, 'I've never said I'm the only one who's done the whole thing.'[25] Nevertheless, the histories of *Ray Gun* continue to be dominated by the discourse of Carson's authorship, with the danger of marginalizing other contexts of interpretation: the technological, the musical and the youth cultural.

19  Heller, 'The Me Too Generation', p. 5.

20  Blackwell, End of Print.

21  Carson and Brody, 'Face to Face', 30.

22  Ibid., p. 30.

23  Cameron, 'The King', p. 1.

24  Ray Gun 14, March 1994, p. 6.

25  Players and Sawhill, 'The Font of Youth', p. 16.

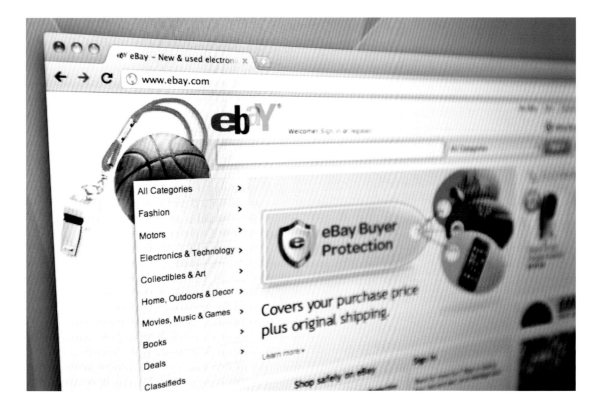

*eBay Homepage. Image courtesy of iStock.*

# 19

## eBay.com, USA
## (Pierre Omidyar, 1995)

*Ida Engholm*

Celebrated as one of the leading and most valuable brands in the world, eBay has acquired iconic status on a par with century-old brands such as Coca-Cola and Disney. The eBay logo is now synonymous with the world's leading online auction website, and its design is associated with the company's purpose: selling millions of goods, some of which are 'designer' items and some of which are considered design icons.

### History and Debate

The eBay story cannot be understood independently of the general development of the Internet. eBay was founded in 1995, two years after the launch of the World Wide Web, which in just a few years transformed the Internet from a command- and code-based distribution channel to a commercial mass medium. eBay, called AuctionWeb for the first two years, was founded in the same year as Amazon.com, the world's first virtual book store, and one year after Pizza Hut in the USA had accepted its first online order.[1] According to eBay's founder, the French-born Iranian-American computer programmer Pierre Omidyar, the company's business idea was to transfer real-world person-to-person sales, at garage sales, flea markets and auctions, to a digital context.[2] As proclaimed on the front page of the company's first website: 'AuctionWeb is dedicated to bringing together buyers and sellers in an honest and open marketplace. Here, thanks to our auction format, merchandise will always fetch its market value. And there are plenty of great deals to be found!'[3] The following year, the company secured its first commercial licensing agreements, thereby expanding the business to include the sale of new goods, a move that resulted in tremendous growth. In 1997, AuctionWeb hosted 2 million auctions, compared with 250,000 during all of 1996.[4] Also in 1997, the company changed its name to eBay and launched a new corporate identity, where the monochrome grey palette was replaced by a white background, picture icons and brightly coloured graphic bars. The new logo was designed by Bill Clearly of the CKS Group and featured the name *e-b-a-y* in bold primary colours; the colours were intended as a reflection of the quirky personality of the company, while the overlapping letters reflected the trust binding the community together. According to Clearly, the logo had a 'little bit of the ponytail about it'.[5]

With ongoing developments of both the technological and the business platform, by 2000 eBay was one of the few online companies to have survived the dot-com crisis, which later earned the company a reputation as 'one of the most notable success stories of the dot-com bubble'.[6] In 2002, eBay took over the online bank PayPal, which further improved the company's platform for online buying and selling by making it safer and simpler for users to send and receive money.[7] With the integration of Web 2.0 technologies in the mid-2000s, eBay further refined its tools for user involvement and community building. Today, eBay is mentioned alongside Google and Amazon as being among the most successful companies based on extensive developer communities, which not only create the primary content but also refine existing applications. Thus, some 40 per cent of all the merchandise on eBay is currently uploaded automatically from the inventory systems of third-party stores

1 *Kathryn Vercillo, 'The History of Online Shopping', 25 January 2010,* http://www.promotionalcodes.org.uk/9519/the-history-of-online-shopping/#b. *Accessed 2 May 2012.*

2 *Ben Gomes-Casseres, 'The history of eBay', 2001,* http://pages.cs.brandeis.edu/~magnus/ief248a/eBay/history.html. *Accessed 2 May 2012; Lauren Thompson, 'History of the eBay Auction',* http://www.ehow.com/about_6496604_history-ebay-auction.html. *Accessed 2 May 2012.*

3 *The 1997 site shown at* http://shivamsharma.wordpress.com/2010/08/08/10-entertaining-eBay-facts-you-might-not-know/. *Accessed 2 May 2012.*

4 *Ellen Lewis,* The eBay Phenomenon: How One Brand Taught Millions of Strangers to Trust One Another *(London: Marshall Cavendish, 2008).*

5 *Adam Cohen,* The Perfect Store: Inside eBay *(Boston: Little, Brown and Company, 2002), p. 89.*

6 *For example, Wikipedia,* http://en.wikipedia.org/wiki/EBay. *Accessed 2 May 2012.*

7 *Troy Wolverton, 'It's Official: eBay Weds PayPal', 2002,* http://news.cnet.com/Its-official-eBay-weds-PayPal/2100-1017_3-960658.html. *Accessed 2 May 2012.*

that use eBay as an alternative sales channel.[8] With local versions of the site in more than thirty countries the company was named as the forty-eighth most valuable brand in the world in 2007. Today, there are more than 250 million registered eBay users worldwide.[9]

Until now, the eBay phenomenon has only been the topic of sporadic research interest, mainly in the e-business literature and usability studies.[10] In more popular contexts, however, eBay has been the topic of intense online debates, and broader publications have discussed the company from a variety of perspectives including branding and marketing, technological development and usability. These debates have further served to consolidate the company's iconic status.

## Genre and Style

In terms of genre, eBay can be classified as an e-trade site based on consumer-to-consumer sale. Applying media theorists Jay Bolter and Richard Grusin's concept of remediation,[11] denoting the way that new media draw their cultural and usage-related meaning from previous media, eBay's site can be viewed as a remediation of traditional classified print media such as *The Recycler*, print advertising folders, real-world bidding in auction halls and the haggling and personal interaction at fairs.

Graphically, eBay's sites have reflected developing technological possibilities and usage conventions. According to the graphic options available at the time, the initial monochrome AuctionWeb site of 1995 featured a grey background with clearly defined text sections and purple hyperlinks. The second (eBay) site from 1997 was in full colour, with a layout that featured a logo in the upper/lower left-hand corner, a main menu in the top half, a secondary menu on the left and news and in the centre. This arrangement reflected an emerging convention for the layout of websites based on usability ideals and a certain degree of standardization with the purpose of quick identification and easy access to content. The guidelines were circulated in web developer environments and via the first how-to books on website design, which appeared in the mid-1990s.[12] According to media theorist Miriam Rivett, eBay's commercial approach differed fundamentally from the laissez-faire approach of the early years of web development when grassroots and populist web publishers dominated the scene.[13] For eBay and other e-commerce sites, design was tied to function and related to the overall goal of generating and expanding market share. This involved a growing focus on form and a certain degree of design standardization, similar to the establishment of conventions that had occurred in other professional communication genres in other media. eBay's 1997 site represented a design norm that remains largely unchanged today and that, despite debate in usability designer circles about the user-friendliness of the various site versions, has enabled consumers to successfully navigate the vast platform, interact with other users and carry out a wide range of transactions. The interaction design and its ongoing adjustment is one of the main sources of eBay's continued success.

## Bricolage Design and Complex Authorship

eBay's current site design represents a sophisticated mediated environment for interaction and distribution. The visual content is presented within a typology that allows users to browse, compare products, buy and sell. The platform for interaction and transaction was designed by eBay's own development team. The secondary designer is the community of vendors and buyers, the individuals and external companies that generate and contribute content and add new applications to the site. In that sense, the site is a result of an interaction among multiple senders and a variety of co-producing users.

8 *Don Tapscott and Anthony D. Williams*, Wikinomics *(London: Atlantic Books, 2007), p. 184.*

9 *Lewis*, The eBay Phenomenon, *p. 7.*

10 *Jacob Nielsen and Marie Tahir*, Homepage Usability *(Indianapolis, IN: New Riders, 2002), p. 131; Phil Dunn, 'Web Development and Web Sites', 2006,* http://www.allbusiness.com/sales/internet-sales-ebay/3876696-1.html#ixzz1l8fTnPm0. *Accessed 10 May 2012.*

11 *Jay David Bolter and Richard Grusin,* Remediation *(Cambridge, MA: MIT Press, 1999).*

12 *Jeffrey Veen,* Hot Wired Style *(San Francisco: Wired Books, 1997); Jacob Nielsen,* Designing Web Usability *(Indianapolis, IN: New Riders, 2000); Nielsen and Tahir,* Homepage Usability *(Indianapolis, IN: New Riders, 2002).*

13 *Miriam Rivett, 'Approaches to Analysing the Web Text: A Consideration of the Web Site as an Emergent Cultural Form',* Convergence 6, *no. 3 (2000): 34–56.*

The visual identity is discreet and 'Google-like', with a white background, subtle grey highlighting of menus and a blue search and sign-in function. The design is closely related to platforms such as Amazon, Facebook and Flickr, which also use white, blue or grey as their dominant colour. With their relatively static appearance, the sites spark associations with established genres, such as corporate investment and banking sites (such as eBay's sister site Paypal) where white, grey and/or blue have achieved almost global recognition as the normative palette based on the notion that these subtle colours communicate credibility and cultural authority in many countries.[14] In that sense, apart from the logo, eBay's design is not notably different from other commercial sites, which use a layout and a selection of functions that seem to have stabilized in accordance with a fairly uniform convention that matches widespread user conventions as well as cultural norms in established networks of designers and companies. The content pages provide a neutral frame for the vendors' posts and product photos, and this neutral design may be key to a discussion of eBay's iconicity, in that it seems almost iconic by stealth, as the company's visual frame is subordinate to the user-generated content which is what the site visitor really wants to see. In that sense eBay's visual face is something the user takes for granted and looks beyond when browsing through dresses, coins, chairs, lighting fixtures, or whatever.

As an online marketplace eBay tells us more about the consumption of design than its ideation. The user-generated visual and textual content is a fascinating example of user-driven design and complex authorship. That is also reflected in the eBay logo: the colours and bouncy letters promote the amateur style and bricolage experience that the site offers, but they are kept in check by the platform's neutral and functional design.

When environmental problems are moving up the agenda, eBay seems to offer a sustainable consumer practice where used merchandise finds new users when it is re-sold on eBay. The point in time when products are scrapped or end up in landfills is delayed as products are redistributed on eBay. eBay offers buyers a wide range of items at reduced prices and offers vendors the satisfaction of unloading unwanted objects responsibly. However, eBay is also a platform for commercial distributors of new merchandise sold directly to consumers, and thus as a whole, eBay constitutes a vibrant ecosystem around shopping in all its forms. Until a few years ago, new and used merchandise was posted separately, but since 2010 the presentations have been mixed, so today, vintage pieces appear alongside contemporary editions of an iconic watch or handbag together with more cheaply-manufactured mass market goods.

While the initial site was characterized by a special online culture with a distinct set of practices (such as buying and selling iconic design products and fan merchandise etc.), the platform now constitutes a large global marketplace that has entered into and made a considerable impact on the way we buy and sell goods online. The consumer interacts with the products through scrolling, browsing or by contributing with comments, as a digital variant of the shopper strolling the streets. With its diverse content and multifaceted visuality, eBay constitutes a bricolage-like spectacle aimed at consumption and leisure for contemporary consumers who can find entertainment and inspiration, take part in discussions, and buy and sell via the platform, with its almost endless selection of goods. With its many local versions eBay is continually produced, marketed and interpreted in consumer and vendor networks all over the world, and it is this growing acquisition and use that has given eBay its unique status and iconic character.

14 *Ida Engholm and Karen Lisa Salamon, 'Blue is the Colour of Banking',* Future Ground, *Conference Proceedings, Monash University, Australia, 8–12 November 2004; Ida Engholm & Lisbeth Klastrup, 'Websites as Artefacts',* Proceedings – 2nd International Conference on New Media and Interactivity (NMIC), *Istanbul, Turkey, 28–30 April 2010, pp. 380–7.*

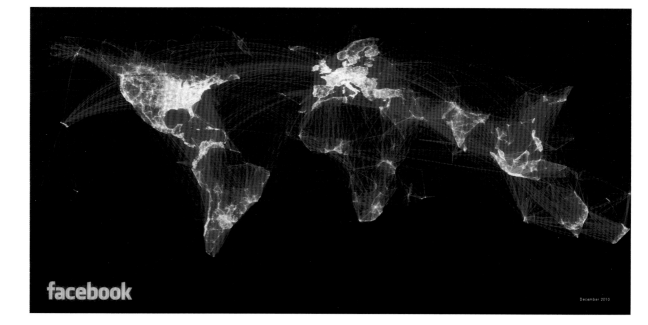

*Friendship Visualization, Facebook, USA*
*(Mark Zuckerberg, Eduardo Saverin,*
*Dustin Moskovitz, Chris Hughes, 2003).*
*Image courtesy of Facebook Inc., Palo Alto,*
*California.*

# 20

# Facebook, USA
# (Mark Zuckerberg, Eduardo Saverin,
# Dustin Moskovitz, Chris Hughes, 2003)

*Alison Gazzard*

## Web 2.0 and the Rise of Facebook

Facebook attempts to get to the heart of who we are. As a platform it allows us to create online profiles and communicate with others around the world. However, these are not new concepts. Since the World Wide Web was unleashed on the public, users have had the potential to create their own space within the vast virtual landscape. The potential of cyberspace, with the implied freedoms of basic website creation through code and eventually software packages, allowed users to mark their territory and explore the possibilities offered by online communities. Personal homepages, often hosted on free space provided by Internet Service Providers (ISPs), detailed people's lives, their online personae (whether representations of real lives or constructed fictional ones), their hobbies, holiday photos and fan communities with which they wanted to connect. In writing about the personal homepage phenomena of the early web, Charles Cheung notes that it was 'produced by an individual (or couple, or family)' and 'centred around the personality and identity of its author(s)'.[1] Many of these sites, such as the ones constructed via Geocities, enabled users to link to other people with similar interests, creating fan communities and groups through what were termed 'web-rings'.[2] However, the user had to learn HTML (hyper-text mark-up language) or a related software package in order to create these online places. Users had to understand how to lay out text and images, link pages and upload all the files necessary in order to have a functioning site. This was the online world, pre-Web 2.0.[3]

Facebook changed this structure. Starting as an American college-wide phenomenon in 2004, Facebook now enables online users everywhere to create their own pages through the tools provided to them. The website allows anyone to have their own Facebook page about themselves, to upload photos, create status updates and connect their lives to groups of friends through a standardized system. People signing up to the site don't need to know how to edit code: the functionality of the system means most of this is hidden to allow for ease of use. Now, the Facebook page becomes iconic in its own right, laying out a set vocabulary of text, imagery and video commentaries shared amongst personal links and interactions with others online. Of course, Facebook was not the first website to serve this purpose. The early 2000s saw an influx of social media platforms, from Bebo to Myspace, from people engaging with blogging sites to users uploading video content to YouTube and holiday snaps to Flickr. The age of Web 2.0 was born and along with it, a perceived flexibility of user-generated content. It is through this content that users start to make connections, and it is through these connections that social media platforms thrive.

1 *Charles Cheung, 'A Home on the Web: Presentations of Self on Personal Homepages',* in David Gauntlett (ed.), Web. Studies: Rewiring Media Studies for the Digital Age *(London: Arnold, 2000).*

2 *Geocities was discontinued as a service in 2009, but further information can be found through this service:* http://archive.org/web/geocities.php. *Accessed 28 May 2012.*

3 *On the term* Web 2.0, *see* http://oreilly.com/web2/archive/what-is-web-20.html *Accessed 28 May 2012.*

## Designing Connections

*'Participation in digital media increasingly means social participation.'*[4]

The Facebook icon is one design element that now infiltrates our online and offline media lives. Based on the 'Klavika' font, designed by Eric Olsen of Process Type Foundry in 2004, the Facebook typeface has since been modified by Cuban Council to create the final iconic type. The Facebook lettering has been stripped down to the pale blue 'f' logotype that has been synonymous with the Facebook brand for other companies to use and link their social media profiles. This shorthand logo acts not only as a way of associating activities with the Facebook brand, but also works on mobile platforms with the logo displaying in app icons on smartphones. Although variations of the Facebook layout have changed over the years, the Facebook typeface and 'f' icon have remained fairly constant throughout.

As the map of friends around the world shows, Facebook is about connecting people. The layout, structure and imagery found on Facebook are in some ways meaningless without the users' contributions. Through their connections of contacts online, users structure and reveal parts of themselves, and in so doing, structure their pages' overall design. Companies, hobbies, people and places can be 'liked' both inside and outside of the platform since its integration in 2009. This concept of liking in itself has turned the 'thumbs up' icon into another recognizable Facebook brand, so much so that it is now used by people as a way of leaving a 'like' icon as a comment in wall posts. These key components have been developed over the years to highlight the concept of Facebook as a brand interweaving through our media lives. Facebook as a platform thereby allows for a convergence of media types.

As media theorist Henry Jenkins states, convergence in these terms is 'the flow of context across multiple media platforms, the cooperation between multiple media industries and the migratory behaviour of media audiences who will go almost anywhere in search of the kinds of entertainment experiences they want'.[5] The 'collective intelligence' of Facebook has parts of its design being constructed through groups, consumer pages and events, all created through the templates offered by the interface. Although these templates determine much of the layout, the personalization comes in our writing, imagery, commentary and use of media content such as videos, to create various spaces of connections, adding to the overall map of what Facebook offers. In discussing the design elements of social media content, David Gauntlett notes, 'Design templates help users to present what they want to express clearly, avoiding mess or usability problems, and helping them to make their material look presentable without having to study the nuances of graphic design.'[6] Therefore, it is the clear structure of Facebook that helps with its overall usability and appeal. The interface allows people to interact and construct content with the platform. It is an interface that remains accessible to all users able to login and create an account. By interacting with these accounts, users are able to explore personalities and ideas online through the instant creation of pages built into the system.

## Identity and Interface

As Matt Hills notes in his discussion of Facebook and identity, the platform can be seen to 'place a new-found digital-cultural emphasis on the presentation of the self'.[7] One of these presentations, or digital identity constructions, comes through the profile image. Along with the user's name in a larger font in bold nearer the top of the page, the profile image becomes one of the most recognizable parts of a user's page. It is the profile image that is displayed in miniature beside users' status updates in the timeline as well

4 *Janet Murray,* Inventing the Medium: Principles of Interaction Design as a Cultural Practice. *(Cambridge, MA: MIT Press, 2012), p. 56. Italics in original.*

5 *Henry Jenkins,* Convergence Culture: Where Old and New Media Collide *(New York: New York University Press, 2006), p. 2.*

6 *David Gauntlett,* Making is Connecting *(Cambridge: Polity Press, 2011), pp. 195–6.*

7 *Matt Hills, 'Participatory Culture: Mobility, Interactivity and Identity', in Glen Creeber and Royston Martin (eds),* Digital Cultures: Understanding New Media *(Maidenhead: McGraw-Hill Open University Press, 2009), p. 118.*

as alongside any comments users make on photographs and other people's pages. The profile image marks out the connection between users and the messages they are leaving, and it defines, albeit temporarily, how that user wishes to be seen. This has recently been extended with the introduction of Facebook Timeline profiles, allowing further customization of personal imagery at the top of the profile page. In many ways, the profile picture in this new layout is secondary to the banner picture at the head of the page. The banner seems to lend itself to imagery that defines personal hobbies, memories or desires, such as photographs of recent holiday landscapes, favourite television or videogame characters or pictures of children in a family unit.

However, the profile image remains of key importance in the process of identity construction in the opening page of Facebook. Its importance is recognized by users: 'different subgenres of picture have emerged, ranging from the "glamour" shot in which the self is seemingly auto-objectified for others … to the potentially resistant "quirky" or non-representational picture where object correlatives or abstract images stand in for the self'.[8] This notion of the digitally constructed 'avatar', or character of a person's online persona, resonates through the integration of the profile image into the design of both mobile and web Facebook interfaces. Throughout digital media, it is becoming increasingly common for users' design decisions to be integrated into the construction of online avatars or characters. Facebook is no exception, the design template offered by the platform restricts the online picture to a square frame, shaping how much of the image is viewed and how each picture is displayed uniformly, whatever the frame holds. The frame becomes part of the connotation of memory and, as such, adds layers of meaning to what is presented on our pages.

By using Facebook we are able to leave traces of our lives using our own words and images, the words of others and the images people contribute to our pages along the way. These traces can act as layers of memories that we seek to share, small snapshots of frustrations, celebrations and sometimes-daily commentaries about who we are at those digitally created moments in time. We can view these in terms of what José Van Dijck calls 'memory objects'. Through using technologies to create such objects, we are also able to modify them: 'Like human brains tend to select, reconfigure and reorder memories upon recall, people also consciously manipulate their memory deposits over time: they destroy pictures, burn their diaries, or simply change the order of pictures in their photo books.'[9] Facebook also allows users this change. Comments and status updates can be deleted, photographs un-tagged and accounts abandoned or closed. The structure of Facebook allows for the design of each person's page to be continually modified, not always in terms of layout, but certainly in terms of content. Some memory objects may be private and closed off to particular groups of friends, and even the same page can present itself in different ways tailored for the individuals accessing it.

The individual's Facebook page becomes iconic to the user and variations become associated with them depending on the levels of access the user offers each person viewing and interacting with their page. Each person has personal photo album titles, 'likes' that reflect where they've been online or the messages they've received from others. These memories left through stories and statements construct fragments of our online selves. Through these fragments—status updates, image uploads, friends' comments and 'likes'— we contribute to a constant stream of information about our digital lives. In building our Facebook profiles, we connect with others and constantly (re)form the faces of Facebook, the individual pages that construct the system for others to see in order to add to the cycle and continue the map of connections already spreading out across the online world.

8 *Ibid.*
9 *José van Dijck,* Mediated Memories in the Digital Age *(Stanford, CA: Stanford University Press, 2007).*

Part Three

# Genius at Work

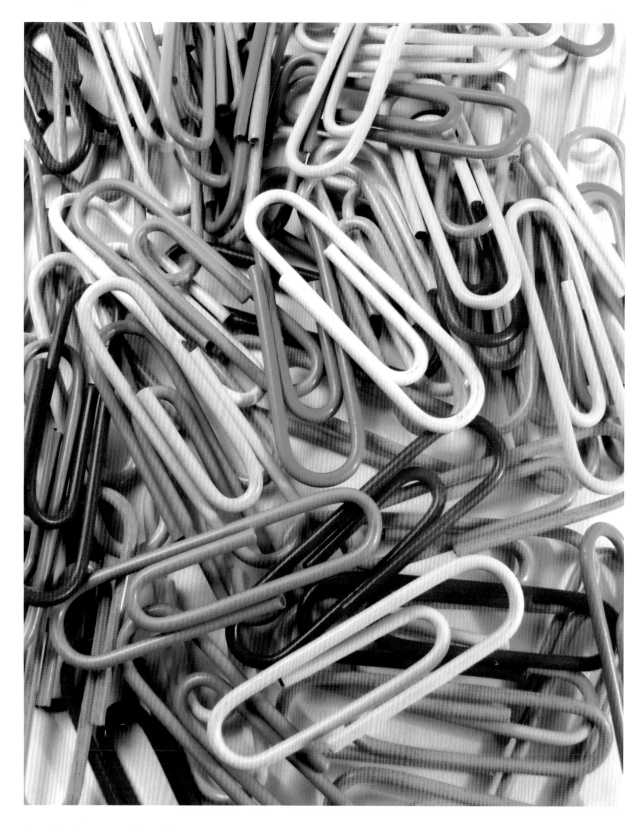

Paper clips. Image: www.bigstockphoto.com.

# 21 Paper Clip, USA
## (Samuel B. Fay, 1867)

*Joe Moran*

'If all that survives of our fatally flawed civilization is the humble paper clip, archaeologists from some galaxy far, far away may give us more credit than we deserve', the design critic Owen Edwards argues in his book *Elegant Solutions*. 'In our vast catalog of material innovation, no more perfectly conceived object exists.'[1] The double oval shape of a paper clip is instantly recognizable. The way that it turns in on itself with its three hairpin bends and rounded top and bottom—in France paper clips are known as *trombones*—seems like the perfect marriage of form and function. Cheap and easy to reproduce, paper clips have remained virtually the same for more than a hundred years. Despite the odd variation—coloured paper clips with plastic coatings, square-edged rather than rounded ones, jumbo clips with corrugated finishes, avant-garde versions with a 'v' replacing the inner curve—the design of the classic paper clip remains unchallenged. At 'Hidden Heroes: The Genius of Everyday Things', an exhibition at the Science Museum in London held in 2011–12, it was celebrated as a 'humble masterpiece' and a 'utilitarian and aesthetic marvel'.[2] With the gentle, sliding action of a paper clip we bring paper, and some small element of our lives, under control.

### The Origins of the Paper Clip

Yet the paper clip does not quite fit our conventional understandings of an iconic object. We like to think of such objects as being created by serendipitous or 'Eureka!' or at least clearly defined moments, but the origins of the paper clip are fuzzy and confused. The rise of the modern office, with its increasing amounts of paper that needed to be fastened together with something more convenient and temporary than permanent binding, led to papers being attached together with strips of cloth, ribbon or string, or simply, if the sheaf of paper was thin enough, punctured with pins. But these improvised solutions were time consuming and troublesome or they left unattractive holes in the paper, often developing an accompanying patina of rust.

The mass-produced paper clip as we know it dates back to the late nineteenth century, when the first machines emerged that could bend and cut steel wire cheaply and cleanly. The modern paper clip is based on the theory of elasticity or springiness, as elaborated as early as 1678 by the physicist Robert Hooke in his *Lectures de potentia restitutiva*. Hooke's law, *Ut tensio sic uis*, or 'as is the extension so is the force', means that the extension of a spring, or the displacement from its original position, is directly proportional to the force applied. The spring-steel wire of a paper clip is easily bendable but also wants to revert to its original shape (provided it is not bent too dramatically), allowing it to glide over papers easily and to fasten them reasonably securely.

In 1867, the American Samuel B. Fay patented a bent-wire 'ticket fastener' known as the 'cinch' paper clip. This was meant mainly for attaching tickets to cloth, but the patent also mentioned that it could be used to fasten papers together. It was a flawed design because it did not have the final, securing loop that we see on the modern paper clip. Norwegians like to think that this modern paper clip was invented by Johan Vaaler, a

1 *Owen Edwards*, Elegant Solutions: Quintessential Technology for a User-Friendly World *(New York: Crown, 1989), n.p.; cited in Henry Petroski*, The Evolution of Useful Things *(London: Pavilion, 1993), p. 70.

2 *Exhibition held at the Science Museum, London, 9 November 2011 to 5 June 2012.* http://www.hidden-heroes.net/. *Accessed 2 January 2012.*

clerk in a patent office in Kristiania (now Oslo). He applied for a patent for a paper clip in Germany in 1899, but his design also failed to have the inner loop inside the loop.

This double-looped design now synonymous with the paper clip is actually 'the Gem', a name that can still occasionally be seen on some boxes of paper clips today. On 27 April 1899, William Middlebrook of Waterbury, Connecticut, filed a patent application for a 'machine for making paper clips'. But Middlebrook did not patent the clip itself, suggesting that it may have predated the machine (not to mention Vaaler's imperfect design of a different type of paper clip), but in one corner of the patent drawing is today's common paper clip, called 'the Gem' because Middlebrook developed his machine for the Gem company in England. In his book *Brutal Simplicity of Thought*, the advertising executive Maurice Saatchi argues that this 'last turn of the wire … wrote the Gem into history'.[3] Not quite: within a year the office suppliers Cushman and Denison, who bought Middlebrook's patent, made important amendments to the design by rounding the sharp points so they would be less likely to tear or leave marks on the papers.

## The Paper Clip as Symbol

In folk memory, this untidy history of the paper clip has, unsurprisingly, been tidied up. The demonstrable fact that Johan Vaaler did not invent the modern paper clip has not prevented the paper clip becoming an iconic object and symbol of national ingenuity in his home country of Norway. In 1999, a hundred years after Vaaler applied for the German patent, the Norwegians issued a commemorative postage stamp, proudly depicting not Vaaler's design but the Gem paper clip.[4] A 23-foot paper clip monument, erected in honour of Vaaler outside a business college in Sandvika near Oslo in 1989 is also a model of the Gem. Encyclopaedias (particularly, of course, Norwegian ones) still often cite Vaaler as the inventor of the paper clip.

In a spontaneous grassroots movement that developed under Nazi occupation during World War II, Norwegians demonstrated their patriotism and passive resistance by wearing paper clips on their lapels. The paper clip became 'a visual memorial of people holding together in small ways'.[5] It was the smallness and inconspicuousness of the paper clip that made the protest viable. Ivar Kraglund, Deputy Director of the Norway Resistance Museum, claims that Norwegians at first wore red hats and red vests to symbolize their opposition, but these articles of clothing were too noticeable.[6] Hence they started wearing paper clips: a tiny, unobtrusive statement of noncompliance.

In 1998, one of the children at a middle school in Whitwell, a small, rural town in southeastern Tennessee, discovered that Norwegians wore paper clips during World War II. The students decided to ask people to send them paper clips to represent the number of Jews killed by the Nazis (believing, wrongly, that Norwegians had worn the paper clips as a protest against anti-Semitism and the rounding up and deportation of Jews). They received over 30 million paper clips, many of them sent by Jews in memory of relatives they had lost in the concentration camps. On 9 November 2001, the anniversary of *Kristallnacht*, the students unveiled a Holocaust memorial at the school: a railcar like those used to transport Jews to the concentration camps, filled with 11 million paper clips (6 million for murdered Jews and 5 million for homosexuals, Gypsies, Catholics and other persecuted groups). A sculpture designed by a local artist stands next to the car, commemorating the 1.5 million children murdered by the Nazis, incorporating another 11 million paper clips. In 2004, *Paper Clips*, a documentary film about the project, was released.[7]

Some have criticized the amassing of millions of examples of a humble object such as the paper clip to illustrate the enormity of an event like the Holocaust. Marc Gellman, a rabbi and columnist for *Newsweek*, argued that such thought experiments had always failed

3 *Maurice Saatchi*, Brutal Simplicity of Thought: How it Changed the World *(London: Ebury Press, 2011), p. 31.*

4 *Lars Roede, 'Whose Paper Clip?'* Times Literary Supplement, 25 June 1999, *p. 19.*

5 *Ben Macintyre*, The Last Word: Tales from the Tip of the Mother Tongue *(London: Bloomsbury, 2010), p. 6.*

6 *'Days of Remembrance: Days of Equality and Solidarity, 1–8 May 2011'*, http://www.paperclipcampaign.com/why.asp. *Accessed 2 January 2012.*

7 Paper Clips, *directed by Elliot Berlin and Joe Fab, 2004.*

to teach the children at his synagogue the scale and meaning of the event: 'All of these audio-visual aids fail utterly, not because of any lack of love, dedication or teaching ability but simply because people are not paper clips, or grains of rice.'[8]

## The Ubiquity of the Paper Clip

The paper clip, then, satisfies one literal definition of an icon in that it has inspired at least two significant monuments. And yet, in the Whitwell Holocaust memorial, it was the very worthlessness and interchangeability of the paper clip that made it both noteworthy and contentious as a symbol. A paper clip on its own has virtually no monetary or aesthetic value, which is why so many remain forever unused, absentmindedly vacuumed up by cleaners or twisted into a useless elongated wire by bored office workers. The phrase 'minister for paper clips' is used in British political life to describe a job of no importance, usually in the Cabinet Office. In July 2005, a 26-year-old Canadian, Kyle McDonald, announced that he was embarking on a quest to trade a single red paper clip for a house. Advertising this almost worthless piece of stationery on the Internet, he succeeded in swapping it for a succession of bigger and better things until nine months and only ten trades later (including a doorknob, a party pack of beer and a snowmobile), he was the owner of a one-bedroom bungalow in Phoenix, Colorado.

The paper clip endures, though, because it remains a useful everyday object. It owes its continuing ubiquity to the nonappearance of that perennial chimera, 'the paperless office'. This phenomenon was supposed to arrive with the computer: The *Times* newspaper predicted in 1986 that 'the partnership of word processor and e-mail almost eliminates the need for paper'.[9] In fact, as Abigail J. Sellen and Richard H.R. Harper point out in their book *The Myth of the Paperless Office*, computers have actually increased the amount of paper circulated in offices.[10] Whatever the advantages of virtuality, paper remains invaluable in the modern office for its portability, navigability and durability—and wherever papers gather together, they attract paper clips.

But the history and design of the paper clip is much messier and more nuanced than what is usually implied by the increasingly casual use of the word *iconic*. As the engineer and design historian Henry Petroski argues in *The Evolution of Useful Things*, it is nowhere near as perfectly functional an object as it at first appears. Paper clips are at best an elegant compromise between loose leafs and the stapler: their grip on the paper can be too firm (they can dig into the top page and leave scratches) but also too loose (they have a tendency to slide off, particularly when placed in piles with other paper-clipped documents). And this is perhaps the best evidence of the paper clip's iconicity, that it has a reputation for design flawlessness it does not deserve. As Petroski puts it, 'its grip on the minds of critics is no doubt more secure than its grip on their manuscripts'.[11]

8  Marc Gellman, 'Paper Boats', Newsweek, 10 August 2005, cited in Daniel H. Magilow, 'Counting to Six Million: Collecting Projects and Holocaust Memorialization', Jewish Social Studies, new series, 14, no. 1 (Fall 2007): 29.

9  'Computer Horizons: At Home with the Cabinet Secrets', Times, 14 January 1986.

10  Abigail J. Sellen and Richard H.R. Harper, The Myth of the Paperless Office (Cambridge, MA: MIT Press, 2002), pp. 13–14.

11  Petroski, The Evolution of Useful Things, p. 75.

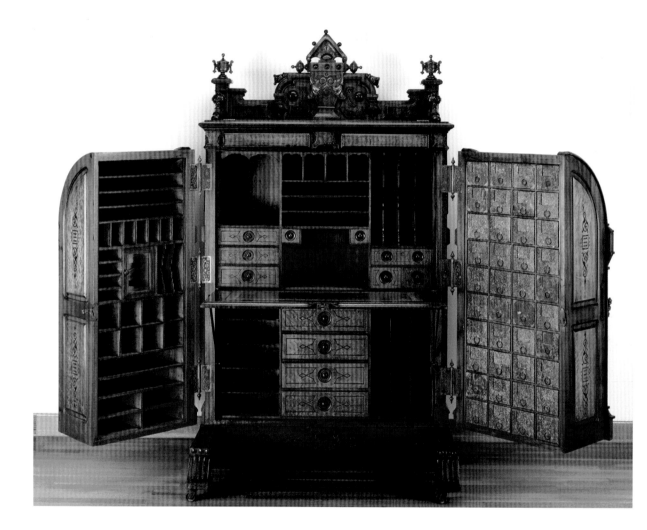

*Extra Grade Cabinet Secretary, William S. Wooton,*
*patentee; Wooton Desk Manufacturing Company,*
*Indianapolis, Indiana, manufacturer.*
*Walnut, maple, white pine, cardboard and bronze.*
*82 x 42.5 x 31 inches (206 x 108 x 79 cm).*
*High Museum of Art, Atlanta,*
*Virginia Carroll Crawford Collection, 1987.*

# 22

# Wooton Desk, USA
# (William S. Wooton, 1874)

*Kenneth L. Ames*

Had it appeared at any other time, inventor William S. Wooton's patent desk might merely have been a cumbersome curiosity. But Wooton's timing was felicitous. Within months of its introduction in 1874, his office desk had become an international sensation, sold by agents in more than a dozen American cities and at least three foreign countries, including Britain, and purchased by the rich and powerful around the globe. Wooton may or may not have been a genius but he was indisputably very lucky. The world was ready to buy what he had to sell.

The Wooton firm eventually produced fifty or more different desks, but the iconic object was the massive and visually assertive Cabinet Secretary. The exterior seemed to consist of two doors below a quarter-cylinder upper section, but this arrangement was deceptive and offered little clue to the interior. Once unlocked, the desk actually opened side-to-side to reveal an intricate and complex private world of drawers, shelves, pigeonholes and other accommodations for the paperwork of business. The interior must have come as a surprise to many and may have accounted for some of the desk's appeal. But by no means all.

## An American Patent Mania

The Wooton desk gave material expression to major cultural preoccupations of the nineteenth century and the United States in particular. From today's perspective, Wooton desks are powerfully evocative icons of Gilded Age America. Like so many artefacts of that age, they were products of restless experimentation. Historian Howard Mumford Jones saw the late nineteenth century in the United States as the age of energy.[1] Swiss historian Siegfried Giedion was struck by the unprecedented patent mania that swept the United States, especially in the 1870s and 1880s, when more patents were issued than before or since.[2] In those years, the country enjoyed a period of entrepreneurial openness and ambition found nowhere else in the world. It is worth noting that Wooton desks emerged from Indiana, in the heart an American Midwest, which had only relatively recently been settled by Europeans and was anxious to assert its cultural identity as part of the project of state- and nation-building. The prevailing cultural truth there and nationwide was that any object or function might be improved through mechanical, technological or scientific innovation and that any might play the game. Minds ranged freely and widely. Many patents came to nothing but others, Wooton's among them, met with great success.

## The Old Improved Upon

Desks in one form or another had been known in the United States since the early eighteenth century, but Wooton claimed that his product was 'as much superior to the ordinary Desk, as a steamship is to a canal boat'.[3] Wooton's desk offered two innovations, the first patented, the second not. What Wooton described in his patent of 6 October 1874 was 'a secretary constructed in three parts, two of which are together equal in width to the other, each part being provided with compartments or pigeon holes suitable for storing books, papers, &c., and the lesser parts hinged to the greater part, to serve as doors'.[4] Part of the novelty lay in doors that were themselves storage units and part in the many and varied interior compartments provided. The latter had ample antecedents in earlier desks, safes

1 *Howard Mumford Jones,* The Age of Energy: Varieties of American Experience, 1865–1915 *(New York: Viking, 1971).*

2 *Siegfried Giedion,* Mechanization Takes Command: A Contribution to Anonymous History *(New York: Oxford University Press, 1948), p. 393.*

3 *Quoted in Betty Lawson Walters, 'Makers of the King of Desks', in J. Camille Showalter and Janice Driesbach (eds),* Wooton Patent Desks: A Place for Everything & Everything in Its Place *(Indianapolis: Indiana State Museum and Oakland: The Oakland Museum, 1983), p. 38.*

4 *Walters, 'Makers of the King of Desks', p. 35.*

and other storage forms; but what distinguished Wooton desks were the sheer number of compartments and their potential for providing systematic and orderly management of the paperwork then becoming increasingly important within the rapidly changing business climate in the United States. Taking advantage of the possibilities for organization and efficiency offered by the Wooton desk, one person might still manage an office in the 1870s.

Wooton's second innovation, not patented, was the fusion of two previously separate classes of desk—counting house and high-status domestic, or plain and ornamented. Furnishings for commerce had long been utilitarian and, holding little attraction as antiques, are barely known today. Luxurious desks for use and display in homes and palaces, on the other hand, are readily traceable from the eighteenth century onward and survive in great numbers. Although available in many forms, the most prevalent was the desk and bookcase, a key prestige piece in the eighteenth century that only declined in the nineteenth century as the very rich built libraries for their books. Wooton combined these two traditions, continuing and enhancing the utilitarian function of the desk on the interior and catering to elite taste for visual splendour on the exterior. In linking these two currents, Wooton desks became precursors to the later power environments of corporate America.

Giedion described the two strands that converge in Wooton desk as 'constituent' and 'transitory'. 'Constituent' he defined as 'marked by creative force and invention … the core of historical growth', transitory as 'short-lived … performances' no more or less meaningful than fashion.[5] Put another way, while the utilitarian aspects of the desk placed it within the long trajectory of office furnishings, its decorative features tied it to the ruling taste of its time.

## Paris in Indiana

And there, too, lies cultural evidence. If the innovative form of the desk documents the extraordinary patent energy of the still-open American society, its decorative overlay reveals the long reach of French cultural authority. The Wooton desk is a distant and diminished relative of Garnier's Paris Opera and kin to the multitudinous and varied manifestations of Second Empire taste that proliferated around the world. It shares the pseudo-monumentality of that taste and its enthusiasm for opulence, ostentation and visual complexity. It exhibits, in black walnut, design tendencies and preferences elegantly expressed in stone on the avenues and boulevards of Second Empire Paris. The decorative features themselves are without meaning; their function is to express affiliation with the ruling taste and the ruling caste. The style leads nowhere but only subsequently gives way to another ruling taste. After 1880, responding to the emergent transfer of international design hegemony from France to Britain, Wooton began producing desks cloaked in dress described as Queen Anne and Eastlake.[6] The external changes were superficial; the interiors remained much the same.

## Size, Gender, Hierarchy

Other cultural values embedded in the desk transcend narrow matters of style. Size, for instance. The iconic Wooton desk came in three sizes, all large. Wooton desks shared the overscaling affecting the furniture of American interiors whenever purchasers could afford it. Hallstands, sideboards, étagères, pier mirrors, dressing cases and bedsteads were all available in massive sizes. Beyond the household, worship of bigness was prevalent, whether of buildings, cities, railroad empires, or circuses. As the century progressed, consolidation made big businesses of every variety even bigger.

Reflecting and reproducing the world at large, Wooton desks were gendered. Most documented purchasers were male, just as most businesses and institutions were predominantly male, at least at the top. Although the Seneca Falls Women's Convention, which produced a famous suffrage resolution, took place in 1848, American women

5 *Giedion,* Mechanization Takes Command, *p. 389.*

6 *Illustrated in Deborah Cooper, 'Evolution of Wooton Patent Desks', in Showalter and Driesbach,* Wooton Patent Desks, *pp. 70–1.*

received the vote only in 1920. The male orientation of the desks was made explicit in Wooton's trade catalogue's inclusion of a 'Ladies' Secretary', which was, not surprisingly, significantly smaller and more delicate than the Cabinet Secretary and is today considerably less common as well.[7]

Predictably for male-gendered objects, Wooton's desks embodied hierarchy. At the outset, the Cabinet Secretary came in four grades: ordinary, standard, extra and superior (the example illustrated here is extra grade). Furthermore, each grade came in three sizes. Thus the Cabinet Secretary could be had in twelve variants ranging in price (in 1876) from $100 to $750. This diversity in price, size and opulence served both the manufacturer and the customer. The manufacturer profited by designing the product to appeal to multiple tastes and pocketbooks, while the customer had some degree of choice in selecting the desk that best suited his business, psychic and social needs. Over time, however, the standard and extra grades proved most popular, and the ordinary and superior grades were dropped from production, suggesting that sometimes in America middle-of-the line goods, even when relatively expensive, proved most attractive to buyers.

## Paper Made It Possible

Wooton Cabinet Secretaries were manufactured as isolated entities, self-sufficient forms visually unrelated to other office furnishings. They were, however, inseparably connected to paper in its many forms. The introduction of typewriters and carbon paper and the increasing scale of business enabled by developments in communication and transportation meant more paper to sort and file. Improvements in paper manufacturing and printing technologies made that material cheaper and more abundant. Wooton desks were introduced about the same time as national and international advertising started to appear. Printed trade catalogues became stock features of American business about 1870. Sales vehicles then, these catalogues have since become important sources of information about period manufactures, including Wooton desks. Inexpensive to print and illustrate, trade catalogues could be cheaply mailed across the United States and beyond. In 1874, the year of Wooton's patent, the Treaty of Bern established the General Postal Union, later the Universal Postal Union, making it possible to send mail anywhere in the world for a flat fee. All these factors favoured the sale of Wooton desks.

Intimately linked to specific and temporary business practice and culture, Wooton desks sold well as long as those conditions endured, but they became obsolete once paper moved into file cabinets and executives turned outward to survey their domains over broad, flat-top desks. And, like most elaborate products of the nineteenth century, Wooton desks fell further out of favour when tastes turned toward the simpler, more austere look of the twentieth century. The 1950s mark the nadir in appreciation of such goods, but in the years following, bits and pieces of nineteenth-century material culture were resurrected and reappraised, Wooton desks among them. By the 1980s, Wooton desks had become cult objects of sorts, enthusiastically sought, restored, collected and exhibited.

Today Wooton desks are famous; less so their inventor, who remains a shadowy figure. William Wooton gave his name to the firm but was probably not a principal player. Wooton was a patternmaker by trade and also a Christian minister and active in the Young Men's Christian Association. He lived in Indianapolis between 1870 and 1880, then moved several times around the country until his death in Denver, Colorado, in 1907.[8] He was, in many ways, a rather ordinary American man who came up with a highly saleable idea. To what extent he profited from it is unknown. But if Wooton's desks reveal little about Wooton himself, they are rich in information about an important moment in the cultural and commercial history of the United States—and rightly considered key icons of America's Gilded Age.

7  Cooper, 'Evolution of Wooton Patent Desks', pp. 62–3.
8  See Betty Lawson Walters, The King of Desks: Wooton's Patent Secretary (Washington, DC: Smithsonian Institution Press, 1969).

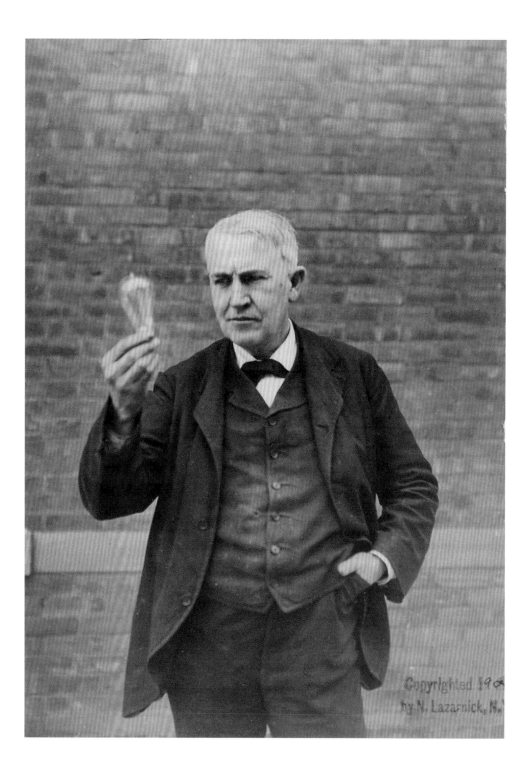

Copyrighted 19∞
by N. Lazarnick, N.Y

*Edison and his light bulb, from the Edison family photograph albums.*
*US Department of Interior. National Park Service. Thomas Edison National Historical Park.*

# 23 Incandescent Light Bulb, USA (Thomas Edison, 1880)

*Carroll Pursell*

In 2011, the grandson of Thomas Alva Edison, the inventor of the incandescent light bulb, published an article suggesting that his grandfather, because he believed in technological progress, would have applauded the current banning of that bulb in favour of more energy-efficient designs. His speculation was illustrated with a photograph of Edison contemplating what was arguably his most famous invention in a manner almost identical to that of Sarah Bernhardt playing Hamlet, holding the skull of poor Yorick and meditating on the fact that we all must eventually die.[1] The conceit suggests that even iconic designs are not immortal, but the image also underlines the power of such designs to invite meanings far removed from their practical purposes.

## Spectacle

In her book *When Old Technologies Were New*, Carolyn Marvin writes that in the late nineteenth century, the electric light was

*present in exhibitions, fairs, city streets, department stores and recreation areas. It was physically and symbolically associated with whatever was already monumental and spectacular. It appeared in grand displays, processions, buildings and performances. It borrowed from every established mode of dramatic cultural self-promotion.*[2]

In a period when most people still did not have electrical illumination in their homes, they were treated to public spectacles of light, which sometimes appeared to be nothing short of sublime.

By 1895 in New York City, besides municipal street lights, street signs, often on theatres, spelled out messages in 'letters of fire', each being typically 25 inches high with five bulbs used for each vertical stroke and four for each horizontal. A Boston clothing store in 1903 had not only illuminated windows but 'on upper floors it had a 6-foot-high green shamrock, a 10-foot electric American flag, four lines of illuminated text running the width of the building beneath the windows, and spotlights on ten other signs mounted between upstairs windows'. As historian David E. Nye has suggested, 'like the accident of the city skyline, the electrified city was something fundamentally new, an unintended sublimity'.[3]

There were also numerous deliberate sublime electrical illuminations planned and executed. At an 1898 celebration in Pittsburgh, Pennsylvania, among other features, a triumphal arch bore 1,685 bulbs, and a Christian cross atop the courthouse, 100 feet high and 60 feet wide, was 'outlined by a double row of 688 red lamps, above illuminated letters made up of 2,300 frosted white lamps'. The next year the First Greater America Colonial Exposition in Omaha, Nebraska, featured 45,000 lamps. In 1901 Buffalo, New York's Pan-American Exposition featured a tower which alone was covered with 40,000 bulbs. 1909 saw a celebration in New York City for which 1.2 million bulbs were added to the usual city illumination. In a sense such dazzling visual events were successors to the

1 *David Edward Edison Sloane*, 'Edison Would've Loved New Light Bulb Law', *CNN, 31 December 2011,* http://edition.cnn.com/2011/12/31/opinion/sloane-edison-bulbs/index.html. *Accessed 2 January 2012.*

2 *Carolyn Marvin,* When Old Technologies Were New: Thinking About Electric Communication in the Late Nineteenth Century *(New York: Oxford University Press, 1988), p. 158.*

3 *Marvin,* When Old Technologies Were New, *p. 163; David E. Nye,* American Technological Sublime *(Cambridge, MA: MIT Press, 1994), pp. 179, 173.*

fireworks displays of an earlier age: more accurately, however they were overwhelmingly examples of what Wolfgang Schivelbusch called the 'Industrialization of Light'.[4]

## Meanings

It is in the nature of an icon that it is available to be appropriated to serve as a signifier of a variety of cultural tropes. It announces its intended meaning clearly but takes on others as well. With the phasing out of the iconic bulb as a physical presence, its metaphorical power will no doubt continue to have cultural power.

The iconic status of the Edison light bulb finds an almost pure manifestation in the work of such designers as the German Ingo Maurer. His 1966 'Bulb' table lamp (chrome-plated metal and glass), which is in the collection of New York's Museum of Modern Art, consists of a 100-watt bulb inside a larger housing shaped like the bulb itself. The lamp is a simple and powerful assertion of the beauty and integrity of the bulb, beautiful in its simplicity.

Better known in popular culture is the light bulb as symbol of the 'Aha! Effect', or the 'Eureka!' moment. In this cartoon manifestation, the bulb floating above the head of the suddenly inspired person flashes with enlightenment. As the *Collins English Dictionary* has it, the lit bulb represents 'a moment of sudden inspiration, revelation, or recognition'.

A second classic use of the light bulb as a cultural signifier is the naked bulb. In his book *The Lotus and the Robot* (1961) describing his travels in Japan after World War II, Arthur Koestler cited 'the naked light bulb hanging from the ceiling' in Japanese homes as evidence that modern technology had never been integrated into the ancient aesthetic of Japanese traditional culture. It was an aesthetic reaction not unrelated to the psychological one that drove Blanche, in Tennessee Williams' play *A Streetcar Named Desire*, to hang a Chinese lantern over a light, explaining, 'I can't stand a naked light bulb, any more than I can a rude remark or a vulgar action.' Blanche, of course, shrank from the naked truth of her own condition (as well as her fading appearance), preferring to cover it up with a sad tissue of illusion.

An even more sinister use of the naked bulb is to suggest the brute act of violent interrogation. Hanging over a wooden table in a bare room, it powerfully invokes the notion of the police 'third degree' or the attempt to extract the 'naked truth' from suspected terrorists. The suspect is like Blanche but without any hope of covering up or denying their guilt. In an age of rendition and waterboarding, the naked bulb suggests an earlier time of film noir or Cold War secret police but has lost none of its power to strike terror to the heart. This power to stand aside from its mundane purpose and historical moment, while invoking widely understood meaning, is the true test of an iconic design.

## Purpose and Moment

Edison, who received a patent for his 'Electric-Lamp' in 1880, was neither the only nor even the first inventor to work on the incandescent lamp. Following the early experiments by Humphrey Davy in England in 1802, at least twenty others had struggled with the problem of making a satisfactory lamp in which a filament, most often of carbon, would glow in a glass globe, either evacuated, filled with some inert gas or simply with air.[5]

This number did not include the many others, including Davy, who were at work trying to improve the arc light. Unlike the incandescent bulb, this light was produced by an electric arc which jumped between two rods, usually made of carbon. A successful arc light system was introduced by the American inventor Charles F. Brush in 1879, the same year Edison applied for his patent. This light was very successful in illuminating large spaces, either out of doors or for large interiors, for example department stores. The arc light, however, proved too intense for domestic and most other indoor purposes.

4 *Marvin,* When Old Technologies Were New, *pp. 160, 165; Nye,* American Technological Sublime, *pp. 149, 161; Wolfgang Schivelbusch,* Disenchanted Night: The Industrialization of Light in the Nineteenth Century *(Berkeley: University of California Press, 1988).*

5 *Robert Friedel and Paul Israel,* Edison's Electric Light: Biography of an Invention *(New Brunswick, NJ: Rutgers University Press, 1986), p. 115.*

Nor was electric lighting the only kind on offer in the late nineteenth century. Kerosene, a petroleum derivative, was available for use in lamps, but the Edison lamp's greatest competitor was gas lighting. Gas, usually produced by the controlled burning of coal, was widely used for street lighting, and indoors, including in homes. Its major drawback, however, was that it consumed oxygen, which could become uncomfortably low in enclosed spaces. Gaslight eventually took on a romantic aura of gracious times past, but its drawbacks, compared with the advantages of the incandescent bulb, led to its rapid abandonment. Ironically much of Edison's success was in adopting the system of central production and delivery network of gasworks as a model for his own electrical supply structure. Indeed, Edison had to invent not only the light bulb but the entire menu of technologies that allowed it to be used: dynamos, wiring, transformers, meters, power points, wall switches, sockets and so forth. Part of the power of the light bulb as an icon is that it has come to stand for this entire system of integrated technologies. Over the years each element of the system has been improved. The bulb, for example, eventually came to use a tungsten filament heated in a globe filled with an inert gas.

The number of bulbs needed to satisfy the rapid spread of Edison's system was enormous. It has been estimated that in 1885, just five years after Edison's patent was granted, 300,000 bulbs were sold in the United States. In 1914, some 88.5 million were in use, and sales for 1945 were 795 million. In London alone, the number of lamps connected was 180,000 in 1890, 700,000 three years later, 1.1 million in 1895 and 6.8 million in 1899.[6]

The earliest bulbs were handmade, but the invention of automatic machinery for their mass production was an obvious priority. The scale of all this is indicated by the estimate that when ductile tungsten bulbs were introduced by General Electric (which had been formed out of a merger of Edison and other interests in 1892), in 1911, about the time that GE bought out the National Electric Lamp Co. and concentrated its lamp division at NELA Park in Cleveland, Ohio, the company had to discard a million dollars worth of instantly obsolete stock and manufacturing machinery.[7]

In the early twenty-first century, the banning of incandescent bulbs in favour of more energy-efficient types, especially fluorescent, has had a similar and much larger effect. Vaclav Klaus, then the President of the Czech Republic, is said to have urged its citizens to hoard 'enough incandescent bulbs to last their lifetime'.[8] It was no doubt a futile attempt to hang on to a useful, and as was becoming apparent, loved icon. In his autobiography *The Education of Henry Adams* (1918), the American historian famously described the Virgin as the great symbol of the Middle Ages and nominated the dynamo as that of the twentieth century. Over the long nineteenth century, the popular symbol of industrial modernity had moved from the 'dark satanic mill' of the early years to the locomotive by mid-century. The focus had shifted again by the end of the century, not to the dynamo, which few people had ever seen, but to Edison's incandescent light bulb, which, in their millions, populated homes, workplaces and the streets between.

6 *Wikipedia, 'incandescent light bulb'*, http://en.wikipedia.org/wiki/Incandescent_light_bulb. *Accessed 29 November 2011; Marvin*, When Old Technologies Were New, *p. 164.*

7 *'Nela Park',* The Encyclopedia of Cleveland History, http://ech.case.edu/ech-cgi/article.pl?id=NP1. *Accessed 9 May 2012; Carroll Pursell*, The Machine in America: A Social History of Technology, *2nd edition (Baltimore: Johns Hopkins University Press, 2007), p. 223.*

8 *'Phase-out of incandescent light bulbs'*, http://en.wikipedia.org/wiki/Phase-out_of_incandescent_light_bulbs. *Accessed 29 November 2011.*

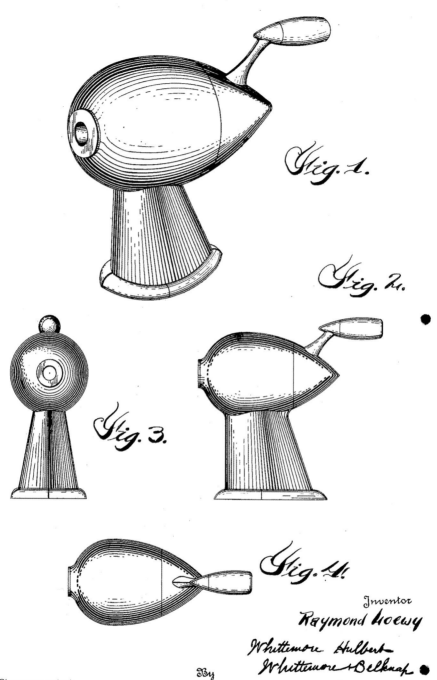

R. LOEWY

PENCIL SHARPENER

Filed May 29, 1933

Des. 91,675

*Fig. 1.*

*Fig. 2.*

*Fig. 3.*

*Fig. 4.*

Inventor

Raymond Loewy

Whittemore Hulbert

Whittemore + Belknap

By

Attorneys

*Design for a Pencil Sharpener, patent,*
*Raymond Loewy, 6 March 1934.*
*United States Patent and Trademark Office.*

# 24

## Streamlined Pencil Sharpener, USA
## (Raymond Loewy, 1933)

### Nicolas P. Maffei

Raymond Loewy's 'teardrop' pencil sharpener typifies the expressive exuberance and technological romanticism of 1930s American design. Evidence of its iconicity was its selection for the US Postal Service's 'Pioneers of American Industrial Design' stamp collection (2011) and its appearance as a representative of American design, for example as the sole cover image of *Design in the USA*, Oxford History of Art series (2005).[1]

### Design Debate

Coinciding with a full-blown national craze for streamlined goods of all kinds and fabricated as a prototype in 1933, Loewy's pencil sharpener was never mass-produced. Yet, since its debut in 1934 it has been at the centre of an often-heated discussion concerning the essence of American design. In the 1930s and 1940s, the curators of the influential Museum of Modern Art (MoMA), New York, zealously promoted functionalist design and derided the popular trend of streamlining inanimate objects, taking special aim at Loewy's pencil sharpener. In their book *Art and the Machine* (1936), critics Martha and Sheldon Cheney defended the streamlined style as a significant expression of contemporary machine-age values. In 1955, industrial designer Henry Dreyfuss described streamlining as evidence of the 'strange detours' taken by inexperienced early 'pioneer' industrial designers.[2] By the 1970s, however, streamlining had been recognized by scholars of American culture, such as Meikle, as a significant expression of the Depression decade—a metaphor for frictionless consumption and the symbolic flight from economic hardship. More recently, Loewy's pencil sharpener has been compared to the conceptual designs of London design group Dunne and Raby and placed at the beginning of a tradition of supposedly 'useless' polemical objects whose primary function is to stimulate design debate.[3]

In March 1933, perhaps aware of the parallel influences of streamlining and high modernist Bauhaus design, Loewy patented two pencil sharpener designs—one derived from the teardrop and the other from the sphere. Yet, it was the former that Loewy had fabricated for its 1934 debut. While the patent, which provided a mere three years of protection, may have discouraged imitators, the real impact of Loewy's 5½-inch high teardrop bombshell followed its first public appearance in 1934 at New York's Industrial Arts Exposition, a groundbreaking display of American industrial design that included work by key exponents of aesthetic streamlining, Dreyfuss, Harold Van Doren and Walter Dorwin Teague, members of America's first generation of industrial designers. The exhibition aimed to establish a national style after years of French Art Deco dominance and the increasing influence of German Bauhaus design.

It is significant that April 1934 witnessed both the Industrial Arts Exposition and MoMA's Machine Art exhibit, which displayed American machine parts alongside European modernist furniture to reverse widely held assumptions about America's dependence on European culture. Comparisons of the two shows by design critics firmly established the Loewy sharpener as the bête noire of design, initiating a debate that polarized functionalism and streamlined style. A contemporary reviewer considered MoMA's exhibit 'brilliant' and

1 *Jeffrey L. Meikle, Twentieth Century Limited (Philadelphia, PA: Temple University Press, 1979).*

2 *Henry Dreyfuss, Designing for People (New York: Simon and Schuster, 1955), p. 74.*

3 *Peter Hall, 'A Good Argument', Metropolismag. com, 18 March 2009,* http://www.metropolismag.com/March-2009/A-Good-Argument/.

the Industrial Art Exposition a 'fetish' of '"modernism"', resentfully demanding, 'Is there genuinely a reason why our pencil sharpeners should be "streamlined"?'[4] Another reviewer, however, defended the exhibition on aesthetic and economic grounds—it showed that 'beauty and sales value go hand in hand' and 'that there is a trend towards a national style, an adaptation of design to American conditions of living'.[5]

In a public presentation of May 1934 entitled 'What is Wrong with American Industrial Design', Eugene Schoen, an industrial designer and key contributor to the Industrial Art Exposition, 'attacked the unguided use of "stream line [sic]"', in '[n]apkins and pencil sharpeners'.[6] By 1936, Loewy's pencil sharpener remained the scapegoat of the design press, 'I think the term "streamline" means precisely nothing.' In a recent design exhibition '… one found streamlined pencil sharpeners and was brought to full, wondering pause …', wrote one reviewer, adding, 'the term has been misapplied to a distressing degree'.[7]

## Modernist Points

Preferring the pure geometries of the sphere to the ovoid forms of streamlining, Philip Johnson, curator of the Machine Art exhibit, praised the austere modernism of the Bauhaus and dismissed aesthetic streamlining as one of many unfortunate influences on American design, including the 'French machine-age aesthetic' of the 1920s.[8] In a 1934 letter to Norman Bel Geddes, a pioneer of streamlined design, MoMA's director Alfred Barr decried the 'absurdity' of Loewy's 'streamline pencil sharpener', which made it 'difficult to take the ordinary industrial designers seriously'.[9] For Barr's followers, modernist design was about function, restraint and honesty, achieved, for example, through revealing structure and avoiding decoration. Streamlining, on the other hand, was considered nonfunctional and deceptive, employing a decorative sheath to hide mechanical components that were beautiful in their own right.

Loewy later used the MoMA's own functionalist arguments to defend his design, 'My colleagues made fun of me … What they didn't understand is that I tried to minimize maintenance and cleaning and simplify function. Streamlining is reduction to essentials.'[10] Cultural historians later argued that streamlined objects, though dismissed as having no utilitarian purpose, were in fact extremely functional: 'Their chief function was to delight the eye and attract buyers.'[11]

A few days after the opening of MoMA's pioneering Bauhaus exhibition of 1938, John McAndrew, Curator of Architecture and Industrial Art, was confounded by the public's association of streamlining with Bauhaus design. He explained that the 'Bauhaus [school] was closed about the time the streamlined mania began, but it would have rejected the streamlined form for objects such as cocktail shakers and fountain pens where its use is nonsense'. In an implicit critique of stylistic obsolescence, he dismissed industrial designers for '"restyling" almost everything, so that what we owned might look old fashioned as soon as possible'.[12] After World War II, as streamlining spread through the American automotive industry, the style continued to attract criticism. In his *Mechanization Takes Command* of 1948, Siegfried Giedion extended MoMA's formalist argument: 'Streamline form in the scientific sense aims at the utmost economy of form, at a minimum volume … streamline form in the objects of daily use aims to produce an artificial swelling of volumes.'

By 1955, in an attempt to deflect the continued criticism of industrial design, Dreyfuss explained, 'despite twenty years of scoffing by engineers and aesthetes', the designer of 'pencil sharpeners', 'stupidly modelled after the teardrop', 'learned a great deal about clean, graceful, unencumbered design. He learned to junk useless protuberances and ugly corners'. Dreyfuss offered a new term which might act as a corrective to decades of criticism, 'Call it cleanlining instead of streamlining.'[13]

4 *Edward Alden Jewell, 'High Spot of the Week: Industrial Art'*, New York Times, *8 April 1934, p. X7.*

5 *Walter Rendell Storey, 'Beauty Linked Firmly to Design'*, New York Times, *1 April 1934, p. SM16.*

6 *'Old Craft Spirit Urged: Designers Told Machines Need Not Make Workers into "Robots"'*, New York Times, *2 May 1934, p. 19.*

7 *'Under Postage'*, New York Times, *15 March 1936, p. X8.*

8 *Philip Johnson and Alfred H. Barr, Jr,* Machine Art *(New York: MoMA and Harry N. Abrams, 1994) reprint of 1934 edition, n.p.*

9 *Alfred H. Barr to Norman Bel Geddes, 4 December 1934, file 296, cited in Meikle,* Twentieth Century Limited, *p. 181.*

10 *Susan Heller Anderson, 'The Pioneer of Streamlining,'* New York Times Magazine, *4 November 1979, p. 101.*

11 *John A. Kouwenhoven, 'Up Tails All: The Theory of the Detroit Bustle', in* The Beer Can by the Highway *(Baltimore, MD: Johns Hopkins University Press, 1961), p. 182.*

12 *John McAndrew, '"Modernistic" and "Streamlined"',* Bulletin of the Museum of Modern Art *5, no. 6 (December 1938): 2.*

13 *Dreyfuss,* Designing for People, *p. 75.*

## Con to Icon

With the first stirrings of the environmental movement in the 1970s, critics of industrial styling moved beyond issues of form. In *Design for the Real World* (1971) Victor Papanek, concerned with the ecological impact of consumerism, warned of industrial design's embrace of styling and obsolescence. Five years later, *Art in America*'s Richard Pommer accused Loewy of being engaged in an industrial shell game. Loewy's response was typical, 'I've been accused of being a shell designer—But in many cases the shell is essential … A locomotive without a shell would be nonfunctional [sic].'[14] Asked about his pencil sharpener's functionality, 'Loewy responded with two small sketches, one depicting an ordinary pencil sharpener bristling with exposed parts, the other his streamlined design. The former, he explained, was a greasy, dirty mess; the latter could be quickly dusted with the wipe of a tissue.'[15]

After decades of being dismissed as absurd, dishonest and ecologically unsound, streamlining was presented in the design discourse of the 1970s as a uniquely American style and an important symbol of escape from the Depression decade. This new appreciation led to its positive reassessment within design circles. 'I once accused [Loewy] of making streamlined pencil sharpeners', Johnson conceded in 1979. 'In [MoMA's] fundamentalist view, there was no point in streamlining something that didn't move. Now we appreciate streamlining as a valid movement in American design. And he started it.'[16]

What was it that made this diminutive office apparatus loom so large in design debate? Arguably the answer is its status as a contradictory object. '[C]ritics pointed out that … a streamlined pencil sharpener couldn't get away if it tried because it was screwed down', Dreyfuss noted, illustrating his point with a caricature of the appliance emphasizing its two exposed screws.[17] Dreyfuss's biographer, Russel Flinchum considered this a 'pointed critique' of the object's innate 'cognitive dissonance'.[18] Cognitive dissonance may have also contributed to the success of Philippe Starck's Juicy Salif lemon squeezer, which resembles a 1930s alien spacecraft and was criticized for its lack of functionality. Not surprisingly, Starck is considered Loewy's contemporary counterpart.[19] In 2009, design critic Peter A. Hall described as 'useless', but 'important icons of product design', 'Loewy's streamlined pencil sharpener … [and] Starck's famously dysfunctional … lemon squeezer'. Arguing that, whereas much twentieth-century debate around 'good design' focused on issues of 'form', '[t]oday the stakes are too high, and the world too complex, for a superficial response'. Placing Loewy's design in a tradition of conceptual, rather than practical design and commenting on the modernist tendency to conflate 'good design' with functional design, Hall points out that 'the problem with usefulness as a standard is that it doesn't allow for useless objects, which are actually quite an important part of design practice'.[20]

Loewy may have been embarrassed by the notoriety of his pencil sharpener. While his designs for NASA, Studebaker and Coca-Cola were prominently included in his autobiographical monograph *Industrial Design* (1979), his streamlined sharpener was conspicuous by its absence. While others appreciated the symbolic, conceptual and iconic qualities of his teardrop appliance, Loewy continued his, seemingly contradictory, modernist defence of the aerodynamic style. As a streamlined stationary object, Loewy's prototype amused and infuriated. As a design paradox—a form that denied its function—and thrusting symbol of the machine-age, ironically, it found a fixed place in the canon of American design.

14 *Anderson, 'The Pioneer'*, p. 98.

15 *Jeffrey L. Meikle*, Design in the USA *(Oxford: Oxford University Press, 2005), p. 122.*

16 *Anderson, 'The Pioneer'*, p. SM23.

17 *Dreyfuss*, Designing for People, *p. 77.*

18 *Russell Flinchum*, Henry Dreyfuss: Industrial Designer *(New York: Rizzoli, 1997), p. 70.*

19 *Helen Rees, 'Patterns of Making', in Peter Dormer (ed.)*, The Culture of Craft *(Manchester: Manchester University Press, 1997), p. 128.*

20 *Hall, 'A Good Argument', n.p.*

*Volivik 50 Red, lamp, with shadows. Luca Muñoz, Madrid.*

# 25

## Bic Cristal Pen, France
## (Société PPA, 1950)

*Susan Lambert*

The Bic Cristal ballpoint pen has been with us for more than 60 years. When launched, an average of 10,000 were sold daily in France. Now, many millions of the almost identical pen are sold daily in more than 160 countries.[1] Few brands share such longevity or geographical penetration, and no other pen has sold in such abundance. Its iconicity is further evidenced by its addition to leading museum collections, including the Museum of Modern Art, New York, in 2001 and the Pompidou Centre, Paris, in 2006 and by its inclusion in such design compendiums as *Phaidon Design Classics* (2006) and *Hidden Heroes: the Genius of Everyday Things*, an exhibition organized by the museum of furniture makers Vitra in 2010.[2] Significant also is its use as a source of inspiration for the design of other artefacts where its recognition is vital to the product's success, as in the lamp illustrated here. Its shade is made from fifty Bic Cristal pens, and its stand has a colour-coded cable which imitates the way the pen's ink stops just short of its end.

### Biro to Bic

The first patent for a ballpoint pen was granted in 1888.[3] It was for a pen to write on coarse materials, such as wood and leather, and had a vent hole to allow air to enter the system and replace the ink as it was used, a design feature that the Bic Cristal shares. It was not, however, produced in large numbers. Many more patents in various countries followed, but only during World War II did mechanical engineering and plastics technology develop to make the level of industrial production vital to the commercial viability of such a product possible.

The breakthrough was made by Lázló Biró, whose surname became the generic term for ballpoint pens. Biro took out his first patent in 1938 in Hungary, but it was not until 1942 in Argentina, where he had sought sanctuary from Jewish persecution in a Europe on the brink of war, that the first commercially produced ballpoint pen, the 'Eterpen' (signifying eternal writing), went on sale. It used a piston ink delivery mechanism rather than a mixture of gravity push and capillary pull that was to be key to that of the Bic Cristal. In 1943, Biro patented such a system and used it in the Stratopen, also made in Argentina, but he wished it to be sold at a higher price than the distributors thought appropriate, and sales did not take off.

Biro's various patents were used by different firms in the Americas and Europe. Especially significant for the Bic Cristal was the Miles Martin Pen Company, which introduced a ballpoint entitled 'Biro' to the British public in 1943 at the expensive price of £2 and 15 shillings, which would then have bought 300 loaves of bread.[4] Shortage of raw materials and labour, however, meant that retailers were limited to stocking only twenty-five pens per month.[5]

A year later Marcel Bich, then only thirty years old, set up Société PPA,[6] a factory for making writing instrument parts in a suburb of Paris. By 1948, he had realized that manufacturing for others would not make his fortune and, aware of Biro's initiatives, set up an in-house research and development team, Décolletage Plastique, to design a

1 '60 Years Cristal press kit', http://www.bicworld.com/img/pdf/presskit_60yearsCristal_EN_light.pdf. *Accessed 6 August 2012,*

2 http://www.hidden-heroes.net/. *Accessed 6 August 2012.*

3 *On patents see L. Graham Hogg,* The Biro Ballpoint Pen *(Merseyside: LGH Publications), 2007.*

4 *A loaf cost less than 2 old pence; there were 240 pence to a pre-decimalization pound:* 'Food Time Line', http://www.foodtimeline.org/ukprices1914.pdf. *Accessed 6 August 2012.*

5 *Company records owned by Graham Hogg.*

6 *Porte-plume, Porte-mines et Accessoires (Pen Casings, Propelling Pencils and Accessories).*

ballpoint pen. Two years later, in December 1950, the Bic Cristal was launched in five ink colours. It sold initially at 60 old francs, dropping to 50 old francs in November 1951,[7] roughly the equivalent of 12 shillings,[8] a fifth of the cost of its rivals.

Its cheap price was achieved by unprecedented industrialization of its manufacture. Sixty processes were involved, including high-precision grinding of the writing balls on machines imported from Switzerland, injection moulding of the plastic parts, manufacture of the ink to the correct viscosity, assembly, quality control and packaging. Their mechanization in-house, rather than being out-placed to specialists (as Société PPA had been at its outset), enabled the unit price to be cut dramatically.[9]

All seemed well until, early in 1952, an infringement of patent was served by the aforementioned Miles Martin Pen Company, which had by then acquired Biro's patents. Eventually, the matter was settled with PPA's agreement to pay 6 per cent of the pen's retail price and 10 per cent of that of its refills. It was further resolved in 1957, when Société Bic (which PPA had become) bought a large share of the Biro Swan Company (by then incorporating the Miles Martin Pen Company), along with the patent rights,[10] indicative of the market dominance Bic had achieved.

## A Modernist Pen

The name Bic 'Cristal' alludes to crystallography, a rapidly developing research area in the early post-war years. It thereby associates the pen with up-to-the-minute science. The Bic Cristal pen also shared, or aspired to, key characteristics of crystals: transparency, toughness and longevity.

The Cristal consisted of six parts: a one-millimetre-diameter steel ball, a brass point which held the ball and supported a transparent cellulose acetate ink reservoir, a cellulose acetate bung and cap and a crystal-clear hexagonal polystyrene tube with a small vent hole in its side. The tube appeared to be straight but actually slightly tapered on the outside to facilitate removal from the moulding tool: modern examples vary from 7.4 to 7.6 mm along their length. Significant changes have been made to the pen over time. The cellulose acetate parts are now polypropylene, which was not invented until 1954. The brass point and ink tube support were separate parts; the point is still brass, but the support is now also made of polypropylene and incorporates the venting mechanism. The ball has become textured and, since 1961, has been made of tungsten carbide. Since 1991, the cap has had a hole at its end to prevent suffocation if inhaled, and the hexagonal section now becomes cylindrical at the bung end. Originally the pen could be refilled. Later, it became a sealed unit, for safety reasons, but recently a refillable model has been reintroduced.

The hexagonal section has many advantages. It has three grip points, making it easy to hold and preventing it from rolling around. Most importantly, it is an unusually strong structure. Dissection of a modern Bic Cristal shows the point and bung end are thicker to withstand the stresses induced by the tight push-fits of their assembly, but the rest of the casing has a thickness of less than 1mm. Bic has striven to reduce the weight of the pen from its original weight of 16 grams to 4 grams.[11] The less material used, the cheaper the product; and the lighter the product, the cheaper its transport costs.

Earlier ballpoints had been conceived as luxury items in competition with fountain pens and tended to imitate their bulbous forms. Although, like fountain pens, ballpoints were often made of plastic, they had screw caps embellished with precious metal bands, and whatever the material of the pen, the clip was always metal. In contrast, the Bic Cristal has the minimal straight lines of the pencil and is also often hexagonal in section—the only hint of styling is in the streamlining of the clip. The cap pushes on, and it and the clip are made from a single plastic moulding. Embellishment is limited to the cap, the bung's

7  *Laurence Bich*, Le Baron Bich, un Homme de Pointe *(Paris: Perrin, 2001), p. 70.*

8  http://fx.sauder.ubc.ca/ etc/GBPpages.pdf. *Accessed 14 August 2012.*

9  *Bich*, Le Baron Bich, *64. For today's process: 'How do they do it: Bic Cristal Ballpoint Pen',* http://www.youtube.com/ watch?v=f2fQ16zpG8s& feature=related. *Accessed 10 August 2012.*

10  *Hogg*, The Biro Ballpoint Pen, *p. 77.*

11  *Bich*, Le Baron Bich, *p. 63.*

functional colour coding matches the colour of the ink, and the ink is visible in its reservoir, making clear how much remains.

Bich claimed, 'The pen is beautiful because it is functional.'[12] Such functional and unembellished design conformed to the tenets of modernism: 'form follows function' and 'ornament is crime',[13] echoed by the Société Bic's mantra 'just what's necessary'.[14] In 2012, Bic became the first manufacturer of writing implements to receive the French ecolabel NF Environnement for seven of its products, including the refillable Bic Cristal. The award was made in recognition of its good ratio between quantity of raw materials and writing length: at least two kilometres. Recently Société Bic has become a partner in the first programme for the recycling of used writing instruments (Bics or otherwise), enabling it to participate in the end of life management of the Cristal.[15]

## Socialism in Practice

The mass production of the Bic Cristal required a market to sustain it. This was achieved by a marketing campaign unusual at the time for its scale and diversity on which Bich was advised by the French Agency for Advertising. In 1953, Société Bic won the first French publicity Oscar. In 1952, the year of the infringement notice, the marketing budget was 100 million francs, of which 45 per cent was spent on press advertisements. Ironically, Bics were themselves being imitated under the names of Bik, Big and Bip, and the advertisements stressed the importance of being sure that you were buying a true Bic and that it was only the level of mass production that made it possible to make such a delicate instrument at such a low price. Twelve per cent of the advertising budget was spent on cinema commercials, including one showing the Cristal dancing to a fragment of Bach. Nine per cent each was spent on radio and posters, many of the latter designed by Raymond Savignac, who created the Bic logo. The rest was spent on events, including participation in the Tour-de-France caravan with ever more fantastic vehicles. That of 1954 resembled a cockpit formed from the point of a Bic Cristal, another nod to the era's fascination with aerodynamics.[16]

The Bic Cristal even pioneered a new way of reaching customers. Previously, pens were retailed through stationers and were possessions made in relatively small numbers that gave their owners status. Retailers were reluctant to sell the much cheaper and fast-becoming-ubiquitous Bic Cristal because it yielded a smaller profit. As a result, Cristals came to be sold in tobacconists along with lighters, stamps, newspapers and other unremarked paraphernalia of everyday life.

It is likely that everyone reading this chapter has used, and indeed owned, a Bic Cristal. The pen has been used and owned by many who did not know that it was a Bic Cristal. There is photographic evidence of its use by many famous people, from Salvador Dali to Margaret Thatcher.[17] The continuing and widespread use of the pen supports the claim made in 1986 by the philosopher and writer, Umberto Eco, that it is 'the sole example of socialism in practice ... as it cancels out all the rules of ownership and social distinction'.[18]

12 Ibid., p. 62.
13 Louis Sullivan, 1896, and Adolph Loos, 1910.
14 'Bic 2009 Sustainable Development Report', http://www.bicworld.com/img/pdf/BIC_RDD_US.pdf. Accessed 14 August 2012.
15 'Bic and Terra Cycle Press release', http://www.bicworld.com/img/pdf/BIC-TerraCycle-Pressrelease_09MAR11.pdf. Accessed 14 August 2012.
16 Bich, Le Baron Bich, pp. 68–78; http://www.thebicwall.com/#/uk_en/60-years-of-history. Accessed 14 August 2012.
17 Mrs Thatcher cited in Phaidon Design Classics (London: Phaidon, 2006), pp. 2, 380; '60 Years Cristal press kit'.
18 L'Espresso, 16 February 1986.

Thanks to Steve Akhurst, Design Consultant, for advice on technical matters, Claire Gerard, Société Bic, for answering so many questions, and Graham Hogg, collector, for sharing his knowledge and collection of Bic Cristals and related archives and advertising so generously.

*Chair Tower, using Robin Day's 1963 Polypropylene chairs. Photograph by Josefin Boren, 2011.*

# 26 Polypropylene Chair, UK
## (Robin Day, 1960–1963)

*Susan Lambert*

The polypropylene[1] chair was immediately recognized as something special. Within weeks of its launch in April 1963, the *Architects' Journal* reported: 'This excellent solution to the multipurpose side chair will certainly prove to be the most significant development in British mass produced design since the war.'[2] In 1965, *Design Magazine* referred to it as 'a technological breakthrough'.[3] The same year it won the Design Council's Duke of Edinburgh's Award for elegant design, a first for a plastic product, and was acquired by the Victoria and Albert Museum, the UK's national museum of art and design. Nonetheless, no one could have foreseen its prolific future: that it would come to be manufactured globally in multiple millions, that it would be used in such diverse locations as Mexico's Olympic stadium and in Botswana in dug-out tree trunk canoes;[4] that it would be widely copied and that it would still be in production and seem 'of today', fifty years later. Its literal stamp of approval was its appearance on a Royal Mail first class stamp in a 2009 series, British Design Classics.

## From Muscle to Machine

Traditionally chairs were made by assembling a variety of wooden components by hand. The designer of the polypropylene chair, Robin Day, grew up and briefly worked in High Wycombe, a centre for the manufacture of such traditional furniture. He found the labour-intensive nature of the furniture industry outdated and developed a vision of well-designed furniture, mass-produced at affordable prices, stretching the boundaries of possibility with new technology and new materials. The polypropylene chair, the first with an injection moulded plastic seat, epitomizes this approach.

It was commissioned and put into production by S. Hille & Co Ltd. Hille's Joint Managing Director, Leslie Julius, discovered Day when he won a first prize at the 1948 International Competition for Low-Cost Furniture at the Museum of Modern Art, New York. A prototype chair by the American designers Charles and Ray Eames won a second prize at the same competition and, although prototyped in metal, was manufactured the following year in glass-reinforced polyester by the Herman Miller Furniture Company as a series of dining-height chairs. They were the first chairs of unadorned plastic. Day admired them, but they did not fit his design ethic: they 'were not the low cost which I was seeking, because of the cost of the material and the lack of genuine high industrial production techniques'.[5]

Key to the polypropylene chair's development was the discovery of a strong plastic that could be injection moulded, a mechanized process that involves forcing plastic pellets at melting point into a metal tool in the form of the finished product. That plastic was a polyolefin produced by the polymerization of polypropylene gas discovered in 1954 by the Italian Nobel prize-winning scientist Giulio Natta and exploited commercially in Italy from 1957 by Montecatini. A single tool made two shells every three minutes, a unit production rate previously unimaginable.

1  *S. Hille & Co Ltd always called it the* Polypropylene chair. Polyprop chair *is a recent term.*

2  *Brian Henderson, 'Furniture Polypropylene Chairs',* Architects Journal *137, no. 23 (1963): 3.*

3  *Richard Carr, 'Design Analysis Polypropylene chair',* Design Journal *194 (1965): 37.*

4  *Lesley Jackson,* Robin & Lucienne Day: Pioneers of Contemporary Design *(London: Mitchell Beazley, 2001), pp. 121–2.*

5  *AAD/2011/0/309, Robin Day, typed, for Sylvia Katz, 1993. The Lucienne and Robin Day archive, at the Archive of Art & Design, Victoria & Albert Museum – here referred to by its AAD file numbers – has been a rich source of information.*

## Designing for Ubiquity

Writing about plastic in 1957, the French literary theorist Roland Barthes described it as '[M]ore than a substance, plastic is the very idea of its infinite transformation ... It is ubiquity made visible.'[6] Plastics, released from servicing the requirements of war, were beginning to transform the design of consumer products.

In 1960, when development of the polypropylene chair began, it was a relatively uncharted plastic. It was known to be cheap, strong, unusually resilient, lighter than any existing plastic, easy to clean, hard to scratch and capable of integral colouring. But, in spite of elaborate analysis undertaken by Shell Chemicals, which had acquired its rights in 1958, it was still not known exactly how polypropylene would behave. There were no British Standards for chairs with plastic seats. Those that existed were for flat seats, not curved ones. The joining of metal legs to polypropylene was also new territory and hard to do mechanically. The tool for such a moulding was unusually large, and the difficulties of the process meant the profile thickness had to be limited to 4 to 5 mm. Polypropylene took on a glossy surface from the smooth metal and thus showed any shrinkage or other imperfection that occurred. The biggest problem was that the design could not undergo tests in polypropylene until huge investment had been made in the moulding tool. Thus, tests were initially done in other materials, which reacted differently.

Polypropylene's mechanical properties were known to differ greatly from those of glass-reinforced polyester, the only plastic previously used to make a chair. The key difference was in the stiffness, defined by Young's Modulus ($E$),[7] the ratio of stress to strain. $E$ for polypropylene is several times less than that for an average glass reinforced polyester, so it is much more flexible, although no less strong. The Eames design would have been much too 'bendy' in the polypropylene then available. The design solution was to create a stiff cross-section by increasing the curl-over of the edges shared with the Eames seat to a U-shape towards the junction of seat to back, where the highest loading occurs.

Once the shape was agreed, plaster shells on wooden skeletons were tried out and modified until it was thought satisfactory sections had been achieved. A fibreglass prototype followed and then a resin mould to guide the toolmaker, Talbot Ponsonby of Petersfield. The decision was taken to attach the base, to be made by Hille Metals Ltd, with self-tapping screws in integral bosses moulded on the underside of the seat. To minimize the cost of the moulding tool, the bosses pointed along the 'line of draw'. This meant that they were orientated at about 45 degrees to the base, which was not ideal in terms of strength. The face of the mould that formed the shell's upper side was engraved with a leather grain imitating that of a suitcase, which Day supplied.[8]

The first batch of polypropylene shells came off the production line in October 1962. However they proved too flexible and showed signs of distortion around the screw holes.[9] The moulding tool had to be altered by gouging the metal out with hand tools and the leather texture re-engraved. The next batch was also problematic leading to reinforcement of the bosses with radiating ribs calling for further tool modification.

Early in 1963, the chair that became known as Mark I went into production. Complimentary samples were sent to 600 opinion formers to try out. Again there were problems. Some chairs fractured, the texturing snagged stockings and most seriously, they were not comfortable. In Day's words: 'the modifications had made the dimensions of the shell unsatisfactory and I would not have gone through with its manufacture had it not been agreed that a new tool would be invested in to make a completely new version of the chair, drawing upon all the experience we had gained in the original exercise'.[10]

Mark II was successfully launched in March 1964, and the chair's shell has remained the same ever since. It was made from a more recently developed grade of polypropylene, had more generous overall dimensions with deeper structural turnovers at the edges and

6 *Roland Barthes, 'Plastic', in Penny Sparke (ed.),* The Plastics Age from Modernity to Post-Modernism *(London: Victoria and Albert Museum, 1990), p. 110.*

7 *Named after the English polymath, Thomas Young (1773–1829), it is used to quantify a materials tendency to be deformed under stress.*

8 *AAD/2000/4/29, letter from Thermo Plastics to Day, 29 June 1962.*

9 *See Carr, 'Design Analysis', pp. 32–7, for detailed information on the testing of Mark I and Mark II.*

10 *Ibid., p. 35.*

less of a front-to-back slope. The bosses were re-aligned in the direction of stress imposed and additional ribs added at the front; the seat texture was applied with a new photo-etching process; and the leg bottoms, always cut at an angle, were given new polyethylene caps that sat squarely on the floor and were sufficiently pliable to adjust to variations in posture.

It was issued in pale grey, flame red and charcoal, with tubular steel legs, either stove enamelled in black or chromium plated, and cost from 59 shillings and 6 pence. Its potential ubiquity was emphasized in its marketing. The most economical manner of packaging was found to be in stacks of six. Cardboard boxes, illustrating the chairs stacked, were designed to be used in the retail display of the chairs, piled one above another stacking the chairs apparently to infinity.

## The Polypropylene Programme

Hille had invested more than £20,000 upfront and the injection moulders, Thermoplastics Ltd, had invested £28,000 for a new machine capable of doing the job, at a time when an average annual salary was £700. Such risk taking was based on it not being 'a question of producing a chair, but ... of producing a continuous chair programme'.[11] Following the model of the Eames dining height family, the shell came to be mounted on many different bases, giving it the widest possible range of applications. A Hille advertisement ran, 'What has 44 legs, but is very light on its feet, a weatherproof shell yet wears many different covers, sometimes has arms—sometimes hasn't, works alone, or in large groups, can be seen all over the world but is only three years old?'[12] The armchair version came out in 1967. By 1978, the shell had more than twenty different bases. There were also clip-together versions for all manner of situations (such as for the serried ranks of audiences at performances) and versions with writing arms and (now discontinued) ashtrays. The related Series E school chair and Polo chair followed in 1971 and 1975, respectively.

In the early 1980s, testing levels for severe contract use meant the base had to be changed to a stronger version. Day was never happy with it: 'Finally our last effort in terms of cost and strength required for a 5 rating was the M5, now in production. Although it does the job, this frame is visually undistinguished and comparatively commonplace. The design of the old standard M frame ... represents an original elegant and ingenious solution to supporting the shell, with which in weight and form it is in perfect harmony.'[13] Recently, after Day's death, Hille relaunched the chair with a frame of the original appearance.

In 1999, the designer, Tom Dixon, then head of design at the UK furniture retailer Habitat, launched a range that capitalized on the translucency that had become achievable with polypropylene. As he said later, reflecting on this initiative, '[I]t was a chair that was comfortable almost anywhere'.[14] It is estimated that currently some 500,000 of the various models are produced annually under licence worldwide.

There have been many other significant plastic chairs. Some share the Polyprop's first-of-its-kind status, for example Joe Colombo's *Universale* in acrylonitrile butadiene styrene (ABS) and manufactured by Kartell, the first all-plastic injection-moulded chair, and Verner Panton's glass-reinforced-polyester stacking cantilever for Herman Miller, the first one-piece moulded-plastic chair, both commercially produced from 1967. However, even though they and also the Eames shell were later modified for production in cheaper polypropylene, none has been produced in such volume or as widely plagiarized as Day's polypropylene chair. Nor do they share its combination of invisibility and cult status, conflicting characteristics addressed by the artist's image 'Chair Tower'.

*I should like to thank Steve Akhurst, Design Consultant, for advice on technical matters and Cherrill Scheer, a member of the Hille family, for reading and commenting on the text.*

11 *AAD/2011/9/309, Robin Day, 'The Polypropylene Story'.*

12 *Advertisement,* Architectural Review *(September 1966): n.p.*

13 *AAD/2000/4/30, Robin Day, 'Stacking M5 Base for Polypropylene Chair'.*

14 Contemporary Days, the Designs of Lucienne and Robin Day, *DVD (Design Onscreen, USA), 2010.*

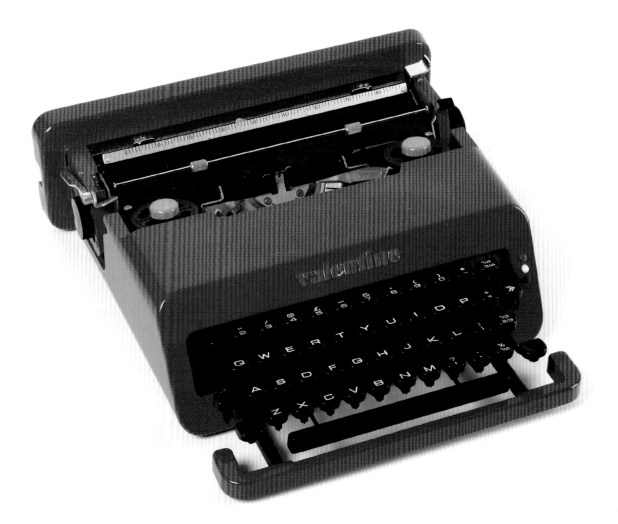

'Valentine' typewriter, designed by
Ettore Sottsass Jr. and Perry A. King
for C. Olivetti S.p.A., Italy, 1969.
Image courtesy of Museum of Design in Plastics,
Arts University Bournemouth.

# 27 'Valentine' Typewriter, Italy
## (Ettore Sottsass Jr. and Perry A. King for C. Olivetti S.p.A., 1969)

### *Penny Sparke*

Ettore Sottsass's 1969 'Valentine' typewriter for Olivetti merits the categorization of an icon for (at least) eight reasons: Firstly, because it represents an important moment in that important radical designer's career; secondly, because it stands for the 'pop' movement in design; thirdly, because it was part of Olivetti's innovative corporate image-making programme; fourthly, because it was visually and materially innovative; fifthly, because it redesignated the location of 'type-writing'; sixthly, because it redefined the nature of a particular human behaviour; seventhly because it has remained a much-reproduced and collected image and object; and eighthly because it inspired several significant designed artefacts that came after it.

## Ettore Sottsass—Radical Designer

The Italian architect-designer, Ettore Sottsass (1917–2007), had a long career that stretched across the second half of the twentieth century. In 1956, having worked up until that point as an artist, architect, interior designer and craftsman, he became a consultant to Olivetti, which was, at that time, in the process of developing a computer. Uniquely, he approached that task as an artist and focused his attention on the visual and spatial aspects of the product as well as on its usability.[1] He described himself as 'someone who stood outside'.[2] Following his work on the 'Elea 9003' computer (1959), Sottsass went on to work on a series of typewriters for Olivetti, among them the 'Tekne 3' (1958–60), the 'Praxis 48 (1962–3), the 'Lettera de Luxe' (1965) and the 'Dora' (1965).

Sottsass's second moment of radicalism came with the creation of a body of personal work, through the 1960s and early 1970s, in the areas of furniture and ceramic artefacts, which stood the aesthetic and ideological values of architectural and design modernism on their head. Inspired by the Indian belief that objects should perform a meditative function, and by the American pop artists' proposition that the artefacts of everyday life are the starting point for artistic production, he created ceramics that looked like altars and desks that resembled traffic lights.[3] Through his design for the 'Valentine' typewriter, Sottsass uniquely took those ideas out of the gallery and into the world of mass production. He went on to become the mind behind the work of the radical 'Memphis' group of the 1980s, which returned designed artefacts to the gallery.

## Pop Design

The iconicity of the Valentine typewriter is enhanced by its role as a seminal item of pop art design. Inspired by pop music, fashion and graphics, pop art design emerged in Britain in the middle years of the 1960s. At one end of a spectrum, it merged with spontaneous outpourings of the newly emergent youth culture of those years, but it also manifested itself in a more self-conscious way through the work of the architectural group Archigram and, among others, the interior designers Max Clendenning and Jon Bannenberg.[4] Pop design overtly challenged the principles of modernism and sought to align itself with the values of instant impact, ephemerality, expressiveness and fun. Several members of the Italian

1 *Penny Sparke*, Ettore Sottsass Jnr. *(London: Design Council, 1982), pp. 40–3.*

2 *Ettore Sottsass,* How to Survive with a Company, Perhaps *(unpublished lecture, 1968).*

3 *Ettore Sottsass, 'Ettore Sottsass Jr.: Mobili 1965',* Domus *433 (December 1965): 35–42.*

4 *See Nigel Whiteley,* Pop Design: Modernism to Mod – Pop Theory and Design, 1952–72 *(London: Design Council, 1987).*

radical design movement, the groups Archizoom and Superstudio among them, looked to Britain and warmly embraced pop art design. However, the movement had only marginally influenced the world of industrial design, remaining, instead, in the arenas of architectural drawings and fashion-related goods, where ephemerality plays a key role. Products—from cars to vacuum cleaners to food-mixers—were not 'naturally' predisposed to the youth-oriented, surface-focused and short lifespan of the pop art object. In that context the Olivetti Valentine typewriter was a rare exception.

## The Olivetti Image

In the history of the development of corporate image programmes, Olivetti stands out as a pioneer. The company was founded in 1908 in Ivrea by Camillo Olivetti. Under the leadership of engineer and humanist Adriano Olivetti, the son of the founder, who took over in 1938 (and died in 1960), the company developed a unique self-image based on the fact that it had a strong sense of its social and cultural responsibilities and that it wanted, in Sottsass's words, to 'give back happy products to society'.[5] It was important also that the function of design was controlled directly by the management and not, as was more common, by the marketing department. Olivetti followed the principle of 'integrated design', which meant that every aspect of its operation was designed and intended to be coherent. A sense of 'elegance and cheerfulness', meant to denote not only the character of Olivetti's machines but also to express the company's belief in its workers as human beings, pervaded everything.[6]

Sottsass planned the advertising campaign for the Valentine himself. Slightly different campaigns from the one implemented in Italy were devised in Britain and Germany. Several of the accompanying posters have themselves become iconic—in particular one designed by Sottsass that features a graphic depiction of the machine in white against a red background and another by the American graphic designer Milton Glaser that locates a Valentine next to a dog in a detail from Piero di Cosimo's painting, *Satyr Mourning over Nymph*. The typewriter was presented in a wide variety of locations, from a cockpit in an aeroplane to a football pitch. While the Italian campaign emphasized the machine's formal elegance, depicting it, for example, poised on the peak of a rock by the sea, in Britain it was featured in more everyday situations, including a London street market pavement. One writer found it 'more startling' in the latter context.[7] Valentines could be purchased in boutiques, record shops and department stores, 'everywhere', that is, 'where the young congregate'.[8] That deliberate targeting of a young market was reinforced in Britain by a series of television and cinema commercials, directed by underground filmmaker, Steven Dwoskin, which aimed to reach 94 per cent of sixteen- to twenty-year-olds.[9]

## A Novel Machine

The Valentine is a radical object, both visually and functionally. Although, mechanically, it was a revamp of an earlier Olivetti typewriter—the Lettera 32—two new features ensured that it was a very contemporary and novel machine. One of those was its mid-red colour (although it was also available in white, green and blue, which proved less popular). The red contrasted sharply with the black used for the keys and the carriage and the white of the letters and numbers.

Equally important, however, was the novel way in which the typewriter could be stored and transported. A sturdy ABS 'bucket' case provided a home for the little machine. It could be dropped into it either way round and released from it by two black rubber fasteners attached to the sides of the case. Internal rubber mouldings were added to prevent the machine moving when it was stowed vertically. The machine's handle was attached to the

5 *Sottsass*, How to Survive, p. 5.

6 *Deborah Allen, 'Olivetti of Ivrea'*, Interiors (December 1952): 102.

7 *Ibid.*, 111.

8 '*A machine for your thoughts*', Design 250 (June 1969): 18.

9 *Ibid.*

PART THREE: GENIUS AT WORK

rear of the body-shell. This enabled the typewriter to be stored on a shelf between books or magazines, which remained undisturbed on its removal. The Valentine was conceived as an everyday writing object, like a biro or a pencil, and not a status symbol. This strategy echoed Sottsass's earlier desire to remove what seemed like the inevitability of objects becoming status symbols and to return them to the world of the everyday to become mere tools assisting human beings in their daily tasks. The positioning of the handle, therefore, had far-reaching implications, transforming the Valentine into an indispensable accessory for a lifestyle defined by mobility and transience.[10]

## Beyond the Office

The Valentine challenged the traditional arena of the office. The design of that space had been transformed several times through the twentieth century, and by the 1960s the idea of 'open plan' had become widely accepted. Sottsass had already realized that typewriters could not be considered in isolation. Elaborating that point he wrote in typically poetic prose:

*Designing a typewriter means knowing what it is to be put on and perhaps therefore signifies designing its support, signifies perhaps even the design of the storage of that which, with a mad terminology, they call data support, which is to say paper and envelopes, but perhaps it also means knowing how the girl who types gets the paper, how she writes, how is the lighting on the machine and perhaps how you get hold of the plug ... This means perhaps designing the chair on which the girl sits to type ... and a great number of instruments which start maybe with the typewriter and finish with the underground which she must take to get to her typewriter and with the house which she must leave and the alarm clock and the espresso coffee machine which must work before she leaves.*[11]

The Valentine suggested a new porosity between the office, the home and the public space and the possibility of typewriters moving between them. Its portability and lightness removed the need for typists to be confined to their desks. The concept of the portable typewriter was not new of course—Nizzoli's little grey Lettera 22 of the early 1950s, among others, had already made that a possibility—but Sottsass created a machine that not only *could* be moved out of the office, but which actually looked as if it *should* be.

With the advent of the Valentine, the typewriter became an everyday object for everyone. New behaviours and a new lifestyle were formed as a consequence. From today's perspective, when so many people are permanently attached to their mobile phones, laptops and tablets, it seems impossible to imagine a time when everybody did not type on a keypad on a daily basis. The Valentine also anticipated a moment when office machines no longer needed to conform to the grey culture of the office—a world from which the colours of pleasure and domesticity were banned—but, instead, could become toys to be played with. Jonathan Ive's later work for Apple—the iMac G3 computer, for example, with its colours recalling children's sweets—owed much to the Valentine.

Finally, the fact that Valentine typewriters have entered into so many collections of twentieth-century design across the world seals its fate as an icon. Whether in New York's Museum of Modern Art or its Cooper Hewitt National Design Museum, in the Philadelphia and the Indianapolis Museums of Art, in Los Angeles's County Museum of Art, in London's Design Museum or in Germany's Vitra Design Museum, the Valentine epitomizes a moment when design was seen as youthful and liberating.

10 *'Due nuove machine per scrivere'*, Domus 475 (*June 1969): 37–41.

11 *Ettore Sottsass, unpublished, untitled lecture (undated, c. 1968–70), 9.*

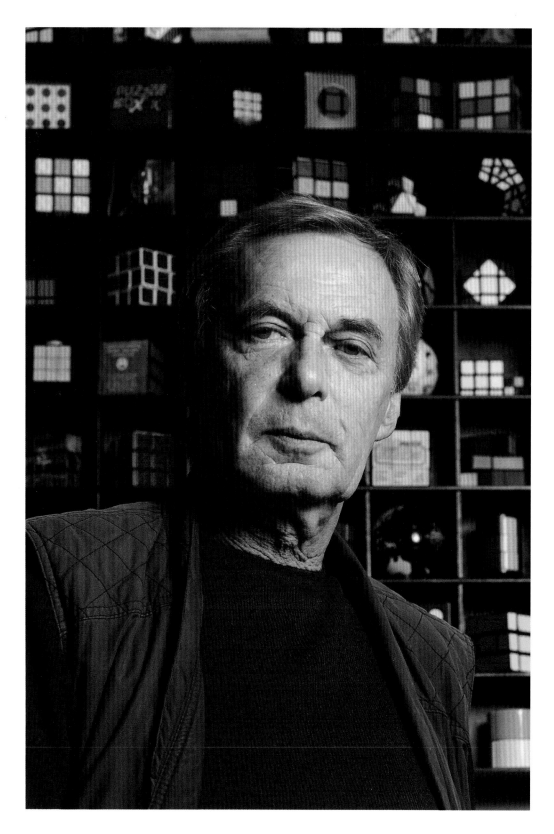

*Ernő Rubik and his cube. Rubik's ® used by permission of Seven Towns limited, www.rubiks.com.*

# 28 Rubik's Cube, Hungary
## (Ernő Rubik, 1974)

*Kjetil Fallan*

Let me count the ways: an icon of toy history, an icon of mathematics, an icon of 'geek' culture, an icon of faddishness, an icon of the 1980s, an icon of design, an icon of frustration. The ingenious little three-dimensional puzzle known as the Rubik's Cube is a product as iconic as they come.

### Hungarian Horror

Designer Ernő Rubik invented and constructed what he would call the Magic Cube in 1974. Trained as an architect, Rubik taught interior design at the Academy of Applied Arts and Design in Budapest (now Moholy-Nagy University of Arts and Design) at the time, and had a profound fascination with geometric models. Familiar with earlier 3D puzzles, like Piet Hein's Soma Cube (1933), Rubik set out to design a cube puzzle of his own for teaching purposes. The main design challenge was to make the twenty-six small component cubes rotate freely along all three axes without the structure falling apart. After initial experiments with rubber strips and magnets, the eventual solution would be a core mechanism connected to the centre piece of each face with spring-loaded screws, with the twenty remaining pieces held in place by interlocking extensions on the rear side and moving around this '3D cross'.[1] Having hand-carved a working prototype of wood, the inventor surprised himself with the complexity of the puzzle—once scrambled, it took him a month to solve. He filed for a patent in 1975, and following two years of product development and preparation for mass production in plastic with Hungarian toy-manufacturer Politechnika Ipari Szövetkezet and distribution by Konsumex, Hungary's state trading company, the first Magic Cube went on sale in Budapest in 1977.[2]

The cube was an immediate hit in the domestic market, and rumours of its existence soon spread abroad; enterprising Hungarians started bringing them along as hard currency on international travels. Intrigued and enthused by the new toy he discovered by chance on a visit to his home country, the Hungarian Vienna-based businessman Tibor Laczi took the cube to the Nuremberg toy fair in 1979 after an agreement with Konsumex. Laczi was not an official exhibitor, but simply walked around demonstrating the cube to potential partners. He eventually landed a contract with the Ideal Toy Company for one million cubes. Ideal renamed it Rubik's Cube, a brand name which could be copyright protected. Sometimes called 'the Hungarian Horror' for its ability to 'induce temporary dementia in otherwise balanced citizens',[3] Rubik's Cube then made it big.

### Fab Fad

Rubik's Cube quickly became a massive success, with more than one hundred million cubes sold in the first couple of years alone, making it the fastest selling toy ever. With market demand outdoing Politechnika's production capacity many times, Ideal Toy licensed production to several other manufacturers around the world. Not even this strategy could meet the massive demand, and millions of unlicensed copies poured out, a problem intensified by the lack of an international patent.

1 *Ernő Rubik, 'In Play',* in *Ernő Rubik, et al.,* Rubik's Cubic Compendium *(Oxford: Oxford University Press, 1987), pp. 6–12.*
2 *Tim Walsh,* Timeless Toys and the Playmakers Who Created Them *(Kansas City, MO: Andrews McMeel Publishing, 2004), pp. 230–4.*
3 *'Hot-Selling Hungarian Horror',* Time, *23 March 1981, p. 50.*

Such was the international cube craze in the early 1980s that the toy was reportedly Hungary's most important provider of foreign currency: 'With all the production sent to the West this Eastern Block is almost unobtainable in the Eastern Block [sic].'[4] The cube's sudden status as a national icon became clear in 1982 when it was featured on Hungarian stamps.[5] Rubik's Cube was described by *Time* magazine at the height of the craze as 'the hottest number to come out of Budapest since the Gabor girls went West'.[6] Fittingly, Ideal Toy hired Zsa-Zsa Gabor to host promotional parties in New York and Los Angeles for the international launch of the Rubik's Cube.[7]

The international popularity and adaptability of the design is shown in the production of two separate unauthorized versions on the occasion of the British royal wedding of Prince Charles and Lady Diana in 1981, featuring flags and images of the couple in place of the solid colour stickers. The instant appropriation of Rubik's Cube in popular culture also included its use in political cartoons as an image of the complex problems with which world leaders struggled.

This three-dimensional puzzle also has an unmistakable visual appeal. Each face of the cube in its solved state is given a solid colour: white, red, blue, orange, green and yellow (nine square stickers per face). So iconic is this form and colouring that it 'could have been designed by Mondrian'.[8] Its finished state, however, is perhaps less interesting than the cube as a work in progress, with more or less chaotic patterning. Its appearance is changed with every move of the blocks, creating a chequered pattern which is both random and instantly recognizable.

The cube craze waned considerably from the mid-1980s, with minor resurgences from time to time. But although it is not as widely used today as it was in its heyday, the colourful cube remains a powerful icon. The rights to the Rubik's Cube are now held by Seven Towns Ltd, and an estimated 300 million cubes have been made to date.

## Tool or Toy; Man or Boy?

Not many designers can be said to have achieved heroic status amongst mathematicians and natural scientists. The odds of mathematics professors around the world becoming obsessed with an interior designer's invention are not great. Beyond the level of personal fascination, many academics quickly discovered the pedagogical potential of Rubik's Cube. One of the most enthusiastic and prolific promoters of the cube was David Singmaster, Professor of Mathematics at London's Polytechnic of the South Bank. In his early booklet exploring the mathematical problem of the cube and proposing a series of processes and strategies for rapid and systematic solving of the puzzle, Singmaster heartily exclaimed, 'The cube is probably the most educational toy ever invented!'[9] 'Educational' is the operative word here.

At least since the eighteenth century, when the modern toy was recognized as an object designed and made by adults specifically for children, toys have been fundamentally educational in purpose. They have been seen as an effective way of instilling in children skills and attitudes deemed appropriate as preparation for adult life.[10] It should be stressed, however, that the Rubik's Cube was not originally intended to be a toy at all, but rather a tool for teaching geometry to interior design students. This only goes to show that the distinction between toy and tool is far from clear-cut, and that perhaps the most interesting objects are those that straddle that line.

Rubik's Cube deftly defies another conventional dichotomy as well: that between child and adult users. Marketed primarily towards the conventional user groups of toys, children and young people, the Rubik's Cube's most enthusiastic audience was adults. Intriguingly, however, with the Rubik's Cube many children could master and even excel at something most adults could not grasp.

More than an executive toy adorning the desks of office workers, though, the Rubik's Cube became what might be called an academic toy. Although Rubik conceived of it as an

4 *David Singmaster,* Cubic Circular: A quarterly newsletter for Rubik *[sic]* Cube addicts *1 (Autumn 1981): 4–5, 15.*

5 *Singmaster,* Cubic Circular *5/6 (Autumn/Winter 1982): 28.*

6 *'Hot-Selling Hungarian Horror', p. 50.*

7 *Singmaster,* Cubic Circular *1: 15.*

8 *'Hot-Selling Hungarian Horror', p. 50.*

9 *David Singmaster,* Notes on Rubik's 'Magic Cube', *5th edition (London: David Singmaster, 1980), p. i. 'The Polytechnic of the South Bank' refers to South Bank University.*

10 *Bo Lönnqvist and Johan Silvander,* Ting för lek och tanke: Leksaker i historien *(Lund: Historiske media, 1999), pp. 40–4.*

aid to teaching spatial conception to design students, it was within a far more formal and theoretical sphere of academia that the toy became an indispensable tool. Singmaster, and others like him, found in the cube an excellent tool for teaching mathematics, especially the field known as group theory.

Group theory is concerned with how groups of elements can turn, rotate and stretch back onto themselves. The 54 tiles on the 26 'cubelets', or 'cubies', making up Rubik's Cube and their various configurations and moves can be considered as mathematical groups. Each twist of the cube rearranges the patterns, and such rearrangements are called *permutations*. The number of different possible permutations, or patterns, is 43,252,003,274,489,856,000. With only one correct solution and more than 43 quintillion wrong ones, the odds are not great of solving it fast without a theoretically founded strategy. In 1980, it was estimated that it would take a computer 1.4 million years [sic!] to count all these possible patterns.[11] The true reason why it is so difficult to solve the puzzle, though, is not the impressive number of possible (wrong) patterns, but that you cannot move each cubie independently—if you move one, you move nine, 'forcing us to head for the solution by way of sophisticated detours'.[12]

It turns out that the Rubik's Cube provides a tangible and very didactic approach to a fairly abstract field of mathematics, and it has therefore enjoyed a second life as an academic tool. In fact, Rubik's Cube has become such an icon of group theory that a picture of the toy illustrates the entry on the topic in Wikipedia.[13]

## Revenge of the Nerds

Rubik's cube has become an icon of intelligence, especially the kind of intelligence associated with the stereotypical nerd or geek character in popular culture. This easily caricatured figure played a particularly prominent role in high-school movies, which emerged as a major category in Hollywood productions in the 1980s. The paradigmatic example of this genre is *Revenge of the Nerds* directed by Jeff Kanew (1984). Simultaneously an icon of both the role and the period, the Cube is effectively a shorthand for the stereotypical characteristics of the geek.

The relation between geek culture and the Rubik's Cube is not restricted to the 1980s, though. A powerful illustration of its continued relevance can be found in the set of the TV show *The Big Bang Theory* (2007–), where design appropriations of Rubik's Cube appear in abundance: on t-shirts, as a tissue box cover, as coasters and as a coffee mug. The fact that these items are also sold as merchandise through CBS's online store only works to further consolidate the iconic status of the Cube and its signification of 'geekiness'. The coasters are especially interesting in terms of the cultural meaning of design, as they are not even cubic. It would seem that the chequered pattern resembling a scrambled cube alone is enough to make it instantly recognizable as that of Rubik's Cube, making the cubic form itself of secondary importance, if not altogether redundant.

Despite the strong geek connotations, Rubik's Cube also functions as material metaphor for intellect in general. In the *Seinfeld* episode 'The Abstinence' (season 8, episode 9), Jerry postulates that George's sexual abstinence (caused by his girlfriend's illness) works wonders for his mental capacity, seeing signs of intelligence not normally shown by his friend. This is illustrated by George casually watching quiz show *Jeopardy* and suddenly knowing all the answers while at the same time tinkering absentmindedly with a Rubik's Cube and solving it effortlessly, whereupon he tosses it to a baffled Jerry.

The smart design is decidedly a conversation piece, making it smarter to be smart. At the height of the craze, at least, academic mathematicians and self-proclaimed geeks alike found Rubik's Cube improved their social lives, as real or potential cube-solving abilities were suddenly considered a major asset.[14]

11 *Singmaster*, Notes, *p. 12.*

12 *Christoph Bandelow, Inside Rubik's Cube and Beyond (Basel: Birkhäuser, 1982), p. 45.*

13 http://en.wikipedia. org/wiki/Group_theory. *Accessed 24 May 2012.*

14 *Singmaster*, Cubic Circular *1:15.*

*Post-it Notes used in public spaces following the London riots of August 2011. Photograph by Stuart Matthews.*

# 29

# Post-it Note, USA
## (Spencer Silver and Arthur Fry for 3M, 1980)

*Alice Twemlow*

Launched by the US adhesives and abrasives conglomerate 3M in 1980, the Post-it Note would go on to become one of America's top five best-selling office products and to earn a place in the Museum of Modern Art's permanent design collection. As a consumer product, a mode of communication and as a design icon, the biography of this 3-inch square piece of paper backed with a strip of low-tack adhesive, then, is an archetypal American rags-to-riches story.

Simple and economical in its rectilinear form, with just the right amount of stickiness to allow it to be repositioned or to stay in place until the user removes it, the square or rectangular piece of paper is neatly collected into sharp-edged cubes or bricks. And although, due to its familiarity today, it also seems to represent the beloved modernist design adage of 'form follows function', in fact, when it was first introduced there was no function for its form to follow, no desire to fulfil. Just like 3M's other most successful product, transparent tape, no one knew they needed such a thing until they were presented with it and, in the case of the Post-it Note, trained to use it. The launch of the Post-it Note necessitated not just a savvy marketing plan but instruction in a new behaviour—that of affixing notes to self and others in particular locations, be they documents or desk-spaces, car dashboards or bedroom doors. It didn't take long for consumers to invent their own uses for the little note, however. Carrie Bradshaw's boyfriend used one to dump her in a 2003 episode of the HBO series *Sex and the City*,[1] and today it is used as a quirky material choice by artists and fashion designers and as a tool for facilitating the design brainstorming process.

### 'A Eureka Head-Flapping Moment': The Invention of the Post-it Note

In 1968, Dr Spencer Silver, a senior chemist in 3M's corporate research laboratory, was experimenting with adhesives when he produced a substance with low-grade stickiness which he described in its 1972 patent as 'inherently tacky elastomeric copolymer microspheres'.[2] Silver, who has said that he thought of himself as a 'molecular architect', was convinced that this failure, this partial adhesive, could be useful, and he frequently promoted its virtues in seminars for his colleagues, but it wasn't until 1974 that its life as a practicable product began. Arthur Fry, who worked in 3M's tape division lab, heard about the invention and started to experiment with its application to small paper bookmarks for marking the pages of his church hymnal. The sticky mini-bookmarks worked well but, since they could be reused endlessly, they weren't consumable enough for the company to turn a profit from them. When Fry used one at work to append a question to a report he was reading, however, and his supervisor responded using the same note, it became clear that by writing on the notes Fry and his supervisor had hit upon a means by which they would be used up and therefore would represent a marketable product. 'It was a eureka head-flapping moment', Fry later recalled. 'I can still feel the excitement. I had my product: a sticky note.'[3]

1  *Aired, 3 August 2003.*
2  *United States Patent, 3,691,140, Sept. 12, 1972, column 1, line 34–5. As Greg Beato explains, 'on the molecular level, this substance resembled the pebbled skin of a basketball … the tiny spaces between the microspheres made it impossible to get complete contact between the adhesive and another surface.' Greg Beato, 'Twenty-Five Years of Post-it Notes', The Rake, 24 March 2005, http://www.rakemag.com/2005/03/twenty-five-years-post-it-notes-0/.*
3  Financial Times, *3 December 2010.*

Fry generated interest for this new and silent mode of interoffice communication within 3M offices, and in 1978 3M began test-marketing the product by distributing free samples to offices in the town of Boise, Idaho, in what was referred to within the company as the 'Boise Blitz'. Ninety per cent of Boiseans given samples said they would buy it, and 3M continued to seed the new organizational habit by giving samples to chief executives of Fortune 500 companies. By 1980, 3M was convinced they had a viable commercial product and launched the Post-it Note in US stores on 6 April 1980.[4]

## The Post-it Note at Work and at Play

As a mode of communication and an organizational tool, the Post-it Note was nicely suited to the era in which it was launched. The office environment of the post-Fordist service industry 1980s was typically antisocial in its construction, with warrens of cubicles and networked computers replacing the typing pool and open plan layouts of the 1960s. The Post-it Note provided a means of intercubicle dialogue, and the condensed, urgent prose that its form engendered provided a linguistic parallel to the power-dressing aesthetic and corporate ideals of the time. Post-it Note messages stuck to the cover of one's Filofax or adorning one's work space were private notes to oneself, yet often written with a view to their public display. Scrawled notes such as 'conference call with global partners at 3 pm' or 'arrange breakfast meeting with investors' were meant to be seen by others as signifiers of the author's busy and exciting career.

In the 1990s, even as online communication became more prevalent, the Post-it Note did not die off, as did other media such as the fax, the Dictaphone and the memo. The Post-it Note continued to thrive alongside the computer, often being stuck to the frame of the monitor. It also found its direct virtual equivalent on computer screens in Microsoft's Sticky Notes program, in Apple's Stickies program and 3M's own Post-it Brand Software Notes.

At rest upon the blocks from which it is dispensed, empty, pure and full of possibility—'the color of thought itself, a lightbulb going off in your head'—the Post-it Note seems modernist, but in use, stuck on pages, connecting otherwise disconnected pieces of information in anticipation of the Internet hyperlink, its inherent instability, impermanence and ability to capture fragmentary thought, recommend it more aptly to the label 'Postmodern'.[5]

Through the abbreviated, economical and sometimes-poetic mode of writing that its small surface area encourages, the Post-it Note can also be seen as a progenitor of instant messaging, the bullet-pointed PowerPoint and such social media networking services as Twitter and online tagging.

The product's market reach and longevity was also helped by its rapid spread beyond the office environment, for which it was intended, and into domestic settings. Stuck to refrigerators the world over, it bears curt missives to family members about the location of their dinners, shopping lists or general reminders of the minutia of household life. It has also found a home in children's craft kits, with a whole series of books devoted to Post-it Note art activities.

Indeed, its playful qualities, and its similarity to a mosaic tile or a digital pixel has been recognized by artists who have used it to create large-scale installations. In late 2011, the public's imagination was captured by the so-called 'Post-it Wars', in which a French game design company, Ubisoft, created likenesses of characters from classic video games like Space Invaders, Donkey Kong and Angry Birds by affixing Post-it Notes to their office windows, inciting a nearby branch of the BNP Paribas bank to respond with more complex and ambitious collages of their own. The meme spread across

4 *In 1981, Post-it won 3M's Golden Step award for its most lucrative products. In 1985,* Time *magazine declared Post-it Notes one of the best products of the previous twenty-five years.*

5 *Beato, 'Twenty-Five Years'.*

Europe, reaching its apotheosis in creations that extended the height of buildings.[6] More poignantly, the Post-it Note has found a new role in public life when posted on walls or boarded up windows in impromptu notice boards to make appeals for information on missing persons or elegiac reflections in the wake of disasters such as Hurricane Katrina in 2005 and the London Riots of 2011. Post-it Notes with messages of mourning and mosaic portraits also covered the windows of Apple Stores following the death of Apple CEO Steve Jobs in the autumn of 2011.

## The Post-it Note as Design Icon and Design Tool

Its recognition as a design icon, for example via its inclusion in an exhibition titled 'Humble Masterpieces' at MoMA in 2004, came during a time in which the design establishment was newly attuned to the significance of quotidian design.[7] Also celebrated in the exhibition, and in much design discourse of the period, were other exemplars of humdrum office equipment such as the GEM paperclip, the Bic Cristal, and the Swingline stapler, all of which had achieved a newfound everyday-hero status inspired, at least in part, by nostalgia for the quaint-seeming physical apparatus of bureaucracy in an era of the much-heralded paperless office.[8] As Paola Antonelli, curator of the 'Humble Masterpieces' exhibition, has explained, her decision to collect and display everyday objects was less a rupture in MoMA's approach to collecting and displaying design, and more of a continuation of its founding mission to celebrate examples of everyday design.[9] Yet in the early 2000s, amid a period characterized by the Millennial Baroque excesses and complex forms of computer-generated design, everyday design's re-emergence into the design press and its institutions was striking nevertheless and was often used by its advocates as a pointed, if gentle, political statement in the face of a star-obsessed media and the elitist connoisseurial collecting and exhibiting practices of decorative arts and design museums.

As well as being a design icon in its own right, the Post-it Note also figures prominently in the process of designing and can therefore be seen contributing to the creation of other design icons. Designers use it as a tool in the brainstorming or idea-generation stage of a project. Typically, participants in a collaborative project will write or draw their ideas or questions on Post-it Notes to be stuck to a wall. These can then be rearranged, sorted and grouped by colour of the note or its content as a way to visualize convergence and divergence of thought, to externalize and materialize the intuitive and nonverbal thought processes of design. With the increasing popularity in the last decade of Design Thinking, a problem-solving protocol derived from design practice but applicable to business and which, according to US product design and innovation firm IDEO, 'allows people who aren't trained as designers to use creative tools to address a vast range of challenges', the Post-it Note has assumed a new role as the most tangible and photogenic aspect of the design process.[10]

Today the Post-it Note is available in twenty-seven sizes, fifty-six standard shapes, fifty-seven colours, twenty-two different dispensers and even twenty different fragrances including dill pickle, pizza and bubblegum. In 2012, in an effort to tap into the personalized lifestyle product market, 3M introduced eight new fashion-conscious hues such as 'Farmer's Market', 'Tropic Breeze', 'Jewel Pop', 'Electric Glow' and 'Sunwashed Pier'. A design icon, design facilitator, art material, method of creative expression and means of public discourse—while the Post-it Note has clearly transcended its original office cubicle habitat, its small, blocky, sticky materiality endures.

6 *Artist Immony Men employed assistants working for 15 days, 9 to 5, using 10,000 Post-its to recreate a typical office cubicle in a Vancouver gallery installation.*

7 Humble Masterpieces, *8 April–27 September 2004, The Museum of Modern Art, New York.*

8 Humble Masterpieces *exhibition checklist*, www.moma.org.

9 *Paola Antonelli, Introductory text to* Humble Masterpieces, *www.moma.org. From the* Machine Art *and* Useful Objects *exhibitions of the 1930s, MoMA has collected and displayed examples of everyday design.*

10 *'The predominant image of design in the [twenty-first] century is that cliché of the empty conference room or studio – just after some feverish brainstorming extravaganza – plastered with Post-it Notes … as if the act of design had suddenly morphed into some strange game of pin the Post-it on the mind map.'* Jamer Hunt, *'Why Designers Should Declare Death to the Post-it', 20 May 2005, FastCompany. com.* http://www.fastcompany.com/1650243/why-designers-should-declare-death-post-it.

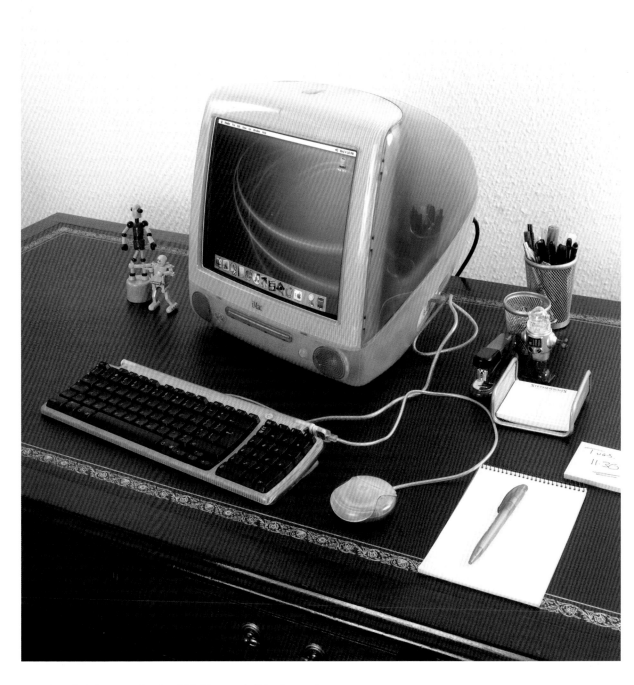

*Apple iMac G3 in Blueberry, October 1999. Photograph: Brian Cavanagh.*

# Apple iMac G3, USA
## (Jonathan Ive for Apple, 1998)

*Paul Atkinson*

Jonathan Ive's design for the iMac marks the very point at which computers ceased to be pedestrian objects of work production and became instead aspirational signifiers in their own right. Selected for the permanent collection at MoMA and the recipient of many accolades, including a Gold 'Design of the Decade' Award from the Industrial Designers Society of America, the iMac is undoubtedly an icon of personal computing.

## A Breath of Fresh Air

It might be difficult to remember in these days of highly desirable, consumer-oriented, fashionable technological products that at one point (at least from a design perspective) the technological landscape was a far more bleak and uninspiring place. In its earliest inception during the Second World War, the electronic computer appeared as a series of faceless grey cabinets controlled via a large, desk-like operator's console. As the market for computers gradually increased over the next two decades, various companies produced different forms of computers, which started to appear in bright corporate colours. As a manifestation of futuristic technology, computer designs took inspiration from the machines of the space race and the illustrations of golden-era science fiction. At the height of this diversification in the latter half of the 1970s, computers appeared as exciting products. This exuberance, though, did not last.

By the early 1980s, the German Institute for Standardization (Deutsches Institut für Normung, or DIN) had specified, among its standards, a neutral beige colour as the most ergonomically suitable to prevent operator eyestrain. Keen to ensure the largest customer base, market leaders such as IBM readily adopted the standard.[1] Allied to this fact, IBM changed the computer industry completely in 1981 with the launch of the IBM 5150—better known as the IBM PC. The detailed story of how this most influential of computer designs came to be is told elsewhere.[2] Suffice it to say here that the resulting product, backed by the largest computer company in the world, quickly became the standard that everybody copied. Although there was no technical reason why competing companies should match the design of the IBM PC, it was clearly desirable not only for their operating systems to be IBM-compatible, but also for their products to be seen to be reassuringly visually compatible. By the mid-1980s, millions of personal computers were identical clones of a necessarily plain design—a rectangular beige box alongside a bulky beige monitor, a beige keyboard and a beige computer mouse. Although computers continued to develop technologically, getting faster and more powerful with every passing year, visually they remained completely static. As time went by, the form of the personal computer appeared to be forever set in stone.

This was why the iMac, when it was first announced in a huge blaze of publicity on 6 May 1998, had such an impact. Computers had looked identically dull for so long that the iMac was seen not just as another personal computer, but as a completely new class of product altogether. The iMac was an all-in-one design, combining the monitor, processor and hard drive into a single, softly organic, teardrop-shaped form with a built-in handle in

1 *Interview with Tom Hardy, World Head of Design at IBM at the time.* 17 January 2011.
2 *Paul Atkinson,* Delete: A Design History of Computer Vapourware *(London: Bloomsbury, 2013).*

the top. The semi-translucent body in white and 'Bondi Blue' polycarbonate plastic (which incidentally cost more than $60 per unit—three times the cost of a 'standard' casing)[3] gave a tantalizing glimpse of the esoteric internal workings of the machine and meant as much attention was paid to the appearance of internal components as to the external parts. A matching semitranslucent keyboard and a strangely round mouse completed the ensemble, which was sold as Internet ready 'right out of the box'. This was not a machine intended for the office desk; it was an information appliance for the home. The radical design was a breath of fresh air and attracted many new buyers. Surveys indicated that around 70 per cent of all iMac purchases were to people that had never before bought a computer or as a replacement for an IBM-compatible machine, adding to the total number of Apple computers in use.

## The Second Coming

The iMac was a turnaround product for Apple. The once hugely successful company had gone through a particularly turbulent period that saw the driving force behind the company, the late co-founder Steve Jobs, ousted in 1985 in a boardroom coup. The company ethos that put design at the forefront of every decision had been replaced by a focus on finance and marketing pushed by the new CEO John Sculley, the ex-president of Pepsi-Cola. A string of product failures, most notably the proto Personal Digital Assistant (PDA), the Newton MessagePad, heralded the downfall of Sculley and a number of Vice Presidents, a series of quarterly financial losses and a declining share of the computer market.[4]

'Macolytes', those hard core fans of everything Apple, saw the return of Steve Jobs to the Executive Board in 1997 as a second coming: Apple would rise again. The first thing Jobs did on his return was to put design back at the top of the corporate agenda. He elevated the status of the director of Apple's Industrial Design Group, Jonathan Ive, to Vice President and gave him free reign to design a new product missing from the Apple product line—'a compelling consumer model priced under $2000'.[5] The faith Jobs placed in Ive certainly paid off. Before it became available for sale on 15 August 1998, Apple had received advance orders for 150,000 iMacs. By the end of 1998, the iMac had become the fastest selling Apple computer ever. The sales figure of 800,000 iMacs represented one iMac sold 'every 15 seconds of every minute of every day of every week' and doubled Apple's worldwide share of the computer market.[6] *Newsweek* magazine wrote, '[I]t is not only the coolest-looking computer introduced in years, but a chest thumping statement that Silicon Valley's original dream company is no longer somnambulant' while *Forbes* quite rightly called the iMac 'an industry-altering success'.[7]

In some respects, the iMac was a reincarnation of perhaps the most important Apple computer of all time—the original Apple Macintosh of 1984. Like the iMac, the Macintosh was an all-in-one design, bringing a monitor, processor and disc drive together into a small, beige vertical format casing with a unique, 'friendly' product identity. The Macintosh, being the first commercially successful computer to have a graphical user interface (GUI) and mouse had a huge impact on users' perceptions of how computers should work. The advantages of the Macintosh interface over IBM-compatible machines were clear, and Microsoft (who produced the IBM PC's operating system) was quick to copy Apple's GUI with their own Windows operating system. Very quickly, instead of a perplexing command-line prompt of 'C:\>_', almost every computer had an icon-based screen and an arrow-shaped cursor. Pointing and clicking replaced the typing of commands, allowing users to easily manipulate images and text. Without the Macintosh and the Aldus PageMaker software written for it, the whole desktop publishing

3 *Walter Isaacson*, Steve Jobs *(London: Little, Brown, 2011), p. 350.*

4 *Owen W. Linzmayer*, Apple Confidential 2.0: The Definitive History of the World's Most Colorful Company *(San Francisco: No Starch Press, 2008), p. 203.*

5 *Ibid., p. 294.*

6 *Ibid., p. 295.*

7 *Isaacson*, Steve Jobs, *p. 355.*

phenomenon might never have happened. Steve Jobs once famously predicted that the Macintosh would 'put a dent in the Universe',[8] and it did indeed make an incredible impression. But the Macintosh had little impact on how computers looked. Instead of others changing to match the Macintosh, Apple slowly changed their computers to look almost identical to the proliferation of IBM-compatible clones.

In contrast, the iMac did little or nothing to affect the way in which people actually used computers, but its design had a massive impact on a wider scale. For Apple, one significant advantage was the distancing of their computers from their competitors: 'Apple has proved that the commodified personal computer can be made distinct and desirable, even when its turned off. The by-product is that for those people who could never understand the difference between Mac and Windows, the iMac provides a tangible differentiator.'[9] For Apple's competitors, the iMac raised the bar on design as it 'shattered forever the myth that computers had to look dull' and in response, 'manufacturers rushed to emulate the form of the iMac in their products'.[10] Packard Bell, Silicon Graphics and others tried to jump on the bandwagon by suddenly advertising computers with softer shapes and in colours from pastel green to purple. The impact was also felt on a much wider scale as all manner of consumer products, ranging from desk lamps to electric irons, suddenly appeared in translucent, brightly coloured plastic.

Just as the competition started to catch up, Apple revised the iMac, replacing the Bondi Blue colour with 'five flavours' in January 1999: Strawberry (pink), Lime (light green), Grape (purple), Tangerine (orange) and Blueberry (a slightly lighter blue than the original). Although this was expensive to achieve from a manufacturing and distribution point of view, Steve Jobs proudly predicted, 'One of the most important questions when buying a new computer is going to be "What's your favourite colour?"'[11] The similarity of the colours to those of translucent boiled sweets was the reason for the revision's internal project codename of 'Life Saver' after the American brand of hard candy, and for the later misquoting of Jobs's comment that the iMac 'looks so good you kinda wanna lick it'.[12] Over the next few years, Apple extended the theme to a wider range of their products: the Power Mac G3 minitower, the iBook laptop and the Power Mac G4 cube all bore translucent finishes.

## Legacy

The iMac repositioned Apple as the leading manufacturer of high-end computer products for consumers and paved the way for the company to release a wider range of technology products, all of which used the iMac as a 'digital hub'—the iPod in 2001, the iPhone in 2007 and the iPad in 2010—products which took Apple from the brink of bankruptcy to becoming the most valuable company in the world.[13] It also raised the status of Jonathan Ive as a designer beyond all expectations. Before the iMac, his name was heard only within design circles. Afterwards, he became far more widely known, being made a Royal Designer for Industry in 2003, receiving a CBE in 2005 and a knighthood in 2012. 'Ive has become a household name … The work that Ive has done with Apple is the most powerful demonstration that there is nothing fluffy or cosmetic about design … He has made his reputation not with chairs or lemon squeezers but with the electronics that have reshaped the way that most of the world works.'[14]

8  Steven Levy, Insanely Great: The Life and Times of Macintosh, The Computer That Changed Everything (London: Penguin, 1995), p. 4.

9  Gitta Soloman, 'Inside Story', Design (Autumn 1998): 42.

10  Joe O'Halloran, 'OK Computer?' newdesign 3 (March/April 2001): 35–6.

11  Steve Jobs, cited in Alex Summersby (ed.), 'The Story of iMac', The Macformat Guide to iMac, Spring 1999, p. 13.

12  In an interview in 2000, Jobs referred not to the iMac but rather to Apple's new operating system, Mac OS X, when he said, 'We made the on screen buttons look so good you'll want to lick them'. Christine Y. Chen, 'Steve Jobs' Apple gets way cooler …' Fortune Magazine, 24 January 2000.

13  Nick Wingfield, 'Apple Sets Stock Market Record, With Asterisk', New York Times, 20 August 2012, p. B1.

14  Deyan Sudjic cited in Mark Prigg, 'The 2012 Wired 100: Jonathan Ive', Wired (UK Edition), July 2012, p. 99.

Part Four

# Home Rules

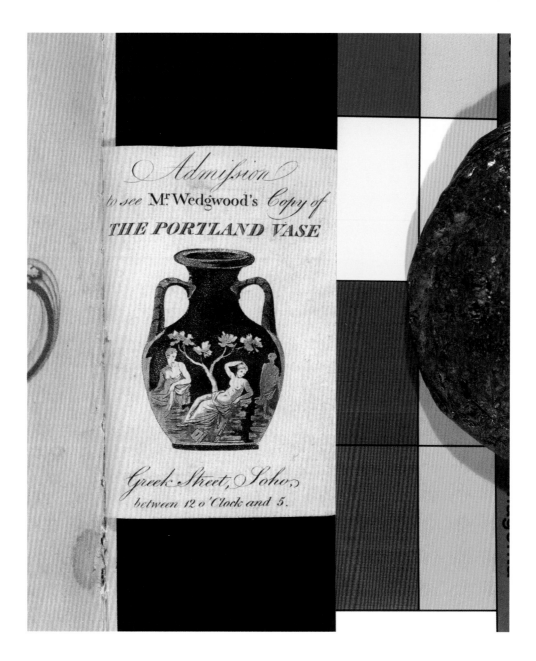

*Josiah Wedgwood and Sons (manufacturer), Vase,*
*1790. Jasper, with black 'dip' and white reliefs.*
*V&A CIRC.732-1956. © Victoria and Albert Museum,*
*London.*

# Portland Vase, UK
## (Josiah Wedgwood, 1789)

*Glenn Adamson*

### Buying the Portland Vase

If objects have their own stories, their own 'social lives',[1] then the story of the Portland Vase is a Hollywood thriller, packed with incidental and larger-than-life characters. The original vase, beautifully carved in cobalt blue and white glass, was made in Rome at about the time of Christ. It has been a subject of mythmaking and speculation ever since its discovery, purportedly in a sarcophagus under a great burial mound in 1582. It passed from hand to hand over the succeeding two centuries, each time occasioning the expenditure of vast sums of money. Known originally as the Barberini Vase, it was sold out of that family to cover the gambling debts of a wayward *principessa*. Sir William Hamilton, an enthusiast for all things antique, purchased it in 1782 for the eye-watering amount of £1000, commenting, 'God knows it was not very convenient for me.'[2] Sure enough, Hamilton had to sell it almost immediately, to another great collector of the age, the Duchess of Portland. She also owned it for only a year, as she died in 1785, but her son bought it at auction, and her title came to be forever attached to it.

There is also an action film quality to the Portland Vase's story. Like many precious objects surviving from Roman times, it has been broken repeatedly. Sometime early in its life, the original base of the vessel (probably a graceful, conical taper to a point, not a flat plinth) was lost, and replaced with a flat disc bearing a cameo figure. In 1845, by which time it was on view at the British Museum (where it remains), a young man smashed it in a rage, leaving it in 189 separate fragments. Since then it has been reconstructed three times according to the latest techniques of conservation, most recently in 1989.

Another breakage occurred in the late 1780s, when the vase was temporarily in the possession of the potter Josiah Wedgwood. He had borrowed it from the Duke of Portland in order to copy it. The Duchess of Gordon (Jenny of Monreith), who was visiting Wedgwood, carelessly dropped the vase, knocking off the replacement base disk.[3] One can only imagine his dismay; not only was it in his possession on loan, but he may have known that his own fame and that of the Portland Vase would soon be inseparable.

### Copying the Portland Vase

In 1981, Jean Baudrillard famously identified modern capitalism as offering nothing but a 'precession of simulacra', a frictionless flow of copies which lack originals.[4] In Wedgwood's imitations of the Portland Vase, however, we have an episode from the early history of capitalism that operates almost in the reverse manner. In this case, the iconic value of the original (however abused) and the difficulty of duplicating it were the necessary preconditions for a path-breaking feat of capitalist entrepreneurship. Wedgwood seems to have decided that he should copy the Portland Vase as soon as he heard of it from his friend and colleague, the artist John Flaxman. At that time, there was no consensus about how the object had been made. Perhaps the remarkably fine, shallow-relief figures had been enamelled on to the glass? Or perhaps it was not glass at all, but a miracle of nature: a single chunk of two-coloured stone, the shape of which had prompted its carvers to

1 *Arjun Appadurai (ed.)*, The Social Life of Things *(Cambridge and New York: Cambridge University Press, 1986)*.

2 *Brian Fothergill*, Sir William Hamilton: Envoy Extraordinary *(London: Faber and Faber, 1969); also Milo Keynes, 'The Portland Vase: Sir William Hamilton, Josiah Wedgwood and the Darwins',* Notes and Records of the Royal Society of London *52, no. 2 (July 1998): 237–59.*

3 *Keynes, 'The Portland Vase', 243.*

4 *Jean Baudrillard*, Simulacra and Simulation *(Paris: Éditions Galilée, 1981; trans. 1984).*

recognize the form of a figured vase, much as Michelangelo reputedly found his sculptures in the lineaments of particular blocks of marble.

Once Wedgwood got his hands on the object in 1786, he was able to dismiss such guesswork: '[T]hat the matter of the vase is factitious [i.e. not natural] is now well known.'[5] It was certainly glass, with the blue-black core dipped into white and then blown on a pipe while red-hot. The thin outer layer had been carved in shallow relief, with infinite care. Wedgwood was overawed: '[T]he expense of working, in this manner, a vase of such magnitude would necessarily be so great, so much time, labour, and address would be required for the production of a single piece, that I fear no modern artist, however capable of the execution, would engage in it.'[6]

Wedgwood dismissed his private doubts about his ability to reproduce the vase and set to work with his customary energy. His copy would not be glass, but ceramic, specifically Jasperware (a formula he had originally developed in the 1770s to mimic stone, as the name implies). The modelling would be done by the best sculptor at his factory Etruria, Henry Webber, with assistants.[7] Because the vase had suffered wear to the surface, it would not be duplicated exactly, and the copy would therefore, in some respects, improve upon the original.[8]

Over three years later, in October 1789, Wedgwood finally completed his 'arduous, and by some deemed even presumptuous, undertaking'.[9] The ceramic copy lacked the translucency of the glass original, though Webber's modelling was extraordinarily fine. It was arguably in the promotion rather than the manufacture of the vase, however, that Wedgwood showed his real genius. Wedgwood buttressed the Portland Vase's already considerable fame with commissioned testimonials attesting to the 'accuracy of the copy' from luminaries such as Joseph Banks (then president of the Royal Society) and the artist Joshua Reynolds.[10]

## Selling the Portland Vase

More innovative was Wedgwood's initial plan for selling different types of copies at different price points: direct casts of the vase, all in one colour; casts with a painted blue ground; his own copies, not cast but hand-fabricated; and the finest of all, copies with a high polish applied by a 'lapidary' (stone worker).[11] The Duke of Portland authorized this elaborate sales strategy, but Wedgwood in fact made only one small subscription edition of forty-five handmade copies: a good number were imperfect, and Wedgwood's son suggested that only about ten were sold.[12]

Although this sounds like a commercial disaster, Wedgwood's real innovation was that the project did not need to succeed: it was an early instance of the 'loss leader' strategy today adopted by luxury brands and supermarkets alike. Copying the vase was highly unlikely to be profitable—after all, it took nearly four years of research to manage the feat, and there was a tiny market for such elite masterpieces in any case. But as promotion, it was a masterstroke.[13] Exclusivity is not absolute, but a matter of persuasion. Wedgwood demonstrated that preciousness can indeed flow outward from a singular object through a cascade of associations, which in turn inflect that original's meaning.

First, there were the early Portland Vase copies, and the many later editions issued by the company. Then there were all the other Jasperware objects made by Wedgwood, which lacked the prestige of the Portland Vase but still basked in its ancient glow. Over time, his products would themselves become antiques. In 1882, a writer for the magazine *The Art Amateur* rightly positioned Wedgwood as a key figure in the development of a new market for historic artefacts:

5 *Josiah Wedgwood, Description of the Portland Vase, Formerly the Barberini: The Manner of its Formation, and the Various Opinions Hitherto Advanced on the Subjects of the Bas Reliefs (London: John Bowyer Nichols and John Gough Nichols, 1845 [1790]), p. 6.*

6 *Wedgwood, Description, p. 11.*

7 *Robin Reilly, Josiah Wedgwood 1730–1795 (London: Macmillan, 1992), p. 318.*

8 *Wedgwood had previously designed two 'ruined vases', capitalizing on the fashion for antique remains.*

9 *Wedgwood, Description, p. 2.*

10 *Ibid., p. 60.*

11 *Reilly, Josiah Wedgwood, p. 320. Wedgwood did not sell casts of the vase, but art dealer James Byres commissioned 60 copies, which apparently did 'remarkably little justice to the original'. Hilary Young (ed.), The Genius of Wedgwood (London: Victoria and Albert Museum, 1995), p. 117.*

12 *Ibid., 328; Keynes, 'The Portland Vase', 248; Aileen Dawson and Ann Eatwell, 'Appendix: Early Copies of the Portland Vase', in Aileen Dawson (ed.), Masterpieces of Wedgwood (London: British Museum Press, 1984), pp. 149–50.*

13 *See Neil McKendrick, 'Josiah Wedgwood: An Eighteenth-Century Entrepreneur in Salesmanship and Marketing Techniques', Economic History Review 12, no. 3 (1960): 408–33.*

'My wares need only to be scarce to be considered beautiful,' Josiah Wedgwood wrote, as if with prophetic vision of our day when lovely objects that he gladly sold for pence and shillings would be greedily bought for pounds by a generation with artistic teeth on edge for the sour fruits of bad taste eaten by their fathers.[14]

At around this time, further copies of the Portland Vase were made by various companies as proofs of skill, echoing Wedgwood's own achievements. The Corning Glass Museum in New York State has gathered a collection of these, including a remarkable 1876 glass version from the Red House Glassworks, Wordsley, England, which took three years to complete.

The original Portland Vase is off the market, 'priceless' in every sense of the word. But it has continued to generate spinoff value, its own celebrity magnified by the fame of its copies, from Wedgwood's 'original duplicates' to the £5000 custom-ordered copy available through the British Museum gift shop, alongside £30 neckties and scarves decorated with images from the vase. Along this commodity chain, each version relates metonymically to the original, with diminishing but still real returns. Wedgwood might therefore be considered an ancestor of more recent artist-entrepreneurs like Thomas Kinkade, claimed to be the most successful living artist.[15] He sold millions of paintings worldwide, often through outlets in shopping malls, at varying price points depending on the amount of handwork on the canvas, from his autographed originals to colour prints. Wedgwood's approach was less calculated, but he did understand how a system of commodities could circulate around an original.

In an ironic, Hitchcockian twist, the Wedgwood Company recently filed for bankruptcy—victim of offshore manufacturing and rising pension costs. The company's museum in Barleston, Stoke-on-Trent, has been threatened with closure and the auction of its assets. If this happens, the top lot will unquestionably be the earliest known copy of the Portland Vase, which might fetch as much as £1 million. Had Wedgwood not manufactured uniqueness so very effectively, then his company's archive would be of historic, rather than financial, interest. Then, perhaps, the museum dedicated to his achievements would have a more secure future.

14  In Margaret Bertha Wright, 'Ceramics', Art Amateur 7, no. 2 (July 1882): 31–3, 31.

15  See Susan Orlean, 'Art for Everybody', New Yorker, 15 October 2001, pp. 124–30.

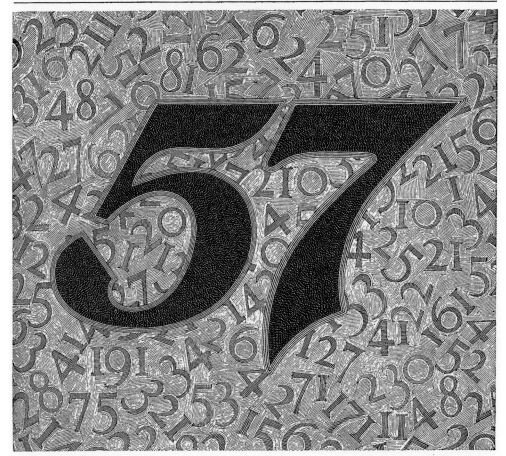

© 1923, H. J. H. Co.

56 is just a number—58 is just a number—but *57* means good things to eat

# Here are Heinz *57* Varieties. *How many do you know?*

1 Heinz Baked Beans with Pork
  and Tomato Sauce
2 Heinz Baked Beans without Tomato
  Sauce, with Pork—*Boston Style*
3 Heinz Baked Beans in Tomato Sauce
  without Meat—*Vegetarian*
4 Heinz Baked Red Kidney Beans
5 Heinz Peanut Butter
6 Heinz Cream of Tomato Soup
7 Heinz Cream of Pea Soup
8 Heinz Cream of Celery Soup
9 Heinz Cooked Spaghetti
10 Heinz Cooked Macaroni
11 Heinz Mince Meat
12 Heinz Plum Pudding
13 Heinz Fig Pudding
14 Heinz Cherry Preserves
15 Heinz Red Raspberry Preserves
16 Heinz Peach Preserves
17 Heinz Damson Plum Preserves

18 Heinz Strawberry Preserves
19 Heinz Pineapple Preserves
20 Heinz Black Raspberry Preserves
21 Heinz Blackberry Preserves
22 Heinz Apple Butter
23 Heinz Crab-apple Jelly
24 Heinz Currant Jelly
25 Heinz Grape Jelly
26 Heinz Quince Jelly
27 Heinz Apple Jelly
28 Heinz Dill Pickles
29 Heinz Sweet Midget Gherkins
30 Heinz Preserved Sweet Gherkins
31 Heinz Preserved Sweet Mixed Pickles
32 Heinz Sour Spiced Gherkins
33 Heinz Sour Midget Gherkins
34 Heinz Sour Mixed Pickles
35 Heinz Chow Chow Pickle
36 Heinz Sweet Mustard Pickle
37 Heinz Queen Olives

38 Heinz Manzanilla Olives
39 Heinz Stuffed Olives
40 Heinz Ripe Olives
41 Heinz Pure Olive Oil
42 Heinz Sour Pickled Onions
43 Heinz Worcestershire Sauce
44 Heinz Chili Sauce
45 Heinz Beefsteak Sauce
46 Heinz Red Pepper Sauce
47 Heinz Green Pepper Sauce
48 Heinz Tomato Ketchup
49 Heinz Prepared Mustard
50 Heinz India Relish
51 Heinz Evaporated Horse-Radish
52 Heinz Salad Dressing
53 Heinz Mayonnaise
54 Heinz Pure Malt Vinegar
55 Heinz Pure Cider Vinegar
56 Heinz Distilled White Vinegar
57 Heinz Tarragon Vinegar

If you know only 4 or 5, you can be assured that the other 53 or 52 are just
as good. If your grocer does not have the ones you want please write us

## H. J. Heinz Company, *Pittsburgh, Pa.*

*Heinz 57 advertisement, 1923. Courtesy H.J. Heinz Company.*

# 32

# Heinz 57 Varieties, USA
# (Henry J. Heinz & L. Clarence Noble, 1869)

*Michael J. Golec*

## Numerical Iconicity

A brand helped Heinz take up a monopolistic position in the post-Civil War marketplace in the United States. The brand assisted, it acted; in other words, it made a difference. '57 Varieties' appealed to mundane objectivity as an inventory of good food. As an entreaty to a community of consumers, the brand *added up*, in what I call its numerical iconicity, to the eradication of any semblance of a divide between the factory and the home. Heinz was not only in the business of selling processed food to Americans, the company distributed the idea of goodness and purity to kitchens in the United States. '57 Varieties' transported the idea of quality to American homes—that it should be shared—as much as bottling and canning procedures did.

'57 Varieties' allowed Heinz to achieve its market position, in no small part, by way of its numerical iconicity.[1] When I refer to numerical iconicity I mean to acknowledge how an emphasis on numbers and figures constructs and registers an experience of reality as an additive or cumulative process. Following C.S. Peirce's notion that icons as units of signification resemble their objects, but not always in 'looks', I take the syntactic and typographic structure of '57 Varieties' to *resemble* the multiplicity of production and consumption such that it very effectively drew these two arenas together. Numerical iconicity, therefore, admits to the importance of multiplicity in the supply of and in the demand for mass-produced goods. The Heinz brand's tally of goods translated supply-side initiatives into demand-side innovations, thereby producing new habits of food preparation in the home. Where there was more in the factory and on the shelves of stores there was more in the household cupboard. Multitudes were (and are still) aggregated into the trademark slogan. That numerical iconicity shaped social quantities and qualities testifies to the effect and endurance of the brand.

Founder Henry Heinz established his iconic brand '57 Varieties' in 1896 while on one of his many sales trips to New York City. As the often-repeated story goes, Heinz was riding a Third Avenue 'el' (elevated train), somewhere between the forties and the sixties, when he came upon an advertising sign for twelve styles of shoes. Excited by the prospect of advertising numbers of products, Heinz performed a mental count of his company's product line. He was soon into the sixties, but kept returning to fifty-seven. Mulling over the number, Heinz later recalled that (fifty) seven had a special significance such that '"58 varieties" or "59 varieties" did not appeal at all.'[2] Thus, by instituting the '57 Varieties' brand, Heinz had established the 'most substantial tool' in the marketing of Heinz products.[3] The numerical iconicity of the brand—numbers structuring spaces—made sense in a world where more and more goods populated an expanding marketplace. Indeed, the growth of industry, agriculture, and urban dwelling space in the late nineteenth century, better known as the Gilded Age, provided a medium for capitalism to flourish.

In the case of canned and bottled foods, however, such a market expansion was not without its detractors. Consumer scepticism increased as a result of on-going, unregulated

1  Brian Rotman, Mathematics as Sign: Writing, Imagining, Counting *(Stanford, CA: Stanford University Press, 2000).*

2  *In Nancy F. Koehn, 'Henry Heinz and Brand Creation in the Late Nineteenth Century: Making Markets for Processed Food',* Business History Review 73, no. 3 (Autumn 1999): 378. On the history of Heinz see Stephen Potter, The Magic Number: The Story of '57' (London: M. Reinhardt, 1959); Robert C. Alberts, The Good Provider: H.J. Heinz and His 57 Varieties (Boston: Houghton Mifflin, 1973) and Eleanor Foa Dienstag, In Good Company: 125 Years at the Heinz Table, 1869–1994 (New York: Warner Books, 1994).*

3  *Koehn, 'Henry Heinz', 392.*

expansion in bottled and canned food production. Dodgy food products and the rise of a dubious shopper created an opportunity for Heinz, who in 1869 with the founding of his company, had established a national reputation for pure goods. All marketing materials produced by Heinz himself or within the company emphasized distinction in a crowded marketplace. Indeed, a community of quality conscious consumers would form around pure food products. That there existed '57 Varieties' (and more) only encouraged such a community to grow. Heinz's great innovation was his emphasis on brand recognition, which was due in no small part to the numerical iconicity of his trademark slogan.

Today, the idea that a brand can function like a tool (a translator or a mediator) is hardly new, but in the late nineteenth century, Heinz's application and use of '57 Varieties' was an innovation in the marketplace. Not only did he apply '57' to his product labels, he also inscribed the number on the side of mountains, so that passengers on trains would be treated to the spectacle of variety, on the pier in Atlantic City, and on Manhattan's first electric sign on Fifth Avenue and 23rd Street. He even went as far as to name the company organ *The 57*.

As Theodor Adorno once observed, 'Mass culture is unadorned makeup. It assimilates itself to the realm of ends more than anything else with a sober look that knows no nonsense.'[4] Adorno knew well a history where purpose or function challenged aesthetic barbarism but too easily degenerated into the very ornament it sought to depose. He added, 'The practical is all the more beautiful, the more it repudiates the semblance of beauty.'[5] Yet semblance was hardly done away with where and when there were appeals to the practical. Enchantment reached a new measure of brilliance where the success of its special effects was in direct proportion to its lack of illusion. Nowhere was this more the case than in Heinz's declaration, '57 Varieties of good things to eat.'

## Variety and Universality

The Heinz brand produced and promoted an illusory universality where the food manufacturer sought to unify all manner of mass-produced items under the commodity. Heinz's '57 Varieties' in the form of a label and a bottle unified processed condiments, giving them shape and delivering then to the consumer in the name of variety. The Heinz trademark slogan also unified consumers who increasingly put aside rational reflection to identify with a whole range of signifiers reflected in the commodity sign. This isn't to say that consumers were duped into giving up informed consideration in the face of advertising. Indeed, such a diagnosis might be far more disturbing, since we have to admit that consumers were fully aware of their enchantment when facing the trademark. This is what Adorno meant when he criticized mass culture as 'unadorned makeup'. Yet, branding products required that manufacturers take responsibility for the quality of their goods, since there was a name attached to the stuff circulating as consumables, thus heightening accountability.[6]

In striving toward universality, no matter how illusory, '57 Varieties' formed a collective of consumers of goodness and purity. In 1906, the United States Congress passed the Pure Food and Drug Act, the result of which was boom in sales for Heinz.[7] Because packaged food producers were legally bound to abide by the 1906 law, the public became more trusting of what they found on the grocer's shelves. Home preparation of condiments declined in favour of store-bought items, thereby shifting the habits of consumption in the home. An effective marketing and advertising programme could alter the flow of power from producer to consumer. In the case of Heinz, Koehn argues, 'By establishing a credible brand that offered taste, purity and convenience, Heinz showed the benefits of processed foods, encouraging them to purchase mass-produced goods that they had once made at

**4** *Theodor W. Adorno, 'The Schema of Mass Culture', in J. M Bernstein (ed.),* The Culture Industry: Selected Essays on Mass Culture *(London: Routledge, 1991), p. 78.*

**5** *Adorno, 'The Schema', p. 78.*

**6** *Susan Strasser,* Satisfaction Guaranteed: The Making of the American Mass Market *(New York: Pantheon Books, 1989), pp. 30–7.*

**7** *Dienstag,* In Good Company, *pp. 42–5.*

home.'[8] Having bet on purity since 1869, when the company was formed, Heinz had greatly influenced the American culinary culture. Far from the illusory at the turn of the century, the 1906 law matched the prerogatives of the brand and the expectations of the consumer. Heinz's motto—good things to eat—became a maxim for the nation.

The Heinz brand was but a method of forming contiguity—a mapping of consumables to feelings and ideas. In an atmosphere of market contingency, '57 Varieties' guaranteed quality and thereby made way for the manufacturer to control the marketplace. Diversity may have been a goal, but diversity had to be averaged out so that variety came to the kitchen under the auspices of Heinz. The Heinz trademark slogan was deeply implicated in the tendency toward not only the diversification of capital, but also the diversification of flavours and uses.[9] Therefore, a tabulation of all Heinz sales nationwide would certainly have shown signs of variation. The variability of output and consumption, in quantitative terms, would have to reconcile with the variety of tastes and habits of preparation, in qualitative terms.

No doubt numerical iconicity, 'more is more', as Heinz was known to say, helped to square the quantitative with the qualitative.[10] The issue of credibility was important here, because Heinz's promise of quality was *performative*: the felicitous results of the promise could only have been judged from inside the home, on the plate and according to one's standard of culinary taste.[11] Of course, marketing was in the business of *averaging* America's standard of taste. Numerical iconicity confronted the problem of there being too many items to ascertain the universality of 'good' and 'pure'. In other words, '57 Varieties' communicated difference on the crowded market shelf. The trademark slogan was a 'sign' for individuality (and not some actual thing in the world) in a marketplace of increasingly standardized products. The prospects of diversification only made quality a more appealing outcome.

## Exact Reproducibility

The technological advances of typographic modernity and mechanical reproducibility made it possible for '57 Varieties' to imprint itself upon everything, thus lending its statistical aura to the most common items—ketchup, horseradish, steak sauce and the rest. The trademark slogan went where sales people (or 'travellers', as they were called at Heinz) went, accompanying them on the job. Also, it travelled where sales people could not. '57 Varieties' followed consumers home, took hold of the advertising space that was the cupboard, occupying valuable real estate on the shelves of American houses. It could do this because of typographic modernity. The character (*typos* or *ethos*) of the trademark slogan allowed it to circulate through all manner of spaces, many of which were not accessible to human agents of the company.

The exact reproducibility—what the sociologist of science Bruno Latour identifies as, the 'immutable mobility'—of the mark lent it a consistency of message across a heterogeneous range of sales opportunities.[12] The trademark slogan '57 Varieties' provided a means to effect change in the marketplace by assembling new allies in marketing, advertising and sales. These allies enhanced sales through the flow of numerical iconicity—information—from one location to another by way of lab print media at all scales of reproduction. The sheer quantity of the same reinforced the association of quality across the entire Heinz product line, both inside and outside the home. The brand distributed numerical iconicity within exact reproducibility of labels, advertisements, signs, billboards and all manner of packaging and marketing media.

8 Koehn, 'Henry Heinz', 352.

9 Frederic J. Schwartz, 'Commodity Signs: Peter Behrens, the AEG, and the Trademark', Journal of Design History 9, no. 3 (1996): 153–84.

10 Dienstag, In Good Company, p. 41.

11 Michael J. Golec, "'The Thinking Man's Filter'": J. L. Austin's Ordinary Language Philosophy as Cultural Criticism', Cultural Critique 72, no. 1 (2009): 66–88.

12 Bruno Latour, 'Drawing Things Together', in Michael Lynch and Steve Woolgar (eds), Representation in Scientific Practice (Cambridge, MA: MIT Press, 1990), pp. 19–68.

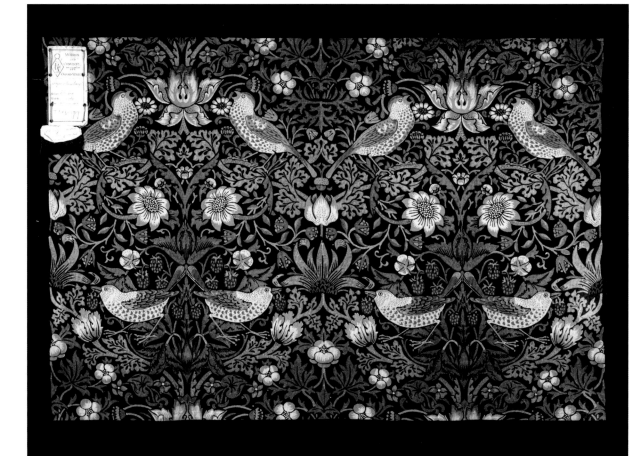

*'Strawberry Thief' furnishing fabric, William Morris, 1883. © Victoria and Albert Museum, London.*

# 33

# 'Strawberry Thief', UK
# (William Morris, 1883)

*Emma Ferry*

'Strawberry Thief' is one of William Morris's best-known designs. Often described as 'iconic', this endearing furnishing fabric resulted from Morris's careful study of natural forms and his painstaking experiments with organic dyes. Designed as a block-printed chintz, 'Strawberry Thief' is now machine-made; however, the iconicity of the design depends not so much upon its uninterrupted production, but rather upon its reproduction on a variety of objects that range from coffee mugs to smartphone cases.

## 'Rascally Thrushes' and Indigo Vats

'Strawberry Thief' is a formal mirrored repeat pattern depicting pairs of birds set among stylized summer flowers, foliage and fruit. While the red strawberries of the design are similar to those illustrated in Gerard's *Herball* (1597), the birds, a significant motif in Morris's textile designs, are based upon his close observation of nature. Textile designer and historian Jacqueline Herald notes how Morris practised drawing birds.[1] This skill is apparent in 'Strawberry Thief', which I suggest depicts two distinct members of the thrush family (*Turdidae*): the speckle-breasted singers are song thrushes (*T. philomelos*), whilst the thieves, with their noticeably darker wings, are mistle thrushes (*T. viscivorus*). The antics of these birds in the kitchen garden at Morris's home at Kelmscott Manor provided the inspiration for this iconic design. His younger daughter, the designer May Morris, recalled:

*You can picture my Father going out in the early morning and watching the rascally thrushes at work on the fruit-beds and telling the gardener who growls, 'I'd like to wring their necks!' that no bird in the garden must be touched. There were certainly more birds than strawberries in spite of attempts at protection.*[2]

The use of pairs of birds in this distinctive 'turn-over pattern' is characteristic of the textiles designed by Morris from 1876 to 1883; this feature relates to his woven textile designs and is based on his study of Medieval Italian silks at the South Kensington Museum (now the V&A).[3] The birds play an important role within the design's structure, a net 'framed of variously proportioned diamonds'—one of the basic forms of pattern construction described in Morris's lecture 'Some Hints on Pattern Design' (1881).[4] However, as May Morris comments, this net-pattern is 'so concealed that you scarcely see the construction'.[5]

At a time when the British textile industry was dominated by mechanized roller printing, Morris used the ancient technique of block-printing, translating his complex design onto twenty-four pear-wood blocks, carved by Barrett's of Bethnal Green.[6] Similarly, condemning fugitive aniline dyes as 'the foul blotches of the capitalist dyer', Morris used natural substances, particularly indigo, 'the great substantive dye'.[7] Living up to his motto, *se je puis* (if I can), Morris experimented for years before mastering the process of indigo-discharge printing at his Merton Abbey workshops, with the successful production of 'Brother Rabbit', 'Rose and Thistle', 'Bird and Anemone' and 'Borage' in 1882.[8]

1  *Jacqueline Herald, 'On Designing Textiles with Birds', in* William Morris & Kelmscott *(London: Design Council, 1981), pp. 117–23.*

2  *May Morris,* William Morris: Artist Writer Socialist, *vol. 1 (Oxford: Basil Blackwell, 1936), p. 45.*

3  *Peter Floud, 'Dating Morris Patterns',* Architectural Review *(July 1959): 14–20.*

4  *William Morris,* The Collected Works of William Morris, *Volume XXII (London: Longmans, 1914), p. 185.*

5  *Morris,* William Morris, *pp. 44–5.*

6  *Gerald H. Crow,* William Morris Designer *(London: The Studio, 1934), facing 76.*

7  *William Morris, 'Of Dyeing as an Art', in* Arts & Crafts Essays *(London: Rivington, Percival & Co., 1893), pp. 209–10, 205.*

8  *Linda Parry,* William Morris Textiles *(London: Weidenfeld & Nicolson, 1983), p. 49.*

'Strawberry Thief' was Morris's first many-coloured printed chintz. The Merton Abbey Dye Book (1881–92), a handwritten record of the recipes used for printing and samples of fabrics, notes that in printing 'Strawberry Thief' the cloth 'comes 3 times on table',[9] while in a letter to his elder daughter Jenny, Morris wrote that he had been 'anxiously superintending' its first printing.[10] The time-consuming processes, which relied upon the skills of the dyers and printers at Merton Abbey, were described in a booklet published by Morris & Co., in 1911:

*The cotton cloth is first dyed to a uniform dark shade of blue in one of the large indigo vats, and is printed with a bleaching reagent which either reduces or removes the blue colour as required by the design. Mordants are then printed on the white parts, where the red has to come, and the whole cloth is dyed a second time with madder. The process is repeated a third time for yellow … the colours are set by passing the fabric through soap at almost boiling heat. The final treatment is to spread the cloth on the grass with its printed face to the light, so that the whites may be purified and all the fugitive colour removed in nature's own way.[11]*

## 'Strawberry Thief' Forever

Unsurprisingly, its lengthy production process meant that 'Strawberry Thief' was among the most expensive of Morris & Co.'s printed chintzes: May Morris suggested that 'Customers who exclaimed at the prices of the many-coloured chintzes would have done well to visit the works … and watch the whole process of several printings.'[12] Priced at 4/9 shillings per yard (equivalent to £110 in terms of relative income value) it was, nonetheless, one of the most commercially popular patterns,[13] both as a chintz and as an upholstery fabric. Its appeal for contemporaries is explained by the design's 'familiarity with nature that makes it human and entertaining'.[14]

Registered on 11 May 1883, 'Strawberry Thief' was exhibited by Morris & Co. at the Foreign Fair at Boston, Massachusetts, in the winter of 1883 to 84. Displayed as a curtain fabric, the Morris & Co. catalogue suggested: 'The Strawberry-thief would also make a very lovely wall-covering for a small room.'[15] Forty years later, 'Strawberry Thief' curtains were displayed in the 'Room Illustrative of the Period 1888' at the British Empire Exhibition of 1924. Indicative of its iconic status, 'Strawberry Thief' has since featured in other notable exhibitions including two at the V&A: the *Centenary of William Morris* of 1934 and *Victorian and Edwardian Decorative Arts* of 1952.

Far from being consigned to history, 'Strawberry Thief' was produced by Morris & Co. using indigo-discharge and block printing methods, until the company went into voluntary liquidation in May 1940. Morris & Co. was bought by Sanderson & Sons Ltd. from the Receiver for £400;[16] however, the original blocks for 'Strawberry Thief' and other Morris designs were bought as part settlement of a debt by Stead McAlpin, the specialist textile printers and dyers (now part of the John Lewis Partnership). From 1941, Stead McAlpin printed from the blocks for various customers including Thorp, Old Bleach Company, M.S.F Carlisle and Warner & Sons. But finally, in 1980, the original blocks were given to the V&A. However, in 1984 Sanderson relaunched Morris & Co as a separate brand and began producing a range of machine-manufactured wallpapers and fabrics, including 'Strawberry Thief'. The design was also rescaled from its original 52 x 44.5cm (20½ x 17½ in.) repeat and produced as a rotary design by Stead McAlpin for Liberty in the late 1980s.[17] The Textiles Collection at the Whitworth Gallery in Manchester holds original examples of both the Morris & Co. chintz and the rescaled Liberty Tana Lawn version, which side-by-side make for a startling contrast. Still recognizable, despite these adaptations to suit different forms of production and different consumers, it is the enduring popularity of 'Strawberry Thief' that suggests its iconic status.

9 '933 *Strawberry Thief*', Merton Abbey Dye Book, 1882–91; *Sanford and Helen Berger Collection, Huntington Library, California*, p. 49.

10 *Norman Kelvin (ed.), The Collected Letters of William Morris, vol. II: 1881–1884 (Princeton, NJ: Princeton University Press, 1987)*, p. 192.

11 A Brief Sketch of the Morris Movement *(London: Morris & Company, 1911)*, p. 30.

12 *Morris,* William Morris, p. 44.

13 *Linda Parry (ed.),* William Morris *(London: Philip Wilson, 1996)*, p. 262.

14 *Morris,* William Morris, p. 37.

15 *George Wardle,* The Morris Exhibit at the Foreign Fair *(Boston, MA: 1883), K1598: William Morris Gallery, Walthamstow.*

16 *Michael Parry,* Morris & Co. *(Denham: Morris & Co., 2011)*, p. 44.

17 *Alan C. Cook, Archivist, Cummersdale Design Collection, part of the John Lewis Partnership Textile Archive, email 2 April 2012.*

## 'If I can' to iPad

If the word *iconic* has been overused and misapplied, it might be argued so too has 'Strawberry Thief'. Although the print appeared on Royal Mail postage stamps commemorating *British Textiles* issued on 23 July 1982, its ubiquity really began with the manufacture of Morris merchandise for the V&A Exhibition *William Morris 1834–1896* in 1996. The museum's collection holds the original blocks and a sample of the chintz and displays an example of the transfer-printed stoneware mug decorated with 'Strawberry Thief' manufactured by Dunoon Ceramics for the 1996 Centenary Exhibition.

Certainly since 1996, the number of 'Strawberry Thief' commodities has expanded— due largely to the use of digital technologies in reproducing patterns: 'Strawberry Thief' is among the many Morris designs available on CD-ROM. Machine-printed, available in several colour-ways in both drape and upholstery weights, 'Strawberry Thief' is also produced as a wallpaper, even though 'Morris considered that design for a flat surface was one thing, and design for chintz, usually hanging in folds, was another.'[18] Cushions and 'tapestries' can be bought, or made at home using 'Strawberry Thief' embroidery kits, and to ensure success, the home-stitcher can buy a coordinated range of Liberty 'Strawberry Thief' sewing equipment (scissor cases, tape-measures, sewing boxes, thimbles, button jars and pin cushions), and a sewing box in which to store them.

Similarly, garments and accessories, including scarves, ties and watch straps, are available in the Liberty version of 'Strawberry Thief'. An innovative collaboration, 'Liberty X Nike' (2008) resulted in a pair of trainers, where three signature Liberty prints including 'Strawberry Thief' create a 'perfect juxtaposition with the clean design lines of the Dunk silhouette' according to the Nike website. More recently, in May 2012, Liberty's 'Wild Nature' collaboration with Doc Martens has produced a dual-branded version of the 8-Eye Boot (and matching leather satchel) decorated with 'Strawberry Thief'.

For a market with more traditional tastes, 'Strawberry Thief' appears on PVC tote bags, umbrellas, gardening tools and kitchen textiles, including an alarming red version manufactured by Ulster Weavers: here, Morris's painstaking experiments with indigo have been forgotten. Many 'Strawberry Thief' items are sold in the shops of heritage organizations with Morris connections, including Kelmscott Manor; the refurbished William Morris Gallery at Walthamstow, and the National Trust, which owns Morris's Red House and properties with Arts & Crafts Movement interiors including, notably, Wightwick Manor, where an example of a chair covered in 'Strawberry Thief' stands in the Great Parlour. Kelmscott Manor, where the walls of the 'Old Hall' were once hung with 'Strawberry Thief',[19] now sells mugs and jugs that feature the thieving mistle thrush and his stolen strawberry. This fugitive rascal—who first escaped onto presentation packs for the commemorative stamps designed by Peter Hatch—has also inspired a range of jewellery; stained glass and gifts, such as Matt Sewell's handmade wooden bird and berry made exclusively for the V&A Shop. Museum & Galleries Marketing Ltd., which manufactures cards, stationery and gifts for the cultural sector, also offers a range of coordinated 'Strawberry Thief' goods, made under licence from the V&A, which includes Post-it Notes and pencils. For those accustomed to the latest in communications technology 'Strawberry Thief' cases for iPhones, iPods and iPads can be printed-to-order via Zazzle, which is, according to its website, 'the world's leading platform for quality custom products'.

Originally designed for block-printed chintz, 'Strawberry Thief' is now applied to so many other objects that it offers almost as many meanings: to some it represents idyllic summer gardens; to others it means 'William Morris'; 'Arts & Crafts'; 'British Textiles'; or even 'heritage good taste'; while its more recent applications juxtapose the hi-tech with the traditional. Handmade, or handheld, 'Strawberry Thief' is an icon indeed.

18 *Morris,* William Morris, *p. 43.*

19 *Arthur Richard Dufty,* Kelmscott *(London: The Society of Antiquaries, 1984), pp. 4–6.*

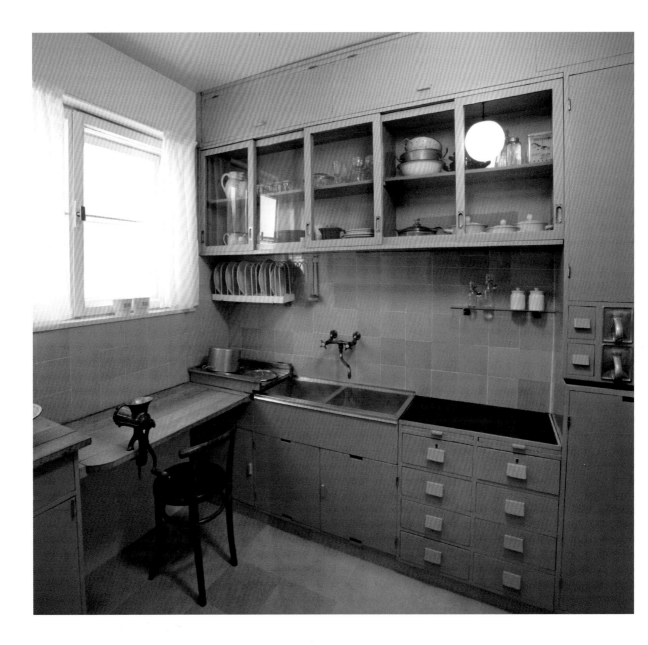

*Frankfurt Kitchen, Germany, designed by Grete Lihotzky, 1926. © Victoria and Albert Museum, London.*

# 34 Frankfurt Kitchen, Germany
## (Grete Lihotzky, 1926)

*Finn Arne Jørgensen*

When contemporary visitors come across one of several surviving Frankfurt Kitchens on display in European and American museums, they may easily miss what made it into an icon of modern kitchen design. After all, it looks very similar to the kitchens we all know from our own homes.

Entering the room through one of the two doors, the visitor faces a compact kitchen with light green cupboards, dark linoleum countertops and a beech work surface under a relatively large window that lets in natural light. The furniture fits perfectly in the small room, utilizing the space as much as possible. A double sink with a water tap reveals that the kitchen had running tap water, not something one could take for granted in the late 1920s. A wall-mounted shelf to the left of the sink holds plates for drying after dishwashing (the placement on the left was intentional, since plates could be placed there after washing and rinsing without switching hands). Doors, many drawers and pull-out labelled aluminium bins provide storage space for food, utensils and other kitchen tools. An electric ceiling lamp is reflected in the sliding glass-windowed doors that let us see into the neatly organized cupboards, while keeping the dust out. A sliding door lets the housewife watch her children play in the adjacent room while working in the kitchen. The cupboards are ventilated, and there is also a ventilation opening over the stove. The built-in rubbish bin can be emptied from the hallway outside the room, and a removable drawer under the work surface allows for easy cleaning. The kitchen furniture is installed on raised concrete platforms to make cleaning easy.

In short, the Frankfurt Kitchen is full of design choices that we have come to take more or less for granted today. At the time of its creation, in 1926, however, the kitchen represented a dramatic reconfiguration of both household work and domestic roles. The kitchen was originally built as part of a large-scale public housing programme in Frankfurt am Main in the 1920s and 1930s, under the leadership of City Architect Ernst May. The 'New Frankfurt' programme rapidly developed after the end of World War I to provide housing for the millions of soldiers who returned, as well as war widows, and served as a testing ground for modern principles of standardization, mass production and technological innovation.

## Grete Lihotzky and the Scientific Management of the Home

Ernst May recruited the young Austrian architect Margrete (Grete) Lihotzky[1] (1898–2000) in 1926 to design a kitchen for his housing programme. While Lihotzky had never run a household and did not cook, not only did she design a kitchen that would change the lives of tens of thousands of workers, she also turned the kitchen into an icon. No longer was the kitchen merely a utility space—it became recognized as a key room in the infrastructure of the home and a design object in its own right.

While studying architecture at the University of Applied Arts in Vienna, Lihotzky visited Viennese workers' districts and saw crowded, run-down houses with poor air circulation, no heating, no electricity and no running water. Kitchens in these houses were multifunctional spaces where residents would cook, eat, socialize, bathe and sleep, but they did none

1 *She changed her last name to Schütte-Lihotzky after marrying the German architect Wilhelm Schütte in 1927.*

of these things very efficiently. Such kitchens were also fairly large, taking up much of the space in the small workers' apartments. For modernist developers, these traditional kitchens represented 'the overcrowded and unhealthy living conditions of the poor'.[2]

Inspired by this, Lihotzky started drawing kitchens, combining progressive thinking with functionalist ideals. She outlined her ideas for the modern kitchen in an article in *Schlesisches Heim*, a monthly architecture journal, in 1921. Here, she called for smaller kitchens modelled after train dining cars, a compact concept that had been well tested in practice. While working for Adolf Loos, then City Architect of Vienna, in the early 1920s, she refined her ideas about kitchens in practice by designing social housing for Viennese workers.

Lihotzky's faith in the transformative potential of scientific work practices stemmed from the international Home Economics movement. Inspired by Frederick Winslow Taylor, who at the beginning of the 1900s developed a vision and a method for scientifically based planning and execution of work, Home Economics developed as a visionary movement for architects, politicians, housewives, writers and others, almost all of whom were women.[3] For Taylor and his followers, inefficiency was an evil to be eradicated; they believed that efficient and rational work practices would lead to social harmony.

The psychologist Lillian Gilbreth was one of the first people to implement Taylorism outside of the factory. Married to Frank Gilbreth, a pioneer in time and movement studies, she was in a unique position to translate between the industrial and domestic spheres. 'The Gilbreth Motion Study Kitchen' implemented the innovative 'kitchen triangle' and linear work surfaces to make kitchen work more efficient.[4]

The Home Economics movement found its unofficial manifesto in 1919, when Christine Frederick's influential book *Household Engineering: Scientific Management in the Home* appeared. Frederick sought to define the essence of the kitchen by stripping away all tasks not related to food preparation. The book is filled with analogies and comparisons between the kitchen, the laboratory and the factory; the modern kitchen should be organized in workstations, on the assembly line principle. In Frederick's writings, the kitchen became a society in miniature, where the woman was the administration and the infrastructure, and her husband and children were its citizens. Frederick's book was translated to German by Irene Witte in 1921 and was soon a very important reference for architects in Weimar Germany.[5]

Germany became a testing ground for turning the ideals of the international Home Economics movement into practice. Edna Meyer's book *Der Neue Haushalt* of 1926 was heavily inspired by Christine Frederick and achieved considerable popularity in Germany. Grete Lihotzky was placed firmly on the radical side of the Home Economics movement— her goal was not just to raise the status of the housewife and to make the drudgery of housework easier, but to change society.

## Designing a Rational Factory Kitchen

After starting work for May in 1926, Lihotzky used the methods and principles set down by Gilbreth and Frederick as she worked closely with housewives and kitchen manufacturers to find the most rational approach to housework.[6] Armed with a stopwatch, she observed, timed, deconstructed and reconstructed the series of motions housewives performed in the kitchen, while integrating electricity and electrical appliances into her kitchen. She also carefully considered window placement, colours, lighting and the relationship between the kitchen and the rest of the house, to maximize efficiency. One of her main goals was to make the kitchen as compact as possible, in order to minimize the distance the housewife had to move. The kitchen was small by current standards, at 1.9 by 3.44 meters.[7] At this size, even one person might be uncomfortable there.

2  Martina Heßler, 'The Frankfurt Kitchen: The Model of Modernity and the "Madness" of Traditional Users, 1926 to 1933', in Ruth Oldenziel and Karin Zachmann (eds), Cold War Kitchen: Americanization, Technology, and European Users (Cambridge, MA: MIT Press, 2008), p. 166.

3  Sarah Stage, 'Home Economics: What's in a Name?' in Sarah Stage and Virginia B. Vincenti (eds), Rethinking Home Economics: Women and the History of a Profession (Ithaca, NY: Cornell University Press, 1997), p. 3.

4  Sarah Abigail Leavitt, From Catharine Beecher to Martha Stewart: A Cultural History of Domestic Advice (Chapel Hill, NC and London: University of North Carolina Press, 2001), p. 56.

5  Greg Castillo, Cold War on the Home Front: The Soft Power of Midcentury Design (Minneapolis: University of Minnesota Press, 2010), p. 9.

6  Charles S. Chiu, Women in the Shadows: Mileva Einstein-Marić, Margarete Jeanne Trakl, Lise Meitner, Milena Jesenská, and Margarete Schütte-Lihotzky, Austrian Culture vol. 40 (New York: Peter Lang, 2008), p. 180.

7  Karel Teige, The Minimum Dwelling (Cambridge, MA: MIT Press, 2010), p. 218.

The Frankfurt Kitchen, with its planned layouts and built-in cabinets, complete with all the necessary equipment, was installed in about 10,000 apartments in the Höhenblick Housing Estate in Frankfurt am Main during the 1920s and 1930s, but it also inspired many kitchens worldwide. The ideas it gave form to spread and became refined and upgraded with new technologies such as the refrigerator.

Perhaps the most innovative aspect of Lihotzky's kitchen design was her close attention to the principles of mass production, standardization and cost reduction, which brought high-standard, rational kitchens within the reach of ordinary people. It closely aligned users' needs, public interest, kitchen design and production capability. The large production scale of Frankfurt's public housing programme was critical to Lihotzky's approach, making the Frankfurt Kitchen into a factory kitchen in more ways than one. It was not the only kitchen based on scientific principles and modernist ideology at the time, but the close integration with the Frankfurt housing programme made it the most significant.

## Iconic Domesticity

The Frankfurt Kitchen's iconicity stems from its position at the junction of the domestic sphere, theories of scientific management and the large-scale public housing programmes of the 1920s. In making the Frankfurt Kitchen, Grete Lihotzky connected the domestic to the political and the scientific. She isolated the kitchen from the rest of the house to keep cooking noises and smells away from the living areas. Her design encouraged proper posture through the use of the correct work height and the placement of equipment. The kitchen went from being a multifunctional space (for cooking, eating, socializing and sleeping) to 'a superbly specialized and technically well-equipped laboratory or—if you will—a miniature factory'.[8] Lihotzky stripped away all functions not essential to food preparation to seek the essence of the kitchen. In so doing, she wanted the kitchen to become a fulcrum of social change and women's emancipation. This is perhaps the key reason why the Frankfurt Kitchen became so central to the German idea of *Existenzminimum*, a life without superfluous and unnecessary elements.[9]

Lihotzky's kitchen design represented women not just as consumers, but also as serious users and designers of technology. In this approach, she perfectly channelled the Home Economics movement's credo that household work was professional work requiring appropriate skills, knowledge and proper tools. At the same time, German housewives were not invited to contribute to the conceptual design stage. Since the kitchen was intentionally designed to break with existing working-class household routines, some users resisted Lihotzky's and the modernist planners' ideas of progress and modernization. Critics argued that women became isolated in the Frankfurt Kitchen and could no longer watch their children or share the kitchen work with others. Other users struggled with the new electrical appliances and what they considered low-performing new technologies.[10]

The debate over who should do the work in the home, how they should do it and why continues. While the kitchen innovations that Lihotzky implemented have now become so ubiquitous as to be invisible, kitchens are far from hidden away in contemporary architecture. They are the centrepiece of many modern houses, having returned to the multifunctional role of older kitchens. The real heritage of Grete Lihotzky's Frankfurt Kitchen rests not so much in the kitchen as a preserved iconic artefact, but rather in the ubiquitous invisibility of the innovations it introduced.

8 *Ibid.*
9 *Jonathan M. Woodham, Twentieth-Century Design (Oxford: Oxford University Press, 1997), p. 50; Teige, Minimum Dwelling, p. 216.*
10 *Heßler, 'The Frankfurt Kitchen', p. 177.*

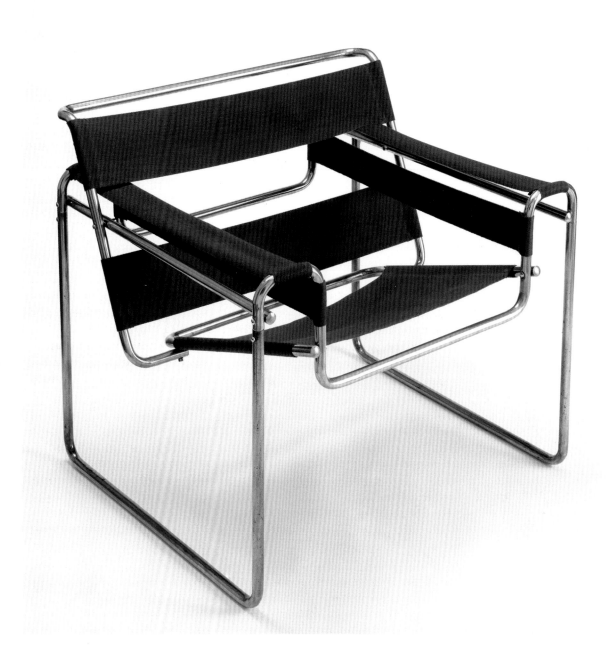

*Armchair, tubular steel with canvas, designed by Marcel Breuer 1925–6 and manufactured by either Standard Möbel or Thonet Möbel in 1927–8, Germany. © Victoria and Albert Museum, London.*

# 35

## *Clubsessel,* 'B3' 'Wassily' Chair, Germany (Marcel Breuer, 1927)

### *Clive Edwards*

### Chairs as Icons

Chairs have received an immense amount of media attention as 'objects of desire', filling books and magazines ad nauseum, with many of them being described as icons.[1] One particular example, the Eames-designed Lounge Chair and Ottoman, described as an icon of modern design, even had its own individual exhibition and book-length catalogue devoted to it as a celebration of its fiftieth birthday.[2]

Iconic chairs, whether the humble Thonet bentwood café chair or Rietveld's red/blue chair, are distinctive objects with essential differences from other chair designs. Iconic chairs offer the viewer/user a complex story that makes reference to a number of facets reflecting the chairs' production, materials, cultural references and points of distinction. Furthermore these chairs can act as signs of ritual, status, lifestyle and identity, upon which choices and consumption patterns are based. Chairs can also be bearers of aesthetic values in which objects have a dual role as function and as a sign in systems of distinction. The iconic status of a chair is therefore defined by the methods and degree to which we recognize and respect it in our common memory. The adulation that iconic chairs are given is reflected in the fact that they are often looked at as much as they are sat in.

Chairs can be recognizable, memorable and representative of an idea or concept. The status of a chair is established through being seen to invoke a valuable narrative of innovation, primacy and impact. As icons, chairs are recognized widely, so they reinforce their own myths and generate publicity that is self-perpetuating.

### B3 Chair as Paradigm of Modernity

By the mid-twentieth century, there was established a set of particular examples of chair design that, it has been suggested, reflected a universal authority and a moment in design evolution that was of great import. Generically these were tubular steel framed chairs of various designs. The critic Reyner Banham pointed out that 'through all these reversals of fortune and reputation, the tubular steel chair remains; physically it remains as one of the artefacts by which remote future archaeologists will recognize the Twentieth century; symbolically it remains as the most nearly perfect embodiment of the Platonic Ideal of Modernity'.[3]

The first, and one of the most particular of these tubular steel chairs, was the *Clubsessel* aka 'B3' or 'Wassily' chair, designed by Marcel Breuer from 1925 to 1927. The rhetoric of the Breuer design is often seen as functional design par excellence. Its materials are a metaphor for modernity, technical progress, efficiency and standardization. The chair argues for modern design and its virtues, and is often seen as modernism exemplified.

### Origins and Development of the B3 Chair

The mythology of the B3 chair suggests that Breuer got the idea from his bicycle's handlebars. Indeed he first mooted his idea of steel tube chairs to the cycle maker Adler,

**1** *See for example, Alexander von Vegesack (ed.),* 100 Masterpieces from the Vitra Design Museum Collection *(Weil-am Rhein: Vitra, 1996); Charlotte and Peter Fiell,* 1000 Chairs *(Cologne: Taschen 2000);* Chairs: Catalogue of the Delft Faculty of Architecture Collection *(Rotterdam: 010 Publishers, 2010).*

**2** *Martin Eidelberg, Thomas Hine, Pat Kirkham, David A. Hanks and C. Ford Peatross,* The Eames Lounge Chair: An Icon of Modern Design *(Grand Rapids, MI and New York: Grand Rapids Art Museum in association with Merrell, 2006).*

**3** *Reyner Banham, 'Introduction',* Tubular Steel Furniture *(London: Art Book Company, 1979).*

who showed no interest, but later he used his own cycle frame tube as a guide to the choice of size for use in his chair. It was no coincidence that in the same year as the unveiling of Breuer's chair (1925), Le Corbusier presented in the Paris exhibition's *Pavilion de L'Esprit Nouveau* a staircase made of tubular steel, which he said was 'built like a bicycle frame'.[4] From its inception the bicycle had been a product of modern technologies and thus a symbol of modernity that was both an object and a sign.

The technology of seamless steel tubes was developed and patented in 1885 by the Mannesmann brothers. The tubing was soon used for a number of applications in industry including bicycle manufacture. In 1921, Machinefabrik Sack Gmbh patented a process for producing a thinner walled tube with the same strength-to-weight ratio that allowed for easier shaping. The way forward for furniture was soon evident.

Breuer's B3 chair is based on the frame outline of the traditional upholstered club chair. Reduced to its skeletal elements, it offers the minimal structure for supporting the sitter. Philosopher Arthur Danto invokes the B3: 'Descartes spoke of the pineal gland, a mysterious organ midway between the cerebral hemispheres—like the seat of Breuer's Wassily chair, suspended between two chrome forms—as the situs of the thinking essence of man.'[5] Indeed, Breuer saw this suspension in supported space as a stage of chair development that would ultimately lead to sitting with no frame at all by simply being supported on columns of pressurized air. Breuer was fully aware of the novelty of his design: 'Two years ago, when I saw the finished version of my first steel armchair, I thought that this out of all my work would bring me the most criticism. It is my most extreme work both in its outward appearance and in the use of materials; it is the least artistic, the most logical, the least "cozy" and the most mechanical.'[6]

Breuer was clearly influenced by the Dutch De Stijl group and El Lissitzky's Prouns artworks, with their compositions of lines and planes, which led to his own considerations of designing chairs that simulated a frame of lines in space without mass. In addition to his developing reductivist programme, he wanted to exploit the modernness of the material. He said:

*Strict standardization of the elements—the use of the same components in different furniture styles—and their reduction into two-dimensional parts (so that about fifty lounge chairs are packed into one cubic metre) results in efficiency of transport. Without me doing all the work, including full consideration of the operational manufacturing demands, the social goal of an affordable price for the broadest masses would not be achieved.[7]*

Interestingly, it was not just modern materials that interested Breuer. Discussing the supporting materials he commented, 'The taut cloth forming the back and seat rests are of a material so far used for tropical belts and bootlaces … The traditional materials thus take on a new meaning, with unknown and so far overlooked potentialities.'[8]

The exact nature of this iconic chair has undergone a number of changes from the prototype to the more recent re-issues. Variations in models demonstrates this process, from the innovative original welded workshop version with four small 'feet' to the screwed-frame sledge versions produced by Standard-Möbel, Lengyel & Company through the Thonet (non-Breuer) versions of 1930/31, which added a cross brace and amended the seat fixing, to the various re-issues of the 1960s onwards. For iconic chair fetishists, the detail of the evolution and adaptation of the chair is very important.

The B3 is technically and aesthetically related to a number of other iconic tubular chair products that represented similar ideals. These included the chairs designed by architects Le Corbusier and Charlotte Perriand, including the LC2 Armchair (1928) and the

4 *Le Corbusier,* Almanach d'Architecture Moderne *(Paris: Cres, 1925), p. 195, cited in Siegfried Giedion,* Mechanisation Takes Command *(Oxford: Oxford University Press, 1948), p. 492.*

5 *Arthur Danto 'Seat of the Soul' in* Philosophizing Art Selected Essays *(Berkeley: University of California Press, 1999), p. 148.*

6 *Christopher Wilk,* Marcel Breuer Furniture and Interiors *(New York: Museum of Modern Art, 1981), p. 38.*

7 *Marcel Breuer, 'Metallmöbel und moderne Räumlichkeit' (Metal furniture and modern space), in* Das Neue Frankfurt *(The New Frankfurt), no. 1 (Frankfurt am Main: Englert and Schlosser, 1928), p. 11. Original German text:* Die strenge Normung der Elemente - die Verwendung derselben Elemente bei den verschiedenen Möbelsorten - ihre Zerlegbarkeit in zweidimensionale Teile (über 50 Stück Klubsessel sind in ein m3 verpackbar: Wirtschaftlichkeit des Transports), und die volle Berücksichtigung der betriebstechnischen, fabrikatorischen Forderungen ergaben nun den sozialen Maßstab, den von den breitesten Massen bezahlbaren Preis, ohne den mich die ganze Arbeit nicht besonders befriedigt hätte.

8 *Marcel Breuer,* Berliner Tageblatt, *19 October 1929, cited in Giedion,* Mechanisation Takes Command, *p. 493.*

LC4 Chaise Longue (1928). The LC2, which is essentially an externally framed *clubsessel*, is a far more literal translation with less invention than the Breuer chair. Although the LC2 clearly signified modernism by its use of a steel tube frame as an external support, the thick cushions reflect its origins too obviously. Other iconic chairs derived from Breuer's initial working of steel tube for chairs include chairs by W.H. Gispen, Rene Herbst, Luckhardt brothers, Mies van der Rohe and Mart Stam, whilst his influence may also be seen in a whole range of anonymous designs that are not part of the canon.

## Iconic to Ironic: Adaptation and Postmodern Appropriation

The re-issue of this design icon occurred around 1960, when the chair was re-introduced by the Gavina Company in Bologna, Italy, and marketed under the name *Wassily* chair, a reference to Wassily Kandinsky who praised the chair when he first saw it in 1925. Gavina updated the chair with black leather straps, though the original fabric version was still made available. In 1968, the American Knoll Company bought Gavina and with this came all of Breuer's designs. In the same year, iconic status was bestowed upon the chair through the conferment of the Museum of Modern Art Award and by the continued adding of examples to museum collections.

When icons become desecrated there are interesting forces at play. For example, the Italian Studio 65's Capitello chair (1971) made of foam but representing an Ionic stone capitol, seems to send up the symbols of classicism. In the late 1970s, designer and architect Alessandro Mendini 'redesigned' the Wassily chair (amongst other recognized classics) as part of a postmodern approach to debunking icons. He suggested that applied decoration would provide intellectual substance to the chair, so he fitted it with painted wooden cut-out decoration. This heretical approach appears to have been intended to introduce an element of emotion and 'soul' to the apparently sparse and functional iconic chair. Two recent violations/adaptations of the B3 chair exemplify the challenges which icons continue to face. In 2002 the artist Mark Hosking devised his *Nine Inventions for Sustained Development*, including an 'eight-piece conversion kit that transforms Marcel Breuer's iconic *Wassily* chair into an emergency stretcher'.[9] In a rather different vein, though with a similar attitude, the *Criollo* by artist Edgar Orlaineta literally connects the Wassily chair with a bicycle to produce an art work based on the ubiquitous load tricycles used in Mexico.[10] This cleverly links the origins of the chair, the local and international issues of object and identity along with the concept of reuse. In a more subtle way, even the contemporary 'authorized' manufacturers of the chair offer it with a choice of thirty-eight leather colour variations but, crucially, with each chair having Marcel Breuer's signature and the Knoll Studio logo stamped into the frame. Thus the all-important emblem of an icon—that of apparent authenticity—is maintained in the face of numerous copies.

Although the B3 has been unhappily compared to an exercise machine, as well as being seen as ergonomically challenging for many, it remains a classic design that links the material object to the impalpable ideals of modernism. In this sense the chair is no longer just a chair, it is a symbolic representation of an idea.

9 *Mark Hosking, Auto Roto Font (London: Bookworks, 2002).*

10 *Smithsonian Institution, Hirshhorn Museum, 2006, Museum number RA005.* http://hirshhorn.si.edu/ visit/collection_object. asp?key=31&subkey=12. *Accessed 25 April 2012.*

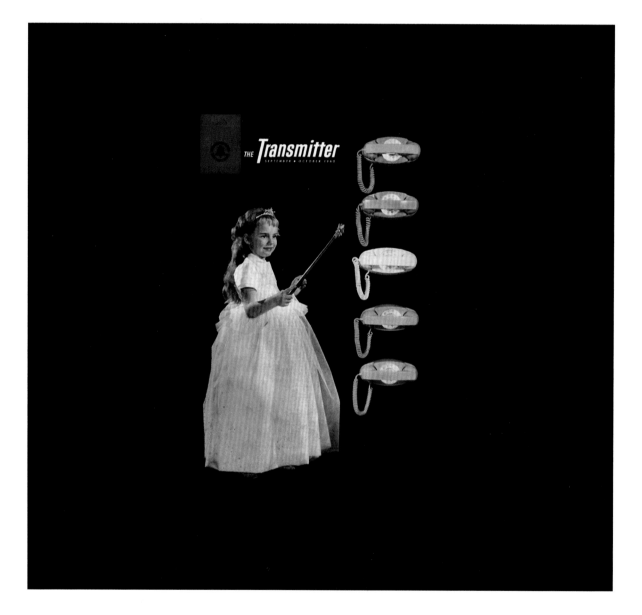

*Princess Telephone on the cover of the Bell magazine,*
The Transmitter, *September–October 1960.*
*Courtesy of the Porticus Centre, Beatrice Technologies, Inc.,*
*subsidiary of Beatrice Companies, Inc.*

# 36 Princess Telephone, USA
## (Henry Dreyfuss for Bell Telephone, 1959)

*Lasse Brunnström*

Telephones are, in my opinion, among the most important artefacts ever produced. Not only have they opened up the possibilities for direct communication over long distances, but they also stand as symbols for an increased dialogue. One of the most striking commercial photographs I know shows a woman resting in a chair chatting into an Ericsson Bakelite telephone. The photograph dates from the 1930s and appears as the perfect symbol for the emerging Swedish welfare state (Folkhem). An even more iconic photographic image shows a group of German workers gathered around and listening with great concentration to a black Volksempfänger standing on a pedestal, which is mediating a propaganda speech. These images make clear the symbolic value of the telephone: *dialogue* instead of one-way radio communication.[1]

It is no coincidence that a woman was shown with the phone in the Ericsson photo. From being a product belonging to the male-dominated corporate office directorates before the 1900s, the phone became, only a few decades later, a typical household appliance and one used especially by women making social calls.[2] 'While women were targeted as principal consumers of phone service in the home, their roles in the workplace typically revolved around the telephone as well', argues the American curator Ellen Lupton. She continues:

*Many jobs pegged as 'women's work' in the [twentieth] century have centered on the device: secretary, receptionist, customer service agent and switchboard operator. Each of these female-dominated occupations has involved a passive use of the phone: women mediate the flow of information by taking messages, transferring calls, receiving orders, dialling for the Boss and so on.[3]*

It may be added that it was also women who dominated the monotonous factory work die-casting mass-produced phone covers.[4]

## From a Symbol of Service to a Consumer Product

The first telephones had appeared by the late 1870s. Since then, three producers dominated technological development in telephony: German Siemens, Swedish Ericsson and, after World War II, American Bell. Until the late 1920s, Europe and the United States focused on two totally different model types: the European handset in which the receiver and the transmitter are linked by a handle and the American standing candlestick phone with a transmitter in a stationary base and a hand-held receiver. By the end of the decade, the Bell Group realized that it must replace its outdated candlestick phones, which occupied both hands. Bell organized a competition inspired by the handset concept. While all ten competition entries' suggestions were refused as more or less unrealistic, at least one of them left a lasting impression. It was a petite handset adorned with speedlines, designed by Gustav Jensen.[5]

1 *The photos are shown in Lasse Brunnström,* Telefonen – en designhistoria *(Stockholm: Atlantis, 2006), p. 17.*

2 *Claude S. Fischer,* America Calling: A Social History of the Telephone to 1940 *(Berkeley: University of California Press, 1992).*

3 *Ellen Lupton,* Archives: The Telephone, I.D. *(USA) 40, no. 5 (1994): 13.*

4 *Brunnström,* Telefonen.

5 *Arthur J. Pulos,* American Design Ethic: A History of Industrial Design *(Cambridge, MA: MIT Press, 1983), p. 341.*

During the 1930s and 40s, almost every telephone was coloured black, made of metal or Bakelite, leased by a telephone company and regarded more as a symbol of the telephone service than as a consumer product in its own right. But when women began to dominate the telephone stage at home and at work, requests for smaller, lighter and more colourful devices gained in influence. Even the Bell Group, which had previously been slow to respond to changes in design and use, reacted to the new markets for their telephones and recruited Henry Dreyfuss as their main design consultant. His mission was to design some new models that would appeal to the average American family. The projects lay dormant during the war but accelerated in the early 1950s. At that time, Bell was alarmed by the information that the Ericsson company had two completely new one-piece phones in the pipeline: the Ericofon (the Cobra phone) and the Unifon (Uniphone), both originally designed by the in-house designer Ralph Lysell in the early 1940s. The Cobra was successfully launched in 1954, while a model of the Unifon was presented to the people of Bell Laboratories in 1946. Studying the variety of experimental models that were presented by the Dreyfuss office, the Unifon—together with the aforementioned Jensen telephone, stands out as their role models.[6]

Another important measure taken by Bell in 1955 was the creation of a new department within the company dedicated to merchandising. Bell now had a powerful tool not only to study customers' needs, but also to determine what customers really *wanted*, something that would prove important in an increasingly segmented market. The first new phone that Dreyfuss and the Bell Labs engineers managed to get into production was a bedside telephone called the 'Lady-Phone' and later named 'Princess'. Giving the phone a name instead of just providing it with a traditional number was a way of priming the consumer market: four different name studies had produced a total of 300 suggestions.[7]

### Feminine by Name and Feminine by Design

The Princess was specifically designed for women and a previously neglected consumer group: teenage girls. It was launched 1959 in white and a suite of pastel colours: beige, pink, blue and turquoise. The inside components were largely the same as those in Bell's volume model 500 but, just like the early Cobra phone, it had no room for a standard ringer, which had to be mounted on the wall. The Princess thereby became extremely compact and light compared to other handsets—*too* light, and with an uneven weight distribution in fact, as the oval phone can spin around on the table when dialling. Users therefore needed to hold the base in place with one hand while using the other to dial and, at the same time, desperately squeezing the handset between their neck and shoulder. No wonder the Princess soon acquired an unflattering nickname from rival firms: 'the two-piece set for three-handed people'. To solve this problem, Bell provided the telephone with a built-in weight, replaced after 1963 with an integral bell. Notwithstanding these problems, the Princess phone featured a new invention with its initial launch: an illuminated face aided dialling in the dark and acted as a bedside light. The latter function was heralded in the accompanying advertisements as 'the silent guardian of your rest'.[8]

Bell launched the Princess with a massive marketing campaign centred upon a special and widely used slogan: 'It's little, it's lovely, it lights.' Other advertisements boasted that: 'America has fallen in love with the new Princess phone', and commanded consumers to 'Promise a Princess phone to someone you treasure.' The princess theme was exploited with advertising copy such as 'To each her own princess'; 'A Princess of her own means privacy for a teen-ager, peace and quiet for parents.' In the Bell magazine *The Transmitter*, a little girl dressed in a white gown and tiara introduced the Princess in

6 *Brunnström*, Telefonen.
7 *Richard Mountjoy*, One Hundred Years of Bell Telephones *(Atglen, PA: Schiffer Publishing, 1995).*
8 *Jay Neale*, The Princess, http://www.beatriceco.com/bti/porticus/bell/telephones-princess.html. *Accessed 10 April 2013.*

five colours with her magic wand, and for a TV advertisement Miss America 1958, Marilyn Van Derbur, marketed the Princess in a similar way.[9]

Companies competing with the dominant Bell System soon presented their own versions of the popular Princess. Kellogg launched the look-alike Cinderella, Stromberg Carlson introduced the Petite, Automatic Electric marketed its Starlite and Northern Electric/Northern Telecom named its competitor the Contessa.[10] The original underwent minor changes through the years and was redesigned with new technology for AT&T's Signature series of 1993.[11] The same year, the Princess was a key exhibit in *Mechanical Brides: Women and Machines from Home to Office* at the Cooper-Hewitt, National Museum of Design of the Smithsonian Institution in New York City. This exhibition and the accompanying catalogue consider the history of design and technology from a female perspective. The book's blurb summarizes the conclusions: 'The telephone, typewriter, washing machine, and electric iron have been central to the definition of "women's work" in twentieth-century America. Cultural ideas about the duties and ambitions of women are reflected and reinforced by the way appliances have been designed, marketed, used, and imagined.' The Princess telephone, characterized as 'feminine by name and feminine by design' in the exhibition and as a 'reclining nude' in the catalogue, is an excellent example of how an artefact can affect and reinforce our perception of what is seen as typically feminine.[12]

## Towards Segmentation and Individualization

The small and decorative Princess telephone marked a new era for the Bell System. Until its introduction, members of a household usually shared a phone set up in the hall. The Princess, however, created a demand for an extension phone. It was made of injection-moulded ABS plastic, which now definitively replaced the black Bakelite, and it was presented in a range of attractive colours. It also marked a shift in marketing and an adaption to an increasing, and increasingly segmented, market. In this regard, the Princess was one of the first nails in the coffins of both a regulated telecommunications market where phones were leased and anonymous mass manufacturing.

The Princess is regarded as an iconic telephone precisely due to the circumstances described here. It was obviously not the first handset telephone; that accolade might be granted to Ericsson's model Ebh from 1884. It was not the first phone in plastic; that was the Monophone from 1925, a little-known Bakelite device manufactured by the Automatic Electric in Chicago. Nor was it the first coloured telephone, as there were many colour experiments with telephones in cellulose acetate in the United States during the 1930s. It was not even the first telephone advertised as a bedside phone, as that had already been done with the Ericofon.[13] Breakthrough products such as these are seldom known by anyone other than experts or connoisseurs. The average consumer instead recognises the bestsellers. The Princess telephone is typical of this group of bestselling artefacts, and it also foreshadows today's gadget-obsessed society, where convenience and personal satisfaction are top priorities, at least in the West.

9 Jody Georgeson (ed.), Dial Log *16, no. 2 (Summer 2012)*, www.telcomhistory. org. *Accessed 10 April 2013.*

10 Neale, *The Princess.*

11 *AT&T, 'Classic AT&T Princess phone now available with new technology', press release, 3 November 1993,* http://www.beatriceco.com/ bti/porticus/bell/princess_ newmodel.htm. *Accessed 10 April 2013.*

12 *AT&T, 'Classic' and Ellen Lupton,* Mechanical Brides: Women and Machines from Home to Office *(New York: Princeton Architectural Press, 1993).*

13 *Brunnström,* Telefonen.

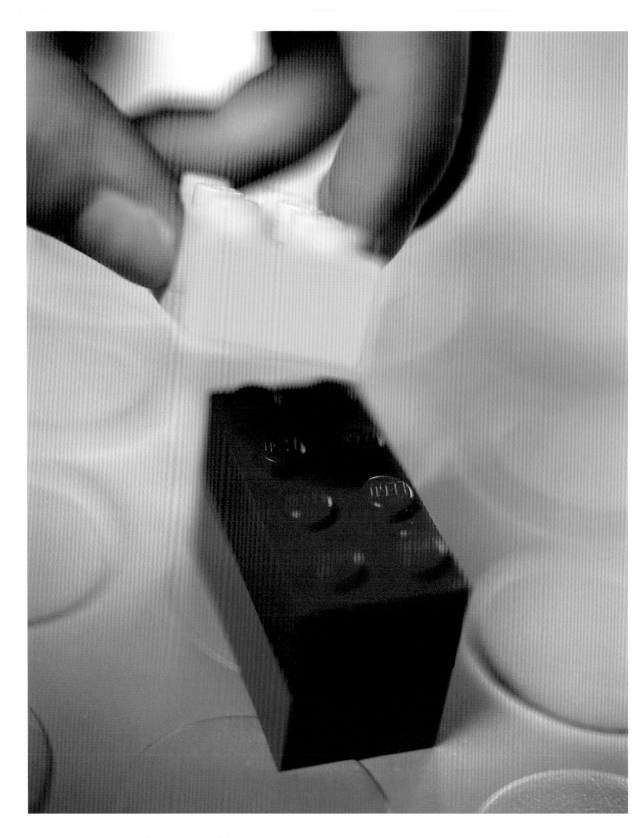

*LEGO bricks being stacked. © 2012 The LEGO Group, used with permission.*

# 37

## LEGO, Denmark
## (Ole Kirk Christiansen, 1958)

*Kjetil Fallan*

An icon of design made from another icon of design, LEGO's recently launched 1962 Volkswagen T1 Camper Van model set adds a second dimension to the iconicity of the celebrated construction toy. LEGO explicitly mines the riches of design history to imbue its own products with added (pop-) cultural cachet. LEGO designer John-Henry Harris points precisely to the shared worldwide recognition of LEGO and the VW Camper Van in explaining the choice of motif.[1] This meta-iconicity represented by the LEGO VW Camper Van may be a new departure into the realm of models drawn from industrial design, but has its immediate precedent and parallel in the LEGO Architecture range. Launched in 2008, this product line is a commercialized adaptation of architect Adam Reed Tucker's larger scale projects in which he built detailed models of iconic buildings using LEGO. The LEGO Architecture range features some of the world's most iconic buildings, including the Sydney Opera House, Fallingwater, the Empire State Building and Big Ben. Indicative of, and adding to, the project's canonizing function, both Tucker's original art projects and the commercial designs have become museum pieces themselves, exhibited at Chicago's Museum of Science and Industry and the National Building Museum in Washington, DC. A double-layered celebration of both the historic buildings and the plastic bricks, both the exhibitions and the models on show work to cement an image of buildings and bricks alike as iconic designs.

Whether or not the VW Camper Van will be followed by other models plucked from the history of industrial design to form a LEGO Design range remains to be seen, but in any case it joins the miniature architectural replicas in demonstrating the very essence of LEGO and why the construction toy is an icon of design: it is a design for designing designs.

### Designed to Design

Invented by the Danish toy manufacturer Ole Kirk Christiansen, the first version of the plastic brick with studded top-side made its debut in 1949 following the company's purchase of a plastic injection-moulding machine two years earlier. Kirk Christiansen's son Godtfred developed the concept into a construction toy *system* launched in 1955, designed for maximum combinatory flexibility. A crucial design feature was introduced in 1958, though: the internal cylinders securing a tight and reliable connection between bricks. The LEGO brick as we know it, therefore, dates to 1958. The basic design was further improved in 1963 through a shift in material from cellulose acetate to acrylonitrile butadiene styrene (ABS), a type of plastic offering greater strength, colourfastness and moulding precision.[2]

It might seem quite a leap from the first, generic plastic bricks to the elaborate 1,332-piece VW Camper Van, but the development towards more preconceived and preconditioned construction began early on. The first LEGO sets accompanied by formal building instructions were already on the market in the 1960s. The 'play themes' concept was introduced in 1978—the first three being LEGO Town, LEGO Castle and LEGO Space—containing much more specialized sets, such as fire stations, medieval castles and space ships. This concept also included the first Minifigures, literally adding character to the LEGO universe. Another key moment is the 1977 launch of the LEGO Technic range, combining

1  http://www.youtube.com/watch?v=utagD0Vh3Rc.

2  *Pernille Stockmarr, 'LEGO klodsen', in Lars Dybdahl (ed.), De industrielle ikoner: Design Danmark (Copenhagen: Det danske Kunstindustrimuseum, 2004), p. 78.*

3 Henry Wiencek, The World of LEGO Toys (New York: Harry N. Abrams, 1987), p. 54.

4 Daniel Lipkowitz, The LEGO Book (London: Dorling Kindersley, 2009), p. 136.

5 Franklyn Turbak and Robbie Berg, 'Robotic Design Studio: Exploring the Big Ideas of Engineering in a Liberal Arts Environment', Journal of Science Education and Technology 11, no. 3 (2002): 237–53.

6 Roland Barthes, 'Toy', in Mythologies (New York: Noonday Press, 1972), pp. 53–4.

7 Maaike Lauwaert, 'Playing outside the Box: On LEGO Toys and the Changing World of Construction Play', History and Technology 24 no. 3 (2008): 228–32.

8 Philippa Goodall, 'Design and Gender', Block 9 (1983): 58.

9 Madeleine Akrich, 'The De-scription of Technological Objects', in Wiebe E. Bijker and John Law (eds), Shaping Technology/Building Society: Studies in Sociotechnical Change (Cambridge, MA: MIT Press, 1992), pp. 205–24.

10 Kjetil Fallan, Design History: Understanding Theory and Method (Oxford: Berg Publishers, 2010), pp. 78–89.

11 Ulrik Pilegaard and Mike Dooley, Forbidden LEGO: Build the Models Your Parents Warned You Against! (San Francisco: No Starch Press, 2007).

12 http://www.wired.co.uk/news/archive/2010-06/2/printer-created-out-of-lego-and-a-felt-tip-pen?page=all; http://www.wired.co.uk/news/archive/2010-06/11/working-sniper-rifle-minigun-and-shotgun-built-from-lego. Accessed 10 May 2012.

13 http://www.iconeye.com/news/video-foster-partners-lego-remake. Accessed 10 May 2012.

14 http://www.dispatchwork.info. Accessed 10 May 2012.

the brick-building properties of conventional LEGO with the 'engineering' parts of traditional mechanical construction toys—rods, axels, gears, beams and so on—enabling older children to build models of much more detailed and realistic functionality and appearance.[3]

This sort of designing for creative technical applications was taken to another level with the LEGO Mindstorms computer brick. Developed in cooperation with the Media Laboratory at Massachusetts Institute of Technology from 1984 but brought to the commercial market only in 1998, this 'Robotic Command System' allowed users to build robots by writing computer programs and downloading them to the control brick, which then made the motors and sensors behave in accordance with the program.[4] Now in its second generation (NXT), the Mindstorms system is popular in educational settings, seen to be a first-rate pedagogical device for explaining complex technology to schoolchildren and students.[5] Nowhere is this more emblematic than in the First LEGO League, a worldwide tournament where teams of children aged 9 to 16 design, program and build robots competing for the best score. With these novel products, LEGO might be said to have returned to the more dynamic, creative use at the core of the original product concept. The prescriptive themed sets, such as Belville and Bionicle, are perhaps more about narrative role-play than about construction, making 'the child … identify himself as owner, as user, never as creator' in the words of Roland Barthes.[6] A crucial element in this return to more open-ended designs was the strategic enrolment of users in the product development process.[7] User participation in the design process has recently been taken one step further: through the website lego.cuusoo.com, anyone can upload images of prototypes of their own designs, and if their creation receives enough supporters (10,000), it will be considered by LEGO for possible manufacture as an official LEGO product.

The key to LEGO's continued appeal lies, in all these cases, in the clever negotiation between prescribed and proscribed modes of interaction: LEGO facilitates creative use but nonetheless offers more or less rigid guidelines. When LEGO's designers design their construction toys, they are simultaneously designing their usage. As Philippa Goodall so poignantly put it: 'design for use is design of use'.[8] 'Designing' does not equal 'determining', here though: detailed building instructions and special-purpose components notwithstanding, there is no guarantee users will interpret and use the LEGO sets as intended by the designers. Madeleine Akrich's notion of 'script' is useful in understanding these processes.[9] A product's script is the designers' intended meanings and uses as 'inscribed' in the object and left for the users to—wholly or partly—subscribe to or write off.[10] The script of a box of ordinary bricks is clearly much less rigid than that of the more specialized kits of recent years, but each has the capacity to allow unintended and utterly creative uses.[11]

## Pro Play

Beyond the modifications and reconceptualizations every LEGO user engages in when ignoring or selectively interpreting the building instructions, new heights and realms are reached by people building functioning computer printers and working guns from LEGO.[12] How LEGO affords creative designing is apparent also from its appropriation by designers, architects and artists. One deceptively simple example is Swedish designer Caroline Byh's jewellery made from stock LEGO bricks—a design so alluring it immediately spawned frantic DIY activity. More tongue-in-cheek, two architects from Foster + Partners combined two sets from the LEGO Architecture range to create the hybrid 'Empire State of Falling Water'.[13] No less playful, but far more socially engaging is Dutch artist Jan Vormann's *Dispatchwork*, a project where he, together with local inhabitants in cities across Europe, uses LEGO bricks to fill cracks in the urban texture—the chipped corner of a building or a missing stone in the pavement.[14]

But LEGO's iconicity can be used for other purposes in the institutionalized world of art and architecture. Celebrating the centennial of the National Association of Norwegian Architects in 2012, a major feature of the Architecture Festival was a 'LEGO city'. In a comparable stunt, in September 2006 Icelandic artist Olafur Eliasson dumped three tons of LEGO bricks on a square in central Oslo outside one of the old buildings of the then recently merged National Museum of Art, Architecture and Design. The public was invited to build, for example, its visions of how the planned new museum building should look. Significantly, in both cases, every single one of the millions of bricks was white. Recalling the white-washed walls of modernist architecture as well as the 'white cube' aesthetic of modernist exhibition practice, the masses of white LEGO bricks at these happenings effectively co-opted LEGO as an icon of 'high' design. In stark contrast, the equally impressive volumes of bricks in play at the annual LEGO Festival at the Norwegian Museum of Science and Technology comprises a cacophony of colours, and can be said to manifest LEGO's status of an icon of 'low' design. This interpretative flexibility only serves to catalyze LEGO's iconicity.

## Toys R Who?

Part of the original design brief for the LEGO system back in the 1950s was that the new toy should be equally suitable and interesting to girls and boys alike.[15] It has often been claimed, though, that LEGO has primarily been a boys' toy, notwithstanding several examples of stereotypically 'girlish' themed sets. The debate on the gendered nature of LEGO ran to unprecedented heights with the recent (2012) introduction of LEGO Friends, a range of role play-centred kits designed specifically for girls and based on four years of market research and product development. Using pastels rather than the usual bright colours, and featuring a cast of heroines placed in environments dedicated to activities such as fashion design, horse riding, music, dancing and parties, these LEGO sets are a far cry from the sinister action figures of the LEGO Bionicle range.

Most controversy, though, has been caused by the design of the Friends figures, which are taller, slimmer, curvier and more revealingly dressed than the ordinary Minifigures—more realistic, perhaps, but also more sexualized. However, the truly intriguing difference lies not in their new appearance, but in their reduced functionality and incompatibility with the rest of the LEGO universe. The female-only Friends figures do not fit into the seats of regular LEGO cars, planes, spaceships, etc., cannot wear the helmets or even ride the horses.[16] They can stand—pose—but not *do*. This gendered pre-/proscription of action recalls Judy Attfield's comparative analysis of Barbie and Action Man: the former has few and stiff joints, whereas the latter has many and flexible joints. One is for posing, the other for doing.[17]

Another marked trend in LEGO's recent history is how the company has become part of the Hollywood merchandizing industry, with product ranges such as LEGO Star Wars, LEGO Harry Potter, LEGO Marvel and DC Superheroes and more. These have become major commercial successes for the company and, in terms of iconicity, have generated the desired synergies. This design practice can be understood as a variety of what is known as 'cross-branding': joining the forces of two strong brands from different industries for mutual marketing benefit. A case in point is the LEGO Ferrari range launched in 2004 bringing LEGO 'an international reputation for speed and quality' while offering Ferrari an inlet to 'young auto fans and grown-up enthusiasts'.[18]

However, these developments in LEGO design cannot be attributed to commercial concerns alone. Everyone who plays with LEGO contributes to the evolution of the practice, which acquires, in turn, its own cultural history.[19] Perhaps, then, in the end the toys *are* us.

15  Stockmarr, 'LEGO klodsen', p. 78.

16  http://torillsin.blogspot.com/2012/02/lego-blondes.html. *Accessed 10 May 2012.*

17  *Judy Attfield, 'Barbie and Action Man: Adult Toys for Girls and Boys, 1959–93',* in Pat Kirkham (ed.), The Gendered Object *(Manchester: Manchester University Press, 1996), pp. 80–89.*

18  *Lipkowitz,* The LEGO Book, *p. 102.*

19  *Berit Overå Johannesen, Å holde på med lego: En empirisk studie i meningsdannelse [Doctoral thesis] (Trondheim: Norwegian University of Science and Technology, 2006), p. 8.*

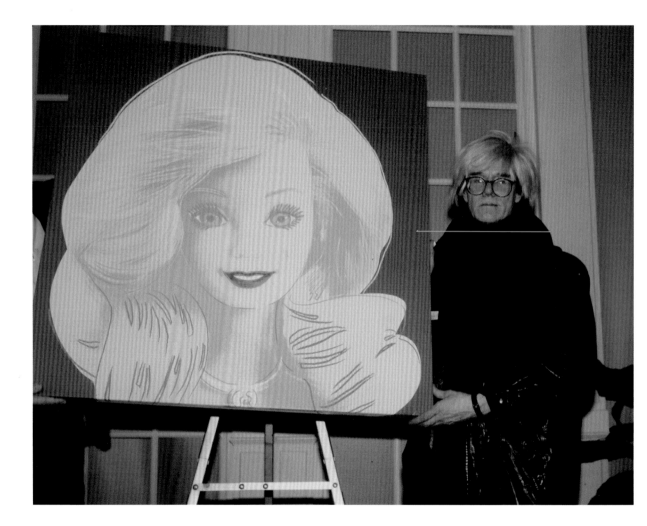

*Andy Warhol with his 'Barbie', synthetic polymer paint and silkscreen ink on canvas, 1985. Getty Images.*

# Barbie, USA
# (Ruth Handler/Mattel, 1959)

*Juliette Peers*

## Barbie and the Valorization of Design

Encountering the Barbie doll in an anthology of iconic design could be a truth self-evident for her many fans, a singular status that she fully deserves. Conversely, classifying Barbie as an iconic design may be judged as inappropriate, even repellent, depending on the reader's understanding of the accepted role of design. Discussing how the Barbie doll reflects back upon *design*, M.G. Lord suggests that Barbie disproves the theory that mass industrial production trivializes an object's impact: '[T]he reality is the reproduction.'[1] Each of the billion Barbies produced since 1959 stands in effectively for her sisters and is therefore equally loved or maligned. She raises questions about design and the everyday world of family life. What is the relationship of childhood, and its particular subset of girlhood, to *design*? Despite the many contemporary publications on design, youthful consumers remain relatively overlooked.[2] Does elevating this 11½-inch vinyl representation of the feminine to iconic design status challenge the widespread intellectual idealization of masculine mind, action and libertinism since the eighteenth-century enlightenment in the cultural imagination? Toys stereotypically associated with boyhood—construction sets, digital games, vintage printed-tin robots, train sets and military themed accessories—are validated as noteworthy objects in architectural and industrial design-based narratives more readily than are dolls. The esteem assigned to the toys of male childhood is symptomatic of a tendency to regard girlhood as both lightweight, yet aberrant; capable of besmirching or destabilizing the systematic and intellectually rigorous, the noble and male-driven and thus even the culturally iconic with which it comes into contact. Whilst Barbie features in many books, both academic and commercial literary nonfiction, most dolls are only discussed in hobbyist doll-collecting literature, which provides more practical information around date and authenticity, and checklists of expected components, rather than cultural discussion. Only Barbie—and perhaps the Bratz dolls—currently have any consistent status and recognition value beyond collectors.

Barbie suggests that the calibration and proof of a design's iconic status extends beyond the object itself and that design objects inform not only debates about visual commodification and styling but also shape social ideals. Mary Rogers claims that Barbie is a fictive icon who is concurrently accepted as a real embodiment of shared and fundamental values around gender and race.[3] To describe a live woman as a 'Barbie' invokes an image that would be immediately recognized by people of different backgrounds. This Barbie image includes blonde hair, shapely legs and large (possibly artificially augmented) breasts and implies a superficial mind. Although inanimate, the doll can stand in for certain types of late-twentieth- and early-twenty-first-century beauty circulating in the media and entertainment industry and thus, via the ubiquitous presence of these industries, can embody the large scale metanarratives of social change over the last four decades. Simultaneously for some religious societies, Barbie represents a secularized, Western and undesirable female ideal. Yet despite public censure, under-the-counter, black-market trading of Barbie offers a surreal moment of overlap between

**1** *M.G. Lord,* Forever Barbie: The Unauthorized Biography of a Real Doll *(New York: Morrow and Co. 1994), p. 73.*

**2** *This point still stands despite first being raised by Judy Attfield, 'Barbie and Action Man: Adult Toys for Boys and Girls 1959–1993', in Pat Kirkham (ed.),* The Gendered Object *(Manchester: Manchester University Press, 1996), p. 81.*

**3** *Mary F. Rogers,* Barbie Culture *(Thousand Oaks, CA: Sage Publications, 1999), p. 3.*

orthodox Israelis and fundamentalist Muslims.[4] Such readings demonstrate how use and user experiences inform understanding of a design object. This coconsumption and coproduction offers perhaps a less traditional view of design than the celebration of the outstanding designer or object. Textual play is also matched by physical play with the dolls themselves: dressing, remaking, repositioning, by both children and adults, further rendering assignment of meaning contradictory and multilayered, and diffusing authorship. However some artists in the late twentieth and early twenty-first centuries were pursued by Mattel in legal cases about inappropriate use and presentation of the doll, placing Barbie within current debates about contested meaning and strategies of representation in visual culture.

Much academic discussion of Barbie is not about design history or theory *per se*, but about social issues, body image, public health, obesity, eating disorders, the construction of gender and the influence of capitalism in everyday life. Remarkably the doll's individual, small-scale malignity can substitute in some critics' eyes for the vast power structures of the American military industrial complex and the expansion of American advertising and consumerism in the postwar period. This substitution is as much about the potential for female stereotypes to trouble the public imagination as it is about social justice.[5] The intense hostility directed towards the doll by her detractors uncannily marks an object's potential to haunt cultural debate and public sense making and by extension *design*'s potential for constituting a shared understanding of reality. In this context, the many female signifiers that Barbie generally presents—for she does manifest in multiple variants listed previously—are not inconsequential. Under the guise of Marxist critique, Victorian/Edwardian obsession with the *femme fatale* receives a tangible—and to some perfectly justifiable—update. Marco Tosa and M.G. Lord suggest that the Barbie doll mediates class prejudices against the everyday and nonpoliticized working class and facilitates hypocritical discussion about ideal tastes and behaviours against the 'cheap', with the norm identified with upper middle class values.[6] Mary Rogers suggests that upper-middle-class professionals, especially women, predominate amongst critics of the doll.[7]

## Fashion Doll

Barbie does register in design literature. Fashion theorist Valerie Steele places the doll firmly within classic design history.[8] For Steele, Barbie is doubly iconic as she catalyzes narrative and conceptual thought as a true icon, but also offers a meticulous documentation of high fashion and styling in a tangible 3D miniature form from 1959 to about 1974. The exquisite detail of the garments and their legible quotations from French designers of the 1950s reiterates how *haute couture* captures attention amongst audiences who will never afford the originals, reflecting the cultural importance of French-derived high fashion in the mid-twentieth century. The first fashion designer employed by Mattel, Charlotte Johnson, attended showings of major Parisian designers in the mid- to late 1950s and insisted on a high fashion element concurrent to the 'girl next door' persona upheld by Mattel director Ruth Handler. Although much literature on Barbie assumes that she is a modernist innovation, both in concept and in form, she relates to pre-existing doll products from the 1950s, particularly North American dolls clad in formal French inspired fashions. Concurrently, the German Bild Lilli doll, sculpted by Reinhard Beuthien and Max Weissbrodt, provided the strongest visual precedent for Barbie's physical form. With the radical changes to personal styling and public behaviours in the wake of both British mod fashions and Californian hippies, face and clothes were changed to express a new, more youthful female ideal after the mid-1960s. Barbie's wardrobe of clothes at this time included some of her most radical and diverse looks; very few of them are pink,

4 'Barbie Doll "Threat to Saudi Morality"', USA TODAY *online*, 10 September 2003, http://www.usatoday.com/news/offbeat/2003-09-10-barbie_x.htm. *Accessed 21 August 2012; Caroline Hawley, 'The First "Jewish Doll"'*, BBC News *online*, 8 March 2002, http://news.bbc.co.uk/1/hi/world/middle_east/1860315.stm. *Accessed 21 August 2012.*

5 *A less Marxist but strongly misogynist history of Barbie and Mattel company is Jerry Oppenheimer,* Toy Monster: The Big, Bad World of Mattel *(Hoboken, NJ: Wiley, 2009).*

6 *Marco Tosa,* Barbie: Four Decades of Fashion, Fantasy, and Fun *(New York: H. N. Abrams, 1998), pp. 12, 114–16; Lord,* Forever Barbie, *p. 183.*

7 *Rogers,* Barbie Culture, *p. 17.*

8 *Valerie Steele,* Art, Design and Barbie: The Evolution of a Cultural Icon *(New York: Liberty Street Gallery, 1995); David Levinthal and Valerie Steele,* Barbie Millicent Roberts: An Original *(New York: Pantheon Books, 1998).*

PART FOUR: HOME RULES

despite this colour being a key element of Barbie's present day expanded universe. The quintessential Barbie—blonde, smiling, mostly dressed in hot pink tawdry Lurex and glittery fabrics—only emerged in 1977, under the marketing name of Superstar Barbie, recalling the *Weltanschauung* of Andy Warhol and linking to mainstream fashion and the emerging disco scene. The 1980s and 1990s were a high watermark of Mattel's constant renewal and reiteration of the doll via seasonal doll releases, with a surreal proliferation of mechanical and exaggerated body formats and functions for the child playline that referenced late-twentieth century belief in the body as malleable and self-constructed.[9] At the same time, a more elite vision of Barbie emerged as the adult collector base expanded, with new dolls commanding three-figure sums. In the last decade, Mattel has concentrated its marketing towards very young children, emphasizing princess and fairy-tale elements and minimizing the precise documentation of changing fashion trends seen even in the playline in previous decades, through such cost saving devices as substituting glitter and flocked paint on the torso for actual garments.

The doll offers a more nuanced reading of taste and fashion than detractors acknowledge. In the early 1960s, Barbie was available in a variety of hair colours, and there have been various face sculpts down the years, from serene and classical through sultry to cheerfully suburban, alongside a range of different arm and hand positions in body sculpts. Barbie's wide-shouldered, small-hipped 'masculine' body shape—simultaneous to the notorious breasts—was only modified in the last decade. Her visual identity also changes with every edition, and depending upon what market sector a doll is intended to serve. Actual historical figures including Marilyn Monroe or Josephine de Beauharnais are 'portrayed' as Barbies, while others such as Hillary Clinton, Princess Diana or Donatella Versace are introduced more covertly as styling references. Multiple Barbies co-exist, from the homely to the grandiose. Barbie's expanded universe includes additional dolls such as boyfriend Ken, sisters Kelly and Skipper, cousins such as Francie, the more homely best friend Midge. In addition, further objects with narrative or visual styling references to accepted iconographic, colour and decorative repertoires around the doll are available: cars, dolls houses and other residential and built structures, carry cases, paper dolls, children's storybooks and human-scale accessories and fashion, such as t-shirts, jewellery, handbags and purses. In Japan and China, the Barbie brand is licensed as an adult fashion label, with the garments sold alongside Barbie dolls. These product tie-ins are perhaps more associated with science fiction-derived narratives and the nerdish fan cultures surrounding them. The cumulative effect of these products brings a rich layering of self-reference and intertextuality across many iterations of the same story into material culture and product design.

With the development of an adult Barbie collector market and the trading of secondary and vintage dolls over the last three decades, the crossover between a classic construct of design and Barbie becomes more explicit as Mattel enters partnership with famous high-end iconic brands and design firms. A number of esteemed fashion designers have worked with Barbie, including the Dior and Givenchy houses, Versace, Calvin Klein, Donna Karan and Escada. The 2009 fiftieth anniversary of the doll was notable for its association with a range of high-end designers including Philippe Starck and Christian Louboutin, who created products that referenced the doll, reflecting the high status of design currently and Barbie's place in these discourses. A sign of the doll's growing high cultural acceptability and, perhaps also the present day cultural visibility and influence of architecture, was the international campaign by architects in 2010 to subvert Mattel's online voting website in order to add architect to the careers for women represented by Barbie dolls.[10] Barbie is a sign of modern life says Marco Tosa—those who loathe her loathe modernity.[11]

9  Juliette Peers, 'Tattooed Fairies and Seductive Ankles: The Doll's Body', in Tina Guglielmino and Mick Peel (eds), The Body: Connections with Fashion (Melbourne: RMIT University in Conjunction with the International Foundation of Fashion Technology Institutes, 2008), pp. 462–4.

10  Alissa Walker, 'Architecture Is Tough! Will Architect Barbie Help More Women Become Designers?' in Good Design, 25 February 2011, http://www.good.is/post/architecture-is-tough-will-architect-barbie-help-more-women-become-designers/. Accessed 21 August 2012.

11  Tosa, Barbie: Four Decades, p. 9.

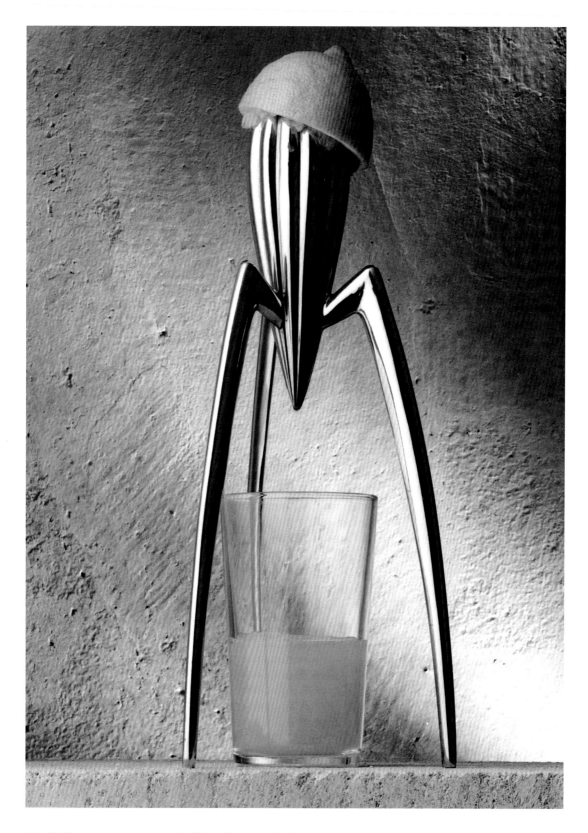

*Juicy Salif lemon squeezer, designed by Philippe Starck for Alessi, 1990. Image courtesy Alessi S.p.A./Murray Weir Willats.*

# 39

# Juicy Salif Lemon Squeezer, Italy/France (Philippe Starck, 1990)

*Grace Lees-Maffei*

1 *Guy Julier,* The Culture of Design *(Thousand Oaks, CA: Sage, 2000), pp. 79–80.*

2 Alessi.co.uk. *Accessed 10 May 2012. See Grace Lees-Maffei, '"Made" in England? The Mediation of Alessi S.p.A.', in Grace Lees-Maffei and Kjetil Fallan (eds),* Made in Italy: Rethinking a Century of Italian Design *(London: Bloomsbury, 2013), pp. 290–1.*

3 *Beatriz Russo and Anamaria de Moraes, 'The Lack of Usability in Design Icons: An Affective Case Study About Juicy Salif',* Proceedings of the 2003 International Conference on Designing Pleasurable Products and Interfaces, *Pittsburgh, 23–26 June 2003 (New York: ACM Press, 2003), pp. 146–7.*

4 *Carl Gardner, 'Starck Reality',* Design *534 (June 1993): 26–7.*

5 *Laura González, 'Juicy Salif as a Cultish Totem', in Barbara Townley and Nick Beech (eds),* Managing Creativity: Exploring the Paradox *(Cambridge: Cambridge University Press, 2009), p. 305.*

6 *Philippe Starck, 'Starck Speaks: Politics Pleasure Play',* Harvard Design Magazine *5 (Summer 1998) cited in Peter Lloyd and Dirk Snelders, 'What Was Philippe Starck Thinking Of?'* Design Studies *24, no. 3 (2003): 237–53, 243.*

7 *See Clive Dilnot, 'The Gift', in Victor Margolin and Richard Buchanan (eds),* The Idea of Design *(Cambridge, MA: MIT Press, 1995), pp. 144–55.*

If iconicity is about being recognizable, then Philippe Starck's Juicy Salif lemon squeezer is a quintessentially iconic design. Its unique shape has not been seen before or since, even though it is imbued with multiple references and has been exceptionally influential. But, Starck's Juicy Salif is *nothing but* recognizable: it barely functions as a lemon squeezer, and therefore its main purpose is to appear, to be noticed and to be recognized. It has been produced in aluminium by Italian household goods manufacturer Alessi since 1990. Alessi is known for a number of iconic designs including Michael Graves' 9093 Kettle with a whistling bird (1985).

## Form Follows Function?

The tide of fashion has turned against the status symbols of late-twentieth-century design, as did Starck himself, at least in his rhetoric. As the design historian Guy Julier has suggested, '[T]he cultural baggage of designerly euphoria, its achievements, excesses and wastages converge in the Juicy Salif.'[1] Yet, Juicy Salif remains an enduring icon more than twenty years after its launch. Alessi calls it 'one of the most renowned icons of contemporary life in all four corners of the globe'. In 2010, Alessi launched Roland Kreiter's mysqueeze, a reinterpretation in stainless steel of the traditional wooden citrus reamer, as 'the new icon, heir to the "Juicy Salif"'.[2] But Juicy Salif's status as an icon is unshakable, even though its success has prompted speculation and criticism.

Researchers in ergonomics and usability Beatriz Russo and Anamaria de Moraes have suggested that the functionality of design icons is often compromised by a neglect of ergonomics. Iconic attention-grabbing designs 'distort the real meaning of the profession, attributing to designers the making of pretty objects'. A tester in their usability study of Juicy Salif complained: 'It's not comfortable, it doesn't feel safe … all the time I felt like I was going to spill everything. Actually, I did once … and after, there w[ere] lemon parts everywhere in the kitchen!'[3]

Another Starck design for Alessi, the Hot Bertaa kettle (1990), attracted criticism for poor functionality in a *Design* magazine article in 1993. Several testers complained that the kettle was too big to fill directly from the tap, the lack of a window made it impossible to know how much water was in it, it was too heavy when filled, the handle heated up during boiling, users risked scalding their arms with steam and it poured badly.[4] Like Juicy Salif, Hot Bertaa does not fulfil its ostensible purpose and, in 1997, Alessi withdrew it.

## Talking Heads

Although Juicy Salif is unsuccessful in functional terms, artist and writer Laura González recognizes that: '[a]s a best-selling design icon, *Juicy Salif* cannot be evaluated by its effectiveness in squeezing lemons'.[5] According to Starck, accusations of Juicy Salif's poor functionality miss the point that it is principally a conversation piece,[6] and this 'social lubricant' function is supported by the fact that Alessi goods are often given as gifts.[7]

Between 1990 and 2003, more than half a million Juicy Salifs were sold at the rate of 50,000 per year,[8] but its influence extends far beyond the number sold. Juicy Salif is successful both in terms of sales and as a cultural icon.

Juicy Salif has attracted a great deal of media attention, much of it dedicated to discovering the secrets of its success. Its success in terms of sales and iconicity, if not in terms of squeezing lemons, is shown in the production of a gold-plated tenth anniversary edition, which could only be displayed and never used, as the acidic lemon juice would ruin the surface. Juicy Salif's success is also communicated in a publicity photograph of the male members of the Alessi family firm bristling with improbably positioned Juicy Salifs. This image denotes Alessi's, and Starck's, wit, and Juicy Salif's symbolic rather than utilitarian qualities, its ubiquity and its importance to the financial success of its manufacturer.[9]

Starck's contention that Juicy Salif is designed as a conversation starter rather underplays its own narrative power. Objects designed by Starck invoke his persona and endow their environments with designer lustre. As well as designing a product which is more or less functional as a lemon squeezer, by deviating from the standard type-forms for that product category, Starck has deliberately designed narrative meaning into Juicy Salif.[10] Juicy Salif works as a conversation piece not because Starck has passively ceded the role of meaning-generation to the consumer, but because he has injected it with a range of ready-made meanings which the consumer can comprehend and further embroider. Interaction designers Julie Khaslavsky and Nathan Shedroff note that Juicy Salif's novel appearance 'transforms the routine act of juicing an orange into a special experience' and 'creates an appreciation and desire to possess not only the object, but the values that helped create it, including innovation, originality, elegance, and sophistication'. In making 'an ordinary action extraordinary', it 'promises to raise the status of the owner to a higher level of sophistication for recognizing its qualities'.[11] *That* is why Juicy Salif is so much more expensive than other lemon squeezers, including ones which squeeze lemons more effectively.

Industrial designers Peter Lloyd and Dirk Snelders have published a sceptical and wryly funny account of the murky origins of this object, with 'no obvious precedent'.[12] They recount Starck's story about how the idea for Juicy Salif occurred while he was eating calamari in an Italian restaurant, following a meeting with Alessi. In a series of sketches on a paper tablecloth, we see Starck's initial intention, to design a lemon squeezer resembling a squid, morphing into a product invoking his early interests in flight, science fiction and evolutionary theory. Lloyd and Snelders elaborate a wide range of potential meanings for Juicy Salif in their efforts to determine exactly what has made it so successful.

Similarly, in asking why 'this disproportioned, menacing-looking, inefficient lemon squeezer is one of Alessi's best selling products, a design icon, a cultish totem', González suggests that the answer lies with Juicy Salif's polysemic nature. It offers the 'possibility of containing different and often contradictory meanings'. It allows for creative consumption or even misuse. And, it is able 'to seduce, to lead consumers and viewers astray from what may be considered right behaviour' such as 'buying a cheaper, more efficient lemon squeezer'. Indeed, González concludes, 'seductive characteristics are crucial for the creation of design icons'.[13]

## Animal Charm

Explanations for Juicy Salif's success, and its iconicity, centre upon its recognizable and unique shape, its healthy sales, disproportionate media attention and its polysemy. But

8 *Lloyd and Snelders, 'What was', 238.*

9 *Grace Lees-Maffei, 'Italianità and Internationalism: The Design, Production and Marketing of Alessi, S.p.A.',* Modern Italy 7, *no. 1 (2002): 37–57.*

10 *Grace Lees, 'Balancing the Object: The Reinvention of Alessi', things 6 (Summer 1997): 74–91.*

11 *Julie Khaslavsky and Nathan Shedroff, 'Persuasive Technologies: Understanding the Seductive Experience',* Communications of the ACM 42, *no. 5 (1999): 45–9, 47.*

12 *Lloyd and Snelders, 'What Was', 238.*

13 *González, 'Juicy Salif', pp. 306, 297, 300, 305.*

another clue to its success is found in its antecedents. The work of the first industrial designer, Christopher Dresser, includes unmistakable forerunners for Juicy Salif. Dresser was an early product of the School of Design, a pioneering experiment in design education that developed into what we know today as the Royal College of Art and the Victoria and Albert Museum. As well as drawing and design, he studied and later taught botany and went on to produce designs which merge these areas of expertise.

The Dresser designs reproduced by Alessi have an animalistic charm, particularly a bowl that resembles a three-legged frog, reproduced by Alessi in brightly coloured plastic as 'Christy' (1993). Dresser's tableware has character and presence. Rather than constituting a naturalistic model of a frog, Dresser's bowl has froggy legs, therefore the biomorphism is an isolated and partial characteristic. Liberated from the compulsion to interpret the legs as part of a frog, we can infer from this object—part bowl, part frog—all sorts of characters and behaviours whether animal, human or pure fantasy. Likewise, while Juicy Salif might be seen to resemble a spider crossed with a squid, the fact that it resembles neither very accurately, and that it also recalls space rockets, means that we are at liberty not only to biomorphize, or attribute to Juicy Salif the characteristics of an animal, but also to anthropomorphize, or imagine it as a human character. Thanks to its long legs and upright bearing, Juicy Salif looks less like a spider than an anthropomorphized spider, especially in the publicity photograph shown here, where it wears a lemon hat and has urinated into a glass.

Lloyd and Snelders note that the name 'Juicy Salif' does not derive from a character in a Phillip K. Dick novel, like many of his other designs, but rather 'from the French word for saliva, *salive*'.[14] We might go further and note that, like many of Starck's other products, Juicy Salif is anthropomorphized in name as well as form. 'Salif' has the qualities of a personal name, and 'juicy' is the adjective that gives the name personality. 'Hot Bertaa' follows the same pattern, and a variation is found in Starck's colander for Alessi, 'Max le Chinois' (produced in the same year as Juicy Salif), which also features a series of faces punched out of the colander's bowl. These household objects are imbued with the presence and scale of small domestic characters or pets. By buying or receiving, displaying, or otherwise using these objects, we populate our homes and extend our family. Family is important at Alessi, a family firm in a country full of family firms; Michael Graves' product groups for Alessi are referred to as families, and ranges have included 'Family Follows Fiction.'[15]

So, the iconic status of Juicy Salif depends not only on its being a pre-eminently recognizable object, but also on its irresistible promise of sociability, not only as a conversation starter and as a gift, but also in its ultimate role as your domestic companion.

14  Lloyd and Snelders, 'What Was,' 253, n. 2.

15  Lees-Maffei, 'Italianità'; Centro Studi Alessi, F.F.F. Family Follows Fiction Workshop 1991/1993 (Omegna: F.A.O. S.p.A., 1993).

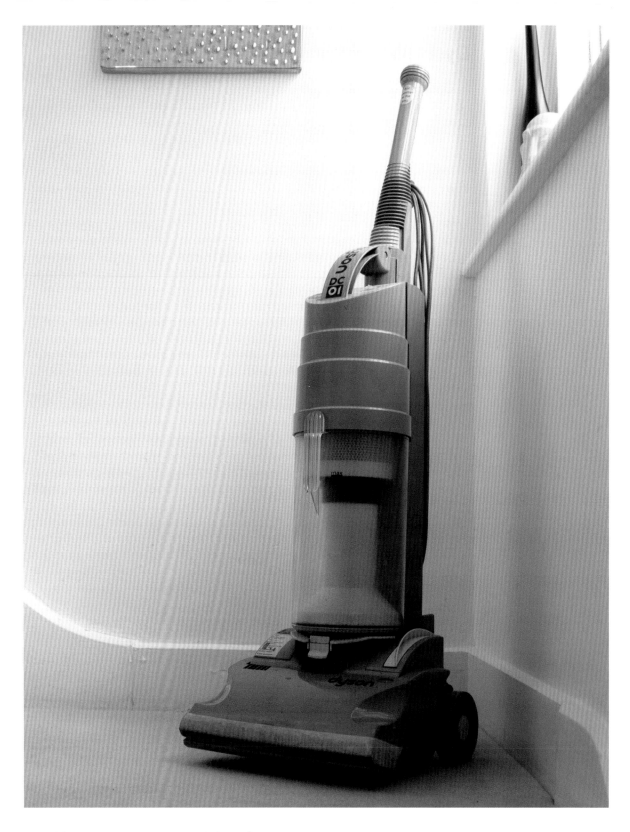

*Dyson DC01 vacuum cleaner. Photography by Louise Crewe.*

# 40

# Dyson DC01 Vacuum Cleaner, UK (James Dyson, 1993)

*Louise Crewe*

## The Man in the Machine

The DC01 vacuum cleaner was launched in 1993 and was marketed as representing a new entrepreneurial sensibility, embodied in this case by its British inventor James Dyson. The individual, the product design and the brand were woven into a coherent and celebratory brand narrative that 'fixed' Dyson's image and identity.[1] Dyson's story is sold as one of rational progress by a British designer-engineer who, through passion and persistence, re-ignited the design world's fascination for innovation, entrepreneurship and engineering. The man and the machine were inseparable in the design and marketing of the DC01, a revolutionary new object that James Dyson had 'conceived, designed, built and tested alone'.[2] He tells how the DC01 was 'a vacuum cleaner designed entirely by me, incorporating innovations up to the very latest point at which my technology has arrived, to be produced and marketed and sold under my exclusive direction. [This] was, to be frank, what this whole thing had been about'.[3]

Engineer-inventor James Dyson demonstrates a clear desire to place himself within an iconic tradition, exemplified not least by his book *Contemporary Design Icons* (1999) that lists his twentieth-century design icons, including his own DC01 that, he argues, is 'up there with Concorde'.[4] His personality is inscribed into the machines, and he reveals a clear desire for his creations to be both iconic and timeless: 'I am a creator of products, a builder of things, and my name appears on them ... I harbour a secret dream of synonymity, and occasionally imagine a time, years from today, when "dyson" replaces "hoover" ... and becomes a noun, a verb.'[5]

Positioned by press and public alike as a pioneering and visionary leader, Dyson was himself at the centre of a debate about the nature of design when he resigned as Chairman of the London Design Museum, arguing that the museum was no longer faithful to its original vision as set out by founder Terence Conran. Dyson accused the museum of pursuing a misguided pursuit of 'empty style over substance' and 'betraying its purpose',[6] becoming a style showcase with an excessive focus on iconography and styling. He argued that the museum had lost its commitment to manufacturing, technology, the industrial design process and 'intelligent problem solving'.[7] Dyson told the trustees that his resignation was prompted by the closure of the museum's Conran Foundation Collection and its replacement by an exhibition on the 1950s flower arranger Constance Spry. Meanwhile, the DC01 quickly succeeded in the marketplace and itself entered design museums and exhibitions. The Dyson is on display in the Twentieth Century Gallery at the V&A and is uniquely on permanent view at both the Science Museum and the Design Museum. The DC01 is internationally recognized and sold, is possessed of narrative qualities and has been the subject of significant media attention. By 2000, the DC01 and its inventor had passed into the vernacular. 'Doing a Dyson' became shorthand for inventing and manufacturing your own product.[8]

1 *Guy Julier,* The Culture of Design *(London: Sage, 2008).*

2 *James Dyson,* Against The Odds *(London: Orion Books), p. 2.*

3 *Ibid.*

4 *James Dyson, 'DC01 Up There with Concorde',* Design Week, *7 January 2000.*

5 *Dyson,* Against the Odds, *p. 3.*

6 *Robert Uhlig, 'Dyson Quits Design Museum after Disgust at "Empty Styling"',* Telegraph, *24 September 2004,* http://www.telegraph.co.uk/ news/uknews/1472703/Dyson- quits-Design-Museum-in- disgust-over-empty-styling .html. *Accessed 10 July 2013.*

7 *'Dyson Leaves Design Museum Role',* BBC News, *27 September 2004,* http://news. bbc.co.uk/1/hi/entertainment/ arts/3693994.stm. *Accessed 10 July 2013.*

8 *Iain Carruthers,* Great Brand Stories *(London: Cyan Books, 2007), p. 107.*

## Creating the Cyclone

The Dyson DC01 undoubtedly redefined the category of vacuum cleaner, both aesthetically and technologically. It was a new and revolutionary product that was designed to do what no other vacuum cleaner had done before: to display the dirt and dust in a transparent drum rather than secrete it invisibly away in a paper bag. The technological innovation of the DC01 lay in its patented dual cyclone system with improved suction, in which dust was spun out of the air. This circular image of cyclonic movement is echoed throughout the styling of the DC01, from the three concentric circles on the wheels to the extendable spiral casing of the hose. The Universal logotype continues the theme of circles that is evident throughout the machine, making a clear association with the Bauhaus movement that promoted the ideals of visual and functional efficiency and fitness-for-purpose.[9]

In the event, it was the advertising promise of 'saying goodbye to the bag' that proved more attractive to the buying public than the earlier emphasis on suction efficiency. The DC01 broke the rules of the category in all sorts of ways. 'Even in the early 1990s, most vacuum cleaners looked like they were just emerging from the 1970s. Metaphorically, they had sideburns. They doddered around like extras in an early police drama, wheezing and ineffective.'[10] By 1996, the Marketing Council had listed Dyson Appliances as one of ten UK companies in a state of hypergrowth and the fastest growing manufacturing company, with turnover growing from £3.5 million in 1993 to £85 million in 1996. The DC01 was the best-selling upright vacuum by revenue within twelve months of its launch and had captured 47 per cent of the market by 2001.

This degree of rapid transformation and penetration is extremely rare, particularly in mature, established markets where new products so often signify little more than a cosmetic restyling or a new colourway. The arrival of the DC01 utterly reshaped and displaced the existing market. James Dyson's ambitions for global dominance of the market were clear: 'the vacuum cleaner was in total control of its awesome potential. It was ready to clean up the planet and ready for a new century. I own it exclusively, and with it, you might say, the key to every household in the developed world.'[11]

## What Lies Beneath? Consuming Dyson and the Duplicity of Design

The Dyson is an interesting example of the extent to which iconic status is conferred on the basis of designed qualities (technological innovation, shape and colour scheme) or via consumption (where iconicity resides in the eye of the owner). Vacuum cleaners are a lucrative object category on a number of levels, not least their comparatively low per-unit-cost and frequent cycles of acquisition and disposal. Although the basic function of the DC01 is the same as that of a conventional vacuum cleaner (to clean floors), its revolutionary design, invitational pull and assumed aesthetic appeal resulted in it becoming a transformative appliance—lusted after, discussed, yearned for: this was no ordinary vac. The Dyson was desired, it conferred capability.

The visibility of dust and dirt within the Dyson cylinder enables the user to 'see' cleanliness, to quantify the dirt removed, to visually confirm one's own competence in maintaining domestic order. The visibility of the dust through the plastic DC01 drum signals, for some consumers at least, its erasure, not its presence. 'When you first use your Dyson, you see all the shit you've been living with … But there it is. The dust. The stray bits of fibre. The alien, indefinable items that you don't really want to investigate … Pieces of fibre from clothing worn by the people who used to live in the house.'[12] Confronting people with their dirt alerts them to the power of the machine that has removed it. It reaffirms our skills as effective maintainers of the domestic order, cleansing and possessing our domestic spaces. Further, it is suggested that operation of the DC01

9 *Julier*, The Culture of Design, *p. 98.*

10 *Carruthers*, Great Brand Stories, *p. 56.*

11 *Dyson*, Against the Odds, *p. 5.*

12 *Carruthers*, Great Brand Stories, *p. 151.*

might become autotelic,[13] whereby its use brings an intrinsic satisfaction, a complete immersion in the activity where there is no boredom, nor worry about performance.

And yet, as with so many electrical appliances, there are often slippages between the meanings that a producer intends and the ones that a consumer interprets. The apparent simplicity of the design of the DC01 alongside its multiple possibilities for failure (blockages, trapped food, kinked pipes, damaged filters) complicates the connections between the object and its user. Because the consumer is conceptualized as a 'user', their role in relation to the product comes to be defined or 'scripted' by the designer 'in' the object.[14] As such, what a consumer can and ought to do is 'written in' to the product itself and is defined in the instruction manual—plug it in, press buttons, insert appropriate materials, maintain as requested. A seemingly mundane, largely invisible appliance, the DC01 is also both hated and feared for its capacities to refuse to do what it was manufactured to do—make matter invisible. Vacuums are ambivalent accommodations within the domestic: we depend on them, desire them but despise them. They fault, they fail and they refuse to behave according to the script. We buy new, duplicate them; they multiply in our homes. We store them, stash them, kick and abuse them. They lie in transition in our homes, in a state of pending, hidden in liminal zones and recurrently being duplicated. And this is particularly the case with the DC01, described in a market research survey as the least reliable vacuum cleaner on the market,[15] and 'the repair trade's saviour'.[16] Yet it is not simply their failure that irritates: even when fully functioning, the DC01 was troubling, 'provoking human disgust and being particularly susceptible to narratives about smell, sight, dirt and disorder. We require that germs, dirt and dust are expelled from our homes, excluded, physically and psychologically'.[17] We see clearly here the significance of the imagined boundaries between presence and erasure. Instead of making matter invisible, the DC01 does just the opposite, exposing it, bringing it into view, holding it in clear suspension.

The DC01 and its inhabitation in contemporary homes reveals a great deal about consumption, the world of goods, how products are placed and used in homes and how our living spaces are organized, orchestrated, imagined and inhabited. The reasons why products become memorable, valued, 'iconic' relates to the complex interweaving of the technological, functional and aesthetic qualities of goods, mediated and refracted by their places in our social worlds and our own subjectivities. Iconicity is simultaneously shaped by the material and immaterial qualities of an object, by its social relations and its technological capabilities, by form and function. The relations between design, marketing, representation and use are complex and relational. While a consumer's initial sensory engagement with an object may be visual, semiotic or brand dependent, users invariably enter a range of other engagements and accommodations as they experience and appropriate domestic objects—tactile, olfactory, aural, physical experiences that mediate and transform object meaning and value. Object status may be as much about the performative practices of consumers in the home as it is about revolutionary technologies, extraordinary advertising campaigns, path-breaking colourways or logotypes or mythological narratives surrounding designer-heroes. Object-value is configured, inscribed and transformed by consumers via both practice and purchase. The mundane movements and moments that comprise homemaking encompass a whole suite of entanglements between objects, subjects, agency and space. Object categories are therefore as much socially and culturally constructed as they are engineered, produced through manufacture or desired through design.

**13** *Mihaly Csikszentmihalyi and Eugene Rochberg Halton,* The Meaning of Things: Domestic Symbols and the Self *(Cambridge: Cambridge University Press, 1975).*

**14** *Madeleine Akrich, 'The De-Scription of Technical Objects', in Wiebe Bijker and John Law (eds),* Shaping Technology/Building Society *(Cambridge, MA: MIT Press, 1992).*

**15** *Which,* Consumer Review Guide: Vacuum Cleaners *(London: Which, 2004).*

**16** *Tim Dowling, 'On the Mend',* Guardian, *15 January 2007.*

**17** *Carruthers,* Great Brand Stories, *p. 21.*

Part Five

# Personal Effects

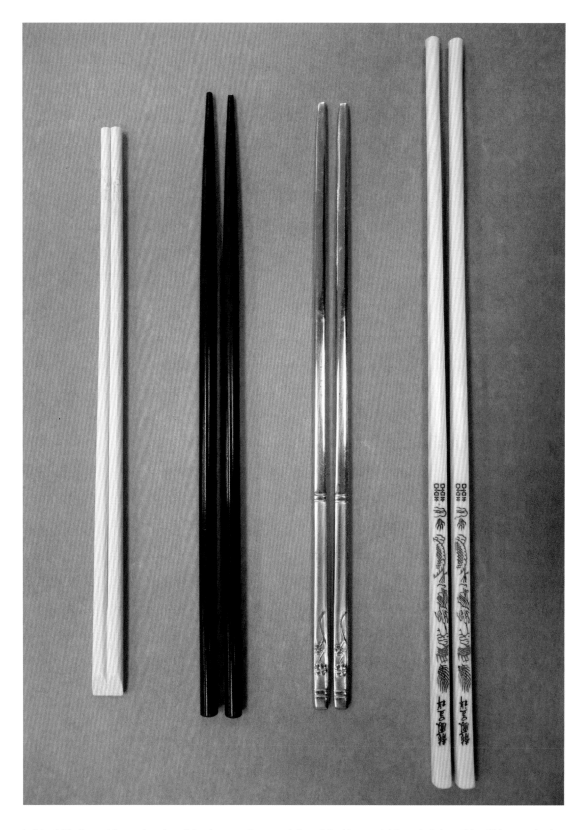

*Left to right: disposable wooden chopsticks; Japanese lacquered chopsticks; Korean stainless steel chopsticks; Chinese melamine chopsticks, 2000s. Photograph by Sirpa Kutilainen.*

# 41

# Chopsticks, China
## (c. 3,000 BC)

*Yunah Lee*

Chopsticks are used as eating tools in the East Asian region, and mostly in China, Korea and Japan. They consist of two sticks, often made of wood or lacquered wood, metal or plastics. Originally from China, the use of chopsticks spread throughout East Asia and then all over the world. Although the ultimate form and use of chopsticks remain unchanged, the subtle variations and differences in chopsticks from China, Korea and Japan reflect the different customs and cultural values. The iconicity of chopsticks resides in the ubiquity of their fundamental forms, uses and symbolic associations, albeit with differences across the cultures of the East Asian region.

## Typological Origins

It is widely believed that chopsticks originated in about 3000 BC in China. Many popular stories relate that chopsticks were developed from the idea of picking up hot food from large cooking pots with twigs. The earliest remaining example is a pair of bronze chopsticks found at an archaeological site dated back to the ancient Chinese Shang dynasty (1600–1050 BC). They were used for religious ceremonies and burial rituals. Gradually chopsticks made of metal, ivory and wood were used for cooking and eating within Chinese royal courts and elite society. The use of chopsticks for eating spread among the wider population during the Han Dynasty (206 BC–200 AD).[1] By the early sixth century, Koreans started using iron or bronze chopsticks for ceremonial purposes.[2] In Japan, chopsticks were introduced by the eighth century and used mainly for religious ceremonies because they were considered to be precious and spiritual, especially related to God and the dead.[3]

The earliest chopsticks in Japan differed in shape from those of China and Korea, looking more like tweezers made of bamboo and joined at the top. Around the tenth century chopsticks were commonly used as cooking and eating tools in these countries. They were shaped into the archetypal form with which we are familiar today and made of metal, ivory, wood and bamboo. Chopsticks are a prime example of artefacts that are subject to what art critic and historian John A. Walker has described as the typological approach in design history.[4] Chopsticks reached their standard type-form after a long period of experimentation and selection. Mass-produced chopsticks of various materials, sizes and shapes, developed in the specific regional and cultural contexts of each country, exemplify this standard type-form. The chopstick form is iconic because it combines contemporary ubiquity with a historical lineage and represents the cuisine and culture in which it is used.

## Form Follows Use

The function of chopsticks is moving food from plate to mouth, using actions such as pushing, grasping, pinching, plucking and lifting. Most texts on chopsticks concern their use, and the difficulty of mastering chopsticks is not limited to people from non-East Asian backgrounds, but also extends to children, the elderly and the disabled from the

1 *Hashitatsu Honten (ed.), 'Chopsticks: Supporting Roles in Food Culture'*, Food Culture *16 (2007): 11,* http://kiifc. kikkoman.co.jp/foodculture/ pdf_16/e_011_014.pdf. *Accessed 17 March 2012; Miseon Jeong, 'About the Propagation, Reception and Transfiguration of the Common Meal Instrument of East Asian Three Countries',* Journal of Oriental Culture and Design *3, no. 2 (2012).*
2 *Jeong, 'About the Propagation'.*
3 *Honten, 'Chopsticks', 12.*
4 *John A. Walker,* Design History and the History of Design *(London: Pluto Press, 1989), pp. 112–3.*

main chopstick population. During the mid-1980s, '"trainer chopsticks", plastic devices with loops'[5] were popularly used in Japan to educate children. Since then, a number of chopstick training devices have been patented in various countries, including the USA and Japan, but these have rarely challenged the recognized shape and form of chopsticks.

Variations in the form of chopsticks reflect their use within the dining habits and historical conditions of three countries. Chinese chopsticks are significantly longer than those of Japan and Korea. The Chinese usually share food, taking a small amount from plates and bowls in the middle of a table. This requires longer chopsticks that enable one to reach dishes further away. Differences in the shape of chopsticks appear subtle but they are significant indicators of what kind of food is eaten and how. Chinese chopsticks are usually square or round with blunt, flat ends, which allow rice to be pushed in a bowl towards the mouth. Japanese chopsticks are round and taper off to pointed ends, convenient for picking up fish, which is a staple of the Japanese diet. Korean chopsticks are commonly made of metal: the production technique of hammering silver, bronze or iron in the molten state led to the flat shape. These metal chopsticks are short and flat to compensate for the weight of the material, making them lighter and easier to use.[6]

## Personal/Impersonal

Because they touch our mouths with every use, chopsticks are close to one's physical health and personal identity. Chopsticks used at home are often designated to each family member, identified by different patterns and colours. Reluctance to lend one's own chopsticks to others is rooted in a concern for hygiene and the belief that one's spirit resides in the chopsticks. With the rapid growth of restaurants and the catering industry, however, the emphasis on the cleanliness and sanitation of chopsticks contributed to the prevalence of new materials in the mass-produced chopstick market. Being durable and easily sanitized, Korean stainless steel and Chinese melamine chopsticks remain as standard and relatively impersonal tools.

The most pervasive and ubiquitous products of this kind are disposable Waribashi chopsticks. First introduced during the Japanese Meiji period (1868–1912), the joined chopsticks are to be snapped into two sticks only when they are first used, and they are disposed of after each use. Therefore, the joined state clearly indicates their cleanness.[7] With the production of 26 billion pairs of disposable chopsticks in a year, timber replaced scrap wood as the main resource of Waribashi production in China and the East Asian region. Concern for the environmental impact of the disposable chopstick industry on the Chinese forest stock prompted campaigns such as 'Bring Your Own Chopsticks', art projects such as Donna K. Ozawa's 'Waribashi Project' in 2005 and the production of various 'My Hashi' personal chopsticks. Despite the heightened media attention and Chinese government's legislations to reduce the use of disposable chopsticks, they are ever present.

*Phaidon Design Classics* (2006) included Waribashi because 'their utility, elegance and function are indisputable'. A shift in focus in the enquiry of design history, from canonical design artefacts to everyday material things, as eloquently argued by design historian Judy Attfield in *Wild Things* (2000), clearly influenced the rise of a humble Waribashi to a design classic.

## Signs of Culture

In *Empire of Signs*, Roland Barthes interpreted chopsticks as the ultimate sign of the cultural differences between Japan and the West:

5 *James Cross Giblin, From Hand to Mouth: Or, How We Invented Knives, Forks, Spoons and Chopsticks and the Table Manners to Go with Them (New York: Thomas Crowell, 1987), p. 75.*

6 *Helen Lai-Ching Ho, 'Asian Product Design and Its Development', paper presented at the 6th Asian Design Conference, 2004,* http://www.idemployee. id.tue.nl/g.w.m.rauterberg/ conferences/CD_ doNotOpen/ADC/final_ paper/242.pdf. *Accessed 19 May 2012.*

7 *Honten, 'Chopsticks', 13–14.*

PART FIVE: PERSONAL EFFECTS

*In all their functions, in all the gestures they imply, chopsticks are the converse of our knife (and of its predatory substitute, the fork): they are the alimentary instrument which refuses to cut, to pierce, to mutilate … food becomes no longer a prey to which one does violence … but a substance harmoniously transferred; they [chopsticks] transform the previously divided substance into bird food and rice into a flow of milk; maternal, they tirelessly perform the gesture which creates the mouthful, leaving to our alimentary manners, armed with pikes and knives, that of predation.*[8]

Many writers refer to the non-violence and humility of the Chinese philosophy of Confucianism as the basis of the use of chopsticks for eating. In order to avoid a knife, the reminder of killing, food was prepared in small pieces, easy to pick up with chopsticks. Due to the small amount of food that they can carry, chopsticks have been considered an effective way to control greed. From a tool of everyday ordinary activity, chopsticks were turned into a material embodiment of morality and cultural values of the East Asian countries.

With the rise of the economic and cultural status of East Asia in the global stage, chopsticks figure as an umbrella term for the region in business studies and social science. Moni Lai Storz explained the term 'Chopsticks culture' emerged in the late 1980s as 'a descriptive abbreviation to refer to the group of countries and people in Asia who have been influenced in some way by China'.[9] 'Analogous to the intricacy of eating with chopsticks', the identification and understanding of diversities and subtle differences of local cultural values in Asian countries is regarded as key to developing effective marketing.[10] A similar strategy is found in Project Chopsticks, hosted by the Hong Kong Polytechnic University's School of Design, in collaboration with universities in Beijing, Korea and Japan. Through investigating chopstick cultures in each country, the project aims to develop design products for new Asian lifestyles.[11]

Chopsticks are considered representative of the cultural traditions and heritage of East Asian countries. Older Chinese and Koreans have lamented the fact that younger generations of the population fail to learn how to use chopsticks correctly, symbolizing the loss of traditional values and lifestyles due to the adoption of Western food, dining habits and lifestyles.[12] In 1977, Chopsticks Day was established in Japan; every 4 August the contribution of chopsticks to the Japanese culinary culture is celebrated and their correct use is promoted. Borrowing Siegfried Giedion's broad concept of type developed in his seminal book, *Mechanization Takes Command: A Contribution to Anonymous History* (1948), *chopstick* may refer as much to a kind of social behaviour or custom as to material things.[13] Chopsticks are both ubiquitous commodities and distinctive material goods embodying cultural values. Chopsticks are endowed with iconicity in their material presence and the immaterial conceptualization of the cultures in which they are produced and used.

8 *Roland Barthes,* Empire of Signs, *trans. Richard Howard (New York: Hill and Wang, 1982), p. 18.*

9 *Moni Lai Storz,* Dancing with Dragons: Chopsticks People Revealed for Global Business *(Ashburton, VIC: Global Business Strategies, 1999), p. 2.*

10 *Kim-Shyan Fam, Zhilin Yang and Mike Hyman, 'Confucian/Chopsticks Marketing',* Journal of Business Ethics *88 (2009): 393.*

11 *Yanta H.T. Lam, et al., '"Project Chopsticks": An Asian Life-Style Study in Domestic Culinary Habits for Design', http://www.geijutsu.tsukuba.ac.jp/~tyam/projects/ADC/N00000807KRLIP00990.pdf. Accessed 21 September 2011.*

12 *Zhao Rongguang, 'On Several Questions Concerning the Research of Zhu Culture',* Korean Journal of Dietary Culture *17, no. 3 (2002): 337–62.*

13 *Walker,* Design History, *p. 116.*

*Havaianas Flip-Flops. Photograph courtesy Alpargatas USA/Havaianas.*

# Zōri and Flip-Flop Sandal, Japan/World (n.d.)

## Martha Chaiklin

A flat sandal with a thong across the instep is the archetype of footwear. People were shod this way from ancient times to the present in all four corners of the world. Flip-flops are a modern icon, however, not because they represent this connection to past but because they are a product of the industrialization and globalization of the modern world. What is the link to modernity? Synthetic rubbers and plastics. Cheap and waterproof, easy to manufacture, flip-flops span the globe, and the discards clog our landfills and the ocean.

### The Prototype

The flip-flop is known by many names in the English-speaking world, such as *jandal*, *go-ahead*, *thong*, *slaps* and *slipper*, but one of the earliest was the Japanese term *zōri*. Like nearly all traditional footwear in Japan, *zōri* are constructed with a thong between the big and second toe. Today they are considered a formal accessory and are usually made of leather. However in premodern times, *zōri* could refer to a variety of flat-bottomed, less formal footwear of this same basic shape. More casual *zōri* of inexpensive materials are most likely the seed that germinated the flip-flop. In modern Japanese, flip-flops are called *gomu-zōri,* or rubber *zōri*, but the story of how traditional Japanese footwear turned to sponge rubber and spread around the world is complex.

### Natural Rubber Shoes

The modern world was built on rubber. It carried the transportation revolution with tyres and fuelled the industrial revolution with machine belts. Natural rubber (*Hevea brazilienisis*) is the coagulation of the milky-white sap of the rubber tree indigenous to the Amazon basin. When imported to the West in the nineteenth century, it was used to make boots and shoes, especially after 1839 when Charles Goodyear accidently discovered vulcanization, spilling sulphur into a pot of the stuff. Stronger and more temperature-resistant after processing, rubber footwear became widespread. Sandals were not widely worn in Western Europe or the United States until the last half-century, but in places like Greece, Africa and Asia, discarded tyres were converted to sandal soles almost as soon as the car was introduced. A 1922 magazine photo caption of a Mexican man quipped, 'Unlike the Tires, His Shoes are Puncture-Proof and Nonskidding.'[1]

Japan, racing to modernize in the late nineteenth century, moved quickly into rubber—the first factory, the Mitatsuchi Rubber Company, was founded in 1886—but only after tariff control reverted to Japan in 1905 did protective tariffs allow domestic industries to grow. The main rubber product was bicycle tyres, but shoes were also important. In 1905, 300,000 pairs of rubber shoes were exported annually to Canton (Guangzhou) alone.[2] This industry really took off after vulcanization was introduced in 1918. Cheap rubber shoes were exported all over Asia. After the British firm J.P. Ingram set up a factory in Kobe in 1908, and Dunlop the next year, rubber shoe production moved largely to this city because even though these companies principally produced tyres the technological know-how spread to many smaller workshops.[3]

1 'Rubber Footwear Fashioned from Automobile Tires', Popular Mechanics, August 1922, p. 227.

2 It also states, 'Six years ago this trade did not exist.' British House of Commons Accounts and Papers – Commercial Reports LXXXVIII (London: British House of Commons, 1905), p. 7.

3 Teijiro Uyeda, The Small Industries of Japan (New York: Institute of Pacific Relations, 1938), pp. 184, 190.

## Stepping Out—Japan and Rubber Shoes

All-rubber shoes were primarily made for export. Inside Japan, rubber was largely used as soles for uppers of other materials. The earliest form appears to have been what are known as *jika tabi*. Still widely worn by labourers such as construction workers and gardeners, these split-toed socks with rubber soles were marketed at least as early as 1902.[4] By the late 1920s, large quantities of *jika tabi* were exported, especially to Hawaii where, until the Alien Exclusion Act of 1924, many Japanese people emigrated. Another early use was for *gomu-zōri*—but these were not flip-flops. Rather, as an advertisement from 1918 for Kumoi brand *gomu zōri*, clearly states, they resulted from 'a new process scientifically affixing cork and rubber' on the sole of traditional *zōri*.[5]

Marathon runner Kanaguri Shizo (1891–1983) conceived the idea of putting a rubber crepe sole on a traditional Japanese split-toed sock (*tabi*) to create a lightweight running shoe for the 1912 Olympics. Kanaguri failed to finish the race, which Japanese newspapers of the day blamed on a nail wearing through his shoe.[6] Nevertheless, Japanese runners wore this type of shoe until after World War II.[7] Rubber-soled shoes with canvas uppers were very popular in Japan from about 1918 because Western dress was becoming more common, but leather shoes were very expensive. Japanese canvas shoes with crepe soles were worn by the Australian team at Wimbledon in 1923 and thereafter became an international standard.[8] By the 1930s, Japan was exporting rubber boots and shoes to Europe, India, Africa, the United States and South America. Partial and all-rubber shoes were second only to tyres in the rubber production of the 1930s until wartime rationing in 1938.[9]

## Synthetics

Flip-flops only exist because synthetic rubber was invented. Synthetic rubber was better suited to machines and less dependent on external factors like commodity price or trade blockades. The all-rubber thong dates from after the Second World War.

The importance of rubber in the modern economy and the fact that it generally had to be grown in places far from industrialized centres meant that efforts were made to create a synthetic form of rubber beginning in the nineteenth century. The process was complex and based on the efforts of many, but, in brief, real progress on synthesizing rubber began in 1860, when Charles Hanson Greville Williams (1829–1910) produced a synthetic hydrocarbon he named *isoprene*. Thereafter, research continued, but relatively low rubber prices meant that isoprene was not cost effective. Although small quantities of synthetic rubber were produced in Japan and elsewhere, the only country producing synthetic rubber on an industrial scale in 1937 was the USSR.[10] The disruption of supplies and huge demand for rubber in WWII spurred the creation and adoption of synthetic rubber.

The synthetic that was most important for early flip-flops was neoprene. The Du Pont Company invented it in 1931. An expensive material during the Great Depression when rubber was very cheap, neoprene use spread very slowly despite its greater resistance to weather, heat and degradation by grease and oil.[11] As prices came down, the market grew, but the sharp increase in demand for rubber and disruption of supplies of WWII (virtually no natural rubber went onto the market from 1942 until the late 1940s) assured neoprene commercial viability.

## *Zōri* Take Over the World

Although the evidence is sketchy at best, the first flip-flops appear to have been made in Osaka, a place with a long history of shoe manufacturing. What set these sandals apart from other footwear produced with, for example, tyres, was the use of neoprene insulation from aeroplanes and emergency equipment. Made from recycled material, these were

4  *Advertisement*, Asahi *(Tokyo Morning)*, 20 June 1902, p. 8.

5  Yomiuri *(Evening)*, 24 April 1918, p. 3.

6  Asahi *(Tokyo Morning)*, 17 July 1912, p. 5.

7  Hiroshi Tanaka, The Human Side of Japanese Enterprise *(Philadelphia: University of Pennsylvania Press, 1988)*, p. 90.

8  Austin Coates, The Commerce in Rubber *(Singapore: Oxford University Press, 1987)*, p. 259.

9  G.C. Allen, 'Small-Scale Organization in the Newer Trades', in E.B. Shumpeter *(ed.)*, The Industrialization of Japan and Manchukuo *(New York: Macmillan, 1940)*, p. 560.

10  *Coates*, The Commerce, p. 325.

11  John Smith, 'The Ten-Year Invention: Neoprene and Du Pont Research', Technology and Culture 26, no. 1 *(Jan 1985)*: 34–55.

only produced in very small quantities. About 1949 or 1950, production of sandals with neoprene or another synthetic such as polyurethane, in imitation of those from Osaka, became the main industry in a village called Kobayashi at the far western end of Nara Prefecture.[12] Imports of synthetic rubber began in 1950, and by 1954 large Japanese companies and the Ministry of International Trade and Industry began to strategize about moving production to Japan. These companies began to compete with the smaller workshops that had primarily produced rubber footwear, supplanting Kobayashi as the flip-flop centre.[13] By the mid-1950s, Japanese rubber thongs were exported to Southeast Asia as well as to Hawaii, California and Brazil, where there were significant Japanese ethnic populations.

Evidence is lacking to support the popular belief that these sandals were spread by US serviceman returning from Asia, although an army doctor in Osaka writing on skin inflammation caused by rubber thongs in 1954 mentioned 'thousands of servicemen' bringing them home.[14] Even if military men brought some flip-flops back to the United States, it seems more likely that rubber sandals were first imported to Hawaii and their popularity spread with surfing and increased leisure in the postwar economic boom. According to founder Bob Meistrell, Dive 'n Surf of Redondo Beach, California, which was founded in 1952, sold flip-flops sourced from Japan from about 1955. During this period advertisements for flip-flops began appearing in magazines, reading 'Japanese zoris are comfortable attractive sandals.'[15] In this same year, Steve Scott of Scott Hawaii says that his company began imitating and improving on designs using better materials such as EVA and nylon thongs. Surfers, who spent a lot of time on the hot sand, quickly took to them.

Surfing became popular in the United States, in part due to the novel *Gidget* (1957) and the movie adaptation (1959). Flip-flops spread at the same time to New Zealand, where they were known as *jandals*, supposedly from 'Japanese sandals'. Businessmen Morris Yock and John Cowie both claimed to have invented them, but it is most likely that they imitated Japanese examples found in Hong Kong. The name 'jandal' was trademarked by Yock in 1957, but not only were American surfers already wearing them, Jantzen had marketed sandals with this name since 1955. In Australia, Dunlop imported 300,000 pairs from Japan in 1959 and began producing them the following year, according to the company's website.

In 1959 Hawaii became a state, spurring US interest in things Hawaiian, and this probably aided the spread of flip-flops. In the US Congressional Hearings of 1960, it was reported 'most of the imports from Japan consist of zoris or sponge rubber sandals, which are directly competitive with the product of no American industry unless, as has been aptly said, it be the barefoot industry.'[16] Flip-flops became symbolic of Hawaii, to the extent that flip-flop charms of precious materials like gold and diamonds were introduced. In 1962 Havaianas, tellingly meaning 'Hawaiians' in Portuguese, was founded in Brazil, another place with a large Japanese immigrant population.

Although the *Australian Woman's Weekly* declared flip-flops 'out' by 1965,[17] they are still produced and worn all over the world. Flip-flops represent leisure or a rebellion against formality. They even became the centre of political protest when thousands were deposited at a police station in Indonesia in objection to the brutal beating of a fifteen-year-old boy accused of stealing a pair.[18] They live on after they are unfit for their original purpose, salvaged as floats by Colombian fishermen and turned into art from Brazil to Kenya.[19] They are so iconic, celebrated shoe designer Christian Louboutin wishes he had invented them.[20] Flip-flops, archetypical footwear re-formed by the Japanese out of recycled American materials and spread through the popularity of a Polynesian sport, are the footwear of the modern world.

12 Buraku mondai nyūmon *(Kyoto: Buraku mondai kenkyūjo shuppan, 1969), pp. 88–90.*

13 *Eisuke Daito, 'Technology and Labor in a Dual Economy' in Howard F. Gospel (ed.),* Industrial Training and Technological Innovation *(London: Routledge, 1991), p. 172.*

14 *'Zories',* Today's Health, *May 1954, p. 16.*

15 *Advertisement,* New Yorker, *26 February 1955, p. 56.*

16 *United States Congress,* Impact of Imports and Exports on Employment. *87th Congress First Session (Washington, DC: U.S. Government Printing Office, 1962),* 168.

17 *'What's In and What's Out this Summer?'* Australian Woman's Weekly, *3 November 1965, p. 111.*

18 *Sarah Schonhardt, 'Indonesian Boy's Legal Woes Stir Indignant Protest',* New York Times, *5 January 2012, p. A8.*

19 *Orrin Pilkey et al.,* The World's Beaches *(Berkeley: University of California Press, 2011), p. 19; Tristan McConnell, 'Turning Flip-Flops into Art', globalpost.com, 10 September 2009, www. globalpost.com/dispatch/ kenya/090908/turning-flip-flops-art; Catherine Quayle, 'Photo: A fat monkey in flip-flops', pbs.org, 9 November 2010, http://www.pbs.org/ wnet/need-to-know/the-daily-need/a-fat-monkey-in-flip-flops/4986/. Accessed 1 June 2012.*

20 *Genevieve Roberts, 'Red on the Soles of His Shoes',* Independent, *29 May 2012.*

*Actor James Dean on the set of the movie* Giant, *released on 24 November 1956.*
*Photograph by Frank Worth. Capital Art Hulton Archive (Emage International/Getty Images).*

# 43

# Levi's Jeans, USA
# (Jacob Davis and Levi Strauss & Co., 1873)

## *Christopher Breward*

They are everywhere, but blue denim jeans have a complex history. The jeans' familiar indigo has offered a fresh canvas to successive generations of clothing manufacturers, distributors, advertisers, retailers and consumers for well over two centuries. In its earliest, seventeenth-century incarnation, the twill weave of silk and wool, commonly referred to as 'serge de Nimes', claimed connections with the French textile centre Nimes and was well known in England as 'de nim'. But it is likely that the hard-wearing cotton fabric that took on its name was a locally produced English staple, woven for humbler purposes and marketed as 'de nim' to capitalize on superior French associations.[1] Its qualities were perhaps closer to 'jean', a fustian originally blended from cotton, wool and linen, whose history lay in the Italian port of Genoa; and in some unrecorded sense, over time the two fabrics became known by names with increasingly blurred and interchangeable meanings and associations. By the end of the eighteenth-century, Lancashire jean was made entirely of cotton and associated with working-men's clothing, particularly the deep-blue, sea-going trousers of sailors.

## Building a Brand

In a newly independent America, textile production offered an important means of securing economic self-sufficiency, and both denim and jean were staple products of the mills of the East Coast. It was, however, the arrival of the recent Bavarian immigrant Levi Strauss in the Californian boomtown of San Francisco in 1853 that really established the tradition of the modern blue jean. Opening a branch of a family dry-goods business that had been founded in New York in the 1840s, Strauss supplied work clothes, blankets, handkerchiefs and other essentials to general stores throughout the American West and offered essentials to the railroad workers, cattle ranchers and itinerant gold prospectors who were flooding into the region during the 1860s and 70s. It was in answer to the particular sartorial needs of such men that Strauss partnered Jacob Davis, a tailor from Reno, Nevada, to patent riveted pocket corners on men's trousers in 1873. This innovation produced the precedent for the standard Levi 501 jean with a watch pocket at the front, a cinch, buttons for braces and strengthening copper rivets in the crotch and single back pocket. For an active workforce with little recourse to domestic support, laundering services and a ready supply of affordable new clothing, Strauss's industrial product was welcome. His jeans were relatively inexpensive, demanded little maintenance in the way of washing and pressing and endured heavy wear over long periods of time. Their economic, social and aesthetic connotations were modestly practical: Levis jeans were a simple uniform of labour and would continue to operate as such until the 1940s.[2]

Yet even in these early years, Levi Strauss & Co. was acutely aware of its position in the marketplace. The branded leather patch depicting two horses pulling away from a suspended and indestructible pair of jeans was introduced in 1886 as an identifying mark of quality, and the company was proactive in raising its profile as a model employer and charitable foundation in the San Francisco Bay area. An engagement with questions

1 *Lynn Downey*, A Short History of Denim *(San Francisco: Levi Strauss & Co, 2007), pp. 1–2.*

2 *Levi Strauss & Co. Timeline,* http://www. levistrauss.com/library/levi-strauss-co-timeline. *See also Farid Chenoune,* A History of Men's Fashion *(Paris: Flammarion, 1993), pp. 234–40.*

of fashion, though, was a foreign concept, excepting the introduction of a second back pocket in 1901 and belt loops in 1922 (mimicking new styles that were being introduced in the design of suits for office workers and professional city men). Innovations more often occurred through instances such as the introduction of new networks of national distribution in 1912 and assembly-line production techniques through the 1920s. A keen eye for product development led to the 1927 launch of a 10-ounce red selvage denim known as 'XX', woven in 29-inch-wide looms for exclusive use in 501 jeans, and the growing popularity of Levi's styles (and their concurrent vulnerability to copying) led to the registration of 'Levi's' as a protected trademark in 1928 and the invention of the identifying 'red tab', first sewn into the right back pocket in 1936.

## American Apparel

The Great Depression of the 1930s, both challenged the existence of the company (declining demand forced short weeks and a move to non-manufacturing tasks on the Levi's workforce) and provided the context for a shift in the marketing of Levi's products. Besides diversification into the production of women's jeans or 'Lady Levi's', the company also started to trade more overtly on its association with the pioneering West in its adverts and promotions, aided by the growing popularity of the iconic and highly charged figure of the cowboy in national mythmaking, popular fiction and Hollywood films. Levi's location in California, relatively close to the film studios in Los Angeles and distant from the apparently effete centres of political and financial power in Washington and New York, opened up a space in which

*an infant creative industry could exert a new kind of power to define an identity for the whole nation—an identity endowed with the physical prowess, moral fortitude and natural innocence to realize the expansion of American rule. Both film genre and blue jean thus became ever enmeshed in the paradoxical quest for authenticity, and ever-receding ideal haunted by ever-changing images.*[3]

It was as if, through the magic of the film camera, the humble jean was transformed: from long-shot generalization in the majestic settings of the Western landscape, through the honest, everyday visual and sartorial language of William Boyd and Roy Rogers B-movies and television serials, to the big-screen blue-denim pomp of Gary Cooper, Henry Fonda, Ronald Reagan and John Wayne in the late 1940s and 50s.

The entry of the United States into World War II in 1941 widened the potential for jeans-centred propaganda as millions of US soldiers, sailors and airmen introduced Europe and Asia to the physical reality of American denim, albeit a rationed version without rivets, cinches or decorative stitches. By 1947, when the postwar version of 501s began to roll off the production line with rivets and decorative stitching reinstated, blue-jeans had forged an indelible connection with the American way in consumers' minds— so much so that Levi's were selected as the official uniform for staff of the American Pavilion at the 1958 World's Fair in Brussels and were exhibited at the American Fashion Industries Presentation in Moscow the following year. Yet with this seemingly unstoppable co-option of denim as a de-facto national uniform for an increasingly suburbanized and materialistic middle class America came an opposing rhetoric whereby the older narratives of authenticity and freedom encapsulated in blue jeans began to resurface, and the escapist legend of denim came to offer more oppositional possibilities.

The seemingly unchanging, antifashion characteristics of denim and its essentializing ties to action and adventure set jeans up as a badge for subversive intent in the 1950s and 60s, chosen by rebels and outcasts as a marker of difference and refusal.

3 *Leslie W. Rabine and Susan Kaiser, 'Sewing Machines and Dream Machines in Los Angeles and San Francisco: The Case of the Blue Jean', in Christopher Breward and David Gilbert (eds),* Fashion's World Cities *(Oxford: Berg, 2006), p. 241.*

The broodingly contemptuous film stars Marlon Brando and James Dean helped forge the most powerful imagery of sartorial rebellion in their reification of dirty jeans, white vests and leather in the movies *The Wild One* (1952), *East of Eden* (1954), *Rebel Without a Cause* (1955) and *Giant* (1956). Denim's malleability and supremely suggestive symbolic qualities could, in the mid-twentieth century, encompass adherents including Brando and Dean alongside bohemian intellectuals and artists, left-leaning political radicals, feminists, gay men, students and teenage misfits.[4] And all the while, Levi's continued to pioneer technical change and engineer publicity coups, from the introduction of pre-shrunk and crease-free jeans in the mid-1960s to an engagement with countercultural craft trends in its sponsorship of the 1975 national denim art competition 'American Denim'.[5]

## Market Saturation

By the late 1970s, the international fashion industry had cottoned on to the profitability of denim, introducing a range of new and reinvented traditions through intensive advertising and celebrity endorsements. Gloria Vanderbilt and Calvin Klein promoted glamorous lines in elegantly cut designer jeans for the jet set, while Levi's rediscovered its own heritage in the widely celebrated 1982 'Launderette' advertising campaign for 501s by Bartle Bogle Hegarty, starring Nick Kamen in a pastiche of small town 1950s America. A virtual saturation of the global market for denim goods by the turn of the twenty-first century has resulted in some extraordinary regenerations of this staple garment. Now shorn of its innocence, the once all-American jean has been consecutively manipulated as a rare collector's item, hived off to increasingly obscure Japanese and European niche labels and re-engineered to meet the aesthetic and practical desires of a generation enamoured of new technologies, futurism and the social power of subcultural networks, real and virtual.

Perhaps the history of the jean, and of Levi's jeans in particular, provides a metaphor for understanding the increasing importance placed on the role of the fashion process in the operation of the late capitalist system generally. Many writers on consumer culture have identified a broad cultural shift from a society in which a focus on the utility of objects and products was prioritized to one in which much greater value has been placed on their symbolic and associative value.[6] But it is also worth reflecting on the fact that the humble jean continues to play a role in the more humdrum rhythms of everyday life, chosen by many as a staple garment without much conscious deliberation of either the global circumstances of its production or its style signifiers: too easily adopted and rejected, yet profoundly tied to history and memory in the most material of senses.[7]

4 *See Shaun Cole,* Don We Now Our Gay Apparel: Gay Men's Dress in the Twentieth Century *(Oxford: Berg, 2000), p. 96.*

5 *Richard M. Owens and Tony Lane,* American Denim: A New Folk Art *(New York: H.N. Abrams, 1975).*

6 *Jane Pavitt (ed.),* Brand.new *(London: Victoria & Albert Museum, 2000).*

7 *Kitty Hauser, 'The Fingerprint of the Second Skin', in Christopher Breward and Caroline Evans (eds),* Fashion & Modernity *(Oxford: Berg, 2005), pp. 153–71. See also Daniel Miller and Sophie Woodward,* Global Denim *(Oxford: Berg, 2010).*

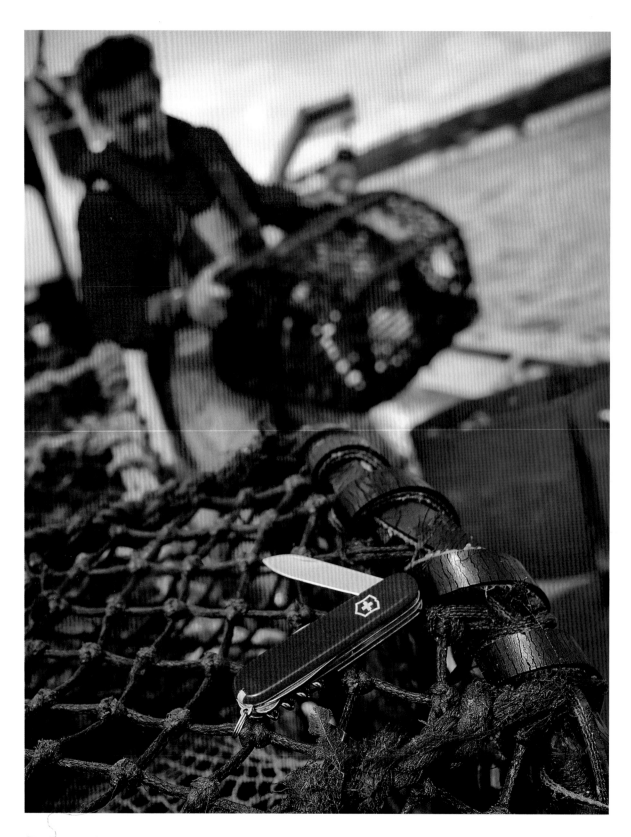

*Seen here on an Isle of Man fishing boat, the Swiss Army knife is an indispensable tool for fishermen, mountain climbers and astronauts alike. Photograph courtesy Simon Prescott.*

# 44

# Swiss Army Knife, Switzerland
# (Karl Elsener, Victorinox, 1891)

*Catharine Rossi*

In 1975, the mountaineers Doug Scott and Dougal Haston were making their ascent up Mount Everest. This would become the first successful British Everest Expedition, but they nearly didn't make it: Haston's breathing apparatus froze, so Scott used the one tool he had that could unblock the ice-clogged equipment and save his life—a Swiss Army knife. These adventurers are not the only ones to have realized the life-saving importance of this portable tool, or rather toolkit, given the multiple instruments it comprises. From astronauts to picnickers, farmers to fishermen, it is an essential for both extraordinary and everyday situations; surely if any object merits the status of a design icon it is the Swiss Army knife.

The knife was first designed in 1891 by Karl Elsener, a Swiss cutler who had honed his skills in the knife-making centres of France and Germany.[1] On returning to Switzerland in 1884, he set up a workshop in the Swiss-German town of Ibach, where he sold his knives through his mother Victoria's hat shop.[2] On her death in 1909, Elsener named the firm after her, and following the introduction of stainless steel to the knife's production in 1921, renamed it Victorinox.[3] While the still-family-run firm now manufactures many other objects, including cutlery, luggage and even fragrances, the Swiss Army knife is its most recognizable product. It is also the most iconic of today's multipurpose tools, and perhaps even the most iconic modern tool.

Its iconicity rests as much on its life-saving abilities as its design credentials; its compact, largely unadorned form and functionality makes it the pinnacle of everyday modernism, included in both New York's Museum of Modern Art and Munich's State Museum of Applied Art and Design's collections, as well as in the pages of several iconic design publications.[4]

## Swissness

The knife's iconic status is tied up with its recognizably Swiss nationality. This is most overt in the casing, which bears the national flag's white cross and red background. The knife also embodies Swissness in less tangible ways. As the design writer Dorian Lucas notes, it shares the same qualities of 'precision craftsmanship' and 'Calvinist functionality' as other Swiss exports such as watches, jewellery and a celebrated graphic design tradition.[5]

Yet while the knife's nationality is a strong part of its iconicity, the folding multipurpose knife is not actually a Swiss invention. The earliest examples date back to the first century AD, when Romans used them primarily as eating tools.[6] Nor is Elsener's knife the first to be spring-loaded, a crucial feature that allows the blades to open and shut firmly and so avoid unpleasant accidents and an invention that led to their leap in popularity in the seventeenth century.[7] Nor do any of Victorinox's versions, such as 1968's SwissChamp with thirty-three different attachments, hold the record for incorporating the most tools. This goes to the British-made Sportsman's Knife, unveiled at the Great Exhibition of 1851, which had more than eighty.[8] Victorinox may be the first, but it is not the only Swiss manufacturer. Wenger, based in French-speaking Delémont, has been manufacturing its own knives since 1893, although it now does so under the umbrella of Victorinox, which acquired it in 2005.[9] Nor is

1  The Knife and its History *(Ibach: Victorinox, 1984), p. 126.*

2  *Ibid., p. 127.*

3  *Dorian Lucas,* Swiss Design *(Salenstein: Braun, 2011), p. 125.*

4  *Hilary Beyer and Catherine McDermott,* Classics of Design *(London: Brown Reference, 2002), pp. 14–15; Deyan Sudjic,* Cult Objects *(London: Paladin, 1985), pp. 47, 49; Simon Alderson, 'Swiss Army Knife',* Phaidon Design Classics *vol. 1 (London: Phaidon, 2006), p. 51.*

5  *Lucas,* Swiss Design, *p. 5.*

6  *Simon Moore,* Penknives and Other Folding Knives *(Aylesbury: Shire, 1988), p. 3.*

7  *Ibid., p. 7.*

8  *Thomas Richards,* The Commodity Culture of Victorian England: Advertising and Spectacle, 1851–1914 *(Stanford, CA: Stanford University Press), p. 33.*

9  'History', http://www.victorinox.com/ch/content/history_page. *Accessed 14 March 2012.*

Switzerland the only purveyor of folding multitools today. From the American Leatherman to the French Opinel and the Spanish Laguiole, several nations have their own versions, albeit none as iconic as their Swiss counterpart.

This initial inspection of the Swiss Army knife not only undermines some presumptions about the knife's origins, but also suggests that one of its most revealing aspects is what it can tell us about the role that national identity plays in the history not only of icons, but designed goods more generally.

## The Origins of the Swiss Army Knife

The Swiss Army knife's origins are connected with the birth of the nation itself — Switzerland became a federal state in 1848, in a period that design historian Jeremy Aynsley has described as having been defined by its developing 'national consciousness'.[10] In 1890, Elsener established the Association of Swiss Master Cutlers, which aimed to replace their army's German-made pocket knives with their own domestic production. Unfortunately, they were unsuccessful: unable to beat the price and weight of the imported knives, the organization collapsed.[11] Heavily in debt, Elsener continued his quest alone and by 12 June 1897, he had patented the *Offiziersmesser* (Officer's Knife), which was both lighter and more functional, adding a corkscrew and additional smaller blade to the existing awl, long blade, can opener and screwdriver. This increased capability was made possible by what remains the key part of Elsener's design, a system allowing all the blades to operate from just one spring, thereby enabling the addition of more tools without increasing the knife's size.[12]

Subsequent developments contributed to the knife's increasingly Swiss appearance. In 1897, Elsener replaced the wooden handle with a red one, made first from fibre, and now Cellidor plastic. In 1909 the Swiss escutcheon, until then an optional feature, was made standard. Coming twenty-five years after the firm's establishment and just thirty since the federation's official adoption of the emblem, its inclusion was indicative of Switzerland's consolidating national identity and an act of protectionism.[13] Only Swiss manufacturers were allowed to use the flag, which distinguished it from the increasing number of copies that testified to its growing popularity. Today this flag is accompanied by a stamp on the blade's shank that verifies that the knife is Swiss made.[14]

The Swiss Army continued to be an important patron of both the Victorinox and Wenger versions of the knife. In the national spirit of neutrality, the Government agreed in 1908 to buy half of its knives from Victorinox and half from Wenger, designating the former purveyors of the 'Original' and the latter of 'Genuine' Swiss Army knives.[15] Yet while this martial customer guaranteed substantial sales, it was the international, not the domestic, market that was most responsible for the knife's growing popularity in the twentieth century. During World War II, American soldiers stationed in Europe took them home as souvenirs, stoking the appetite of the nation that is the knife's biggest market today.[16] Unable to pronounce *Offiziersmesser*, these G.I.s were also responsible for the knife's Anglicized name. Furthermore, America's army wasn't the only one to admire the knife. In 1976, the German army adopted the knife as part of their regulation equipment, albeit in a suitably Teutonic green colour with an Eagle insignia.[17]

## Tools as Design Icons

The Swiss Army knife is not the only iconic design with military origins. In his book *Cult Objects*, Deyan Sudjic includes the knife as part of a larger family of civilian-adopted objects, such as the Zippo lighter and the Jeep.[18] Examining the knife's military patronage not only invites us to question the origins of other objects we rely on today, but also

10 *Jeremy Aynsley,* Nationalism and Internationalism *(London: V&A, 1993), p. 7.*

11 *Alderson, 'Swiss Army Knife', p. 51.*

12 *Ibid.*

13 *Lucas,* Swiss Design, *p. 4.*

14 The Knife, *p. 160.*

15 *Carl Hoffman and Jake Page, 'On Everest or in the Office, It's the Tool to Have',* Smithsonian *20 (1989): 110.*

16 *Hoffman and Page, 'On Everest', 108.*

17 *Mel Byars,* The Design Encyclopaedia *(London, New York: Lawrence King, Museum of Modern Art, 2004), p. 215.*

18 *Sudjic,* Cult Objects, *p. 11.*

provides a way to consider the knife as an example of a fundamental object type: a tool. In particular, the knife shows how tools are objects designed with specific users, and usage, in mind.

As the semiotician Jean-Marie Floch has observed, while the Opinel knife was designed for 'farmers and craftspeople', the Swiss Army knife was designed with a soldier in mind.[19] This intended user determined the configuration of its toolbox. While Victorinox could not predict how they would be used, each tool implied a specific use (for example, the Phillips screwdriver was included so that soldiers could dismantle those other tools: their rifles) making the knife a form of instruction manual to regiment and regulate soldiers' actions.[20]

As Victorinox's range expanded in the early 1900s, they similarly expressed a designated user, both in name, such as the Carpenter, and in tools included, such as the Farmer's knife, with its addition of a saw blade. These examples suggest how tools both constitute and are constitutive of professions and activities more generally; it is the tools we use that make us who we are.

Some later models have retained this link with specific skilled pursuits, although now they are more about leisure than work, as in the Angler model.[21] However, Victorinox's attempt to keep up-to-date by introducing tools such as an LED light, USB drive and MP3 player that can be used for a variety of applications, and including more tools on one model—such as the SwissChamp—suggests a loosening specificity and growing flexibility in terms of intended use and user. This decreasing connection with skilled professions in the increasingly overequipped Swiss Army knife also shows how tools—implicitly useful objects—can slip into the more frivolous realm of gadgets.

In his 1965 essay 'The Great Gizmo', the architectural critic Reyner Banham defined the gadget, or gizmo, as 'a small self-contained unit of high performance in relation to its size and cost'.[22] Banham's essay focuses on the gadget's compact portability rather than its more widespread connotations as a novelty, yet the knife's slippage into the latter as it includes ever-more tools compromises even Banham's definition. Questions over portability and functionality with even the most basic models have seen the emergence of competitors such as the Leatherman, introduced in the 1980s, which puts a pair of pliers, rather than spring-loaded knife, at its centre.[23]

Despite this challenge, the Swiss Army knife remains an iconic object, one promoted by, and used to promote, its nation. In 2006 the Swiss Postal service devoted two stamps from its series to Victorinox, and in 2008 Victorinox beat several competitors to renew its Swiss Army contract—continuing the military patronage that first brought the knife into existence.

## Conclusion

As this brief account has indicated, looking closer at the Swiss Army knife enables examination of concepts of nationality in objects. Specifically, it sheds light on the role of nations in the conception, production, mediation and consumption of design. Its identifiable Swissness also suggests that to be iconic an object doesn't need to be the first, nor the only one of its kind, but it does need to be the most recognizable.

As an object type, the Swiss Army knife also demonstrates the need to attend to the tools that surround us. The names and types of tools included in each model demonstrate how closely tools are tied up with human activities and also how objects are conceived with intended users and usage in mind. Finally, whether they are being used up mountains or on fishing boats, the Swiss Army knife also suggests that icons, due to both their design and representation, have a heightened level of determinism in attempting to guide users' behaviour, however they end up being used.

19 Jean-Marie Floch, Visual Identities, trans. Alec McHoul and Pierre van Osselaer (London: Continuum, 2000), p. 163.
20 Charles Holland, 'Icon of the Month', Icon, June 2012, p. 40.
21 'Swiss Army Knives', http://www.victorinox. com/ch/content/swissarmy/ category/1. Accessed 18 May 2012.
22 Reyner Banham, 'The Great Gizmo', in A Critic Writes: Essays by Reyner Banham (Berkeley, CA: University of California Press, 1996), p. 113.
23 Leatherman, 'Interactive Timeline', http://www. leatherman.com/Timeline/ index. Accessed 18 May 2012.

# Eastman Kodak Co.'s
# BROWNIE
# CAMERAS

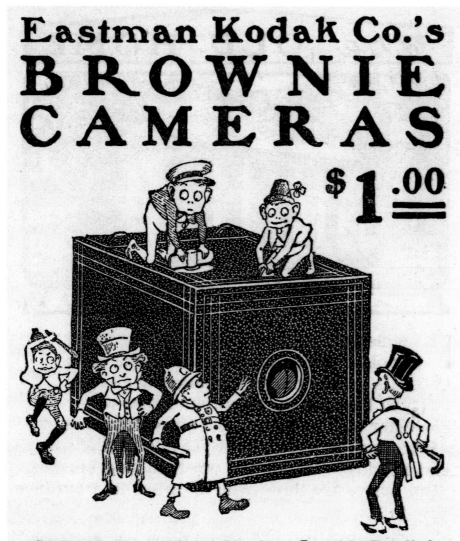

$1.00

Make pictures 2¼ x 2¼ inches. Load in Daylight with our six exposure film cartridges and are so simple they can be easily

## Operated by Any School Boy or Girl.

Fitted with fine Meniscus lenses and our improved rotary shutters for snap shots or time exposures. Strongly made, covered with imitation leather, have nickeled fittings and produce the best results.

Brownie Camera, for 2¼ x 2¼ pictures, -     -     - $1.00
Transparent-Film Cartridge, 6 exposures, 2¼ x 2¼, -     .15
Brownie Developing and Printing Outfit, -     -     .75

*Ask your dealer or write us for a Brownie Camera Club Constitution. $500.00 in Kodak prizes to the members.*

## EASTMAN KODAK CO.,
### Rochester, N. Y.

*Advertisement for Brownie cameras. From* The Youth's Companion, *26 July 1900, p. 371.*

# 45

## Brownie Camera, USA
## (Eastman Kodak, 1900)

*Marc Olivier*

### The Black Box

On the basis of looks alone, the Brownie is a camera that only a minimalist could love—a design icon in the form of a plain black box. To be fair, the Brownie was meant to dazzle the customer with its price rather than its appearance. 'The dollar camera is at last a fact', declared George Eastman in a Kodak trade circular in February 1900. 'Of course there have been pin-hole affairs, with a groove in the back to hold a glass plate, which have sold for almost nothing—and were worth it, but the Brownie is the first really practical instrument at the price.'[1] Designed for Eastman by former cabinet-maker Frank Brownell, the unassuming device was made of wood-reinforced jute board covered in imitation black leather and fitted with an f/14 meniscus lens (a simple lens with one convex and one concave side) behind a rotary shutter with a fixed speed of 1/50th of a second. No focusing or adjustments needed: simply aim, release the shutter with the small lever and wind the toy-like key to advance the film. A hobby previously reserved for well-heeled adults was suddenly accessible to people on a limited budget and children.

When Eastman took out a patent on 'American Film' in March 1884 and then on the Eastman-Walker Roll Holder in May 1885, he was poised to revolutionize the photography market. His system won gold awards at exhibitions in London, Paris, and cities from Moscow to Melbourne, but as Eastman's biographer Elizabeth Brayer observes, 'the roll holder was an accessory; the key would be a simple camera designed to exploit a roll of flexible transparent film'.[2] That breakthrough came in October 1887, when Brownell designed a box camera with an integrated roll holder for one hundred exposures of film. Eastman named the camera the Kodak and began selling them for $25 in May 1888 with the slogan 'You Press the Button, We Do the Rest.' The first half of the slogan points to the ease of use, and the second promises emancipation from the complex and messy process of making prints. Blissfully ignorant, the Kodak owner need never open the camera. Instead, for $10 plus shipping, the entire camera could be sent to Kodak's lab headquarters at Rochester, New York, for processing and then returned to the customer with mounted 2½-inch circular prints and a fresh roll of film installed.

Eastman's primary goal was to sell film, not to create optically superior cameras for the professional market. With that in mind, he asked Brownell to produce new models to fit any budget. Among the most accessible in price were the Model A Daylight Kodak for $8.50, the Model A Ordinary Kodak for $6—both introduced in 1891—and the Pocket Kodak, introduced in 1895 for $5. As Eastman House Technology Curator Todd Gustavson notes, the Ordinary Kodak was 'billed as the "Young Folk's Kodak" and marketed to boys and girls 10 years and older'.[3] For reasons unknown, the Ordinary Kodak failed to capture the market. But in 1900, the Brownie achieved the perfect combination of price, simplicity and brand identity. Only slightly more complicated than the 'We Do the Rest' promise of the first Kodak, the Brownie required users to change their own film cartridges. A removable housing simplified the task, and Kodak lab processing of the six 2¼-inch square prints for 40 cents meant that the less technically

1 *Kodak, 'Trade Circular',* 3 *(February 1900), p. 1.*

2 *Elizabeth Brayer,* George Eastman: A Biography *(Baltimore: Johns Hopkins University Press, 1996), p. 47.*

3 *Todd Gustavson,* Camera: A History of Photography from Daguerreotype to Digital *(New York: Sterling Publishing, 2009), p. 136.*

inclined could forgo initiation into the 'Witchery of Kodakery', (or learning the techniques of photographic printing).[4]

Gustavson estimates that nearly 200 Brownie models and related accessories were launched between 1900 and 1960.[5] During that time, the black box underwent various technical and cosmetic makeovers, such as Walter Dorwin Teague's Beau Brownie (1930), with its art deco faceplate and assorted colour options, and his bakelite Baby Brownie (1934), immortalized by the US Postal Service in 2011 as one of twelve objects to commemorate pioneers of American industrial design. Also made of Bakelite, the Brownie Hawkeye Flash Model (1949) became the most popular Brownie ever produced.[6] Nevertheless, the basic black box form of the Brownie remains instantly recognizable as an icon of snapshot photography.

## No Ordinary Kodak

Whereas the label 'Ordinary Kodak' might have inspired little more than a vague sense of ennui, the 'Brownie' name capitalized on the star power of a popular set of cartoon characters steeped in magic. For just as easily as a child today can tell you who lives in a pineapple under the sea (Spongebob Squarepants), the child of 1900 knew that Brownies were invisible sprites who perform helpful deeds and harmless pranks 'while weary households sleep, and never allow themselves to be seen by mortal eyes'.[7] Inspired by Scottish folklore, writer and illustrator Palmer Cox began publishing illustrated poems about Brownies in children's magazines in 1883, and within months he was licensing his sprites for commercial use.[8] By the time Eastman co-opted the Brownie name and likeness (without permission and with the slightest of modifications, possibly to avoid legal problems), the merry band of characters had appeared in seven books and had endorsed dozens of products.[9] But unlike other Brownie endorsements, Eastman's campaign embraced the Brownie identity to the point of conflating the user, the device and the magical creature. Hence, children became 'Brownie boys and girls' and could be seen photographing Brownie dolls with their Brownie cameras as if they had suddenly gained access to an invisible realm. Brownies themselves used the box camera in the earliest advertisements, and in 1901, Eastman added a picture-taking Brownie to colourful new packaging. Soon, even Palmer Cox inducted a snap-happy Brownie to his official line-up of characters.

In the words of Kodak's March 1900 trade circular, the Brownies were 'going like hotcakes'.[10] The first 5,000 sold immediately—a figure that took the first Kodak nine months to reach.[11] Within a year, Eastman had shipped more than 150,000 Brownies for sale around the world.[12] Yet in spite of the Brownie's unprecedented success, Kodak dealers were reluctant to promote a camera with a profit margin of mere pennies. Consequently, while Eastman reached out to six million subscribers in magazines such as the Saturday Evening Post, the Youth's Companion and Cosmopolitan, he simultaneously fought to inspire dealers with the motivational mantra 'Plant the Brownie Acorn and the Kodak Oak Will Grow', which he emblazoned on the cover and nearly every page of the May trade circular.[13] Eastman pitched the Brownie as a gateway to the Kodak and, more importantly, to a life in which photography takes its place alongside literacy as an essential indicator of a civilized upbringing. 'The time will come and that soon', foretells a 1900 trade circular, 'when those who have not the knowledge or appliances necessary to enable them to do photographic work will be as little in touch with the spirit of the times as is now the man who ignores books, magazines and papers'.[14]

The Brownie promised nothing less than citizenship in a world that mirrored the adventure, enchantment and cosmopolitanism of its eponymous band of characters.

4 Kodak, 'Trade Circular', 5 (April 1900), p. 6.

5 Gustavson, Camera, p. 143.

6 Ibid., p. 152.

7 Palmer Cox, The Brownies: Their Book (New York: The Century Company, 1887), p. vii.

8 Wayne Morgan, 'Cox on the Box: Palmer Cox and the Brownies: The First Licensed Characters; the First Licensed Games', Game Researchers' Notes 2 (1996): 5533.

9 Roger W. Cummings, Humorous but Wholesome: A History of Palmer Cox and the Brownies (Watkins Glen, NY: Century House Americana Publishers, 1973), p. 101.

10 Kodak, 'Trade Circular', 4 (March 1900), p. 2.

11 Brayer, George Eastman, p. 66.

12 Nancy Martha West, Kodak and the Lens of Nostalgia (Charlottesville: University of Virginia Press, 2000), p. 75.

13 Kodak, 'Trade Circular', 6 (May 1900).

14 Kodak, 'Trade Circular', 5 (April 1900), p. 6.

Brownie ownership came with membership in a Brownie Camera Club and a copy of the Brownie Camera Club Constitution. 'Brownie Books' promoted contests and shared the work of fellow Brownie boys and girls. Even as Cox's own Brownies embraced the urge (or newfound anxiety) to photograph their every move, throngs of children and parents learned the importance of documenting daily life. For more than a decade, a series of advertisements pleaded with grown-ups to 'Let the Children Kodak!' as if denial to do so violated an inalienable right. Eastman's booming democracy of the image demanded 'pictures of the children by the children'.[15] The Brownie's low price and simple operation redefined who could take pictures, and the Brownie identity refashioned photography as participation in a community with a shared visual language.

## The Brownie Acorn

In 2010, National Geographic photographer Steve McCurry shot the last roll of Kodak's Kodachrome film, signalling 'the spiritual death of film' according to Wired.com.[16] In 2013, as Kodak scrambled to reorganize under chapter 11 bankruptcy protection, media accounts of the Kodak legacy often took the form of cautionary tales about the perils of resisting change. Among the numerous actors in the complex story of Kodak's decline, we find Polaroid, Japanese competitors, Kodak's failed Disc format, and the rise of mobile and Internet culture. From a corporate perspective, most would agree that Kodak has had its moment. Even though a Kodak engineer invented the first digital camera in 1975 and in spite of the company's portfolio of approximately 1,100 digital patents valued at more than $1 billion, the fact remains that the digital landscape is dominated by Facebook, Flickr and Instagram, and not by 'Kodak oaks'.

Corporate errors notwithstanding, the Brownie acorn forms the roots of democratized snapshot photography. The Brownie fulfilled Eastman's desire to create an international market of film consumers, and in the process, enabled a visual print revolution that embraced the stories of the women and children so often excluded from the production of the printed word. From its introduction in 1900 and well into the 1960s, the Brownie served as a gateway to a photographically mediated life. Henri Cartier-Bresson, father of the 'decisive moment', first learned to capture his world through the lens of a Brownie, as did Ansel Adams, and many of the century's most famous photographers. The ethos of the Brownie permeates not only art photography, but also the blogosphere, photo communities such as Flickr, and visually based social networks such as Instagram and Pinterest.

Perhaps only half-jokingly, Eastman once wrote of a future in which 'children will be taught to develop [film] before they learn to walk, and grown-up people—instead of trying word painting—will merely hand out a photograph and language will become obsolete'.[17] Today, filter apps that mimic the look of the film stocks and processes they replace may be the only 'developing' most children learn. Language, however, continues its march toward the visual. In a 2012 interview, co-founder of Instagram, Kevin Systrom, boasts that he has created 'one of the first truly international social networks' because Instagrammers communicate primarily through images rather than tweets and status updates.[18] Facebook's billion-dollar acquisition of the company draws attention to the importance of photo networks. In 2004, Flickr pioneered the online migration by combining the organization of the family photo album with the camaraderie of a camera club. Since that time, forests of competitors vie for the dominance once enjoyed by Kodak, all of them would-be heirs to a legacy of snapshot photography rooted in a little box camera 'operated by any schoolboy or girl'.

15 *See, for example, Kodak, 'Trade Circular' (November 1915).*

16 *Charlie Sorrel, 'Death of Film: Last Roll of Kodachrome Processed',* http://www.wired.com/gadgetlab/2010/07/death-of-last-roll-of-kodachrome-processed/. *Last modified 23 July 2010.*

17 *Quoted in Douglas Collins,* The Story of Kodak *(New York: Harry N. Abrams, 1900), p. 99.*

18 *'Instagram Founder Kevin Systrom',* http://www.youtube.com/watch?v=IPigMKugJhY. *Accessed 12 May 2012.*

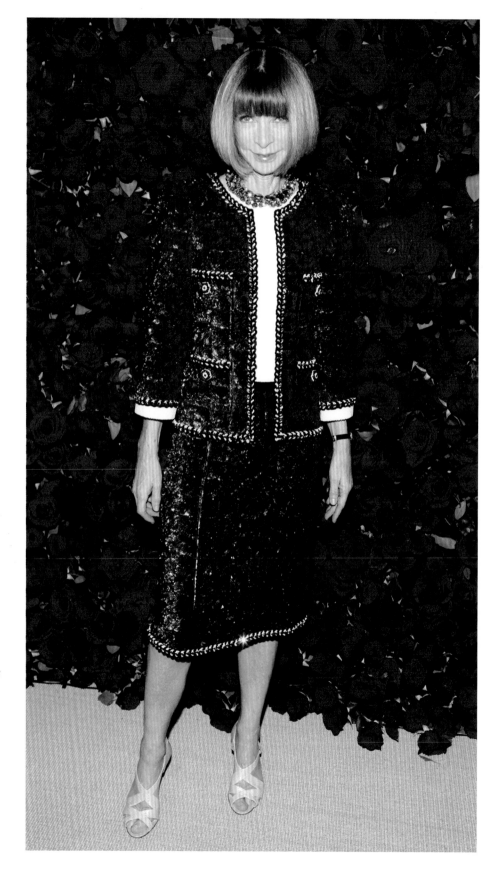

Anna Wintour, editor of
American Vogue, wearing
a blue sequined bouclé
Chanel Couture suit designed
by Karl Lagerfeld to a benefit
held at the Museum
of Modern Art, New York,
sponsored by Chanel
and MoMA in honour
of Spanish film director
Pedro Almodóvar,
15 November 2011.
Permission: Will Ragozzino/
BFAnyc.com.

# 46 Chanel Suit, France
## (Coco Chanel, c. 1913)

*Hazel Clark*

'The suit was made of tweed, wool, jersey, silk—the material governed by whether the suit would be worn for day wear or evening wear. The jacket was invariably short and fitted, decorated with pockets and fastened with gold buttons. The suit was meticulously lined with silk in a toning colour, being a decorative effect in itself.'[1] To this description of the 'iconic' Chanel suit, we can add the characteristic fine gold chain sewn at the inside hem to make the jacket hang straight, and a skirt that skimmed the knee, worn with strings of pearls or gilt chains, two-toned pumps, matching stockings and a hat. But what has deemed the suit iconic or classic? What distinguishes the *Chanel* suit from any other women's suit, and when, why and how did its status develop?

### 'Le Vrai Chic'

Worn initially as a riding habit in the late seventeenth century, the women's suit had become ubiquitous as city wear by the early twentieth century, especially for middle-class young women who were employed in new professions such as office work or elementary school teaching. Based on menswear, it comprised a fitted jacket, full-length skirt and a shirt.

At the beginning of the second decade of the twentieth century, when Gabrielle 'Coco' Chanel (1883–1971) began designing, the suit was already associated with women's emancipation, having facilitated female participation in the 'man's world' of urban work and leisure, as well as being favoured by the suffragettes. Chanel successfully developed a suit that accommodated the rapidly changing lifestyle of modern women. The fact that Chanel began designing during the First World War is key; the war changed lives and ways of dressing across incomes, gender and social classes.

One of the first suits attributed to Chanel is known to us as a drawing by caricaturist Sem, appearing in *L'Illustration,* 28 March 1914. According to the accompanying article, the long thigh-length jacket, trimmed at the hem with fur, with its slim ankle-length skirt, hat and huge fur muff, demonstrated '*le vrai chic*'.[2] By that time Chanel had a millinery business in Paris, established in 1910, a boutique in Deauville, opened in 1913, and another to come in Biarritz in 1915. After 1914, fashionable summer resorts such as Deauville served increasingly as refuges from the realities of war for the socialites who formed a market for Chanel. Chanel's reputation had crossed the Atlantic, where *Harper's Bazaar* reproduced a drawing of an embroidered chemise dress made at the Biarritz establishment in 1916, the same year she showed her first haute couture collection. Already, in 1915, *Harper's* had proclaimed, 'The woman who hasn't at least one Chanel is hopelessly out of the running in fashion.'[3]

With their simple shapes, functional colours, such as Chanel's favourites of beige, black and white, which transcended fashion seasons, and details such as roomy pockets, Chanel's suits matched the practical and psychological conditions of wartime. Jersey in particular proved a popular fabric with numerous designers. From 1916, Chanel purchased hers from the French textile manufacturer Rodier to create belted cardigan jackets, skirts and tops. In 1917, *Vogue* reported that all the great couture houses were

1 *Alice Mackrell,* Coco Chanel *(New York: Holmes & Meier, 1992), p. 75.*

2 *Valerie Steele,* Paris Fashion: A Cultural History *(Oxford and New York: Berg, 1999), pp. 229–31.*

3 *Amy de la Haye and Shelley Tobin,* Chanel: The Couturiere at Work *(Woodstock, NY: The Overlook Press, 1994), p. 20.*

using silk or wool jersey for tailored frocks, afternoon gowns and *manteaux,* declaring that 'jersey defies passing fashion' and had achieved the status of a classic fabric.[4] Three *'Costumes de Jersey'* designed by Chanel were illustrated in the 15 March 1917 issue of *Les Élégances Parisiennes.* In solid-coloured fabric, the belted jackets of two, one in dark blue and the other in white, are delicately embroidered, and the third is in plain beige with a double saddlery-style leather belt. Each is worn with an open-neck blouse with a deep sailor collar and wide-brimmed hat. The hemlines are extremely short for the time, revealing the ankles, and one figure wears the two-tone shoes, in beige and navy blue, which were to become another Chanel classic.[5]

During the 1920s, Chanel's suits helped to define the androgynous *la garçonne*, as demonstrated by photographs of herself and her wealthy clientele. In 1926, the Ranee of Pudukota was pictured wearing a three-piece Chanel cardigan suit comprising a thigh-length checked cardigan jacket with single buttons and pockets near the hem, worn with a matching pleated skirt and a plain sweater beneath. The look was accessorized with a cloche hat, scarf, pearls and leather shoes with two straps across the instep.[6] Similarly, two well-reproduced photographs from 1929 show Chanel alone, and with her friend Vera Bate, wearing a matching patterned jersey jacket and skirt, and striped top, worn with strings of pearls and two-toned shoes.[7] The fact that Chanel wore the suit herself firmly associated the designer's name, and that of her house, with the garment. Its practical ease reflected her interest in menswear; this has been attributed in particular to her relationship (1923–30) with the Duke of Westminster, as has her use of tweeds and Fair Isle knits. Contemporary designers such as Jean Patou and Jane Régny were equally famous for women's sportswear in the 1920s, but Chanel's style of 'deluxe poverty' had become a modern 'classic', a kind of *uniform* that made 'the rich look young and casual'.[8] Despite the marked change of fashions in the 1930s, Chanel continued to produce her uncomplicated suits as daywear.

## Deluxe Poverty

The simplicity of the Chanel suit was, and is, deceptive. Diana Vreeland, the influential editor of *Harper's Bazaar* in the 1930s and a client and friend of Chanel, remarked on her attention to detailed cutting and fitting, which facilitated freedom of movement. 'Coco was a nut on armholes. She never, ever got an armhole quite, quite perfect. The way she wanted it. She was always snipping and taking out sleeves, driving the tailors crazy.'[9] Simplicity and luxury were combined, for example, in the black sequined Chanel trouser suit with a bolero jacket and wide pants worn by Vreeland in 1937/8.[10] When the designer closed her house in 1939 at the beginning of World War II, many of what are now considered the 'iconic' elements of the suit were already established.

Nevertheless, success was not guaranteed when she reopened her business in 1953. The reception of Chanel's designs was very mixed. Christian Dior's 'New Look' of 1947 and Balenciaga's formal sculptured lines had changed the fashion world. Chanel's personal reputation had been marred by the fact that she remained in occupied Paris during the war under the protection of a Nazi officer. Yet on 1 March 1954, American *Life* magazine applauded her return. Gradually, the European press supported her designs. Chanel, now in her fifties, was frequently photographed during the next two decades wearing the suit; these images firmly connected its form, her name and that of the brand. With a straight skirt and a shorter jacket, often trimmed with braid after 1957, typically it had buttons covered in matching fabric or moulded in metal. Nubby wools, tweeds and jersey fabrics produced jackets that were weighted inside with a chain and had practical pockets on the front. They were accessorized with several gilt chains or fake strings of

4 *de la Haye and Tobin,* Chanel, *p. 26.*

5 *This illustration has been widely reproduced in, for example, de la Haye and Tobin,* Chanel, *p. 18; Mackrell,* Coco Chanel, *p. 24.*

6 *Mackrell,* Coco Chanel, *p. 26, Fig. 10.*

7 *Illustrated in de la Haye and Tobin,* Chanel, *pp. 56–7.*

8 *Steele,* Paris Fashion, *p. 248.*

9 *Diana Vreeland,* DV *(London: Weidenfeld & Nicholson, 1984), p. 127.*

10 *Amy de la Haye, '*Vogue *and the V&A Vitrine',* Fashion Theory: The Journal of Dress, Body & Culture *10, no. 1 (March/June 2006): 129, 135: Figure 2.*

pearls, and worn by her affluent clientele, with her distinctive handbags and sling-back shoes with contrasting toe caps.

Chanel was no longer at fashion's cutting edge in the 1960s, when 'the look' was focused on the younger generation; even her contemporaries scoffed at her designs. Yves St Laurent is quoted as telling a reporter, 'I adore my epoch, the yé-yés, the boutiques … A Chanel suit is like a costume from the reign of Louis XIV, a marvelous document.' When Chanel offered to dress Brigitte Bardot, the actress reportedly scorned that 'Couture is for grannies.'[11] Yet the iconic reputation of the suit prevailed, especially amongst stylish, wealthy women.

Jacqueline Kennedy, the wife of the American president, was a famous patron of Chanel couture in the 1960s. Despite the fact that she tended to dress patriotically in the creations of American designers, it was a pink, double-breasted Chanel-design suit and a pillbox hat that she was wearing on the fateful day, 23 November 1963, when her husband was assassinated in Dallas, Texas. Whether the suit was purchased directly from the house, sewn from a Chanel design and fabric by the New York dressmaker Chez Ninon[12] or was a line-by-line copy by Oleg Cassini, the American couturier that Mrs Kennedy favoured, continues to be a subject of debate. Yet that suit remains an iconic, if not *the* iconic Chanel suit, even as it exists now, stained with the President's blood, unwashed and locked away in the American National Archives.

## What's in a Name?

While the House of Chanel continued after the death of the couturière, it was not until Karl Lagerfeld became its chief designer in 1983 that it began to prosper, and the suit was refreshed and revived. A supreme showman, Lagerfeld plumbed the depths of the Chanel archive, heightening its distinctive symbols like the double C logo and providing humorous and ironic twists to the classic designs. Many wealthy and stylish women have continued to wear the suit, including actresses Penélope Cruz and Vanessa Paradis, models Claudia Schiffer and Kate Moss, as well Anna Wintour, the editor of American *Vogue*. Pictured here in 2011, Wintour also wore this suit, immediately after it had appeared on the runway in July of that year, to receive the French *Legion d'Honneur*. She has been a firm fan of the suit, and of Lagerfeld, since she joined *Vogue* in 1983. Together they have succeeded in making Chanel virtually a household name around the globe. The suit à la Karl Lagerfeld is arguably one of the most copied designs in the world, appearing on the high street via such familiar retailers as the British Marks and Spencer.

In the early twenty-first century, as fashion was characterized by separates, mix-and-match, and 'high and low', the suit jacket has gained independence. In 2012, Lagerfeld and Carine Roitfeld, the former editor of French *Vogue,* created *The Little Black Jacket*, a photographic exhibition which began in Tokyo and toured to New York and Taipei, with the intention of further touring. Comprising photographs taken by Lagerfeld and styling by Roitfeld, female, male and child celebrities chose how they wanted to be represented in the same jacket from the 2011 collection. The show is a triumph in the promotion and mediation of the brand, with the jacket as its material icon.

So the question remains: why is the Chanel suit so iconic? Is it the longevity of the design, the reputation and status of its wearers, the promotion of the brand, or the myth and mystique of Coco Chanel? Of course, it is a combination of all of these factors. Just as the rationale and process of design is complex and multi-faceted, so are the things that gain the status of iconic designs.

11 *Steele,* Paris Fashion, *p. 279.*
12 *Justine Picardie,* Coco Chanel: The Legend and the Life *(London and New York: HarperCollins, 2010), p. 304.*

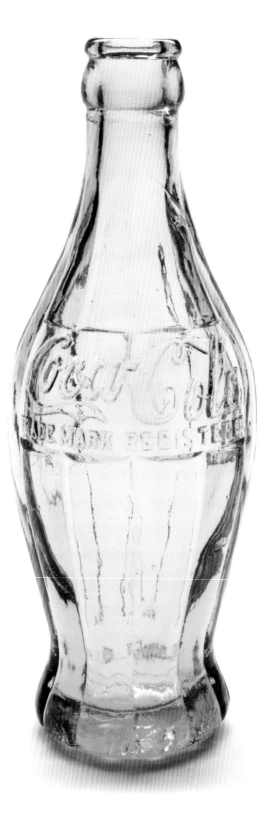

*Coca-Cola prototype bottle. Photo courtesy of Julien's Auctions. Los Angeles.*

# 47

## Coca-Cola Bottle, USA
## (Earl R. Dean, 1915)

*Finn Arne Jørgensen*

The Coca-Cola bottle is one of the most iconic designs in history. While that claim has been made about many designs, Earl R. Dean's Coca-Cola bottle is one of the few that can defend it. The bottle's shape and brand connection is immediately recognizable in all regions of the world. The dynamic ribbon device logo is also iconic and is seconded by the curvaceous serif logo. Coca-Cola's towering brand status can hardly be overstated, as exemplified by its having been featured, parodically, in *The Gods Must Be Crazy* (1981). The bottle as iconic design object cannot be meaningfully understood, however, without examining the complex relationship between the bottle as material artefact, the brand it promotes, the beverage inside it and the consumer who purchases it.

### From Wine Coca to Carbonated Drink

On its launch as a health tonic in the 1870s, the drink we now know as Coca-Cola reportedly contained cocaine, caffeine and alcohol. When the doctor, pharmacist and morphine addict John Pemberton created a patent medicine called 'French Wine Coca' in 1884, he was far from the only one caught in the 'coca-mania' of the 1880s.[1] Countless coca products were available at the time, many invented by people who could best be described as quacks. Pemberton enjoyed reasonable success with his tonic until the growing temperance movement made it too challenging to sell a wine-based drink. He then started experimenting with wine-free alternatives in his laboratory during the winter of 1885, combining coca leaf and kola nut with distillations of fruit flavours, sugar, citric acid and carbonated water.

Pemberton's new Coca-Cola sold well during the temperance period of the 1880s, but its market reach was limited. When Pemberton died in 1888, Asa Candler acquired the legal claims to Coca-Cola and established a franchise model that allowed local bottlers to sell Coca-Cola as long as they bought the syrup directly from the Coca-Cola Company. Previously, Coca-Cola had mostly been sold in soda fountains in bars and restaurants. While he may not have realized it at the time, this new organizational model was the key to Coca-Cola's subsequent success.[2] Yet there was still no iconic Coca-Cola bottle.

### Bottling the Beverage

Successfully bottling carbonated beverages is not without its challenges. In the 1890s, bottles were hand washed, hand filled and hand capped, one bottle at a time. A bottle has functional demands. It needed to hold its contents without breaking during transport. Since all bottles were returned and reused at the time, it had to withstand cleaning as well, and a stopper of some kind needed to keep the beverage in the bottle. The first Coca-Cola bottles used a rubber disk inserted in the neck of the bottle and held with a wire, but this stopper changed the flavour of the drink and made cleaning difficult. The crimped crown bottle cap was invented in 1892 and solved most of the stopper-related problems.

1 *Mark Pendergrast*, For God, Country, and Coca-Cola: The Definitive History of the Great American Soft Drink and the Company That Makes It *(New York: Basic Books, 2000)*, p. 22.
2 *Ibid., p. 71.*

At the same time, a bottle is also a communication device, something which the Coca-Cola Company gradually came to realize.[3] Early on, Coke bottles featured the company's logo embossed on the bottle itself, both to signal that the bottle was the property of the local Coca-Cola bottler and to identify the contents. Glued-on labels did not work since the bottles were cooled in ice, which would detach the label.[4] None of these bottles looked like the iconic bottle we recognize today, except for the Coca-Cola logo. As a result of the broad and decentralized franchising model, Coke was sold in a variety of bottles: brown, green, or transparent, in six or eight ounce sizes. They were small and heavy, made in thick glass to handle rough treatment during transport and cleaning.

## Designing a Standardized Coca-Cola Bottle

The iconic bottle we now recognize was developed in 1915, as a response to the multitude of different bottles in which Coca-Cola was sold, as well as the need to distinguish Coca-Cola from the hundreds of imitators that had appeared in the wake of its market success. In other words, the bottle was an attempt to stave off piracy and to emphasize the authenticity of the Coca-Cola brand. The Coca-Cola Company wanted 'order in the design chaos',[5] and asked bottlers for suggestions for a distinctive bottle design that would enable customers to recognize the identity of the product everywhere, even when feeling the bottle in the dark.[6]

At a bottlers' convention in 1916, a jury of seven bottlers chose a winning bottle from eleven proposals. Designed by the Root Glass Company in Terre Haute, Indiana, it looked very different from most contemporary bottles. Unlike the straight walls of the other bottles, this one was rounded, even bulbous. Ten vertical ribs gave the bottle visual and tactile distinction. The bottom had a solid glass base, skinnier than the middle diameter of the bottle, and the stem end had a short neck. The Coca-Cola logo and the words *trademark registered* were embossed on the front top half, and a small panel on the back had the name of the Root Glass Company. The bottle weighed 14 ounces (approximately 400 grams) and could fit 8 ounces of beverage (0.25 litres). The bottle had a smooth transition from body to neck, making it unlikely to have surges when drinking.

The bottle's origin story within the Root Glass Company has been contested over the years, with the Swede Alexander Samuelson traditionally credited as the inventor. The patent names him as the inventor, but his exact role in this process has gradually been challenged, both by historians and by Earl R. Dean's family. Samuelson was the plant superintendent and was most likely listed by Chapman J. Root as the company's representative in the patent application. Today, most people name Earl R. Dean as the bottle's true creator. He was a machinist in the bottling plant, mould shop foreman and responsible for bottle design. While the story of the bottle's origin within the company is still somewhat uncertain, Earl R. Dean undoubtedly turned the bottle from vague idea into drawn design and a physical product. According to Dean, Samuelson's only role was to ask 'What is Coca-Cola made of?' during the initial brainstorming session, which made C. J. Root send Dean and T. Clyde Edwards to the library to figure out what the coca leaf and kola nut looked like.

## The Cocoa Pod Shape

The distinctive bottle shape has caused historians and marketers much confusion. When Dean and Edwards looked at the *Encyclopaedia Britannica*, they found that the kola nut had no entry at all, and the coca entry had no illustration, but the illustrations in the article about cocoa, 'a beverage fit for gods', inspired Dean.[7] We can see the rounded shape of the kola nut in the bottle drawing in the 1915 patent application. This of course muddles up the

3 *Thomas Hine,* The Total Package: The Secret History and Hidden Meanings of Boxes, Bottles, Cans, and Other Persuasive Containers *(Boston: Back Bay Books, 1995).*

4 *Martin Kemp,* Christ to Coke: How Image Becomes Icon *(Oxford: Oxford University Press, 2012), p. 259.*

5 *Ibid., p. 259.*

6 *Benjamin Thomas quoted in Mike Cheatham,* 'Your Friendly Neighbor': The Story of Georgia's Coca-Cola Bottling Families *(Macon, GA: Mercer University Press, 1999), p. 21.*

7 *Norman L. Dean,* The Man Behind the Bottle: The Origin and History of the Classic Contour Coca-Cola Bottle As Told by the Son of its Creator *(Bloomington, IN: Xlibris Corporation, 2010), pp. 24–5.*

design semantics, since you would expect the bottle to reflect the contents. At the same time, Dean's design choice was very much in line with the tendency of Art Nouveau and Arts and Crafts designers of the 1910s to find inspiration in nature.

The Coca-Cola Company liked the design, but the Root Glass Company altered the lower and middle diameters in order to make the bottle practical for production and packing.[8] The large middle diameter and relatively skinny base made the bottle unstable on conveyor belts and thus unsuitable for mass production and machine bottling. The modified production bottle was smaller than the prototype and contained only 6.5 ounces of beverage.

The bottle shape kept evolving, as documented by successive patent applications. The second version from 1923, and the third version from 1937, refined the look of the bottle, but kept it recognizable. The original pod shape is still hinted at in current designs for Coca-Cola'a beverage containers of glass, plastic and aluminium. The distinctive pod shape makes 'later COKE bottles essentially refer to themselves rather than anything else', according to Martin Kemp.[9] For instance, Coca-Cola's PET bottles still retain the curvature of the original with a bulging centre and vertical ribs, although less pronounced. The outline of the bottle has also appeared as an outline drawing on aluminium cans.

## The Bottle and the Brand

Whatever its origins and notwithstanding its confused design references, the Root Glass Company bottle succeeded tremendously for Coca-Cola. The bottle shape became synonymous with both the drink and the experience of it. Coca-Cola slogans emphasized the authentic feeling of refreshment that came with a bottle of Coke ('It's the Real Thing', 1969; 'Can't Beat the Feeling', 1989). Despite the fact that only two known exemplars of the prototype bottle exist, it is immediately recognizable as the iconic essence of the Coca-Cola brand. One prototype bottle is owned by Coca-Cola and can be seen on display in *The World of Coca-Cola* Pavilion in Atlanta. The other was the property of the Dean family, who sold it at an auction in 2011, for $240,000.[10]

Coca-Cola's original design instructions stipulated that not only should the bottle be familiar in the dark, but 'even if broken it would be recognized at a glance'. This contributed to a growing tension between the immaterial brand and the material bottle.[11] With improvements in bottle manufacturing, the cost of bottle production dropped to the extent that many American bottlers adopted disposable bottles instead of ones that were returned, washed and reused. Coca-Cola followed suit, partly to meet the competition from Pepsi and other beverages, even if that meant using new bottle types. The disposable bottle became popular among both bottlers and consumers, and Coca-Cola increasingly targeted mobile lifestyles and 'people on the go', as reflected in the company's 1954 slogan. But along with disposable bottles came the issue of littering in public and natural spaces, at odds with the developing environmental consciousness of the 1960s and 1970s.[12] In spite of the immediate recognizability of Coca-Cola's bottles — whether glass or plastic — the company chose to retain their iconic elements rather than blend in with all the other litter.

Iconic designs and the brands they build can be tremendously powerful mediators between corporate goals and consumer lifestyles, as the pervasiveness of the Coca-Cola design perfectly reveals. At the same time, as the spectacular failure of New Coke in 1985 shows, when brands and designs become too entangled with consumers' dreams, desires, and daily lives, corporations are no longer fully in charge of what happens to their brand. Rather than simply being a design, the Coca-Cola bottle and all it represents has become a lived, shared, global experience.

8  *Ibid., p. 29.*

9  *Kemp,* Christ to Coke, *p. 268.*

10  *'Coke Bottle Prototype Auctions for $240K', cbsnews. com, 3 December 2011,* http:// www.cbsnews.com/8301- 201_162-57336213/coke- bottle-prototype-auctions-for- $240k/. *Accessed 9 July 2012.*

11  *Cheatham,* 'Your Friendly Neighbor', *p. 21.*

12  *Finn Arne Jørgensen,* Making A Green Machine: The Infrastructure of Beverage Container Recycling *(New Brunswick, NJ: Rutgers University Press, 2011).*

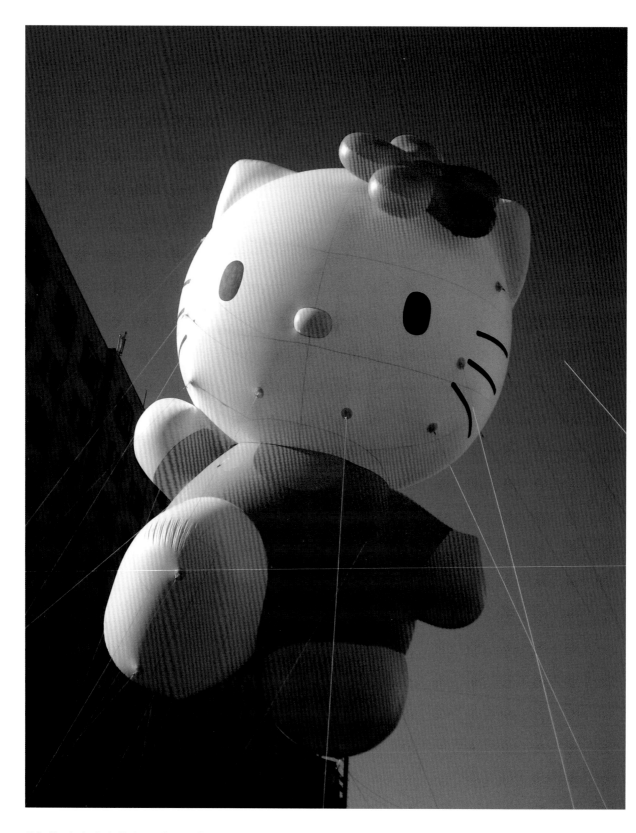

*Hello Kitty in the Paris Christmas Parade, General Liberator Bernardo O'Higgins
Avenue, Santiago, Chile, 2010. Photograph by Jorge Barrios Riquelme.*

# 48

# Hello Kitty, Japan
## (Yūko Shimizu for Sanrio, 1974)

*Brian J. McVeigh*

1 *Ken Belson and Brian Bremner,* Hello Kitty: The Remarkable Story of Sanrio and the Billion Dollar Feline Phenomenon *(Singapore: Wiley, 2004).*

2 *Matt Haig, 'Hello Kitty: The Cute Brand', in* Brand Royalty: How the World's Top 100 Brands Thrive and Survive *(Philadelphia, PA: Kogan Page Ltd., 2004), pp. 287–8; Kathy Merlock Jackson, 'Hello Kitty in America', in Mark I. West (ed.),* The Japanification of Children's Popular Culture: From Godzilla to Miyazaki *(Lanham, MD: The Scarecrow Press, 2009), pp. 41–52; Bart King, 'Hello Kitty', in* The Big Book of Girl Stuff *(Layton, UT: Gibbs Smith, 2006), p. 151; Zachariah Campbell, 'Hello Kitty', in Claudia A. Mitchell and Jacqueline Reid-Walsh (eds),* Girl Culture: An Encyclopedia *(Westport, CT: Greenwood Press, 2008), pp. 347–8.*

3 *Christine R. Yano, 'Wink on Pink: Interpreting Japanese Cute as It Grabs the Global Headlines',* The Journal of Asian Studies 68, no. 3 (2009): 681.

4 *Ibid., 681–8.*

5 *Brian J. McVeigh, 'Commodifying Affection, Authority and Gender in the Everyday Objects of Japan',* Journal of Material Culture 1, no. 3 (1996): 291–312

Her mouthless face, with black dots for eyes, imparts an impassive, inexpressive countenance. With a tidy red bow on her left ear, Hello Kitty exemplifies innocence. But her blank stare gives no clue as to how successful this staple of Japanese pop culture has become. Inspired by 'Kitty' from Lewis Carroll's *Through the Looking Glass*, Yūko Shimizu created Hello Kitty for Japan's highly successful Sanrio Co., Ltd. in 1974. Setsuko Yonekubo and Yūko Yamaguchi have also crafted Kitty's appearance. Motivated by Sanrio's president Shintarō Tsuij's motto 'small gift, big smile' and the three principles of 'friendship, cuteness, and thoughtfulness', Hello Kitty was intended to cash in on the Japanese custom of gift-giving by being marketed as a present. Her debut was as an embellishment on a vinyl coin purse.[1] As evidence of her worldwide impact, both scholars and the mass media alike have devoted their attention to Hello Kitty.[2]

## Narrative Qualities: The Life of Kitty White

The elements of Hello Kitty's backstory constitute a cheerful, cartoon world. Kitty White (her real name) was born on 1 November 1974, in London. She is as tall as five apples, weighs about three apples and enjoys baking, writing poetry, playing tennis, collecting cute things, gardening and playing the piano. Her stay-at-home mother, Mary, wears a frilly hat and makes Kitty's favourite snack, apple pie. Her pipe-smoking father, George, is hard working, and her beret-wearing grandfather (Anthony), loves to tell stories. Her grandmother, Margaret, is a skilled baker who wears half-moon shaped glasses, and her twin sister, Mimmy, wears a yellow bow over her right ear. Kitty's backstory is fleshed out with a colourful circle of friends: Cathy (a friendly white rabbit), Tippy (a brown bear), Jey (a blue mouse), Jodie (an orange dog), Tracy (a mischievous raccoon), Mori (a shy mole), Tiny Chum (a small bear), Tim and Tammy (monkey brothers), and Fifi (a naughty little lamb). Hello Kitty also has a beau, Dear Daniel (named after a character from the 1971 film *Melody*). A famous cat in his own right, Dear Daniel wants to be a photographer, enjoys hip-hop dancing and has spent time in Africa.

## Distinctiveness: Hello Kitty and the Cult of Cuteness

While a well-developed backstory provides Hello Kitty with an appealing personality, her runaway success in Japan cannot be understood without appreciating the context of Japan's most popular aesthetic of the everyday: cuteness (kawaisa); though arguably, rather than just 'cute', kawaii is better translated as 'Japanese cute' in order to capture its local cultural inflection.[3] Cuteness is so ubiquitous that it has taken on a number of stylistic transmutations: disgusting cuteness, sexualized cuteness, creepy cuteness and what might be termed 'ironic cute' or 'cute with a wink.'[4] These adaptations, more adult, edgier and darker, are reflected in certain incarnations of Hello Kitty, such as sado-masochistic Kitty.

What is distinctive about Hello Kitty, then, is how she epitomizes cuteness.[5] Like many other characters populating the cultural landscape of Japan, Hello Kitty acts as a comforting therapist for Japan's overworked, harried and stressed citizens who must

put up with its unforgiving, highly formalized and rigid educational and corporate culture. Drained by the burdens of a demanding economic production system, the average person finds respite in the soothing, warm and fuzzy commercialism of desire-satisfying 'consumutopia'.[6] Hello Kitty, then, injects some emotional balance, providing welcome relief from the stresses of Japan's overheated, competitive lifestyle.

## Making Memorable and Memory Making: Hello Kitty Everywhere

Commercial success is attained when a product becomes inescapable and unavoidable. This certainly characterizes Hello Kitty's branding. Her popularity has transcended not just Japan's borders, but has risen above the faddish and is now well embedded in the mundane, a true sign of a celebrated winner. Helping market 20,000 products, her excessiveness has been normalized as a 'lifestyle brand'.[7] Such an array of goods demonstrates how Hello Kitty appeals not only to the young, but also to adults. Note the different types of products upon which Sanrio has 'painted' (licensed) the image of Hello Kitty: stationery, clothes, purses, lunchboxes, backpacks, guitars, surfboards, cell phones, tote bags, toasters, duffle bags, athletic wear, vibrators, sanitary napkins, mobile phone straps, food stuffs, candies, wine, slippers, umbrellas, toothbrushes, hairdryers, snowboards, microwaves, rice cookers, vacuum cleaners, sewing machines and telephones. Beauty retailer Sephora has a makeup line based on Hello Kitty, and skincare and perfume makers have also utilized the charming feline's iconicity. A number of video games feature Kitty: Dance Revolution Hello Kitty, Hello Kitty: Happy Party Pals, Hello Kitty: Roller Rescue, Hello Kitty: Parachute Paradise, and Hello Kitty: Big City Dreams. In 1981 the movie *Kitty and Mimmy's New Umbrella* appeared, and in 1987 the animated TV series, *Hello Kitty's Fury Tale Theater*, was broadcast in the United States.

In addition to these inexpensive, mundane commodities, Hello Kitty has also been used to endorse pricier goods, such as motor scooters and cars (by Daihatsu). Neiman Marcus has posh Hello Kitty–themed watches and jewellery (Kimora Lee Simmons Hello Kitty Fine Jewelry Collection). There is even a Hello Kitty robot (US $4,000). Kitty has also inspired artists Mariah Carey and Lady Gaga and designers Betsy Johnson, Paul Frank, Giles Deacon and the Heatherette fashion house. Paris Hilton, Perez Hilton and Katy Perry have adorned themselves with Kitty accessories.

Merchandise and personal possessions of daily use are not the only way Hello Kitty has become iconic. In 1990, a Hello Kitty theme park in Tokyo—Sanrio Puroland—was opened, and one year later, Sanrio Harmony Land (Hijimachi, Oita Prefecture) began operations. A Hello Kitty park is supposed to open in Shanghai in 2014. In addition to her own venues, some companies, such as McDonald's (as well as Japan's post office) have hired Hello Kitty to help in their product campaigns.

Besides Hello Kitty, Sanrio markets as many as 400 cute creatures and little critters which were introduced in the 1990s. These other figures often appear with Hello Kitty, inhabiting the same imaginary universe. They include small animals, such as the mouse-like creatures My Melody (whose brother is named Rhythm) and Picke Bicke, who imitates other animals and was born in Sanrio Puroland. Kuririn is a perky hamster. Canine characters include Pochacco, a soccer-playing Golden Retriever puppy who likes pudding and has a friend called Muffin, and Spottie Dottie, a female Dalmatian who is a fashion-expert and wears a large pink ribbon; her father was chief fire-dog with the New York City fire department. Feathered friends include a grinning penguin with a bad-attitude and spiked feathers, called Bad Badtz-Maru; Pekkle, an aquatically challenged duck from Australia who wants to be a lifeguard; and Tuxedo Sam, another penguin from Antarctica who was educated in England and has two brothers, Tam and Ham. Other creatures include

6 *Brian J. McVeigh, 'How Hello Kitty Commodifies the Cute, Cool and Camp: "Consumutopia" versus "Control" in Japan'*, Journal of Material Culture 5, no. 2 (2000): 225–45.

7 *Yano, 'Wink', 687.*

PART FIVE: PERSONAL EFFECTS

a chocolate-coloured cat named Chococat, Keroppi (a sprite, goggle-eyed frog), Monchichi (a thumb-sucking monkey), and Pink no Corisu, a pink female squirrel of royal heritage from Pinkuru Planet. Pippo is a curious pig that likes to tell stories. These characters are not limited to animals: Patty and Jimmy from Kansas and the Little Twin Stars, mystically empowered Kiki and Lala, who are from a star in outer space, are also included.

## International Recognition and Media Attention: 'Pink Globalization'

Though Kitty White was, according to her official backstory, born overseas (which affords her exoticism), she is actually very much a Japanese product. Indeed, despite her globalization, she has been localized in Japan, and therefore 'Japanized'. For example, during New Year celebrations, Hello Kitty might be seen wearing a costume reflecting a creature from the Chinese zodiac. In other examples she is seen sitting on Mount Fuji (a key symbol of Japan), participating in a famous regional festival while donning local attire, performing traditional musical instruments and engaging in everyday activities familiar to the average Japanese, such as visiting a hot spring. She might take the form of a kokeshi (type of cylindrical doll) or dress up as a tanuki (similar to a raccoon) or maneki neko (the good luck cat displayed in businesses who beckons customers). Or she might incarnate herself as a well-known Japanese personage (samurai warrior, poet, etc.). Hello Kitty is also seen in Buddhist temples and Shinto shrines.

We should ask why, given Hello Kitty's ostensible Japaneseness, she has played such a prominent role on the global stage. Note that first of all, from her inception in 1974, she was meant to be a global product, having entered the US market in 1976 and the European and the Asian markets in 1980 and 1990, respectively. But this is only a partial answer. A more satisfactory explanation should take into account 'pink globalization', or the 'widespread distribution and consumption of Japanese cute goods and popular aesthetics to other parts of the industrial world'.[8] But Hello Kitty is not only an element in a larger wave of Japanese pop culture, such as anime (a distinctive cartoon style that characterizes Japanese cinema, comics and TV programmes) and manga (Japanese-style comics). Rather, she has been elevated to the status of a transnational icon, aiding in the global dissemination of Japanese pop art. Her transcultural standing has helped interlink the national (Japan), regional (East Asia) and global (more specifically, youth culture and girl culture).[9] Despite an economic slowdown, Japan's global influence, due to its 'gross national cool', has nevertheless increased; Japan has become a cultural superpower. Indeed, 'Japan has far greater cultural influence now than it did in the 1980s when it was an economic superpower.'[10] Hello Kitty has greatly aided in this national resurgence.

In addition to being an entertainment and consumer product, Hello Kitty entered the international realm in an official capacity in 1994 when she was honoured as the UNICEF envoy to Japan and then became the UNICEF Special Friend of Children. In 2008 the Japanese government selected her as Japan's ambassador of tourism to China and Hong Kong.

Sanrio has cleverly devised a successful business strategy designed to profit from the different stages of an individual's life. As an individual matures, styles of self-presentation that chronologically correspond to childhood, adolescence and adulthood are linked together within one individual: Kitty. This is more than just an appeal to nostalgia or a reconnection with one's past; Sanrio attempts to cash in on the cute, cool and camp. A feline focus ties together an individual's lifecycle: same product, same individual, but different ages, tastes, styles and age-appropriated desires. Rather than an immature, retrogressive childishness, it appears that the more mature Hello Kitty fans are motivated by a playful, childlike and experimental impulse.

8  *Ibid.*, 682–3.
9  *Ibid.*, 687.
10  *Douglas McGray, 'Japan's Gross National Cool', Foreign Affairs 130 (2002): 44.*

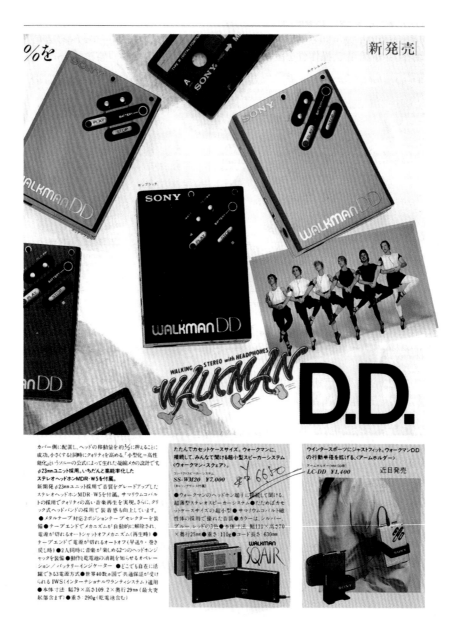

# 49

## Sony Walkman, Japan
## (Nobutoshi Kihara, 1978)

### *Juliette Kristensen*

Design historians often describe the Sony Walkman as the first private mobile consumer technology, radically transforming the individual experience of social space in the late twentieth century. The Walkman's iconicity derives not just from its formal design and its technological function but also, indeed more so, from its social and cultural meanings and effects.

### Inventing the Walkman

In October 1978, the Sony Corporation restructured its organzation, moving the design and production of its radio cassette players from the Tape Recorder Division to the Radio Division. This restructuring created a problem for Kozo Ohsone, the manager of the Tape Recorder Division, as it removed a significant portion of his department's business while the company still expected his section to generate the same profit. Left with only two products, a dictation machine for the business market and a semiprofessional monaural recorder, Ohsone called an emergency team meeting to plan how his division would maintain its profitability.

The resulting idea was to convert the monaural recorder, called the Pressman, from a single-channel recording device to a stereo playback machine. Prototyped with a set of heavyweight headphones, as were standard for the professional sound industry, the division immediately knew it had a strong new product, even though it was uncertain as to the new machine's place in the market.[1]

Following a visit to the Tape Recorder Division from Sony Chairman Masaru Ibuka, the uncertainty around the new stereo player began to fall away as its functional and formal meaning emerged. Ibuka was reportedly deeply enthusiastic about the new prototype machine, but pointed out that the headphones were cumbersome and suggested using the new lightweight headphones that were coincidentally being independently developed by Sony's Research Laboratory. Another shift towards the player's stabilization occurred when Sony President Akio Morita tested the prototype with his golf partner during his weekly game. At this stage, the device still had a residual function from the Pressman, two headphone jacks for joint listening; Morita suggested that the record button was replaced with a mute, so that joint listeners could momentarily stop the sound to talk to each other.

Following these interventions, Ibuka and Morita formed the Walkman Team, an interdisciplinary group of ten people from across Sony, including engineers, designers and marketing professionals, who were together given the brief to develop this new product for the market within a significantly shortened timescale of six months. It was at one of these meetings that the lead engineer Nobutoshi Kihara placed a small block of wood on the table, roughly 13 centimetres high by 4 centimetres wide, to explain the size of device he wanted them to achieve.[2]

On 22 June 1979, Sony launched the world's first portable private music player, the Sony Walkman TPS-L2, in Japan.[3] In blue and silver, with buttons on the long outside, two headphone jacks, a mute button and one pair of lightweight MDR-3L2 headphones, the Walkman's success was immediate, with Sony's stock of 30,000 units selling out within

1  She Ueyama, 'The Selling of the "Walkman"', Advertising Age, 22 March 1982, p. 131.

2  Dorothy Leonard-Barton, 'Inanimate Integrators: A Block of Wood Speaks', Design Management Journal 2, no. 3 (Summer 1991): 65.

3  Paul Du Gay, Stuart Hall, Linda Janes, Hugh Mackay and Keith Negus, Doing Cultural Studies: The Story of the Sony Walkman (Milton Keynes: Open University, 1997), p. 56.

three months and 1.5 million units of the TPS-L2 module sold globally within the first two years.[4] Additionally, in the same period, more than fifty of Sony's competitors launched their own versions of the Walkman, capitalizing on the technology's market success.[5]

## SCOT: Explaining Success

The reconfiguration of an already existent technology, the Pressman, in a simplified form meant that the Sony Walkman was not a technological advance but rather a regression; and therefore, somewhat unusually for a new technology, its success was not part of the story of ever-increasing technological sophistication, but rather was entrenched within a web of social and cultural factors. The story of the creation and early life of the Walkman embodies important questions about the relationship of design and technology to society, culture and experience and exposes problems in how the histories of design and technology are told.

Until the 1980s, a key theory of the history of technology was technological determinism, which separates technological development from societal and cultural concerns while arguing for technology's constant improvement towards an as yet unreached but always potentially possible technologically perfectible end. Against this theory, in the mid-1980s sociologists of science and technology Trevor Pinch and Wiebe Bijker proposed an alternative model called the social construction of technology (SCOT).[6] Their theory is based on a quasi-evolutionary understanding of technological development, underpinned by a process of variation and selection and embedded within a specific environment, so that 'technology design is an open process that can produce different outcomes depending on the social circumstances of development'.[7] Drawn from the sociology of science, SCOT proposes that the emergence of a new technology is first met with a period of interpretative flexibility, during which relevant social groups (RSGs) negotiate the social and cultural meaning of the technological object. In this negotiation, the design of the technology continues to evolve until any potential conflicts in its meaning are resolved to the satisfaction of all groups. The resolution of meanings leads to a closure and stabilization of both the form and function of the object.

Certainly the history of the Sony Walkman can be told through the SCOT framework, as various histories of its creation and its initial functionality highlight its somewhat unclear meaning and function, pointing towards the interpretative flexibility stage of its life. This instability, at the same time as its explosive success in 1979 and 1980, led to notable design developments when Sony launched its second model of the Walkman, the Sony WM2, in February 1981. Developments, including moving the control buttons from the side to the front of the device, relocating the tapehead to the back of the cassette housing cover and removing one of the headphone jacks and the hot-line button, can be seen as attempts to stabilize and fix the Walkman as a device to create high-quality private soundscapes for its users in a portable form.[8] The pursuit of ever smaller and lighter portable private sound devices became the dominant factor in the development of the Walkman (and its imitators) throughout the 1980s, resulting in Sony's pursuit of technological miniaturization, as well as its release of nearly 250 different models of the Walkman between 1979 and 1991.[9]

## The Walkman Effect

While SCOT is a useful framework for understanding the emergence of new technological objects, it does not account for either the success or failure of a technology within a particular culture or set of cultures. Although Pinch and Bijker tried to accommodate the 'wider context' in which a technology becomes closed and stabilised in its meaning, it plays only a minor role in SCOT and its results are, as critics point out, rather limited in explaining how social factors affect the history of design and technology, particularly how relevant social groups are chosen and delimited by SCOT theorists, and how they negotiate their consensus.[10]

4 Susan Sanderson and Mustafa Uzumeri, 'Managing Product Families: The Case of the Sony Walkman', Research Policy 24 (1995): 763.

5 M. Dreyfack, 'Sony Walkman Off to a Running Start', Marketing and Media Decisions, October 1981, pp. 70–2.

6 Trevor J. Pinch and Wiebe E. Bijker, 'The Social Construction of Facts and Artefacts: Or How the Sociology of Science and the Sociology of Technology Might Benefit Each Other', Social Studies of Science 14 (1984): 399–441.

7 Hans K. Klein and Daniel Lee Kleinman, 'The Social Construction of Technology: Structural Considerations', Science, Technology & Human Values 27, no. 1 (Winter 2002): 29.

8 The WM2 device weighed just 280gms, 110gms lighter than the TPS-L2.

9 New models offered additions such as a radio, remote control and solar power. Sanderson and Uzumeri, 'Managing Product Families', 769–70.

10 Klein and Kleinman, 'The Social Construction of Technology', 32–5.

However, in a different field of understanding, cultural studies, the 'wider context' of the Walkman became the subject itself, when the cultural theorists Paul du Gay, Stuart Hall, Linda James, Hugh Mackay and Keith Negus seized upon the Walkman as a paradigmatic object of culture for their seminal introduction to the field, *Doing Cultural Studies: The Story of the Sony Walkman* (1997). In this book, the authors tell a cultural history of the Walkman through such concepts as representation, identity, production, consumption and regulation, identifying the ways in which the Walkman represented and reproduced historically dominant cultural discourses. For, as the first mass-produced commercially available portable sound device, the Walkman's success was rooted in the way in which it radically altered its users' experiences of the everyday, particularly their experience of social space. Therefore, as du Gay *et al.*, together with cultural theorists Shuhei Hosokawa, Iain Chambers and Michael Bull, have argued, the Walkman was both representative and productive of the central discourses of the 1980s—autonomy and mobility. These modes of being were embedded within the Walkman as can be seen in its ever-purified function as an individual and private soundscape production technology, whilst at the same time being refined into ever smaller and lighter models. The autonomy and mobility that the Walkman promised in its form and function can also be seen in its representation in numerous advertising images showing young fashionable individuals (normally women, normally white, normally blonde) listening to their Walkmans whilst cycling, on roller-skates or running. The Walkman was a technology of desire, of freedom and, most importantly, of the self.

Hosokawa explored the relationship between culture and the Walkman, calling the freedom that the Walkman offered its users the 'autonomy-of-the-walking-self', arguing that it was not a technology of alienation but rather one that reconfigured the relationship of the individual to the group, allowing the user to feel a sense of superiority over the crowd through creating a private, and therefore secret, soundscape.[11] Through what he called the 'Walkman Effect', Hosokawa argued that the device allowed the user to 'screen out' the sound of urban life and wall themselves into their own sonic fields, thereby cutting 'the auditory contact with the outer world where he really lives'.[12] This feeling of superiority leads, theoretically, to Walkman users becoming ever more narcissistic and self-involved social actors, separated from the experience of social space by overlaying social experiences with their own private soundscapes, so that there is an 'apparent refusal of sociability'.[13]

Cultural theorists argue that the emergence of this technology of narcissism and self-involvement during the 1980s is no coincidence. The same decade that saw the Walkman as one of its most dominant mass consumer technologies, giving its users the ability to create individual and private habitats, overlaps with the birth of neoliberal conservatism, embodied by Reaganomics in the US and Thatcherism in the UK, a political climate that privileged the individual over the state, the private over the public, and the corporation over society. Within this political landscape, sociologists Carl Gardner and Julie Sheppard note that the Walkman was the 'ultimate consumer commodity' because of its 'a-social, atomizing, individualizing tendencies'.[14]

Sony and its subsidiaries retained over 60 per cent of the private portable cassette player market throughout the 1980s in the face of significant competition from a number of other electronics manufacturers. That this type of device became synonymous with the word 'Walkman' reveals the strength of Sony's branding and market share. Furthermore, even though these devices are now classed as 'dead technologies', overtaken by more technologically advanced machines, the name 'Walkman' still has currency as the name for Sony's contemporary portable media technologies, including smartphones and digital music players.

11 *Shuhei Hosokawa, 'The Walkman Effect', in R. Middleton and D. Horn (eds),* Popular Music, Vol. 4, Performers and Audiences *(Cambridge: Cambridge University Press, 1984), p. 177.*

12 *Ibid., p. 167.*

13 *Ibid.; Iain Chambers, 'A Miniature History of the Walkman',* New Formations: A Journal of Culture/Theory/ Politics *11 (1990): 1–4.*

14 *Carl Gardner and Julie Sheppard,* Consuming Passion: The Rise of Retail Culture *(London: Unwin Hyman, 1989): p. 53.*

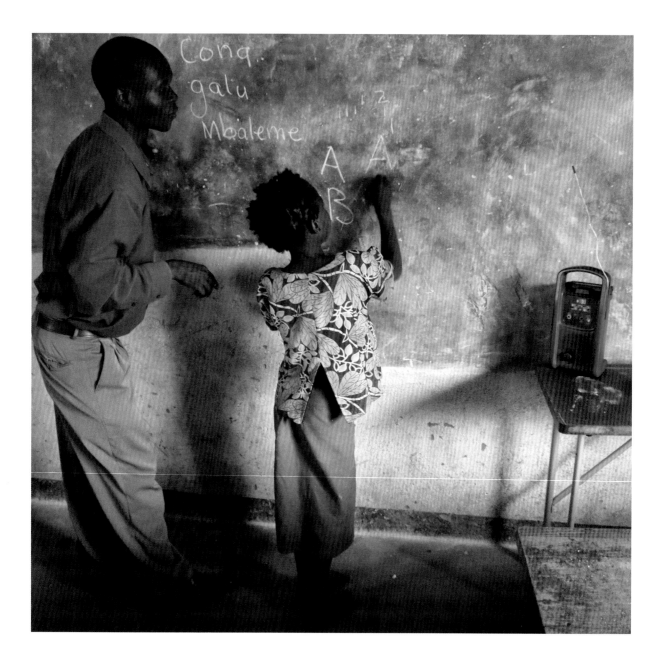

*A schoolteacher using a Prime
radio, launched by Lifeline Energy in
2010, in rural eastern Zambia. Photo
courtesy Kristine Pearson, 2010.*

# 50

# Wind-Up Radio, UK/South Africa (Trevor Baylis, 1992)

*Gabriele Oropallo*

The wind-up radio originally conceived by British inventor Trevor Baylis OBE in 1991 is an example of successful interaction between invention, design, and social-minded enterprise. Baylis had already developed a series of products for disabled people called Orange Aids (1985) when he began work on a human-powered radio. The story of the development of the device is one of fruitful interplay between seemingly antithetical categories such as low-tech and high-tech, developed and developing world, and philanthropy and venture capitalism.

## Information and Empowerment

The first inspiration for the invention of a clockwork radio came from a television show about the rapid spread of HIV/AIDS in Africa, broadcast by the BBC in September 1991.[1] A major problem with the epidemic was the difficulty in reaching and communicating with large parts of the population. In many regions of the continent the only means of mass communication was radio broadcasting, but since these areas were off the grid and access to batteries was difficult for financial or logistical reasons, people were not able to hear news and advice aimed at curbing the spread of the epidemic. A communication device was necessary that could operate without relying on external power sources. In his autobiography, British inventor Trevor Baylis recounts how this problem made him think of the earliest phonographs, which used a hand crank to power a spring-wound mechanism and play music. Human-powered radio transmitters and receivers had in fact already been developed for use by the military in emergencies and survival situations. These devices, however, were bulky and complex pieces of machinery that would not be viable in the context of rural Africa. On the other hand, advances in transistor technology meant that contemporary wireless sets ran on much less power as compared with their thermionic-valve ancestors.

Baylis's approach to solving this problem involved imagining the challenges of daily life faced by the possible users of the product he had in mind and conceiving a somehow site-specific solution.[2] The idea of bringing social inclusion and empowerment to the masses through design and technology was central in the most social-minded strands of modernist design. The question of a radio for the developing world had also been addressed by Victor Papanek, a designer who devoted the best part of his career to the promotion of socially and ecologically responsible design, especially through his book *Design for the Real World*, first published in English in 1971.

One of Papanek's first jobs after design school, according to his own account, was the design of a table radio. He later dismissed the assignment as mere 'shroud design', or 'appearance design', and, in contrast, included in his book a prototype of a 'radio receiver for the Third World' that he developed with George Seeger at North Carolina State College between 1962 and 1967.[3] The device employs a nonselective receiver housed in a used tin can and is powered by a slow fire fuelled by paraffin wax and wick. A variety of fuels can be used, including paper and cow dung. The manufacturing cost on a cottage-industry basis at the time Papanek was writing was merely 9 cents.

1 *See the sections of Trevor Baylis's autobiography dedicated to the Freeplay radio,* Clock This: My Life as an Inventor *(London: Headline, 1999), pp. 197–242.*

2 *On design thinking and the empathic approach to problem-solving, see Tim Brown,* Change by Design *(New York: HarperCollins, 2009).*

3 *Victor Papanek,* Design for the Real World: Human Ecology and Social Change, *2nd revised edition (Chicago: Academy Chicago, 2005), p. 225.*

Papanek's and Seeger's prototypes are examples of an involvement with material culture and technology that goes beyond the surface level of the object and, while tinkering with the inside workings of the product, generates invention. However, like other examples of radios and small devices powered by biological electrochemical means,[4] it functions best as a conceptual piece of design, a 'contemplative act' more effective from the educational and critical perspective than as a viable solution. It is a 'visual myth', as design writer Stuart Walker would put it.[5]

After watching the BBC show, Baylis began experimenting with a transistor radio, a small electric motor taken from a toy car and a hand brace. He then added a gearbox that allowed a logarithmic spring to be wound and unwind to power a small generator. The logarithmic spring soon revealed itself as insufficient to produce a constant and controlled flow of electricity for longer than a dozen minutes. Baylis's intuition was to substitute it with a constant force spring of the same kind typically used in seatbelt systems. He patented the idea on 19 November 1991 and set out to get the radio into production. However, because of the technical limitations of the prototype, interest from the manufacturers approached by Baylis was lukewarm at best. The UK Design Council rejected Baylis's support request arguing that the technology employed by the radio was too low-tech for the potential of the British industry and suggested the product would be best marketed in the developing world.

In fact, television would be pivotal in the development of the clockwork radio after providing the initial input for Baylis's creativity. In 1993, the prototype was featured on a popular BBC programme about technological innovation, *Tomorrow's World*. The segment attracted the interest of two businessmen, British accountant Christopher Staines and South African entrepreneur Rory Stear, who immediately recognized the idea's potential and the social and economic implications it could have in post-apartheid South Africa. Their involvement gave credibility to the project and provided access to the much-needed technical expertise necessary to its development. Together, they were able to secure funding from the UK Overseas Development Agency, as well as the Liberty Life Foundation. The funding allowed them to pay for consulting on the radio's gearbox from the Department of Electronic Engineering at Bristol University and to set up the first BayGen (short for Baylis Generators) plant in Cape Town, South Africa, in 1995.[6]

Market research in Africa concluded that potential customers were interested in a sizeable, heavy, and robust product that could reach sufficiently loud volumes for listening in a big group and while on the job. Mechanical engineer David Butlion and industrial designer Andy Davey of TKO studio (UK) were hired to incorporate these features in the Freeplay (later known as FPR1), the first device based on Baylis's patent, manufactured in a factory that mostly employed disabled people.

The FPR1, now out of production, was powered by a 10-metre-long heavy carbon spring, carefully enclosed in a heavy-duty casing to avoid accidental injury. The radio provided 25 minutes of playing time for 60 winds and had a lifespan of around 10,000 spring cycles, that is between 4,000 and 5,000 hours of operation, after which the spring would start to decay irreversibly. In July 1996, the FPR1 was selected as Best Product and Baylis and Davey as Best Designers at the BBC Design Awards. The radio received a great amount of exposure in mainstream media[7] and its inventor became a regular television personality. In 1997, he was awarded the Order of the British Empire and the President's Medal from the UK Institute of Mechanical Engineers.

In 1998, the radio was redesigned by Roelf Mulder, Byron Qually and Etienne Rijkheer of ...XYZ Design (South Africa) and given a smaller, transparent body. The FRP2 had a run time of up to one hour with a mere thirty-second wind. This version of the radio, while

4 *Stuart Walker reports examples of small appliances powered by fruits used as batteries in* Sustainable by Design: Explorations in Theory and Practice *(London: Earthscan, 2006), p. 163.*

5 *Stuart Walker,* Sustainable by Design, *p. 105.*

6 *BayGen's first radio was called 'Freeplay'. By 1998, the company had changed its name into Freeplay Energy Group. Today there are two companies called Freeplay, neither connected to the original enterprise. Freeplay Energy was sold in August 2008 to Indian businessman Devin Narang. Two years later, Freeplay Energy UK was placed into administration and later liquidation. Narang retained Freeplay Energy India, which focuses on lighting products. Euro Suisse International, a multinational manufacturer of home appliances, bought the assets of Freeplay Energy UK from the administrator and did a deal with Freeplay Energy India to use the brand.*

7 *A clockwork radio also appeared in Danny Boyle's* 28 Days Later *(2002), a film that, with its story of pandemics and emergency broadcasts, curiously reflects some aspects of the Freeplay's genesis.*

almost completely developed in Africa, was designed and marketed with the Western consumer market in mind. Other human-powered devices later developed by the company include flashlights and a wind-up mobile phone charger. The nonprofit Freeplay Foundation, established in 1999 and led by Kristine Pearson, was important in gathering the field knowledge necessary to the design of the Lifeline, a new series of devices that also feature an additional solar panel to lessen the need for winding. In 2010, the Freeplay Foundation changed its name to Lifeline Energy and launched the Prime, a digital media player particularly helpful in formal and informal education. To date, humanitarian programmes run by the UN and EU have distributed large numbers of human-powered radios as part of their development cooperation efforts or after natural disasters, and Lifeline Energy successfully established their social model with listening groups gathering around radios entrusted to 'guardians' who are responsible for the device.

## Human-Powered Sound and Vision

While the original FRP1 only stored energy mechanically, using the uncoiling of the spring as source of power, later Freeplay products contain rechargeable battery packs made with substances that can be environmentally hazardous if not recycled or disposed of properly. The constant force spring eventually disappeared from the mechanics of the radio so that it could store more power and offer better safety and serviceability.

In any case, the impact of the original clockwork radio idea went well beyond the development of consumer devices, however unique it might have been in its context. The wind-up radio was conceived as a means to provide access to information and was extensively used as an educational device. The radio is iconic also because it represented a sort of postmodern take on human muscle power as a source of energy, an object in which categories like low and high technology constantly overlap and intermingle. Disconnected from the immediacy of manual labour, human movement presented itself in a new light. Just like solar, wind, or other alternative sources of energy, muscle power can be easily transformed, or stored and postponed. The kinetic energy of everyday movements like those of the crowds of commuters gathering on a platform of the London Tube or the pounding of the feet on a dance floor are today all being studied in order to develop microgenerators that can harvest their power and re-use it locally.

In the case of the wind-up radio, invention made possible a conceptual leap from contemplative act to viable product. In the process, layers of meaning accrued to the object, information about the connections between us and the world we inhabit. When abstractions are seamlessly made visible and experiential, meaning is reified and a design becomes iconic. The energy-harvesting technology that moves the dynamo and powers the receiver and speaker of a device like the wind-up radio is always educational. It is educational by showing rather than telling. Through the form and function of an iconic object like the wind-up radio, relations are made tangibly material and the system is left open like a conversation to include the user. Cranking a hand brace produces information, education and entertainment. The message could not be more subtle in its simplicity. It tells a story of beautiful, eternal principles of physics explaining how energy never disperses and fades away, but is always converted from one form into another.

# Contributors

**Dr Glenn Adamson** is Director of the Museum of Arts and Design (MAD) in New York City and a specialist on the history and theory of craft and design. He is co-editor of the triannual *Journal of Modern Craft*, author of *Thinking Through Craft* (Berg/V&A Publications, 2007), *The Craft Reader* (Berg, 2010) and *The Invention of Craft* (Bloomsbury Academic, 2013). Dr Adamson's other publications include the co-edited volumes *Global Design History* (Routledge, 2011) and *Surface Tensions* (Manchester University Press, 2013). His most recent project is a major exhibition and accompanying publication for the V&A entitled *Postmodernism: Style and Subversion, 1970 to 1990*.

**Prof Kenneth L. Ames** has been on the faculty of the Bard Graduate Center in Manhattan since 1996. His courses explore aspects of the decorative arts and material culture of Western Europe and the United States of the last five centuries. He has written extensively about historic household furnishings and museological issues. Recent publications include *American Christmas Cards 1900–1960* (editor), published by the BGC in 2011 and *The Circus in America* (co-editor), published by the BGC in 2012. His current interests centre upon travel, tourism and the history of hotels.

**Paul Atkinson** is Professor of Design and Design History at Sheffield Hallam University. He trained as an engineer before studying industrial design and working as a designer, design manager and director of a design consultancy. On entering academia, he took a Masters Degree in the History of Design, with his work on the social history of computing eventually leading to a PhD. He has spoken at many international conferences and has articles published in a number of international design journals. He is the author of *Computer* (Reaktion, 2010) and *Delete: A Design History of Computer Vapourware* (Bloomsbury Academic, 2013).

**Dr Thomas Brandt** is associate professor in history at the Norwegian University of Science and Technology (NTNU) in Trondheim. Brandt earned his PhD with a dissertation on the cultural production, mediation and use of the Italian Vespa scooter in postwar Italy. His scholarly interests lie in the intersection between cultural history and the history of technology and science. His most recent publications include a history of the NTNU (2010) and a chapter on the Vespa user clubs in *Made in Italy: Rethinking a Century of Italian Design*, edited by Grace Lees-Maffei and Kjetil Fallan (Bloomsbury Academic, 2013).

**Prof Christopher Breward** is Principal of Edinburgh College of Art (ECA), Vice Principal Creative Industries & Performing Arts at the University of Edinburgh and a widely published historian of fashion, interested in its relationship to social and sexual identity, place and concepts of modernity. His books include *The Culture of Fashion* (1995), *The Hidden Consumer: Masculinities, Fashion and City Life*

(1999), *Fashion* (2003) and *Fashioning London: Clothing and the Modern Metropolis* (2004). His exhibitions include *British Design 1948–2012* at the Victoria & Albert Museum (2012). Breward sits on the advisory boards for *Fashion Theory* and *Visual Culture in Britain*.

**Prof Lasse Brunnström**, PhD, is Professor of Design History at HDK, School of Design and Crafts, University of Gothenburg, Sweden and Associate Professor in Art History at the University of Umeå, Sweden. He teaches in design history and architectural history at several universities and has published books on the mining city of Kiruna, the architecture of hydro-electrical power stations, Swedish industrial design, telephone design and Swedish design history among many other topics. Now he leads the interdisciplinary project 'The (un)sustainable package'.

**Dr Martha Chaiklin** is a historian of the material culture of Japan, the East India Companies and trade in the early modern world. She obtained her PhD from Leiden University. She has published extensively on Japanese material culture and east-west interaction, including *Cultural Commerce and Dutch Commercial Culture: The Influence of European Material Culture on Japan* (2003), *A Pioneer in Yokohama* (2012), 'Purity, Pollution and Place in Traditional Japanese Footwear', in Giorgio Riello and Peter McNeil, *Shoes: A History from Sandal to Sneaker* (2006) and she co-edited *Asian Material Culture* (2010). She is currently working on a book on Western footwear in nineteenth-century Japan.

**Prof Hazel Clark**, PhD, is Research Chair of Fashion at Parsons the New School for Design. There she initiated the curriculum in design studies and fashion studies, including the MA Fashion Studies that commenced in fall 2010. Her publications include the co-edited *Old Clothes, New Looks: Second Hand Fashion* (Berg, 2005), *The Fabric of Cultures: Fashion, Identity and Globalization* (Routledge, 2009), *Design Studies: A Reader* (Berg, 2009). Her research interests include design, fashion and cultural identity, with a particular interest in New York and East Asia.

**Prof Louise Crewe** is Professor of Human Geography at the University of Nottingham. She works on questions of consumption, commodification, retailing, value and design. She has a particular interest in the fashion industry. She has co-authored a book entitled *Second Hand Cultures* (Berg, 2003) that focuses on car boot sales, retro retailing and charity shops. She has recently published articles on domestic object maintenance and repair (*Journal of Consumer Culture*, 2009); fashion and architecture (*Environment and Planning A*, 2010); disposal, destruction, memory and the impossibilities of erasure (*EPD: Society & Space*, 2011); and digital fashion (*Environment and Planning A*, 2013).

**Prof Clive Edwards** is a Professor of Design History at Loughborough University. After a career in the furniture and interiors business he took an MA in the History of Design at the Royal College of Art/V&A and subsequently completed a PhD on Victorian furniture

technology. His works include scholarly articles and monographs on aspects of interior design, furniture technology, materials and trades, and furnishing textiles, as well as contributions to multi-authored works on interiors, architecture and home furnishings. His interest in cross-disciplinary study is evident in his work, which includes research on design, materials and technology, consumption, business and retailing.

**Dr Ida Engholm** is a design historian specializing in twentieth-century industrial design, material culture and digital design. She is an Associate Professor of Design History and Design Theory at the Royal Danish Academy of Fine Arts, was a founding member of the Danish Network for Design and Aesthetics and is an editor of open access journal *Artifact*. Engholm has published widely, including 'Positions in contemporary design research' (*Design Research Journal*), 'The good enough revolution — The role of aesthetics in user experiences with digital artefacts' (*Digital Creativity*) and 'Research-based online presentation of web design history: The case of webmuseum.dk' (*Web History*).

**Prof Kjetil Fallan** is Professor of Design History in the Department of Philosophy, Classics, History of Art and Ideas at the University of Oslo. He is the author of *Design History: Understanding Theory and Method* (Berg Publishers, 2010), editor of *Scandinavian Design: Alternative Histories* (Berg Publishers, 2012), co-editor, with Grace Lees-Maffei, of *Made in Italy: Reassessing a Century of Italian Design* (Bloomsbury Academic, 2013) and has written numerous articles published in journals such as the *Journal of Design History*, *Design Issues*, *Enterprise and Society* and *History and Technology*. Prof Fallan is an editor of the *Journal of Design History*.

**Dr Emma Ferry** has previously taught at Kingston University, the University of Bristol and at the School of Creative Arts at UWE, Bristol. She currently works as a Senior Lecturer at Nottingham Trent University and as Course Tutor in the MSt in the History of Design at Oxford University. Dr Ferry's most recent publications reflect her research interests in nineteenth-century design and include the introductory chapter on late-nineteenth century interior in Penny Sparke *et al.*, *Design and the Modern Interior* (Berg, 2009) and articles for the *Journal of William Morris Studies* on the writer and craftswoman Lucy Faulkner Orrinsmith.

**Dr Amy E. Foster** is an Associate Professor at the University of Central Florida in Orlando. Trained as a historian of technology, her research focuses on the history of the US space program, the history of engineering and the relationship between gender and technology. Her teaching interests include the history of aviation, history of science, technology and medicine, and the history of women in science and engineering. Her book, *Integrating Women into the Astronaut Corps: Politics and Logistics and NASA, 1972–2004*, was published by the Johns Hopkins University Press in 2011.

**Dr Alison Gazzard** is a lecturer in Media Arts at the London Knowledge Lab, Institute of Education, University of London. She has presented numerous conference papers and

published widely on videogame cultures, design and histories in journals such as *Game Studies, Games and Culture* and *Convergence: The International Journal of Research into New Media Technologies.* Her book *Mazes in Videogames: Meaning, Metaphor and Design* was published by McFarland & Co. in 2013.

**Dr Michael J. Golec** is Associate Professor of the History of Design at The School of the Art Institute of Chicago. His scholarship focuses on typography, image theory and the visualization of data as they intersect with twentieth-century American culture. Golec was the 2010/11 Anschutz Distinguished Fellow in American Studies at Princeton University. He is the author of *Brillo Box Archive: Aesthetics, Design, and Art* (2008) and, along with Aron Vinegar, co-editor and contributor to *Relearning from Las Vegas* (2009). Dr Golec has published his writing in *Design and Culture, The Journal of Design History, Design Issues, American Quarterly* and *Home Cultures.*

**Paul Hazell** is a Senior Lecturer in Design and Photography at the University of Worcester and is currently undertaking doctoral research into the iconicity of technical artefacts with the thesis title 'Properties, functions and value complexes: exploring critical factors in the emergence of the utility Land Rover as an "automotive icon"'. Paul is a regular contributor to motoring and travel magazines, for which he draws on his experience in overland travel, photography and vehicle restoration.

**Dr D.J. Huppatz** is a Senior Lecturer at Swinburne University of Technology's Faculty of Design in Melbourne, Australia, where he works with the Interior Design program and the Design Research group. Dr Huppatz has published numerous articles and book chapters on design history, contemporary art, architecture and literature, and his current research concerns globalization, Australian design, Asian modernism, design theory and contemporary interior design. He is a founding member of the Design History Australia Research Network (DHARN) and a contributing editor of the DHARN website.

**Dr Claire Jones**'s main focus of research is nineteenth-century sculpture and the decorative arts. She is currently writing a book on Victorian sculpture for the Displaying Victorian Sculpture project, a three-year collaboration between the Universities of Warwick and York, and the Yale Center for British Art. Her AHRC-funded PhD at the University of York addressed the complex interconnection of French sculptors, manufacturers and the state between 1848 and 1895. Claire completed her Masters in the History of Design at the RCA/V&A and was formerly Curator of Furniture at the Bowes Museum.

**Dr Dolly Jørgensen** has practical work experience as an environmental engineer and a PhD in history from the University of Virginia, USA. She has worked on a broad array of environmental history projects, including forestry management in medieval England, late-medieval urban sanitation in Europe and a global history of converting offshore oil structures into artificial reefs. She is currently employed at the Department of Ecology and Environmental

Science, Umeå University, Sweden, where she is working on a comparative history of mammal reintroduction in Norway and Sweden.

**Dr Finn Arne Jørgensen** is Associate Senior Lecturer in History of Technology and Environment at Umeå University, Sweden. He holds a PhD in Science and Technology Studies from the Norwegian University of Science and Technology. He is the author of *Making a Green Machine: The Infrastructure of Beverage Container Recycling* (Rutgers University Press, 2011) and co-editor of *New Natures: Joining Environmental History with Science and Technology Studies* (University of Pittsburgh Press, 2013) and *Norske hytter i endring: Om bærekraft og behag* (Tapir Academic Press, 2011). His research interests include waste, recycling, consumption, leisure cabins, kitchens and digital history.

**Dr Juliette Kristensen** works in the fields of visual and material culture, exploring the historical and contemporary relationship between technologies and bodies. Dr Kristensen is a visiting lecturer at the Faculty of Art, Design and Architecture, Kingston University London, and at the Department of English, Linguistics and Cultural Studies, University of Westminster, an editor of the *Journal of Visual Culture* and the publisher and managing editor of *Paperweight: A Newspaper of Visual and Material Culture.*

**Susan Lambert** worked for many years at the Victoria and Albert Museum where her responsibilities included setting up the first global gallery of twentieth-century design and developing the contemporary programme. Her publications include *The Image Multiplied: Five Centuries of Printed Reproductions* (1987); *Form Follows Function (Design in the 20th Century)* (1995); and *Prints: Art and Techniques* (2001). Since 2007 she has been Honorary Head of the Museum of Design in Plastics at the Arts University College at Bournemouth. It is the only accredited UK museum with a focus on plastics.

**Dr Yunah Lee** is a lecturer in History of Art and Design at the School of Humanities, University of Brighton. Her research subjects are varied but broadly related to key themes of representation, identity and modernity in design and material culture. Her current research focused on the development of Korean design history, debates on modernity and identity in Korean graphic representation, design practice and consumption of Korean dress and fashion. Her review article on the recent development of Korean design history and design studies was published in the *Journal of Design History* in 2012.

**Dr Grace Lees-Maffei** is Reader in Design History at the University of Hertfordshire and Managing Editor of the *Journal of Design History*. Dr Lees-Maffei leads the TVAD Research Group working on relationships between text, narrative and image, and researches the mediation of design, through channels including domestic advice literature and corporate literature. Her journal articles appear in, for example, *Arts and Humanities in Higher Education, Women's History Review* and *Modern Italy*, among others and her books include *Design at Home: Domestic Advice Books in Britain and the USA since 1945; Made in*

*Italy*, co-edited with Kjetil Fallan; *Writing Design: Words and Objects*; and *The Design History Reader,* co-edited with Rebecca Houze.

**Christoph Lueder** researches diagrams as devices of analysis, explanation, negotiation and imagination, as well as tools in architectural and urban design processes. He is a graduate of the University of Stuttgart in architecture and urbanism, where he also taught. He practised with Behnisch & Partners before setting up his own office in Zürich, along with teaching and research at the ETH Zürich, Canterbury School of Architecture and Kingston University. Publications include *Diagram Ecologies—Diagrams as Science and Game Board* (Springer, 2012), *Thinking between Diagram and Image* (ARQ, 2011), *Project: Perform* (2008), *Intensive: Extensive* (2008).

**Ellen Lupton** is a writer, curator and graphic designer. She is director of the Graphic Design MFA program at Maryland Institute College of Art (MICA) in Baltimore, where she also serves as director of the Center for Design Thinking. As curator of contemporary design at Cooper-Hewitt, National Design Museum since 1992, she has produced numerous exhibitions and books, including *Mechanical Brides: Women and Machines from Home to Office* (1993), *Mixing Messages: Graphic Design and Contemporary Culture* (1996), *Letters from the Avant-Garde* (1996), and *Skin: Surface, Substance + Design* (2002).

**Prof Celia Lury** is Director of the Centre for Interdisciplinary Methodologies at the University of Warwick. Her research interests include interdisciplinary methodologies, feminist and cultural theory, the sociology of culture and branding and consumer culture. Her recent publications include 'What is the empirical?' a special issue of *European Journal of Social Theory* co-edited with Lisa Adkins; *Inventive Methods*, co-edited with Nina Wakeford (Routledge, 2012); *Measure and Value* co-edited with Lisa Adkins (Blackwell, 2012), and a special issue of *Theory, Culture and Society* on 'Topologies of Culture' co-edited with Luciana Parisi and Tiziana Terranova.

**Dr Nicolas P. Maffei** PhD (RCA) is Senior Lecturer for the Graphic Design programmes at Norwich University College of the Arts. His research on modernism in American design has appeared in *Design Issues*, the *Journal of Design History*, the *Journal of Transport History* and *Design and Culture, The Design and Manufacture of Popular Entertainment* and *Norman Bel Geddes Designs America*. Dr Maffei appeared in the Channel Five television series *Art Deco* and was a consultant for the V&A exhibition and accompanying book of the same name. He convened the Design History Society's international conference, 'Sex Object: Desire and Design in a Gendered World'.

**Dr Brian J. McVeigh** received his PhD from Princeton University's Department of Anthropology. He has lived in Asia for almost seventeen years and authored eight books. His research interests include popular art, cultural psychology, religion, education and nationalism. His most recent book is *The State Bearing Gifts: Deception and Disaffection in Japanese Higher*

*Education* (2006). His latest projects include *The Propertied Self: Wealth, Progress, and Human Nature; Spiritual Physics: Japanese Psychology in Global Perspective, 1875–1950* and *How Religion Evolved: The Living Dead, Talking Idols and Mesmerizing Monuments*. He now teaches in the University of Arizona's East Asian Studies Department.

**Prof Joe Moran** is Professor of English and Cultural History at Liverpool John Moores University. His most recent books are *Queuing for Beginners: The Story of Daily Life from Breakfast to Bedtime* (2007), *On Roads: A Hidden History* (2009) and *Armchair Nation: An Intimate History of Britain in Front of the TV* (2013). He is currently writing a cultural history of shyness. His recent articles have appeared in, amongst others, *Critical Quarterly*, *History Workshop Journal*, *Cultural Studies* and *Historical Journal*, and he writes regularly for the *Guardian* and other newspapers and magazines.

**Dr Julia Moszkowicz** is a Senior Lecturer in Animation Art Theory at Southampton Solent University. Her research examines the relation of contemporary studio practices to philosophical traditions, with a specialist interest in the work of Laszlo Moholy-Nagy and phenomenology. She has also published articles on graphic design, postmodernism and pragmatic design in the *Journal of Design History*, *Design Issues*, *Screen* and *Eye* magazine. She also speaks on the philosophies of Graphic Design at conferences internationally, including the Design Biennale in St Etienne and the Centre for Design and Philosophy in Copenhagen.

**Marc Olivier** is Associate Professor of French Studies at Brigham Young University. His publications include work on photography, cinema, science and technology. In 2005, he served as guest curator for 'Nostalgia and Technology'—an exhibition based on his research and featuring objects from the collections of the Smithsonian, the Cooper-Hewitt and the George Eastman House, among others. Since that time, he continues to study the complex relationship between nostalgia, design and technology. He has been an avid photographer since receiving a Kodak camera at age 7, writes for a photo blog and does commercial photography in his spare time.

**Gabriele Oropallo** is a design writer who lives and works in London and Oslo. He was educated in Naples, Düsseldorf and London before being awarded a Marie Curie Fellowship for a research on design and social commitment at University College London, where in 2010/11 he also curated a series of public seminars on design ethics. He is currently a Research Fellow of the University of Oslo, where he is working on a project on duration and temporality in modern design. His research also functions as a basis for his curatorial and documentary practice.

**Dr Juliette Peers** is a Senior Lecturer at the School of Architecture and Design and School of Fashion and Textiles, RMIT University, Melbourne. She is a historian of visual culture and material history, engaged with a wide range of high and popular art and design forms, including the pre-histories, back stories, social histories and precursors of new media,

technologies and art forms. She is widely published on art and design history, particularly the Heidelberg school of Australian plein airists and Australian women artists, as well as the Pre-Raphaelites, the history of fashion and textiles and aspects of popular visual culture, including dolls.

**Kerry William Purcell** is a writer, critic and historian. His study of the celebrated art director and designer Alexey Brodovitch (Phaidon Press, 2002, re-issued 2011) was followed with a concise biography on the New York photographer Weegee (Phaidon, 2004), a comprehensive study of the Swiss graphic designer Josef Muller-Brockmann (Phaidon, 2006) and his book on the work of Magnum photographer Steve McCurry, *In the Shadow of the Mountains* (2007). Purcell's writing has been published in several anthologies and appears regularly in *Eye* and *Baseline* magazines. He is a Lecturer in Design History at the University of Hertfordshire.

**Prof Carroll Pursell** is Adeline Barry Davee Distinguished Professor (emeritus) at Case Western Reserve University, Professor (emeritus) at the University of California, Santa Barbara, and currently Adjunct Professor in the School of History, Research School of Social Sciences, Australian National University. He is a past president of the Society for the History of Technology and the International Committee for the History of Technology (ICHOTEC). His most recent book is *Technology in Postwar America: A History* (2007).

**Dr Catharine Rossi** is Senior Lecturer in Design History at Kingston University. In 2011, she completed an Arts and Humanities Research Council Collaborative Doctoral Award at the Royal College of Art/Victoria and Albert Museum, entitled 'Crafting Design in Italy, from Postwar to Postmodernism'. Her research spans craft and design, with a particular interest in postwar Italy, and her publications include *The Italian Avant-Garde: 1968–1976*, co-edited with Alex Coles (Sternberg Press, 2013), articles in the *Journal of Design History* and the *Journal of Modern Craft*, and a chapter on Memphis in the *Postmodernism: Style & Subversion 1970–1990* (2011).

**Paul Shaw** is a graphic designer and design historian. He is the author of *Helvetica and the New York City Subway System* (2009) and co-author of *Blackletter: Type and National Identity* (1998); a regular contributor to *Print* and has written for *Eye, Design Issues, Letter Arts Review* and *Baseline*. He teaches calligraphy and typography at Parsons School of Design and the history of graphic design at the School of Visual Arts. Shaw is the editor of the typographic journal *Codex*. His design work includes logos for Barbie and Origins cosmetics and the typefaces Donatello, Kolo and Old Claude.

**Prof Penny Sparke** is a Pro-Vice Chancellor, a Professor of Design History and the Director of the Modern Interiors Research Centre at Kingston University, London. She studied at the University of Sussex from 1967 to 1971 and completed a PhD at Brighton Polytechnic in 1975. She taught at Brighton Polytechnic and the Royal College of Art (1982–1999)

and, between 1999 and 2004 she was Dean of the Faculty of Art, Design & Music at Kingston University. Her publications include *An Introduction to Design and Culture* (1986 and 2004); *As Long as It's Pink* (1995); and *The Modern Interior* (2008).

**Dr Jilly Traganou** is an author, architect and Associate Professor in Spatial Design Studies at Parsons The New School for Design. She is the author of *The Tōkaidō Road: Traveling and Representation in Edo And Meiji Japan* (RoutledgeCurzon, 2004) and a co-editor with Miodrag Mitrašinović of *Travel, Space, Architecture* (Ashgate, 2009). Traganou is Reviews Editor of the *Journal of Design History*. Her current research focuses on design's role in the configuration of national identities, and she is presently working on a book tentatively entitled *Designing the Olympics*.

**Grace Vetrocq Tuttle**, from New Orleans, studied anthropology at Bard College where she focused on visual studies and anthropology of tourism. Always interested in the intersection of natural and human systems, she explored various emerging fields after graduating, ultimately settling on the Parsons Transdisciplinary Design program. While at Parsons, she collaborated with various nonprofits in New York and was able to blend her anthropology background into a design process. Her thesis work developed in collaboration with the World Bank and encompasses developmental resilience thinking and international climate change adaptation policy. She is currently working on independent projects in New York.

**Alice Twemlow** is chair and co-founder of the Design Criticism MFA program at the School of Visual Arts in New York City and a PhD candidate in Design History at the Royal College of Art in London. Alice is a contributor to *Design Observer* and writes about design for publications such as *Eye* and *Architect's Newspaper*. She is the author of *What is Graphic Design For?* (Rotovision, 2006) and of essays in books including *The Aspen Complex* (Sternberg Press, 2012) and *60 Innovators: Shaping Our Creative Futures* (Thames and Hudson, 2009). She often serves on design juries and editorial boards and organizes and moderates conferences.

**Dr Nathaniel Robert Walker** grew up in the Philippines and Arkansas, among other places. He earned a BA in History at Belmont University and an MA in Architectural History at the Savannah College of Art & Design. His PhD studies at Brown University focused on eighteenth- and nineteenth-century works of utopian literature and their reciprocal relationships with architecture and urban planning. He has published on the utopian city plan of Savannah as well as on the film *Metropolis* and other corporate urban utopias, and he curated an exhibition at the David Winton Bell Gallery entitled *Building Expectation: Past and Present Visions of the Architectural Future*.

# Select Bibliography

'The Bic Wall, 60 years of History', http://www.thebicwall.com/#/uk_en/60-years-of-history. Accessed 6 August 2012.

'The Electrifying Experience', *The Magic Carpet* XXXIV, no. 2 (1987): 32–9.

Adorno, Theodor W., 'The Schema of Mass Culture', in J.M. Bernstein (ed.), *The Culture Industry: Selected Essays on Mass Culture,* London: Routledge, 1991, pp. 61–97.

Albus, Volker, Reyer Kras and Jonathan M. Woodham (eds), *Icons of Design: The 20th Century*, London: Prestel, 2004.

Antonelli, Paola, *Humble Masterpieces: Everyday Marvels of Design*, New York: HarperCollins, 2005.

Atkinson, Paul, 'The Best Laid Plans of Mice and Men: The Computer Mouse in the History of Computing', *Design Issues* 23, no. 3 (2007): 46–61.

Back, Les and Vibeke Quaade, 'Dream Utopias, Nightmare Realities: Imagining Race and Culture within the World of Benetton Advertising', *Third Text* 22 (1993): 65–80.

Bagaeen, Samer, 'Brand Dubai: The Instant City; or the Instantly Recognizable City', *International Planning Studies* 12 (2007): 173–97.

Baines, Phil, *Penguin by Design: A Cover Story 1935–2005*, London: Penguin Books Ltd., 2005.

Bandelow, Christoph, *Inside Rubik's Cube and Beyond,* Basel: Birkhäuser, 1982.

Barr, Jr., Alfred, *Machine Art: March 6 to April 30, 1934*, New York: Museum of Modern Art and H. N. Abrams, 1994.

Barthes, Roland, *Mythologies*. Paris: Editions du Seuil, 1957; trans. Annette Lavers, London: Jonathan Cape, 1972; New York: Noonday Press, 1972.

Barthes, Roland, *Empire of Signs*, trans. Richard Howard, New York: Hill and Wang, 1982.

Barthes, Roland, *The Eiffel Tower and Other Mythologies*, trans. Richard Howard. Berkeley, Los Angeles and London: University of California Press, 1997.

Batchelor, Ray, *Henry Ford: Mass Production, Modernism and Design,* Manchester: Manchester University Press, 1994.

*Bauhaus Furniture, A Legend Reviewed*, Berlin: Bauhaus Archiv, Museum für Gestaltung, 2003, Exhibition catalogue.

Beato, Greg, 'Twenty-Five Years of Post-it Notes', *The Rake*, 24 March 2005, http://www.rakemag.com/2005/03/twenty-five-years-post-it-notes-0/.

Berenbak, Jacques, 'The British Airways London Eye Observation Wheel, A Circular Triangle Tube Truss', in Ram S. Puthli and S. Herion (eds), *Tubular Structures IX, Proceedings of the Ninth International Symposium and Euroconference*, Dusseldorf, Germany, 3–5 April 2001.

Bich, Laurence, *Le baron Bich: Un homme de pointe*, Paris: Perrin, 2001.

Blackwell, Lewis, *The End of Print: The Graphic Design of David Carson*, London: Lawrence King, 1995.

Bott, Daniele, *Chanel: Collections and Creations*, London and New York: Thames and Hudson, 2007.

Brandt, Thomas, 'A Vehicle for "Good Italians": User Design and the Vespa Clubs in Italy', in Grace Lees-Maffei and Kjetil Fallan (eds), *Made in Italy: Rethinking a Century of Italian Design*, London: Bloomsbury Publishers, 2013.

Brandt, Thomas, 'La Vespa negli Stati Uniti: il trasporto culturale di una merce italiana', *Memoria e Ricerca*, 23 (2006): 129–40.

Brayer, Elizabeth, *George Eastman: A Biography*, Baltimore: Johns Hopkins University Press, 1996.

Brunnström, Lasse, *Telefonen—en designhistoria*, Stockholm: Atlantis, 2006.

Bull, Michael, 'Thinking about Sound, Proximity and Distance in Western Experience: The Case of Odysseus's Walkman', in

Veit Erlmann (ed.), *Hearing Cultures: Essays on Sound, Listening, and Modernity*, Oxford: Berg, 2004, pp. 173–90.

Calabrese, Omar and Mario Livolsi, *The Story of the Ape—Around the World on Three Wheels*, Pontedera/Pisa: Piaggio/Pacini, 1999.

Carr, Richard, 'Design Analysis: Polypropylene Chair', *Design Journal* 194 (February 1965): 32–7.

Carruthers, Iain, *Great Brand Stories*, London: Cyan Publications, 2007.

Carson, David and Neville Brody, 'Face to Face', *Creative Review* 14, no. 5 (1994): 28–30.

Casey, Robert, *The Model T: A Centennial History*, Baltimore: The Johns Hopkins University Press, 2008.

Chambers, Iain, 'A Miniature History of the Walkman', *New Formations: A Journal of Culture/Theory/Politics* 11 (1990): 1–4.

Cheney, Martha Candler and Sheldon Cheney, *Art and the Machine: An Account of Industrial Design in 20th-Century America*, New York: McGraw-Hill Book Company, Inc., 1936.

Chiu, Charles S., *Women in the Shadows: Mileva Einstein-Marić, Margarete Jeanne Trakl, Lise Meitner, Milena Jesenská, and Margarete Schütte-Lihotzky*, Austrian Culture 40, New York: Peter Lang, 2008.

Clark, F. G. and Arthur Gibson, *Concorde,* New York: Paradise Press, Inc., 1978.

Cohen, Adam, *The Perfect Store: Inside eBay*, Boston: Little, Brown and Company, 2002.

Cole, Shaun, *Don We Now Our Gay Apparel: Gay Men's Dress in the Twentieth Century*, Oxford: Berg, 2000.

Cormack, Robin, *Icons*, London: The British Museum Press, 2007.

Corrias, Piño, 'Beneath Jumpers', *Guardian*, 8 June 1993, p. 16.

Crewe, Louise, Nicky Gregson and Alan Metcalfe, 'The Screen and the Drum: On Form, Fit and Failure in Contemporary Home Consumption', *Design and Culture* 1, no. 3 (2009): 307–28.

Daito, Eisuke, 'Technology and Labour in a Dual Economy: From Natural Rubber to Synthetic Resin', in Howard F. Gospel (ed.), *Industrial Training and Technological Innovation: A Comparative and Historical Study*, London and New York: Routledge, 1991, pp. 171–93.

Davison, Aidan, *Technology and the Contested Meaning of Sustainability*, Albany, NY: State University of New York Press, 2001.

de la Haye, Amy and Shelley Tobin, *Chanel: The Couturiere at Work*, Woodstock, NY: The Overlook Press and London: V&A Publications, 1994.

Dean, Norman L., *The Man behind the Bottle: The Origin and History of the Classic Contour Coca-Cola Bottle As Told by the Son of its Creator*, Bloomington, IN: Xlibris Corporation, 2010.

Design Council, *William Morris & Kelmscott*, London: Design Council, 1981.

Design Museum, *Fifty Shoes that Changed the World*, London: Conran Octopus, 2009.

Dienstag, Eleanor Foa, *In Good Company: 125 Years at the Heinz Table, 1869–1994*, New York: Warner Books, 1994.

Doubleday, Richard B., *Jan Tschichold Designer: The Penguin Years*, New Castle, DE: Oak Knoll Press and Aldershot, Hampshire: Lund Humphries, 2006.

Drew, Philip, *The Masterpiece: Jørn Utzon: A Secret Life*, South Yarra, VIC: Hardie Grant, 2001.

Droste, Magdalena, Manfred Ludewig and Bauhaus Archiv, *Marcel Breuer Design*, Cologne: Taschen, 2001.

Du Gay, Paul, Stuart Hall, Linda Janes, Hugh Mackay and Keith Negus, *Doing Cultural Studies: The Story of the Sony Walkman*, Milton Keynes: Open University, 1997.

Eidelberg, Martin, Thomas Hine, Pat Kirkham, David A. Hanks and C. Ford Peatross, *The Eames Lounge Chair: An Icon of Modern Design*, Grand Rapids, MI, and New York: Grand Rapids Art Museum in association with Merrell, 2006.

Elsheshtawy, Yasser, *Dubai: Behind an Urban Spectacle*, London: Routledge, 2010.

Engholm, Ida and Lisbeth Klastrup, 'Websites as Artefacts: A New Model for Website Analysis', *Proceedings—2nd International Conference on New Media and Interactivity (NMIC)*, Istanbul, Turkey, 28–30 April 2010, pp. 380–7.

Fleischer, Doris Zames and Frieda Zames. *The Disability Rights Movement: From Charity to Confrontation*, Philadelphia: Temple University Press, 2001.

Ford, Henry, *My Life and Work,* London: William Heinemann, 1923.

Friedel Robert and Paul Israel, *Edison's Electric Light: Biography of an Invention*, New Brunswick, NJ: Rutgers University Press, 1986.

Fromonot, Françoise, *Jørn Utzon: The Sydney Opera House*, trans. Christopher Thompson, Corte Madera, CA: Gingko Press, 1998.

Fry, Tony, *Design Futuring: Sustainability, Ethics and New Practice*, Oxford: Berg, 2009.

Gabrys, Jennifer, *Digital Rubbish: A Natural History of Electronics*, Ann Arbor, MI: University of Michigan Press, 2011.

Gardner, Carl, 'Starck Reality', *Design* 534 (June 1993): 26–7.

Gauntlett, David, *Making Is Connecting*, Cambridge: Polity Press, 2011.

Gauntlett, David, *Web. Studies: Rewiring Media Studies for the Digital Age*, London: Arnold, 2000.

Gentleman, Amelia, 'The Trouble with Mobility Scooters', *Guardian*, www.guardian.co.uk/society/2012/may/02/trouble-with-mobility-scooters. Accessed 2 May 2012.

Giblin, James Cross, *From Hand to Mouth: Or, How We Invented Knives, Forks, Spoons and Chopsticks and the Table Manners to go with Them*, New York: Thomas Crowell, 1987.

Giedion, Siegfried, *Mechanization Takes Command: A Contribution to Anonymous History*, New York: Oxford University Press, 1948.

González, Laura, 'Juicy Salif as a Cultish Totem', in Barbara Townley and Nick

Beech (eds), *Managing Creativity: Exploring the Paradox*, Cambridge: Cambridge University Press, 2009, pp. 287–309.

Gustavson, Todd, *Camera: A History of Photography from Daguerreotype to Digital,* New York: Sterling Publishing, 2009.

Haig, Matt, 'Hello Kitty: The Cute Brand', in *Brand Royalty: How the World's Top 100 Brands Thrive and Survive*, Philadelphia, PA: Kogan Page Ltd., 2004, pp. 287–8.

Hanks, David A., *Innovative Furniture in America from 1800 to the Present*, New York: Horizon Press, 1981.

Harriss, Joseph, *The Tallest Tower: Eiffel and the Belle Epoque*, Boston: Houghton Mifflin, 1975.

Hauser, Kitty, 'The Fingerprint of the Second Skin', in Christopher Breward and Caroline Evans (eds), *Fashion & Modernity*, Oxford: Berg, 2005, pp. 153–71.

Heller, Steven, 'Sgt. Pepper's Lonely Hearts Club Band', in *POP: How Graphic Design Shapes Popular Culture*, New York: Allworth Press, 2011, pp. 59–62.

Heller, Steven, 'The Me Too Generation', in *The Graphic Design Reader*, New York: Allworth Press, 2002, pp. 3–5.

*Helvetica*, Dir. Gary Hustwit, Swiss Dots in association with Veer, Documentary Film, 2007.

*Helvetica Forever: Story of a Typeface*, Baden: Lars Muller Publishers, 2007.

Heritage Concorde Website, www.heritageconcorde.com.

Hess, Alan, 'The Origins of McDonald's Golden Arches', *Journal of the Society of Architectural Historians* 45, no. 1 (1986): 6–67.

Hiltzik, Michael, *Dealers of Lightning*, London: Orion, 2000.

Hoffman, Carl and Jake Page, 'On Everest or in the Office, It's the Tool to Have,' *Smithsonian* 20 (1989): 106–16.

Hogg, L. Graham, *The Biro Ballpoint Pen*, Merseyside: LGH Publications, 2007.

Hollis, Richard, *Swiss Graphic Design: The Origins and Growth of an International Style 1920–1965*, London: Laurence King, 2006.

Holt, Douglas B., *How Brands Become Icons: The Principles of Cultural Branding*, Boston: Harvard Business School Press, 2004.

Honten, Hashitatsu (ed.), 'Chopsticks: Supporting Roles in Food Culture', *Food Culture* 16 (2007): 11–14.

Hunt, Jamer, 'Why Designers Should Declare Death to the Post-it', FastCompany.com, 20 May 2005. http://www.fastcompany.com/1650243/why-designers-should-declare-death-post-it.

Isaacson, Walter, *Steve Jobs*, London: Little, Brown, 2011.

Jackson, Leslie, *Robin & Lucienne Day: Pioneers of Contemporary Design*, London: Mitchell Beazley, 2001.

Jackson, Mark and Veronica della Dora, '"Dreams So Big Only the Sea Can Hold Them": Man-Made Islands as Anxious Spaces, Cultural Icons, and Travelling Visions', *Environment and Planning A* 41 (2009): 2086–104.

Jenkins, Henry, *Convergence Culture: Where Old and New Media Collide*, New York: New York University Press, 2006.

Jørgensen, Finn Arne, *Making A Green Machine: The Infrastructure of Beverage Container Recycling*, New Brunswick, NJ: Rutgers University Press, 2011.

Julier, Guy, *The Culture of Design*, London: Sage, 2000, 2008.

Katz, Silvia, *Plastics Designs & Materials*, London: Studio Vista, 1978.

Kemp, Martin, *Christ to Coke: How Image Becomes Icon*, Oxford: Oxford University Press, 2012.

Ken Belson and Brian Bremner, *Hello Kitty: The Remarkable Story of Sanrio and the Billion Dollar Feline Phenomenon*, Singapore: Wiley, 2004.

Keynes, Milo, 'The Portland Vase: Sir William Hamilton, Josiah Wedgwood and the Darwins', *Notes and Records of the Royal Society of London* 52, no. 2 (July 1998): 237–59.

Kircherer, Sybille, *Olivetti*, London: Trefoil, 1988.

Koehn, Nancy F., 'Henry Heinz and Brand Creation in the Late Nineteenth Century: Making Markets for Processed Food', *Business History Review* 73, no. 3 (Autumn 1999): 349–93.

Kravets, Olga and Örsan Örge, 'Iconic Brands: A Socio-Material Story', *Journal of Material Culture* 15 (2010): 205–32.

Labaco, Ron (ed.), *Ettore Sottsass: Architect and Designer,* London: Merrell, 2006.

Lambot, Ian, *Reinventing the Wheel: The Construction of British Airways London Eye*, Surrey: Watermark Publications, 2005.

LaPlante, Mitchell P., 'Demographics of Wheeled Mobility Device Users', Paper presented at the conference *Space Requirements for Wheeled Mobility,* Center for Inclusive Design and Environmental Access, State University of New York Buffalo, NY, 9–11 October 2003.

Lauwaert, Maaike, 'Playing Outside the Box: On LEGO Toys and the Changing Wold of Construction Play', *History and Technology* 24, no. 3 (2008): 221–37.

Leavitt, Sarah Abigail, *From Catharine Beecher to Martha Stewart: A Cultural History of Domestic Advice*, Chapel Hill, NC: University of North Carolina Press, 2001.

Le Corbusier, *Towards a New Architecture*, London: Architectural Press, 1982.

Levin, Miriam R., 'The Eiffel Tower Revisited', *The French Review* 62, no. 6 (May 1989): 1052–64.

Levine, Joshua, 'The Post-it Wars', BusinessWeek.com, 5 January 2012. http://www.businessweek.com/magazine/the-postit-wars-01052012.html. Accessed 30 December 2013.

Levinthal, David and Valerie Steele, *Barbie Millicent Roberts: An Original*, New York: Pantheon Books, 1998.

Levy, Steven, *Insanely Great: The Life and Times of Macintosh, The Computer That Changed Everything*, London: Penguin, 1995.

Lewis, Ellen, *The eBay Phenomenon: How One Brand Taught Millions of Strangers to Trust One Another*, London: Marshall Cavendish, 2008.

Linzmayer, Owen W., *Apple Confidential 2.0: The Definitive History of the World's Most Colorful Company*, San Francisco: No Starch Press, 2008.

Lipkowitz, Daniel, *The LEGO Book*, London: Dorling Kindersley, 2009.

Lloyd, Peter and Dirk Snelders, 'What Was Philippe Starck Thinking Of?' *Design Studies* 24, no. 3 (2003): 237–53.

Lönnqvist, Bo and Johan Silvander, *Ting för lek och tanke: Leksaker i historien*, Lund: Historiske media, 1999.

Lord, M.G., *Forever Barbie: The Unauthorized Biography of a Real Doll*, New York: Morrow and Co. 1994.

Love, John F., *McDonald's: Behind the Arches*, New York: Bantam Books, 1986.

Lucas, Dorian, *Swiss Design*, Salenstein: Braun Publishing, 2011.

Lupton, Ellen, 'Reading Isotype', in Victor Margolin (ed.), *Design Discourse: History, Theory, Criticism*, Chicago: University of Chicago Press, 1989, pp. 145–56.

Lupton, Ellen, *Mechanical Brides: Women and Machines from Home to Office*, New York: Princeton Architectural Press, 1993.

Mackrell, Alice, *Coco Chanel*, New York: Holmes & Meier, 1992.

Magilow, Daniel H., 'Counting to Six Million: Collecting Projects and Holocaust Memorialization', *Jewish Social Studies*, new series, 14, no. 1 (Fall 2007): 23–39.

Marks, David and Julia Barfield, 'More than Architecture', in Dominique Poole and Alan J Brookes (eds), *Innovation in Architecture*, London: Taylor & Francis, 2004.

Marvin, Carolyn, *When Old Technologies Were New: Thinking About Electric Communication in the Late Nineteenth Century*, New York: Oxford University Press, 1988.

McAndrew, John, '"Modernistic" and "Streamlined"', *Bulletin of the Museum of Modern Art* 5, no. 6 (December 1938).

McGilligan, Patrick, *Fritz Lang: The Nature of the Beast*, New York: St. Martin's Press, 1997.

McKendrick, Neil, 'Josiah Wedgwood: An Eighteenth-Century Entrepreneur in Salesmanship and Marketing Techniques', *Economic History Review* 12, no. 3 (1960): 408–33.

McLean, Ruari, *Jan Tschichold: Typographer*, Boston: David R. Godine, Publisher, 1975.

McQuire, Scott, 'Digital Photography and the Operational Archive', in Sean Cubitt, Daniel Palmer, Nathaniel Tkacz and Les Walkling (eds), *Digital Light*, Sydney: Fibreculture, forthcoming, n.p.

McVeigh, Brian J., 'How Hello Kitty Commodifies the Cute, Cool, and Camp: "Consumutopia" versus "Control" in Japan', *Journal of Material Culture* 5, no. 2 (2000): 225–45.

Meikle, Jeffrey L., *Design in the USA*, Oxford: Oxford University Press, 2005.

Meinel, Roland, 'Ein Stuhl macht Karriere: Der Bauhaus Stahlrohrstuhl und seine Folgen', *Kunst+Unterricht*, no. 152 (May 1991): 48–51.

Miller, Daniel and Sophie Woodward (eds), *Global Denim*, Oxford: Berg, 2010.

Minden, Michael and Holger Bachmann (eds), *Fritz Lang's Metropolis: Cinematic Visions of Technology and Fear*, Rochester, NY: Camden House, 2000.

Molotch, Harvey, *Where Stuff Comes From*, London: Sage Publications, 2003.

Moore, Simon, *Penknives and other Folding Knives*, Aylesbury: Shire Publications, 1988.

Morris, May (ed.), *The Collected Works of William Morris*, vol. XXII. London: Longman, 1914.

Mountjoy, Richard, *One Hundred Years of Bell Telephones*, Atglen, PA: Schiffer Publishing Ltd, 1995.

Murray, Janet, *Inventing the Medium: Principles of Interaction Design as a Cultural Practice*, Cambridge, MA: MIT Press, 2012.

Murray, Peter, *The Saga of the Opera House*, New York: Spon, 2004.

Neale, Jay, *The Princess*, http://www.beatriceco.com/bti/porticus/bell/telephones-princess.html. Accessed 10 April 2013.

Neumann, Dietrich (ed.), *Film Architecture: From Metropolis to Blade Runner*, Munich: Prestel, 1996.

Neumann, Dietrich, 'The Urbanistic Vision in Fritz Lang's *Metropolis*', in Thomas W. Kniesche and Stephen Brockmann (eds), *Dancing on the Volcano: Essays on the Culture of the Weimar Republic*, Columbia, SC: Camden House, 1994, pp. 143–63.

Neurath, Marie and Robin Kinross, *The Transformer: Principles of Making Isotype Charts*, London: Hyphen Press, 2009.

Neurath, Otto, *From Hieroglyphics to Isotype: A Visual Autobiography*, London: Hyphen Press, 2010.

Nye, David E., *American Technological Sublime*, Cambridge, MA: MIT Press, 1994.

Oldenziel, Ruth and Karin Zachmann, *Cold War Kitchens: Americanization, Technology, and European Users*, Cambridge, MA: MIT Press, 2008.

Olivier, Marc, 'George Eastman's Modern Stone-Age Family: Snapshot Photography and the Brownie', *Technology and Culture* 48, no. 1 (2007): 1–19.

Owen, Kenneth, *Concorde and the Americans: International Politics of the Supersonic Transport*, Washington, DC: Smithsonian Institution Press, 1997.

Owens, Richard M. and Tony Lane, *American Denim: A New Folk Art*, New York: H.N. Abrams, 1975.

Parry, Linda (ed.), *William Morris*, London: Philip Wilson, 1996.

Parry, Linda, *William Morris Textiles*, London: Weidenfeld & Nicolson, 1983.

Pavitt, Jane (ed.), *Brand. new*, London: Victoria & Albert Museum, 2000.

Peirce, Charles Sanders, *The Essential Peirce, Volume 2: Selected Philosophical Writings*, Peirce Edition Project. Bloomington: Indiana University Press, 1998.

Pendergrast, Mark, *For God, Country, and Coca-Cola: The Definitive History of the Great American Soft Drink and the Company That Makes It*, New York: Basic Books, 2000.

Petroski, Henry, *The Evolution of Useful Things*, London: Pavilion, 1993.

Picardie, Justine, *Coco Chanel: The Legend and the Life*, New York: HarperCollins, 2010.

Poynor, Rick, *Typography Now: The Next Wave*, London: Booth-Clibborn, 1993.

Poynor, Rick, 'The Celebrated Mr. B', *Eye* 35, vol. 9 (Spring 2000).

Prigg, Mark, 'The 2012 Wired 100: Jonathan Ive', *Wired* UK Edition, July 2012.

Rabine, Leslie W. and Susan Kaiser, 'Sewing Machines and Dream Machines in Los Angeles and San Francisco: The Case of the Blue Jean', in Christopher Breward and David Gilbert (eds), *Fashion's World Cities*, Oxford: Berg, 2006, pp. 235–50.

Reilly, Robin, *Josiah Wedgwood 1730–1795*, London: Macmillan, 1992.

Ritzer, George, *The McDonaldization of Society*, 6th edition, Thousand Oaks, CA: Sage Publications, 2010.

Ritzer, George, *McDonaldization: The Reader*, Thousand Oaks, CA: Pine Forge Press, 2006.

Rivett, Miriam, 'Approaches to Analyzing the Web Text: A Consideration of the Web Site as an Emergent Cultural Form', *Convergence* 6, no. 3 (September 2000): 34–56.

Rogers, Mary F., *Barbie Culture*, Thousand Oaks, CA: Sage Publications, 1999.

Rollins, William, 'Reflections on a Spare Tire: SUVs and Postmodern Environmental Consciousness', *Environmental History* 11 (2006): 684–723.

Rubik, Ernő, Tamás Varga, Gerzson Kéri, György Marx and Tamás Vekerdy, *Rubik's Cubic Compendium*, Oxford: Oxford University Press, 1987.

Russo, Beatriz and Anamaria de Moraes, 'The Lack of Usability in Design Icons: An Affective Case Study about Juicy Salif', in *DPPI 2003—Proceedings of the 2003 International Conference on Designing Pleasurable Products and Interfaces*, 23–26 June 2003, Pittsburgh, PA, USA, 146–7.

Saatchi, Maurice, *Brutal Simplicity of Thought: How it Changed the World*, London: Ebury Press, 2011.

Sadler, Simon, *The Situationist City*, Cambridge, MA: MIT Press, 1999.

Sarvas, Risto, and David M. Frohlich, *From Snapshots to Social Media: The Changing Picture of Domestic Photography*, London: Springer, 2011.

Schirman, Danielle, *Le Bic Cristal*, film, Paris: Lapus with Arte France and the Pompidou Centre, 2004.

Schivelbusch. Wolfgang, *Disenchanted Light: The Industrialization of Light in the Nineteenth Century*, Berkeley: University of California Press, 1988.

Schönhammer, Rainer, 'The Walkman and the Primary World of the Senses', *Phenomenology and Pedagogy* 7 (1989): 127–44.

Sculze, Sabine and Ina Grätz, *Apple Design*, Ostfildern: Hatje Cantz Verlag, 2011.

Seago, Alex, *Burning the Box of Beautiful Things: The Development of a Postmodern Sensibility*, Oxford: Oxford University Press, 1995.

Sellen, Abigail J. and Richard H.R. Harper, *The Myth of the Paperless Office*, Cambridge, MA: MIT Press, 2002.

Setright, Leonard, *Drive On! A Social History of the Motor Car*, London: Granta Books, 2002.

Shaw, Paul, *Helvetica and the New York Subway System*, Cambridge, MA: MIT Press, 2011.

Showalter, J. Camille and Janice Driesbach (eds), *Wooton Patent Desks: A Place for Everything & Everything in Its Place*, Indianapolis: Indiana State Museum and Oakland, CA: The Oakland Museum, 1983.

Singmaster, David, *Notes on Rubik's 'Magic Cube'*, 5th edition, London: David Singmaster, 1980.

Sklair, Leslie, 'Iconic Architecture and Capitalist Globalization', *City* 10, no. 1 (2006).

Sklair, Leslie, 'Iconic Architecture and the Culture-Ideology of Consumerism', *Theory Culture Society* 27 (2010): 135–58.

Sparke, Penny, *Ettore Sottsass Jnr*, London: Design Council, 1982.

Sparke, Penny, *Italian Design: 1870 to the Present*, London: Thames and Hudson, 1989.

Stockmarr, Pernille, 'LEGO klodsen', in Lars Dybdahl (ed.), *De industrielle ikoner: Design Danmark*, Copenhagen: Det danske Kunstindustrimuseum, 2004, pp. 78–9.

Storz, Moni Lai, *Dancing with Dragons: Chopsticks People Revealed for Global Business*, Ashburton, VIC: Global Business Strategies, 1999.

Strasser, Susan, *Satisfaction Guaranteed: The Making of the American Mass Market*, New York: Pantheon Books, 1989.

Sudjic, Deyan, *Cult Objects*, London: Paladin, 1985.

Teige, Karel, *The Minimum Dwelling*, Cambridge, MA: MIT Press, 2010.

Tenner, Edward, *Our Own Devices: How Technology Remakes Humanity*, New York: Vintage Books, 2004.

Tessera, Vittorio, *Innocenti Lambretta: The Definitive History*, Milan: Giorgio Nada, 1999.

Themerson, Stefan, 'Kurt Schwitters on a Time Chart', *Typographica* 16 (December 1967).

Thompson, William, 'The Symbol of Paris: Writing the Eiffel Tower', *The French Review* 73, no. 6 (May 2000): 1130–40.

Tosa, Marco, *Barbie: Four Decades of Fashion, Fantasy, and Fun*, New York: Harry N. Abrams, 1998.

Toscani, Oliviero, 'Taboos for sale', interview by Michael Guerrin, *Guardian Weekly*, 26 March 1995.

Tschichold, Jan, 'Mein Reform der Penguin Books', [My Reform of Penguin Books] in *Schweizer Graphische Mitteilungen* 6 (1950).

United States, *The Secretary's Decision on Concorde Supersonic Transport*, Washington, DC: U.S. Department of Transportation, 1976.

Victoria and Albert Museum, *Modern Chairs, 1918–1970*, London: The Whitechapel Art Gallery, 1970.

Victorinox, *The Knife and its History: Written on the Occasion of the 100th Anniversary of VICTORINOX*, Ibach: Victorinox, 1984.

Vidler, Anthony, 'What is a Diagram Anyway?' in Silvio Cassara, (ed.) *Peter Eisenman: Feints*, Milan: Skira, 2006.

Vossoughian, Nader, *Otto Neurath: The Language of the Global Polis*, Rotterdam: NAi Publishers, 2008.

Walker, Stuart, *The Spirit of Design: Objects, Environment and Meaning*, London: Earthscan, 2011.

Walters, Betty Lawson, *The King of Desks: Wooton's Patent Secretary*, Washington, DC: Smithsonian Institution Press, 1969.

Warshaw, Matt, 'Slaps', *Encyclopedia of Surfing*, revised edition, New York: Harcourt, 2005.

Watson, Anne (ed.), *Building a Masterpiece: The Sydney Opera House*, Sydney: Powerhouse Publishing, 2006.

Watson, James L., *Golden Arches East: McDonald's in East Asia*, Stanford, CA: Stanford University Press, 1997.

Wilk, Christopher, *Marcel Breuer, Furniture and Interiors*, New York: Museum of Modern Art, 1981, Exhibition catalogue.

Yano, Christine R., 'Wink on Pink: Interpreting Japanese Cute as It Grabs the Global Headlines', *Journal of Asian Studies* 68, no. 3 (2009): 681–8.

Young, Hilary (ed.), *The Genius of Wedgwood*, London: Victoria and Albert Museum, 1995.

# Trademark Acknowledgements